Art and Public History

ABOUT THE SERIES
The American Association for State and Local History Book Series addresses issues critical to the field of state and local history through interpretive, intellectual, scholarly, and educational texts. To submit a proposal or manuscript to the series, please request proposal guidelines from AASLH headquarters: AASLH Editorial Board, 2021 21st Ave. South, Suite 320, Nashville, Tennessee 37212. Telephone: (615) 320-3203. Website: www.aaslh.org.

ABOUT THE ORGANIZATION
The American Association for State and Local History (AASLH) is a national history membership association headquartered in Nashville, Tennessee. AASLH provides leadership and support for its members who preserve and interpret state and local history in order to make the past more meaningful to all Americans. AASLH members are leaders in preserving, researching, and interpreting traces of the American past to connect the people, thoughts, and events of yesterday with the creative memories and abiding concerns of people, communities, and our nation today. In addition to sponsorship of this book series, AASLH publishes *History News* magazine, a newsletter, technical leaflets and reports, and other materials; confers prizes and awards in recognition of outstanding achievement in the field; supports a broad education program and other activities designed to help members work more effectively; and advocates on behalf of the discipline of history. To join AASLH, go to www.aaslh.org or contact Membership Services, AASLH, 2021 21st Ave. South, Suite 320, Nashville, TN 37212.

Art and Public History

Approaches, Opportunities, and Challenges

Edited by
Rebecca Bush and K. Tawny Paul

ROWMAN & LITTLEFIELD
Lanham • Boulder • New York • London

Published by Rowman & Littlefield
A wholly owned subsidiary of The Rowman & Littlefield Publishing Group, Inc.
4501 Forbes Boulevard, Suite 200, Lanham, Maryland 20706
www.rowman.com

Unit A, Whitacre Mews, 26-34 Stannary Street, London SE11 4AB

British Library Cataloguing in Publication Information Available

Library of Congress Cataloging-in-Publication Data

Names: Bush, Rebecca Elizabeth, editor. | Paul, K. Tawny, 1982- editor. |
 American Association for State and Local History.
Title: Art and public history : approaches, opportunities, and challenges /
 edited by Rebecca Bush and K. Tawny Paul.
Description: Lanham : Rowman & Littlefield, 2017. | Series: The American
 Association for State and Local History book series | Includes
 bibliographical references and index.
Identifiers: LCCN 2016058698 (print) | LCCN 2016058975 (ebook) | ISBN
 9781442268432 (cloth) | ISBN 9781442268449 (pbk.) | ISBN 9781442268456
 (ebook)
Subjects: LCSH: Art and history. | Art in education. | Public history. |
 Museum techniques.
Classification: LCC N72.H58 A77 2017 (print) | LCC N72.H58 (ebook) | DDC
 700.71—dc23
LC record available at https://lccn.loc.gov/2016058698

♾™ The paper used in this publication meets the minimum requirements of
American National Standard for Information Sciences—Permanence of Paper
for Printed Library Materials, ANSI/NISO Z39.48-1992.

Printed in the United States of America

Contents

List of Figures vii

Foreword xiii
 Bob Beatty

Acknowledgments xvii

Introduction: Art and Public History: Opportunities, Challenges, and Approaches 1
 Rebecca Bush and Tawny Paul

PART I: HISTORICAL ARTWORKS

1 Visual Art and the American Experience: Creating an Art Gallery in a History and Culture Museum 23
 Tuliza Fleming

2 Citizenship and Caricature: Teaching the American Past with Images 47
 Jennifer M. Black

3 Investigating the Past through Art: Opportunities for Museum Education 71
 Megan Clark and Heidi Moisan

PART II: CONTEMPORARY ART AND ARTIST COLLABORATIONS

4 "The Art Museum Does History?": Building Connections and Relevancy within Multidisciplinary Museums 99
 Rebecca Bush

5 Coming Face to Face with the Past: Exploring Scottish History
and National Identity through Portraiture 117
Tawny Paul

6 Framing the Collaborative Process 137
Teresa Bramlette Reeves, Julia Brock, and Kirstie Tepper

PART III: PUBLIC ART AND THE BUILT ENVIRONMENT

7 A Call for Proactive Public Historians 159
Nancy Dallett

8 Savannah's Hidden Histories: Using Art and Historical
Markers to Explore Local History 175
Holly Goldstein and Christy Crisp

9 Travelers, Tale-Telling, Truth, and Time 201
Rebecca Keller

Conclusion 227
Rebecca Bush and Tawny Paul

Bibliography 235

Index 245

About the Contributors 249

List of Figures

Figure F.1. Roy McLendon, *Indian River Road with Fisherman*.
Courtesy of Kilby Photo. xiv

Figure 1.1. Robert S. Duncanson, *The Garden of Eden*, 1852.
Collection of the Smithsonian National Museum of
African American History and Culture. Gift of
Louis Moore Bacon. 33

Figure 1.2. David C. Driskell, *Behold Thy Son*, 1956. Collection
of the Smithsonian National Museum of African
American History and Culture. 36

Figure 1.3. Dave Mann, *Till Boy's Funeral, Burr Oaks
Cemetary* [*sic*], September 6, 1955. Collection of the
Smithsonian National Museum of African American
History and Culture. Gift of Lauren and Michael Lee. 37

Figure 1.4. Jefferson Pinder, *Mothership (Capsule)*, 2009. Collection
of the Smithsonian National Museum of African
American History and Culture. Gift of Henry
Thaggert III in memory of Burnell P. Thaggert. 40

Figure 1.5. Designed by Jules Fisher and George Clinton.
The Mothership, 1990s. Collection of the Smithsonian
National Museum of African American History and
Culture. Gift of Love to the planet. 41

Figure 2.1. Charles Paxson, "Rosa, a Slave Girl from New Orleans,"
1864. William Gladstone Collection of African American
Photographs, Library of Congress, Prints & Photographs
Division [Reproduction number LC-DIG-ppmsca-11240]. 48

Figure 2.2. Nathaniel Currier, *The Fruits of Temperance*, 1848.
Library of Congress, Prints & Photographs Division
[Reproduction number LC-USZC2-2380]. 53

Figure 2.3. Currier & Ives, *The Bad Husband: The Fruits of
Intemperance and Idleness*, 1870. Library of Congress,
Prints & Photographs Division [Reproduction number
LC-USZ62-699] 55

Figure 2.4. Edward William Clay, *Life in Philadelphia:
Miss Chloe*, 1830. Courtesy of The Library Company
of Philadelphia. 59

Figure 2.5. David Claypoole Johnston, *Women's Rights at
the Polls*, 1849. Courtesy of Old Sturbridge Village
Research Library. 61

Figure 2.6. Unknown artist, *Florence Nightingale vs.
Bridget McBruiser*, 1866. Reprinted from
Samuel R. Wells, *New Physiognomy: Or, Signs of
Character, as Manifested through Temperament and
External Forms, and Especially in "the Human
Face Divine"* (New York: Fowler & Wells, 1875
[1866]), 537. Available online at http://archive
.org/details/newphysiognomyor00well. 63

Figure 3.1. This worksheet allows students to view a color
version of the painting up close and helps them
record initial thoughts and ideas. Chicago History
Museum Education Department. 76

Figure 3.2. In the gallery, students view and discuss the
original artwork during a conversation driven
by the details they found in the painting. Photograph
by Stephen Jensen for the Chicago History Museum. 77

Figure 3.3. The language and visual cues on the gallery worksheet
evolved throughout pilot testing. Chicago History
Museum Education Department. 79

Figure 3.4. While the workshop focuses on Julia Lemos and her
painting, it sparks student curiosity about the Great
Chicago Fire, and they enjoy the opportunity to see
additional artifacts related to the fire up close.
Photograph by Stephen Jensen for the Chicago
History Museum. 80

Figure 3.5. Students use movement to express the details they
found in the painting. Photograph by Joseph Aaron
Campbell for the Chicago History Museum. 82

Figure 3.6. Student details and their observations from
discussing Julia Lemos's written account are
annotated on a projection of the Lemos painting.
Chicago History Museum Education Department. 83

Figure 3.7. On average, students include interpretations of
four "Lemos" details in their book drawings.
Chicago History Museum Education Department. 90

Figure 4.1. Najee Dorsey, *B4 Rosa—Here I Stand*, 2014.
Collection of the Columbus Museum, Georgia;
Museum purchase made possible by the Edward
Swift Shorter Bequest Fund, G.2015.1. 105

Figure 4.2. Images from artist Ronie Dalton's *A Break in the
Battle: Tattoo Project/Fort Benning* fill the Galleria
of the Columbus Museum in 2016. Courtesy of the
Columbus Museum, Georgia. 109

Figure 4.3. The exhibition *We Tattooed Your Father:
The Global Art of Tattoos* included designs by
local tattoo artists and contemporary artists' own
interpretations of tattooed bodies. Courtesy of the
Columbus Museum, Georgia. 110

Figure 4.4. Henry Inman, *Opothle-Yoholo (Creek Chief)*,
1831–1832. Collection of the Columbus Museum,
Georgia. Museum purchase made possible in part
by the Ella E. Kirven Charitable Lead Trust for
Acquisitions, The Crowley Foundation Acquisition
Fund, and a gift of Robert M. and Jane D. Hicklin in
memory of Mr. and Mrs. Robert M. Hicklin Sr., G.2011.3. 112

Figure 4.5. Thomas L. McKenney and James Hall, *Opothle Yoholo—A Creek Chief*, 1836–1844. Collection of the Columbus Museum, Georgia. Gift of C. Dexter Jordan, G.1954.80. 113

Figure 5.1. Portraiture is woven into the fabric of the Scottish National Portrait Gallery building. Photography by Tawny Paul. 120

Figure 5.2. Some of the Gallery's exhibitions such as *Blazing with Crimson* might be seen to uphold more traditional images of Scots. Photography by Tawny Paul. 122

Figure 6.1. Installation view, *Forget Me Not*. Zuckerman Museum of Art, August 22–December 6, 2015. Photograph by Mike Jensen. Courtesy of the Zuckerman Museum of Art. 138

Figure 6.2. Installation view, *Forget Me Not*. Zuckerman Museum of Art, August 22–December 6, 2015. Photograph by Mike Jensen. Courtesy of the Zuckerman Museum of Art. 139

Figure 6.3. Installation view, *Hearsay*. Zuckerman Museum of Art, July 26–October 25, 2014. Photograph by Mike Jensen. Courtesy of the Zuckerman Museum of Art. 150

Figure 6.4. Installation view, *Hearsay*. Zuckerman Museum of Art, July 26–October 25, 2014. Photograph by Mike Jensen. Courtesy of the Zuckerman Museum of Art. 151

Figure 8.1. Michael Mergen, *Lee's Retreat, M-11*, 2015. Courtesy of the artist. 186

Figure 8.2. Michael Mergen, *The Last Fight, K-156*, 2015. Courtesy of the artist. 186

Figure 8.3. Dylan Wilson, *Former Site of Lucy Robert's House in Raccoon Bluff*, 2014. Courtesy of the artist. 188

Figure 8.4. Dylan Wilson, *South End House*, 2014. Courtesy of the artist. 189

Figure 8.5. Charlie Swerdlow, *Reconstruction of the Yamacraw's Village*, 2014. Courtesy of the artist. 190

Figure 8.6. Charlie Swerdlow, *Yamacraw Village Housing Community*, 2014. Courtesy of the artist. 191

Figure 8.7. Erica Corso, *Slaves on Fort Pulaski Wearing Old Union Uniforms, Living in Outbuilding Around the Fort*, 2015. Courtesy of the artist. 192

Figure 8.8. Erica Corso, *Some of the First Black Soldiers*, 2015. Courtesy of the artist. 192

Figure 8.9. Elizabeth Cara, *Savannah Arts Academy Hallway*, 2015. Courtesy of the artist. 193

Figure 8.10. Elizabeth Cara, *Savannah Arts Academy Original Wooden Chairs*, 2015. Courtesy of the artist. 194

Figure 9.1. *Home/Work House/Work: A Meditation on Labor*, Glessner House Museum, 2006–2007. Courtesy of the author. 210

Figure 9.2. *Fingerprint by Fingerprint*, Jane Addams Hull-House Museum, 2010. Courtesy of the author. 212

Figure 9.3. *Attributes of the Gods: Veselius*, International Museum of Surgical Science, 2011. Courtesy of the author. 214

Figure 9.4. *Attributes of the Gods: Imhotep*, International Museum of Surgical Science, 2011. Courtesy of the author. 215

Figure 9.5. *Knowledge Distillery*, International Museum of Surgical Science, 2011. Courtesy of the author. 215

Figure 9.6. *Taking Flight*, Chesterwood, 2013. Courtesy of the author. 218

Figure 9.7. *Conversations: Wings of Clay*, Chesterwood, 2013. Courtesy of the author. 219

Figure 9.8. *Dreams Are the Guardian of Sleep* installation view, Museum of Contemporary Art Chicago, 2014. Courtesy of the author. 222

Figure 9.9. *Scent and Trace of Truth and Desire*, 2013. Courtesy of the author. 223

Figure 9.10. *The Organ for Binding and Writing* and *Against My Skin*, 2013. Courtesy of the author. 224

Figure 9.11. *Migrant Objects*. Courtesy of the author. 225

Foreword

Bob Beatty

"I don't know art from Adam" is something I commonly say when in a conversation about art. It's a cliché (and frankly nowhere near as funny as it was the first time I understood it), but it's true nonetheless. I'm far from an expert in art, and after nearly twenty years in the history and museum business, I'm sometimes still intimidated in discussions with art-minded colleagues or even when I go to art museums and galleries.

That said, I regularly remark to colleagues over the years how envious I am of art museum professionals. Art is a blank canvas with few of the "rules" we have to follow in the history discipline. Virtually anything can be art, and anyone can make art.

Yes, the material with which we work diverges. As editors Rebecca Bush and Tawny Paul wrote in their proposal for this book, "Artists and public historians have different ways of 'knowing,' researching, and communicating the past. While creativity and interpretation are inherent to both fields, art can challenge the certainties of evidence-based research." But while art and history use primary sources differently, that does not mean the disciplines are mutually exclusive. As author Susan Cahan remarked to Carol Bossert on Bossert's podcast *The Museum Life*, "In our culture, art is considered one of the highest forms of human expression."[1] Therein lies the connection between the two disciplines: people. This offers opportunities galore.

Art is a powerful way to connect with people, and I embrace its potential for our institutions and for our communities. I seek to better understand the possibilities and intersections between art and history because I know it is a potent weapon in our arsenal. I first discovered this in the early 2000s through an exhibition on the Florida Highwaymen at the Orange County Regional History Center where I worked.

The Highwaymen story is fascinating. They are an informal cadre of twenty-six untrained African American painters who, beginning in the mid-1950s, painted Florida landscapes and sold them door-to-door to banks, law offices, real estate agents, motels, and the like. As African Americans excluded from the world of art galleries and studios, this was their primary means of sale and distribution. It is a remarkable story of how twenty-five men and one woman survived, and thrived, as artists living within the caste system that was Jim Crow segregation.

Many who lived along Florida's east coast between Miami and Jacksonville in the 1950s through the 1980s remember well these itinerant artists. Countless people, including my own father, can recount stories of buying Highwaymen art. It appealed to many because it reflected an idealistic version of Florida: sunsets, moonlit rivers, palm trees, and beaches, among other subjects. By no means was it fine art. Their work, painted on inexpensive Upson board and framed in crown molding, typically cost around $25— sometimes less. For this reason, as people redecorated homes and offices, they discarded many Highwaymen paintings.

In the mid-1990s, interest in the art of the Highwaymen resurged. In 1995, Florida art collector Jim Fitch dubbed them "The Florida Highwaymen." In 2001 author Gary Monroe named for the first time the twenty-six artists comprising the group. Paintings that originally sold for $25 were sometimes worth $1,000 (or more).

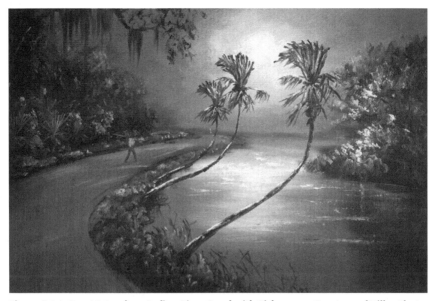

Figure F.1. Roy McLendon, *Indian River Road with Fisherman.* Courtesy of Kilby Photo.

In 2002, the History Center hosted its first Highwaymen exhibit. How we organized that exhibit demonstrated to me a clear intersection between art and history—something that remains with me today. I wish I could take credit for the concept, but I can't. It was completely the brainchild of the late Barbara Knowles, my colleague in our exhibits department.

At the time of the launch of our first exhibit we had no artifacts that represented the artists or their story. We only had paintings from a local collector to display and a mandate from our director, Sara Van Arsdel, to mount an exhibition. None of us were versed in art history or in interpreting art. We were public historians, and this challenged us. Then Barbara one day suggested, "Why don't we use the paintings as artifacts to tell the Highwaymen story?" It was a brilliant idea and an honest-to-goodness breakthrough for me in terms of how I approach my work.

Barbara's idea allowed us to use this truly beautiful artwork as images that highlighted the Highwaymen's tale. This was what we were most qualified to do: putting the saga of the artists in the context of the times in which they and their customers lived.

Our exhibit didn't emphasize implied meanings in the individual pieces of art. In fact, most of the artists eschewed these distinctions altogether. They proudly proclaimed they produced their art for commerce. It was a means for them, as people systematically deprived of economic, social, political, and educational power, to make a living as something other than menial laborers or in domestic service.

That initial exhibit was a tremendous success. We subsequently hosted several more exhibitions, put together a traveling exhibit, and hosted dozens of events with Highwaymen artists themselves. I eventually published a book on the Highwaymen based on the research of Barbara and others.

Because the story was well known to many Floridians—and many had owned (and later scrapped) Highwaymen paintings over the years—the exhibition had record crowds. But I'd argue that the best thing that came of it was the way it used art to share history. People came to see Highwaymen art, and sometimes to meet a genuine Highwayman artist. But they got so much more when they explored an exhibit that presented that art in historical context.

People can certainly be as intimidated to visit a history museum as I can be talking about art. A display of Highwaymen art and complementary programming lowered the barrier for guests. It's my experience that art is a very, very effective way to do so.

This book offers examples of other intersections between art and history. It began with a panel that Rebecca and Tawny organized at the 2015 National Council on Public History conference. As in our session, *The Art of Public History* offers examples from here in the United States as well as in Great Britain. These projects highlight local and national history museums,

art galleries, online archives, classrooms, historical markers, and public art. Together, they bring to the fore some of the key lessons I learned when I took my first tentative steps toward bringing art into my work in the world of history organizations.

So thank you, Barbara, for what was a truly creative way to tell the Highwaymen story. Your ideas and inspiration stay with me today.

I hope you will find much in this volume to inspire you likewise.

NOTE

1. Susan Cahan to Carol Bossert, "Encore: Mounting Frustration," *The Museum Life*, podcast audio September 23, 2016, https://itunes.apple.com/us/podcast/the-museum-life/id705700091?mt=2&i=374854900.

Acknowledgments

Any book, especially an edited volume with multiple authors, cannot come together without significant help. We wish to sincerely thank all of our contributors, who brought their varied perspectives and experiences from all corners of the history and art worlds. Without them, this work would not exist. The idea for this book was born out of a session at the 2015 annual conference of the National Council on Public History and was further refined at that year's annual meeting of the American Alliance of Museums. We greatly appreciate all those who participated in and attended those panel discussions, offering feedback on ideas discussed and suggesting the names of colleagues who shared our interests. These stimulating conversations might never have moved to the page had it not been for Bob Beatty, who encouraged us to publish with the American Association for State and Local History's book series; to him, we owe much gratitude for believing in the merits of this project at its early stages. Finally, we would be remiss if we did not thank our family, friends, and colleagues on two continents who have heard many musings on the intersection of art and history during this book's creation. Whether suggesting new directions, listening to frustrations, or injecting moments of levity, your insights have been invaluable to this book's progress and our sanity. To all of the above contributors and collaborators, we offer a hearty thank you.

Art and Public History

Opportunities, Challenges, and Approaches

Rebecca Bush and Tawny Paul

This book began life as a panel called "Bringing Art into Public History" at the National Council of Public History's annual conference in 2015. At the time, Tawny was teaching European History at a university in the UK, and Rebecca was working as a curator at a multidisciplinary museum in Georgia. It was an unlikely collaboration, and it's fair to say that we both came at the idea of integrating art with public history a bit by accident. After graduating with a degree in history, Rebecca took her job as a history curator at an institution primarily thought of as an art museum, and found herself both pondering and defending her role as a historian in that context. Tawny came to this topic through an academic study of portraiture. While spending time in Scotland's National Portrait Gallery, she noticed how deliberately this institution integrated art with the telling of history, and wondered about how well visitors engaged with portraits as they learned about the nation's past.

In response to our respective experiences, we submitted nearly identical panel proposals to the annual conference of the National Council on Public History. We then decided to join forces and put out a call for papers. We were overwhelmed with interest from individuals working in diverse fields, as curators, educators, artists, and academics. After receiving over twice as many proposals as we could take, we turned our session into a roundtable in order to include as many voices as possible. On the day of the presentation, the room was packed. The audience seemed interested in both the conceptual implications of collaboration between art and public history and the practical tools that some of our presenters shared. Spectators tweeted questions and comments about how art in museums engages or does not engage with conversations in public history, about differences in convention between the two fields, and about the politicization of images. They were eager to know how exactly visitors engaged with art, and to see examples that would help

them think through how they might combine art with public history in their own practices.

Clearly, the theme of integrating art and public history hit a nerve. And yet when we looked around, there was not a single book that dealt comprehensively with the topic. There were several journal articles and the odd chapter in an edited collection, but no single place that would bring together some of the theoretical, methodological, and practical questions that interested our audience. This volume attempts to rectify that problem. Each chapter presents a case study where public history and art were combined. It includes authors who presented as part of our panel in 2015, and others who we invited to share projects. The book is divided into sections on historic art; contemporary art and artist collaborations; and public art and the built environment. Within these sections, each chapter touches on three central concerns: engaging audiences, challenging histories, and making meanings. We consider academic theory and practical experience. It is our hope that the combination of the theoretical/pedagogical and the practical/methodological will encourage a deeper understanding of the benefits and challenges of integrating art and history, as enterprising public historians, art historians, and artists engage in diverse projects. In these pages, readers will find much to discuss and ponder, as well as helpful tips and how-to guides for developing interdisciplinary initiatives of their own.

A TRADITION OF COLLABORATION: THE ARTIST INTERVENTION

Art and history have had a long relationship. Most history museums hold art in their collections. Most art museums place their collections in historical context. The idea that art and history somehow come naturally together is thus not new. Our concern, however, is with a more active and intensive collaboration between the two fields, and how interdisciplinary working can yield new meanings, new stories, and new forms of engagement with the public. Collaborations between history and art have often taken the form of an artist intervention, a now established practice wherein a contemporary artist interacts with a historic collection in order to make new meanings or to offer institutional critique.

The tradition of art's interventions with public history can be traced back to the Maryland Historical Society's collaboration in 1992 with the African American artist Fred Wilson and the Contemporary Museum of Baltimore in the exhibition *Mining the Museum*. In this exhibition, Maryland Historical invited Wilson to reinterpret its collections. Wilson was given access to the

Society's extensive archives of historical artifacts, which included decorative arts, paintings, and sculpture. He redisplayed and juxtaposed objects in a series of installations that reinterpreted the significance and meaning of these historic decorative items, using them to tell new stories and expose the experiences of actors often left out of standard historical narratives. In particular, Wilson's installations highlighted forgotten, invisible, and lesser-told histories of slavery and racism. For example, in the installation *Metalwork 1793–1880*, ornate silver objects, including teacups, pitchers, and teapots, were displayed alongside a pair of slave shackles. By making apparent the links between these two kinds of metal objects, Wilson reminded viewers that social relations of subjugation and enforced labor were intimately bound with early America's material culture, and that the beauty of arts and crafts had a relationship with histories of trauma. While we admire and carefully preserve beautiful objects from our nation's past, and we remember the stories of the people who used them, we sometimes forget who made those objects, and in turn, what those objects might tell us about their stories and experiences.

Mining the Museum drew attention to the potential of art within public history initiatives. A multidisciplinary collaboration between two very different kinds of institutions, it was more than just an exhibition. It was an intervention. While weaving new perspectives into the museum's interpretations of the past, it also did much more. As the exhibition's curator, Lisa Corrin, reflected, *Mining the Museum* was not just about what objects mean but how meaning is made when they are "framed" by the museum environment and museum practices. The intervention allowed the Maryland Historical to ask some tough questions about the role of the museum and the positions of different stakeholders within that institution. It threw into flux commonly held definitions of "museum," "history," "exhibition," "curator," "artist," "audience," "community," and "collaboration."[1]

While challenging the museum, *Mining the Museum* also helped the institution better achieve its aims by addressing two particular concerns at the time: the need to better address public interests and to develop audiences more representative of the community's cultural diversity.[2] By telling more complex, nuanced, and inclusive histories of the state, the museum might appeal to more people and broaden its audiences. *Mining the Museum* also played with the tenor of communication and audience engagement within the museum walls. New users would not only be viewers and learners but also subjects and interpreters. Furthermore, by positioning the artist as curator, it disrupted the relationship between curator, subject, and artist. An African American would be positioned as historical interpreter of the exhibition rather than only its subject. The objectives of challenge, diversification, and ownership were encapsulated in the exhibition's title. As Wilson later explained, "I called the installation

Mining the Museum because it could mean mining as in a gold mine—digging up something rich with meaning—or mining as in landmine—exploding myths and perceptions—or it could mean making it mine."[3]

Mining the Museum has become a model in the practice of artistic intervention. Since this landmark exhibition, the integration of contemporary art and public history has grown in practice. The use of art has come to supplement, and on some occasions, even to replace, more "traditional" exhibition formats based upon the display of artifacts. This goes against the grain of decades, even centuries, of collecting objects to preserve and represent the past. The practice of integrating contemporary art and public history has also grown in scope, beyond "intervention," to include a variety of strategies and mediums. As public historians seek new ways to connect with people, art seems to offer interpretive possibilities. Numerous initiatives have shown that art is a useful tool for representing human experience and can help us to materialize intangible human emotions. Digital platforms, from online exhibitions to archives, make use of images in order to provide opportunities to engage new audiences and capture new stories. Collaboration with artists can take diverse forms, moving outside the museum walls into a variety of new spaces and places. The integration of visual arts and public history can include incorporating historic imagery into storytelling, as well as contemporary artistic collaboration.

Marking the twenty-five-year anniversary of *Mining the Museum*, the chapters that follow provide an updated and critical evaluation of the intersections between art and public history. We address how public historians can incorporate art into their practice by outlining opportunities, challenges, and insights drawn from recent projects in the United States and Britain. The projects represented in this book have taken place across a variety of platforms, including local and national history museums; art galleries; classrooms; public history markers; and public art projects. The case studies draw on the perspectives of different stakeholders, including public historians, artists, curators, and audiences. We incorporate curatorial, artistic, and academic perspectives, and share insights developed through both personal experience and empirical research. We hope that by presenting these diverse case studies and perspectives our collective experiences will help current practitioners think through the opportunities and challenges that they face as they integrate art and public history in the future.

ART AND PUBLIC HISTORY: BEYOND INTERVENTION

Twenty-five years after *Mining the Museum*, we now have a plethora of international case studies to draw upon as we consider the relationship between

art and public history. As museum practices and scholarship have developed and changed, new projects have emerged and new insights into the integrative potential of art and history have become apparent. At the same time, collaboration between these two fields seems to follow discernible patterns.

Public historians look to art to help interpret particular kinds of history, in particular kinds of contexts. Artistic collaboration has been used especially as a tool for telling "difficult" or "challenging" histories.[4] One recent and powerful example in the UK was the use of contemporary art to address Britain's role in the history of slavery. In 2007, museums throughout Britain responded overwhelmingly to the controversial bicentennial commemorations of the abolition of the British slave trade through contemporary art. Some responses, like *Uncomfortable Truths: The Shadow of Slave Trading on Contemporary Art* at London's Victoria and Albert Museum, involved artistic intervention. Works by prominent artists, including Keith Piper, were placed throughout permanent galleries in order to juxtapose contemporary art installations and historical design objects. When placed side by side, the contemporary installations created a visual dialogue, challenging the meanings of historical objects, many of which were rooted in histories of imperialism and slavery.[5] Like *Mining the Museum*, *Uncomfortable Truths* created a dialogue about the collection's connections with the slave trade.

Other artistic responses to the bicentenary involved high-profile purchases of contemporary art. The British Museum, for example, acquired Romuald Hazoumé's *La Bouche du Roi*, a multimedia artwork consisting of 304 plastic petrol cans arranged to echo a famous eighteenth-century abolitionist print of the layout of a Liverpool slave ship, the Brookes. Incorporating sound, spiritual objects, and individual masks, the installation critiqued the iconic engraving and highlighted the limitations of traditional narratives of abolition.[6] As two institutions whose collections have deep connections with imperialism, the exhibitions at the V&A and BM were part of an effort to engage in a politically appropriate, sensitive, and nuanced commemoration of the bicentenary.

Art's potential for addressing difficult and potentially traumatic histories has been explored in a number of different contexts, including both exhibitions and educational programming. The Manchester Museum in northern England has used objects to facilitate storytelling and memory work among Somali refugee women.[7] The Imperial War Museum in London has exhibited art as a means of exploring responses to the Holocaust among survivors and documentary artists.[8] Because some survivors found their experiences difficult to talk about or were not encouraged to discuss them, many turned to art as an outlet. Employing art to address difficult histories offers institutions a way to acknowledge that for some episodes of history, in the words of

Miranda Stearn, "traditional, rational museum text and exhibitions, however revisionist the content, seem an inadequate response."[9] Incorporating a variety of media to create visual, auditory, and olfactory sensory experiences, all of these exhibitions acknowledged that some histories are beyond words. As one study of the 1807 commemorations suggested, "Alternative forms of representation might be required above and beyond formal historical exhibitions."[10]

Case studies exemplifying art's potential to help address "difficult" pasts have included work dealing with politically contentious issues. Museums have often been considered "contact zones" between different genres of interpretation, different cultures, and different ideas and ways of doing things.[11] Within spaces of encounter, art can help facilitate contact and debate by diversifying the styles of communication possible. In Europe and America, for example, there is a tradition of using art installation to talk about the thorny issues of multiculturalism, diversity, and immigration. The Brooklyn Museum's installation *Connecting Cultures* uses the process of looking at art as a means of making connections between cultures.[12] *Destination Donegal*, an exhibition addressing cultural diversity in Ireland, focused on individual stories through a series of installations that mounted clothing as a form of self-portrait in the style of "Felt Suit" (1970) by Joseph Beuys.[13] Similarly, in *Towards the Other* (2011), in the State Museum of the History of St. Petersburg, video installations featuring individuals talking about migration were mounted in order to "celebrate the positive aspects of the cultural transformations migration has brought about in European culture" and to help viewers "understand, and sympathise with, the difficulties migrants experience upon entering that culture."[14] Though the "funeral" thrown for an abandoned house in Philadelphia was conceived of as an art project, the addition of a public historian project led to a deeper consideration of racial politics and neighborhood geographies.[15]

When dealing with difficult histories, visual art and artistic practice have been considered particularly useful tools for conveying humanistic connections. Art can be a powerful tool for representing human experience and materializing human emotion. Recent examples include *Into Body Into Wall*, a collaboration between Jane Addams Hull-House Museum, The 96 Acres Project, and artist Maria Gaspar, which looked at architectures of power and incarceration at the Cook County Jail on Chicago's West Side.[16] The Brooklyn Museum's *Tipi: Heritage of the Great Plains* combined objects from the Brooklyn Museum's collection of Plains material, objects by contemporary Plains artists, photographs, and three full-sized tipis. Here, the tipi became a focal point to explore cultural, social, religious, and creative traditions of the Great Plains across time by using mixed media.[17] At

the Eastern State Penitentiary in Pennsylvania, artists are invited to submit proposals that "evoke a broad range of emotions" and find connections between the site's historical purpose and "today's criminal justice system and corrections policies." In a short statement titled "Why Collaborate with Artists?" Eastern State's Sean Kelley writes that the goal of the project is to "humanize [the site's] difficult subjects" and challenge visitors, acknowledging that in doing so, the institution must also be "prepared to face some provocative questions ourselves."[18]

In addition to materializing emotion, art holds a useful place in public history by tapping into different kinds of knowledge and knowledge production. Artists and public historians have different ways of "knowing," researching, and communicating the past. While creativity and interpretation are inherent to both fields, art can challenge the certainties of historical evidence-based research. One recent collaboration between artists and a historian at Bank Street Arts in Sheffield, England, explored what was missing from textual evidence. Using domesticity and the home as a focal point, a series of installations explored the knowledge that can be gleaned by interacting with the material environment, rather than just studying it.[19] Not only do these kinds of projects challenge how we do history, but they also have the potential to expand how we communicate in dialogue with our audiences. Art theorist Doris Sommer emphasizes art's power to provoke and to communicate. We can move beyond a teacher-learner relationship between museum and visitor to support what museum theorist Andrea Witcomb calls "dialogical presentation."[20] This might include disrupting the roles of curator, interpreter, and audience, encouraging visitors to move between the roles of history consumer and history creator. One installation at Bank Street Arts, for example, invited visitors to "engage directly with the materiality of the building by depositing a written token through the floorboards and leaving only a button exposed. In so doing visitors recreated historic practices of deliberately concealing objects within the frame of a house."[21]

The incorporation of artistic practice into public history initiatives often involves connecting the past with contemporary problems. As Wilson's work underscored, "History is an act of interpretation and . . . contemporary events are part of its flux."[22] Art installations can also help connect experiences across time through place. Consider *Planet Ord*, 2014, at the Santa Cruz Museum of Art and History, which connected the layers and traces of lives across time at Ford Ord, once the largest military base in the West. But while in these examples art can be a provocative tool of connection, we must also be sensitive to the implications of drawing a line between past and present, an issue frequently debated by historians. Is it appropriate, for example, to understand the past in light of society's current problems? Or are we imposing modern

ways of thinking onto the past, in ways that would have been foreign to contemporaries? Should we consider the past, in the words of L. P. Hartley, as a "foreign country" where they "do things differently"?[23] While understanding the past through the present can make history more "useful," it can also subject history to a kind of artificial linear narrative. While being attentive not to gloss over the distinctiveness of past experiences, helping visitors to connect with past events through familiar themes and problems can be one of the benefits of incorporating art into public history.

THE CHALLENGES OF COLLABORATION

Drawing on numerous examples of successful collaboration, practitioners, theorists, and academics point to art's great potential to challenge and support public history initiatives. But integrating public history and art is not without its challenges. There are a number of significant practical considerations of concern to public history professionals that remain underexplored in the current literature. First, if history and art present different ways of knowing, how do we achieve an appropriate balance between historical understanding of accuracy and artistic interpretation? Doris Sommer has recently commented that "art's work in the world is not yet a core concern for an academic field that remains sceptical and pessimistic."[24] Challenges associated with disciplinary biases can discourage collaborative working.

Bringing art into the fold of public history, or conversely, public history into the fold of art, is not just about contact between different genres of interpretation but potentially different ways of doing things. Some of the most successful projects have involved modifying or even disrupting the traditional institutional roles of curator, artist, subject, and audience. But in partnerships involving communities or individuals outside of the institution, institutional contexts can discourage the true sharing of creative power. Bernadette Lynch, former deputy director of the Manchester Museum, suggests that efforts at shared authority are often fictitious. It can be difficult to truly relinquish control, and in many cases, when museums attempt in many efforts at co-creation or collaboration, they maintain positions of distance and objectivity. Consensual decisions tend to be worked through on the basis of the institution's agenda or strategic plan, thus leading us to question whether these efforts really challenge institutional practices at all.[25] Furthermore, when museums invite or import critique of their collections, this creates a modified role for the artist. The artist intervention can become essentially a form of transferring risk from institution to individual. Miranda Stearn suggests that when artists work within rather than outside of the museum, this limits the forms and ex-

tent of the critique that are possible. It can end up serving the institution rather than challenging it. Art, in other words, can end up supporting institutional agendas and serving the institution rather than being given true space to challenge and intervene.[26]

In addition to the challenges of creating and curating collaborations, there are challenges associated with audience reception. Museum professionals applaud art's ability to challenge institutional narratives, but do visitors have the interpretive tools that they need? Art galleries are often considered the least accessible type of museum, and visitors might have trouble understanding how art is meant to address historical themes. Furthermore, many visitors expect an educational experience at museums, and might not welcome a step into different forms of interpretation.[27] Anticipating visitor responses and equipping individuals with interpretive tools can be a challenge for any institution. Just as audiences might be partially equipped to interpret art, so public historians themselves might lack the necessary skills to work with visual arts. Just as visitors might find encounters with contemporary art intimidating, so can professionals. All of a museum's stakeholders, including visitors, curators, and education teams, need to be equipped with appropriate tools.

While artistic collaboration has plenty of theoretical potential, how well does it actually work in practice, and what are some of the strategies and tools that can help ensure the success of public history projects?

BOOK STRUCTURE

This volume is organized into three sections organized around types of art. In general conversation, the designation of artistic "types" can be as precise as medium or school, or it can include broader definitions of genre. We discuss three broadly defined categories of art: historical artworks, contemporary art and artist collaborations, and public art and the built environment. Within the first section, authors discuss what we have termed *historical artworks* or *noncontemporary art*. Rather than works that depict historical subject matter, or works in the genre of history paintings, these chapters deal with projects involving art created before the twenty-first century, regardless of subject matter. These works present opportunities for public historians and art historians to engage with the context in which a work of art was originally created. Beyond just a particular style or school, artists are influenced by local, national, and world events. They are often engaged with their communities and in conversation with other artists about political and economic issues. They view other works of art, perhaps traveling to do so, and share their own philosophies and experiences with others. Thus, each work of art is not just the

work of a particular artist but also a product of its time. Beyond its aesthetic value, the artwork becomes a historical artifact, allowing visitors and curators to draw new meanings and employ different approaches.

Many history museums exhibit images. However, these are often used to illustrate themes within the institutions' larger exhibition narrative. Tuliza Fleming explores the challenges and benefits of including a dedicated art gallery within a history museum. Her case study is *Visual Art and the American Experience*, a permanent art gallery in the new National Museum of African American History and Culture. She considers the role that art can play in a museum whose wider ambition is to document African American life, art, history, and culture, as well as what it means to exhibit art in a way that moves beyond illustrating people or landscapes to instead engage audiences in the aesthetics of art and the biographies of artists. In the new museum, visitors access art on multiple levels: historically, culturally, and aesthetically. Here, art and history develop a mutually beneficial relationship. While art complicates history exhibitions, history also complicates fine art curatorial practices. Counteracting essentialist notions of "the black community" and representing a diverse American experience required Fleming and her team to challenge prevailing notions of the art canon. In exploring the styles, complex histories, and diverse experiences of American artists of African descent, *Visual Art and the American Experience* looks beyond the traditional boundaries between art movements and time periods and blurs the established categories of university-trained artist versus informally taught craftsman.

In the second chapter, image becomes artifact. The use of historical images as primary sources and the study of visual cultures of the past are well established within academic history. Visual sources also provide ripe opportunities for public interpretation. However, one of the challenges that we face when using images for public history is how to equip visitors with the tools that they need to effectively interpret images. Using the undergraduate history classroom as a case study, Jennifer Black translates theoretical understandings of how we look and how we understand images into practical strategies for helping students to develop their own skills for sophisticated visual analysis. According to Black, images hold particular promise in helping public historians counter dominant narratives that structure public understandings of the past by providing insights in how individuals might have "seen" the world around them. In Black's study, visual culture provides opportunities to investigate belonging and otherness in nineteenth-century America. Images can offer students personal connections to the past. However, moments when assumed points of identification between viewer and subject are disrupted can offer the most powerful opportunities for learning. Images can reveal "competing truths" and contradictory narratives, reshaping students' interpretation

of the past, and in this case, their understandings of race, citizenship, and belonging.

The experiences of museums and secondary educational institutions clearly show that historical artwork can be used to help facilitate new understandings of history. But how broad are the audiences that we can engage with through art? Furthermore, looking beyond interpretation on the gallery wall, what potential does programming hold to help enhance art's potential? Heidi Moisan and Megan Clark share their experience of developing, evaluating, and delivering an educational workshop program for elementary school students in Chicago. Using art that depicts events related to the Great Chicago Fire, they use images to approach a very familiar story in a new way. Looking can be combined with role-play, bodily movement, reading, and drawing to encourage active learning inside and outside of the gallery. With a teacher's help, images can facilitate thinking about memories and acts of interpretation. Developing programming is of course not without challenges. Moisan and Clark's experiences offer insights into strategies for integrating an evaluative framework into program planning and supporting learning and teaching under the new Common Core State Standards framework.

Older works of art do not stand alone in the opportunities they present to interpret history in different ways. Contemporary artists often draw inspiration from historical people and events, depicting well-known subjects or lesser-known incidents. They often engage with questions of historical representation and accuracy, investigating and presenting new viewpoints of old events. These interpretations often garner additional interest when the artist seeks to provide an imagined voice or point of view for a person who was silenced due to their race, ethnicity, class, gender, or sexuality. Though the archival and artifact record traditionally favors those who held power in a particular time and place, the imaginative intervention of an artist offers a chance for new conversations around topics sometimes thought to be settled and done. The second section focuses on these contemporary artworks and opportunities for collaboration with public historians, historical museums, and historic sites.

Sometimes a museum's primary obstacle comes not from its weaknesses but from an overbearing strength. When one subject area is clearly the star in a multidisciplinary museum, how can staff members raise awareness of the museum's forgotten half? Rebecca Bush grapples with this question as she considers her experience at the Columbus Museum, a Georgia institution where installations and collections of American art were consistently better known than exhibitions and artifacts related to the regional history of the Chattahoochee Valley. To create a more equal and truly dual mission, board and staff members examined their own assumptions, experimented with

new exhibition topics and promotional strategies, and committed to using language that more accurately reflected all that the museum had to offer. As Bush reports, initial results suggest greater engagement with broader swaths of the community and increased opportunities for relevancy in a crowded cultural landscape. Bush pairs an overview of past and ongoing projects with a frank assessment of stumbling blocks and the potential for future progress through interdisciplinary partnerships.

Faced with outdated interpretation and a collection that does not reflect the demographics of its community, a museum might choose to commission new works of art to reflect a more diverse reality. Such was the case at the Scottish National Portrait Gallery (SNPG) in 2011, which Tawny Paul explores in an in-depth case study. The SNPG recognized that its Victorian roots and collection failed to accurately depict the portraits of contemporary Scots, so curators reinstalled permanent galleries and developed temporary exhibitions with an eye toward sparking discussion and presenting a more comprehensive picture of the nation's history. In addition to examining the stated goals of these efforts, Paul contrasts expectation with reality, conducting visitor surveys to ascertain if visitors walked away with the intended messages. Her analysis reveals sometimes unexpected connections between visitors' museum experiences and political beliefs, as well as the gap that often exists between curatorial goals in development and their effectiveness in the final execution. Still, hope for the future can be found in SNPG success stories, reminding us that while not every innovative idea will work as hoped, less beloved initiatives that spark dialogue can still be quite instructive.

When artists work side by side with curators or engage in curatorial work themselves, the results can lead to new insights for all involved. Teresa Bramlette Reeves, Julia Brock, and Kirstie Tepper explore the projects of their curatorial collective, Selvage. The three curators come from different educational backgrounds as art historian, public historian, and artist, but all three are interested in collaborative processes to enhance the museum experience. In particular, the collaborators have undertaken several projects focused on narrative and uncovering hidden histories. To do so, they utilize the fields of relational art, which presents new ways to share aesthetic and historical information; and narratology, which considers how the construction of a narrative affects the perception of viewers/readers. Reeves, Brock, and Tepper argue that the use of these methodologies constitutes a new kind of public history work, one that rewards a deeper understanding of the complexities of conveying meaning and understanding.

Perhaps the most common way for the public to encounter works of art and historical information is not by visiting a traditional brick-and-mortar museum but by encountering art in a public space. Whether the object in

question is a sculpture designed to be seen in a public park or a busy downtown street, an artist's intervention on the walls of a historic building, or a sign meant to share historical information, people encounter art and history in their surroundings every day. Hence, projects encompassing public art and the built environment comprise the third section. The projects in this section, though somewhat disparate, are bound by their placement in spaces that people walk and drive past on a regular basis. When viewers/readers are not specifically looking for a cultural experience, perhaps just moving through their day, how can artists, curators, and public historians engage them in a meaningful experience, however brief it might be? The book's final section seeks to address this question through a variety of projects.

The "natural habitats" of a public historian are often thought of as museums/historic sites, archives, or consulting firms, but governments at all levels can also benefit from bringing a historian on board. Nancy Dallett examines one aspect of this work in her role as a consultant on public art master planning across the United States. Dallett uses her expertise as a historian to broaden the perspective of groups planning significant public art installations in American cities, bringing another voice to a process that already combines artistic expression, community voices, and urban design. By connecting with stakeholders who are actively engaged in shaping a city's interpretation of its past, consulting public historians can share new insights about the role of existing architecture, geographic placement, and historically relevant topics. Public historians also possess familiarity with controversial histories and competing narratives, offering chambers of commerce, tourism/economic development directors, and urban planners an additional set of skills when working with multiple organizations with wildly different priorities. Perhaps most importantly, Dallett argues that by advocating for a place at the public art table, public historians demonstrate their value and commitment to utilizing a city's past for the betterment of its cultural and economic future. Her chapter concludes with several helpful tips for those eager to try a new form of community engagement.

In stark contrast to public art, roadside historical markers are sometimes seen as staid reminders of local "hysterical societies" of the mid-twentieth century, erecting a plaque to commemorate every founding family's store or minor military skirmishes. Even as local and state nonprofits work to diversify today's crop of historical markers, the overwhelming majority of existing signs still privilege the history of well-to-do white men. The Georgia Historical Society and the Savannah College of Art and Design (SCAD) chose to turn this quandary into an interactive learning opportunity, as explored by Christy Crisp and Holly Goldstein. As students completed a SCAD course about the hidden history of Savannah, they began to research little-known

events and people who coexisted with more prominent histories at the site of existing markers. Students created artworks to express their perception and interpretation of these forgotten stories, accompanied with their own traditional marker-like text. Crisp and Goldstein analyze several examples from this project, highlighting ways in which the students' work reaches beyond the confines of a classroom into Savannah's colonial streets. The authors also discuss ways in which the course or its final products could be adapted for use in various settings, simultaneously enhancing student learning and tourism experiences.

Though artists often create within their own studio, others draw inspiration from public buildings or historic sites. Such is the case with Rebecca Keller, a professor at the School of the Art Institute of Chicago and an active artist. For the past decade, Keller has engaged with historic sites, both on building walls and in the great outdoors, through her project *Excavating History*. This series of exhibitions encompasses sites as diverse as a forest in Germany and a medical history museum housed in a reproduction of Versailles's *petit palais*. Keller interacts with the physical material of these sites for her interventions, utilizing natural materials, building walls, and reproductions of artifacts and archival material to illuminate a site's history in new ways. In addition to the satisfaction an artist might derive from creatively engaging with a historical collection or an evocative building, Keller's chapter highlights the importance of building links between different sensory experiences. An artwork might focus on an aspect of a site's history that is difficult to put into words but can evoke strong feelings. Access to archival records can inspire an artist in new ways and help spotlight objects that are often ignored. The ephemeral nature of these installations preserves a site's historical integrity while still sparking discussion for both new and repeat visitors. Keller presents the process and final product for several of her exhibitions, grounding them within a framework that places the artist at the center of crafting new perspectives, collaborating with both site historians and public visitors to the site. Recognizing that some stakeholders may resist nontraditional interpretation or any change to the site that seems to stray from strictly factual interpretation, Keller also offers candid insight about the importance of organizational buy-in at all levels when crafting interdisciplinary projects.

Throughout each section, three overarching themes emerge: engaging audiences, challenging histories, and making meanings. The contributors to this volume present varied approaches to each of these central concerns, which reflect ongoing conversations in the field of public history. Such discussions continue to be vital to both academics and practitioners because there are no "one size fits all" solutions, no singular method that will guarantee engaged

and diverse visitors who immediately grasp staff members' or artists' intentions. Instead, these pages present several options for analysis and discussion.

As more cultural institutions seek to maintain or increase relevancy to their local communities, the concept of audience engagement has become vital. Several museums of all disciplines have created new positions with titles like "director of audience engagement" or "curator of engagement and dialogue." In discussions about the nature of audience engagement, these professionals agree that their primary goal is connecting with visitors, often by attracting nontraditional audiences in new ways.[28] In seeking to create these connections, interdisciplinary projects offer an exciting way forward. If the goal is to challenge long-held assumptions about the nature of a particular cultural institution, which might have been seen as stodgy or staid, the mere act of collaborating with new partners in a different discipline can produce a jolt of organizational energy. Around the world, museums of the nineteenth and early twentieth centuries were primarily created for a cultural elite, thought to have both the right upbringing to appreciate an institution's offerings and the financial wherewithal to ensure its continued operation.

As today's museum employees work to break free of decades of narrow collecting and exhibitions to reflect a more diverse constituency, experimenting with interdisciplinary projects offers a more audience-centric approach. Paul analyzes the efforts of a government-funded museum to more fully reflect the faces of its country, framing greater audience engagement as a political and cultural imperative. This strategy is not limited to museums, as Black demonstrates in her chapter. Utilizing art in the classroom to explore historical events allows students to learn material in a more visually compelling manner than merely reading words on a page. As educators, Clark and Moisan base a large part of their success on the ability to directly connect with K–12 students. In their programs, both the budding artist who ignores his social studies homework and the eager young historian whose main artistic success is her stick figures find some material to engage them.

As cultural organizations seek to appeal to a broader swath of the population, building on audience engagement goes hand in hand with challenging traditional histories. Historical societies and museums expanding their interpretation beyond the great man theory that dominated the historical narrative for so long face similar challenges as art museums whose collections traditionally favored the work of white men who were lauded and placed in the canon by a select group of critics and collectors. Organizations focused on both art and history have made significant efforts in the past three decades to include people of color and women in their regular offerings, while also shining a light on LGBTQ topics previously considered impolite or too controversial. By crafting more inclusive narratives, museums not only engage

with more members of their community, they also show a willingness to challenge existing stories if they are found to be too narrow. Reeves, Brock, and Tepper have focused their curatorial collective on this sort of work, using methodological tools focused on visitor experience and the perception of narrative to illuminate hidden histories through innovative combinations of contemporary art and archival materials. In her chapter, Bush considers the work of an African American artist who spotlights little-known historical people of color, and does so in a way that directly challenges the viewer to learn more. By exhibiting such work, museums share authority with artists and visitors to encourage curiosity and deeper exploration. This approach need not be confined to the walls of a museum, as Crisp and Goldstein demonstrate. As college art students researched and reinterpreted the sites of traditional historical markers, the traditional understanding of who or what "deserves" a historical marker is flipped on its head. The inclusion of moments of tragedy as well as celebration, the presentation of people who had once been erased from a city's narrative, challenges assumptions in the most factual way possible. Their work does not dispute the worthiness or truth of existing historical markers; it simply asserts that other events, representative of many people, happened here, too.

One of the central activities of daily life is making meanings. This experience is heightened when considering art and artifacts, which are already imbued with meaning as objects worthy of preservation by experts. When visitors find meaning in objects in front of them, they draw on more than the interpretation offered to them; they also bring years of lived experience, memories, and biases. Rather than ignoring these prior experiences, cultural organizations seek to leverage them into new understandings by sparking connections. The meaning-making process can be particularly vital to artists, who communicate primarily through visual media. Keller writes eloquently of the inspiration she finds in working with the preexisting material of a historic site, creating new meanings for herself and others from an established narrative. When historians engage with public art planning, Dallett argues, historians can add additional layers of meaning to projects that will be viewed by residents of an entire city. Fleming suggests that as much as historical organizations use artwork to *illustrate* historic people or events, only rarely is artwork used to *analyze* these topics—a distinction that suggests a new world of interpretive possibilities. After all, the inclusion of art in history museums and vice versa is not a radical concept. How, then, can we as historians, curators, and artists be more purposeful in our deployment of existing resources?

As contributors discuss their work, several practical tips, tools, and strategies emerge. Some warrant discussion at the institutional level. As practitioners consider how to embark on interdisciplinary projects, it is worth considering the

benefits and challenges of a "top-down" or "bottom-up" approach. An organic project, born out of natural interest and commitment from one or two dedicated staff members, can grow with natural energy and demonstrate staff willingness to experiment and see what works. However, expanding such efforts will be stymied without buy-in at the highest levels, including board members and directors. When these upper-level figures encourage (or mandate) interdisciplinary collaborations, projects can move forward with the assurance of organizational support. This kind of commitment can smooth the way in questions of funding or reaching out to other cultural organizations, but the impetus behind it can affect staff perception of the effort. A museum might seek to strengthen its audience engagement as part of a strategic plan meant to ensure continued relevancy, affecting continued financial support and long-term survival. Educators might find themselves required to redesign programs at a moment's notice to meet new state or federal education requirements, perhaps making interdisciplinary programming a practical necessity. Other cultural organizations, especially those funded by governmental organizations, might seek to respond to new social and cultural realities that require the acknowledgment of difficult pasts and find art a particularly effective way to do so. Institutional motives and methods for pairing art and history vary widely, but as staff members embark on new collaborations, it is imperative that they consider their institution's short- and long-term goals to see whether such projects will be a good fit for all partners.

In addition to institutional planning, the authors suggest a number of practical considerations that collaborators should build into their projects. While Bush stresses the importance of cooperation from board members, Keller astutely describes why buy-in from docents and volunteers is equally important, especially when these individuals set the daily tone of visitor interactions. As well as emphasizing volunteer training, Moisan and Clark propose that evaluation, often seen as the last step of any new venture, should actually be done throughout the planning and implementation process, with a method they term *developmental evaluation*. Black and Paul also describe the importance of comprehensive evaluations, though the latter notes that such evaluation may yield less-than-ideal results. In particular, the "if you build it, they will come" approach may not always work, a realization that should prompt reflection on future projects. Within the overarching topic of diversity, Fleming highlights the importance of not stereotyping or pigeonholing particular groups. When there is no monolithic "black [or gay, or Latino, or women's, or disability] community," cultural institutions must take special care to explore an even greater multitude of stories. Crisp and Goldstein, as well as Dallett, make strong cases for stepping out of your comfort zone to collaborate with dissimilar organizations. Though institutional missions and goals might not im-

mediately align, the benefits of attracting new audiences and making meaning in different ways can outweigh the initial growing pains. Dallett in particular offers several helpful tips for public historians who need direction in beginning a conversation with public art planners. By being willing to learn what is, in many ways, a different language and educate others on the importance of our field, historians can advocate more effectively for their own work. When many new partners work together, differences in management styles and curatorial approaches can manifest. Reeves, Brock, and Tepper discuss how they successfully blend three disparate perspectives in their curatorial collective while simultaneously working with contemporary artists.

REFLECTING ON CASE STUDIES

From intervention, to education programing, to road markers, to public history projects, the case studies in this book reveal the diverse potential that collaborations between art and public history can bring, both inside and outside of the museum walls. Twenty-five years after *Mining the Museum*, integrating art with public history continues to be a strategy that puts people at the center. This includes people of the past, whose diverse voices and stories deserve to be remembered and told. By making meanings and challenging narratives, art opens new possibilities for interpretation and contributes to a more inclusive past. It also includes people today. Art can help us to engage, provoke, and inspire audiences, whether those are students or museum visitors. The case studies in this book also reveal the diverse challenges of collaboration. Integrating art is not the solution to every public history problem, and there is no one-size-fits-all model for collaboration. But as we move forward, we hope that studies in this book will contribute to greater awareness and understanding as readers engage in future projects.

NOTES

1. Lisa Corrin, "Mining the Museum: An Installation Confronting History," in *Reinventing the Museum*, ed. Gail Anderson (Oxford: AltaMira Press, 2004), 250–52.

2. Corrin, "Mining the Museum," 249.

3. Fred Wilson, quoted in J. Putnam, *Art and Artifact: The Museum as Medium* (London: Thames and Hudson, 2001), 158.

4. Miranda Stearn, "Contemporary Challenges: Artist Interventions in Museums and Galleries Dealing with Challenging Histories," in *Challenging History in the Museum: International Perspectives*, edited by Jenny Kidd, Sam Cairns, Alex Drago, and Amy Ryall (Oxford: Routledge, 2014), 101–14.

5. http://www.vam.ac.uk/content/articles/u/uncomfortable-truths-installation/.

6. For further discussion of *La Bouche du Roi*, see Stearn, "Contemporary Challenges."

7. Bernadette Lynch, "Challenging Ourselves: Uncomfortable Histories and Current Museum Practices," in *Challenging History in the Museum*, 87–100.

8. http://www.iwm.org.uk/history/artists-responses-to-the-holocaust.

9. Stearn, "Contemporary Challenges," 107.

10. "1807 Commemorated," *Topic Four: The Present Past: The Use of Art in the Marking of the Bicentenary* (York: Institution for the Public Understanding of the Past and Institute for Historical Research, 2007); http://www.history.ac.uk/1807commemorated/discussion/present_past.html, accessed September 1, 2016.

11. James Clifford, "Museums as Contact Zones," in James Clifford, *Routes: Travel and Translation in the Late Twentieth Century* (Cambridge, MA and London: Harvard University Press), 188–219.

12. https://www.brooklynmuseum.org/exhibitions/connecting_cultures.

13. Harriet Purkis, "Making Contact in an Exhibition Zone: Displaying Contemporary Cultural Diversity in Donegal, Ireland, through an Installation of Visual and Material Portraits," *Museum and Society* 11, no. 1 (March 2013): 50–67.

14. *Towards the Other* website, http://www.miekebal.org/artworks/exhibitions/towards-the-other/.

15. Patrick Grossi, "'Plan or Be Planned For': Temple Contemporary's *Funeral for a Home* and the Politics of Engagement," *The Public Historian* 37, no. 2 (May 2015): 14–26.

16. http://www.hullhousemuseum.org/intobody/.

17. https://www.brooklynmuseum.org/exhibitions/tipi.

18. Sean Kelley, "Eastern State Penitentiary Historic Site Guidelines for Art Proposals, 2017 Cycle," last modified June 15, 2016, http://www.easternstate.org/sites/default/files/Guidelines%20for%20Artists%202017.pdf.

19. Karen Harvey, "Envisioning the Past: Art, Historiography and Public History," *Cultural and Social History* 12, no. 4 (2015): 527–43.

20. Andrea Witcomb, "Migration, Social Cohesion and Cultural Diversity: Can Museums Move beyond Pluralism?" *Humanities Research* 15, no. 2 (2009): 49–66.

21. Harvey, "Envisioning the Past," 532.

22. Corrin, "Mining the Museum," 249.

23. L. P. Hartley, *The Go-Between* (New York: New York Review of Books, 1953).

24. Doris Sommer, *The Work of Art in the World: Civic Agency and Public Humanities* (Durham and London: Duke University Press, 2014), 6.

25. Bernadette Lynch, "Collaboration, Contestation, and Creative Conflict: On the Efficacy of Museum/Community Partnerships," in *Redefining Museum Ethics*, ed. J. Marstine (London: Routledge, 2011).

26. Stearn, "Contemporary Challenges," 109.

27. Stearn, "Contemporary Challenges," 108.

28. "An Introduction to Audience Engagement: Notes from the Field," Museum-iD, accessed September 30, 2016, http://www.museum-id.com/idea-detail.asp?id=395.

Part I

HISTORICAL ARTWORKS

Chapter One

Visual Art and the American Experience

Creating an Art Gallery in a History and Culture Museum

Tuliza Fleming

On September 24, 2016, the National Museum of African American History and Culture (NMAAHC), the newest Smithsonian museum, opened its doors. Created by an Act of Congress in 2003, the NMAAHC is devoted exclusively to the documentation of African American life, art, history, and culture. It occupies a prominent position on the Mall on a five-acre site between the Washington Monument and the Smithsonian's National Museum of American History. The overarching mission of the museum is to be a place where all Americans can learn about the richness and diversity of the African American experience, how that experience intersects with our lives, and the ways it helps to shape the history and culture of our nation and our world.

Telling the complex story of the African American experience, which is by definition an American experience, required multifaceted and unique interpretations and exhibition strategies. One element of this strategy was to include an art gallery in the museum. Although visual art is widely recognized as an integral component to and reflection of human existence, it is rarely exhibited using both art historical and historically based lens. Written in the weeks following the museum's opening, this chapter reflects on our approach to designing a permanent art gallery in a history and culture museum. It explores how we expanded upon existing methods of exhibiting and interpreting art with the goal of incorporating broader themes and narratives woven throughout the NMAAHC while maintaining a traditional gallery experience. *Visual Art and the American Experience* is the culmination of our efforts to create a new paradigm through which museum visitors, whether they are art experts or novices, can experience works of art on a variety of levels—historically, culturally, and aesthetically.

VISUAL ART AND THE AMERICAN EXPERIENCE: FORMULATING A NEW APPROACH

The NMAAHC is not an art museum. Therefore, we did not assume that all of our visitors would expect to engage with visual art, encounter a dedicated art gallery, or have interest in or previous exposure to art history. Often, when visitors encounter art in history museums, it is exhibited as a support vehicle to the institutions' larger exhibition narrative. For example, portraits are often used to show the image of a famous person, landscapes as examples of a particular place in time, history paintings to illustrate an important event, and other examples. As such, one rarely encounters artwork in history museums where the aesthetics of the art, the biography of the artist, or an interpretation of the subject matter is included within the exhibition narrative. Rarer still is the presence of abstraction or conceptual art within this type of museum. Thus, our gallery required a new approach to interpretation and exhibition.

The development and implementation of *Visual Art and the American Experience* was a joint endeavor between me and Dr. Jacquelyn Days Serwer, chief curator of the museum. Prior to coming to the NMAAHC, we both trained as American art historians and previously worked in traditional art museums. One of the first questions that Dr. Serwer and I sought to address as we embarked upon this journey was the issue of audience and curatorial approach. As American art curators with a history of art museum experience, Dr. Serwer and I were used to curating exhibitions and overseeing permanent art galleries using traditional methods of narrative interpretation. For example, in my former position at the Dayton Art Institute, the permanent exhibition space was organized in a linear fashion, from the colonial era through the twenty-first century. An artistic movement punctuated each gallery, with an implicit nod to the idea of aesthetic progression. Furthermore, like many other American art museums, the American art wing was organized and interpreted in a manner that assumed the audience would have some interest in and/or knowledge of the history of American art.

To address the many concerns that we had with regard to our unusual status as a dedicated art gallery in a history and culture museum, we formulated four project goals: (1) to change the way people think about art created by Americans of African descent from "African American Art" or "black art" to simply "American Art"; (2) to present American history, culture, and art history through the lens of the African American artist; (3) to show artwork and feature artists who have been widely accepted by the "mainstream" art world, those artists who have been recognized and celebrated by African Americans, as well as those who have been ignored, marginalized, or yet to be discovered

by the wider art population; and (4) to provide a safe and engaging space where visitors can learn about art and its relevance to their lives.

1. CHANGING THE WAY PEOPLE THINK ABOUT ART CREATED BY AMERICANS OF AFRICAN DESCENT

When we began the process of establishing the curatorial framework for the exhibition, we decided that it was important to promote the idea that art created by Americans of African descent is "American art," as opposed to "African American art." In an art museum, this issue could easily be addressed by simply integrating artwork by African Americans throughout the museum without regard to race, ethnicity, or gender—unless it is germane to a proper understanding of the artwork in question. However, within the context of a museum whose primary focus is African American history and culture, we knew that shifting this paradigm within our gallery would be a more complex endeavor.

The concept of "black art" evolved in the 1920s during the New Negro Movement, popularly referred to as the Harlem Renaissance. It was created, in part, as a strategy to bring attention to the unique and rich cultural and artistic contributions of black Americans. It was during this period that the "Negro art" exhibition emerged. Beginning with the Harmon Foundation in 1929, a variety of institutions began to mount exhibitions specifically focused on art by African Americans. Among the earliest institutions to do so include Howard University in 1929, Atlanta University in 1942, the South Side Community Center in the early 1940s, and Washington, D.C.'s Barnett-Aden Gallery in 1943.[1] These exhibitions provided African American artists with the opportunity for their art to be seen by the public at a time when they were barred from most historically white museums. Later in the century, historically white institutions began to take a greater interest in audience diversity and outreach to underserved ethnic communities. One of the most popular methods of achieving this goal was to continue the tradition of the segregated art exhibition. Our contention was that while the creation of race-based exhibitions has its merits, in terms of generating greater audience diversity during the run of the show and exposing visitors to artwork that they would not normally see, in the long run, it does a great disservice to the art, the artist, as well as the visitor.

Given our strong feelings about the efficacy of the "black art exhibition," we realized that we would have to be careful not to reinforce the notion that art by black people should be exhibited separately and interpreted outside of the "mainstream" art canon. To counteract this perception, we implemented a series of strategies that would emphasize our contention that art by African Americans is American art.

The first line of defense against the "black art" trope was the decision to name our exhibition *Visual Art and the American Experience*. In addition to the exhibition's title, we also included a second more explicit message in the form of a quote silkscreened on the wall. We chose to feature a statement made by mid-century modernist painter Charles Alston during a 1969 interview with the *New York Times*. The quote reads, "I don't believe there's such a thing as 'black art,' though there's certainly been a black experience. I've lived it. But it's also an American Experience."[2] We were especially drawn to this profound statement as it masterfully articulates the fundamental concept connecting the themes, art, and artists in the gallery.

The third element of this strategy relates to our interpretive methodology. As African American curators working in a field nearly completely comprised of Americans of European descent, we were acutely aware of how the work of black artists has historically and, in some respects, continues to be viewed through the lens of the "other." This lack of diversity within the curatorial realm sometimes results in a perspective that restricts the interpretation of work by Americans of African descent along racial lines. For example, it is not unusual to encounter object labels written for artwork created by American artists of African descent that call attention to the race of the artist, even when race is completely irrelevant to the work on display. These labels tend to start with phrases like, "African America abstract artist, Sam Gilliam . . . " Conversely, one might find a label in the same exhibition for a work by a white artist that ignores racial classification, such as "American abstract painter, Kenneth Noland . . . "

Because of this legacy of racialization as it pertains to art by black artists, we made the decision to allude to race only when it is appropriate to the explication of the artwork. We also took into account the feelings of individual artists about race as it intersected with their art and career.

2. PRESENTING AMERICAN HISTORY, CULTURE, AND ART HISTORY THROUGH THE LENS OF THE AFRICAN AMERICAN ARTIST

One of the methods that we employed in our approach to interpreting art in *Visual Art and the American Experience* was to use the lens of the artist. Whenever possible, we consulted artist interviews, looked for pertinent quotes in various literary sources, and solicited statements from living artists in our collection. Our goal was twofold—to incorporate the voice of the artist within our extended text labels and to gain a more nuanced understanding of how these artists viewed themselves and their art within the context of American history and culture.

3. A COLLECTIVE HISTORY: MERGING THE MAINSTREAM AND THE MARGINALIZED

Although we mounted the exhibition in a traditional fashion, it is more than just a showcase of beautiful art by well-known artists. *Visual Art and the American Experience* also challenges prevailing notions of the art canon by juxtaposing widely celebrated artists with those who have been overlooked; interspersing artwork from various time periods within the same gallery; ignoring categories that separate university-trained artists from those who learned their craft outside of established art institutions; and by organizing the exhibition by themes as opposed to art movements or a linear trajectory. Most importantly, it reveals the deep connection that many African American artists have to our nation's complex history and the ways in which that history has intersected with their work.

4. PROVIDING A SAFE AND ENGAGING SPACE WHERE VISITORS CAN LEARN ABOUT ART AND ITS RELEVANCE TO THEIR LIVES

This goal reflects our concern that many average Americans feel uncomfortable in art museums. They feel that they don't have the knowledge base to understand various art forms, may be intimidated by the space, and often don't have enough information to process what they are seeing. To help alleviate some of these issues, we made certain that all of the objects in the exhibition had extended text labels. We also included fourteen interactive stations where visitors will be able to delve more deeply into the history and context of each work of art. Through the interactive, visitors are able to learn more about the artist, the artwork, its relationship to the broader art world, and the era in which it was created. In addition to providing our audience with a variety of perspectives through which they can engage the work of art, the interactive also connects important themes and objects throughout the museum to artworks contained in our gallery.

THE EXHIBITION

Visual Art and the American Experience fits within the museum's broader thematic structure that addresses the myriad of pathways through which visitors can explore the American experience through an African American lens. The museum is organized into three broad groupings: history, community,

and culture. Each grouping contains discrete exhibitions that engage various topics and/or eras. In total, the museum has eleven semipermanent or inaugural exhibitions listed as follows:

History

- Slavery and Freedom
- Defending Freedom, Defining Freedom: Era of Segregation 1876–1968
- A Changing America: 1968 and Beyond

Community

- Making a Way Out of No Way
- The Power of Place
- Double Victory: The African American Military Experience
- Sports: Leveling the Playing Field

Culture

- Cultural Expressions
- Musical Crossroads
- Taking the Stage
- Visual Art and the American Experience

Our goal in creating an art exhibition within the history museum was to introduce our audience to the broad range of American art styles, movements, and themes. However, we also wanted to create a place where visitors would appreciate the deep connection between the artwork in the gallery and the stories, histories, and narratives woven throughout the rest of the museum. For example, *Slavery and Freedom*, the first exhibition in the history cluster, explores the complex experience of free and enslaved people of African descent, the history and legacy of slavery, and the never-ending pursuit of freedom through the Reconstruction era. *Defending Freedom, Defining Freedom: Era of Segregation 1876–1968* focuses on the challenges African Americans faced as they fought to gain their rights as free citizens between Reconstruction through the modern civil rights movement. *A Changing America: 1968 and Beyond* engages issues such as class, immigration, gender, and political activism during the latter half of the twentieth century through the early years of the twenty-first.

The community exhibitions challenge the popular notion of a monolithic "African American community" through the exploration of sports, military life, geography, and institution building. *Making a Way Out of No Way* exam-

ines the various strategies that African American individuals, families, communities, and organized groups employed to create educational institutions, businesses, social organizations, religious establishments, and media outlets despite the omnipresent obstacles of racial segregation and discrimination. Through a series of exhibition vignettes, *The Power of Place* explores the ways through which identity, culture, religion, and history are intimately connected to where we live, when we were there, and the communities with whom we identify. *Sports: Leveling the Playing Field* embraces the complex role African American athletes have played in the arenas of politics, social movements, and culture. And finally, *Double Victory: The African American Military Experience* documents the African American participation in and contribution to American society through military service.

The section on culture reveals how African American creative production is both a product of and a contributing factor to American expression and identity. *Cultural Expressions* introduces the visitor to the broad concept of culture as it intersects with African American and African diasporic creative traditions. *Musical Crossroads* expands upon the notion of what is commonly perceived as black music (i.e., blues, jazz, R&B, hip-hop, etc.) to include all musical genres and styles (i.e., classical, rock, musical theater, etc.), as well as those styles that resist category. *Taking the Stage* explores how the African American presence in film, theater, and television enriched American culture and fostered social change.

The last exhibition in the culture cluster is *Visual Art and the American Experience*, a 3,800-square-foot gallery containing nine discrete sections with seven permanent exhibition themes. The first section of the exhibition, the introductory gallery is a welcoming space created to entice visitors to enter the exhibition. We purposely selected what we felt would be unexpected examples of works by African American artists—William T. Williams's abstract painting, *Truckin*, 1969; Therman Statom's glass sculpture, *Orto Botanico*, 2008; and *Question Bridge*, 2012, a video by Hank Willis Thomas, Chris Johnson, Bayeté Ross Smith, and Kamal Sinclair. Our decision to showcase artworks that defy traditional notions of "black art" at the very beginning of the exhibition is intended to introduce visitors to a different way of viewing and interpreting art by Americans of African descent.

New Materials, New Worlds

The first thematic section of the *Visual Art and the American Experience* exhibition is *New Materials, New Worlds*. This gallery explores how artists employ nontraditional art materials to create new and innovative art forms. Many of the artworks in this gallery were created from discarded materials,

while other types of materials were chosen because of deep-seated personal associations. With the exception of McArthur Binion's oilstick and wax crayon "painting," *Rutabaga: In The Sky*, 1978–1979, the majority of artworks in this gallery were created within the past twenty years. By connecting the materiality of these very contemporary and abstract works to concrete stories of artistic process, we are able to provide our audience with a strategy to engage comfortably with the works to see how they connect with the artistic process.

The Beauty of Color and Form

The Beauty of Color and Form is a gallery that, within an art museum context, would be categorized as abstraction. Much like contemporary installations and conceptual art, American abstraction is for many people a very difficult art genre to understand. When I was a curator at the Dayton Art Institute, I would often sit in the American abstract and contemporary galleries to observe visitor reactions to the works on view. On more than a few occasions, I would witness patrons discuss their reaction to what they saw in very negative terms. The phrase, "My child can do this" most readily comes to mind. It is no surprise that works of art that do not have easily recognizable subject matter tend to be viewed with skepticism by many museum visitors. This may be due in part to the lack of comprehensive art education in schools as well as the reticence of many museums to provide additional context for this genre. Whatever those reasons may be, I did not want our audience to feel as if they didn't have the tools to understand why these works were important, even if ultimately they decide this style of art isn't their cup of tea.

We chose the title *The Beauty of Color and Form* to put the viewer at ease and provide them with a descriptor rooted in everyday language. Furthermore, we made a special effort to incorporate the voice of the artist within the extended object labels. Although we did this throughout the gallery, we felt it was particularly important in this section to provide a glimpse into the thought process of the artist, thereby empowering the viewer with a greater depth of understanding.

Religion and Spirituality

Upon exiting *The Beauty of Color and Form*, visitors enter a corridor comprised of six subject-based galleries. The first of these galleries is *Religion and Spirituality*. This section explores how artists have incorporated aspects of religion and spiritual practice in the service of self-expression, religious devotion, political and social messaging, and enlightenment. Visitors to this

gallery learn about the richness and diversity of African American spiritual expression, which includes Christianity, Islam, Buddhism, spiritualism, Judaism, and Catholicism. It also touches upon issues of race and representation in religious imagery.

African Connections

Throughout our history, Americans of African descent have sought to investigate, connect with, retain, and celebrate African histories and cultures. *African Connections* interrogates the ways through which African American artists have engaged with the concept of Africa and its connection to who we are as individuals as well as a society. Works of art in this gallery illustrate the ways through which the culture and history of African and diasporic nations have inspired African American artists to reclaim aspects of their history, engage in broader social and political movements, and incorporate a variety of styles and traditions in their work.

The Politics of Identity

The Politics of Identity explores how the terms by which we define ourselves and are defined by others have deep and lasting implications on our lives. For African Americans, issues of identity can be particularly complex, as how you are perceived by others, and therefore who you "are" in the world, is often filtered through the lens of race. For many black artists working within a majority-white art world, the filter of blackness can be at once a source of pride and inspiration and an unwelcome burden, as it often overrides other primary identities the artist may prefer. *The Politics of Identity* visually illustrates the vast diversity of artistic expression created by American artists of African descent and how those forms of expression intersect with concepts of gender, race, sexuality, age, class, and religion.

The Struggle for Freedom

"The struggle for freedom" has and continues to be an integral part of their lives of the African American experience. Since the moment that black people were taken from their homeland to the new world, they have struggled to be recognized as human beings deserving the rights, freedoms, respect, and opportunities afforded to other people in the nation. This gallery reveals the various ways through which artists have interpreted, experienced, and fought against racism, discrimination, segregation, and oppression. It also explores themes of hope, resilience, protest, unity, activism, and patriotism.

The World Around Us

The final thematic gallery is *The World Around Us*. The concept of this gallery is deceptively simple, that our surroundings—whether natural, man-made, human, or animal—can inspire artists to reflect upon and interpret their environment. The gallery features a variety of styles and subjects—landscape, portraiture, genre painting, still life, and neoclassicism. By juxtaposing styles, eras, and subjects within a single space, we challenge our visitor to see that even though artistic styles may change over time, the impulse to represent how we experience our world remains constant.

Changing Gallery

The final space in the exhibition is our changing gallery. The changing exhibition gallery is a space where we showcase new acquisitions, contemporary installations, small thematic shows, and feature sound and video art.

CONNECTING HISTORY AND ART: CASE STUDIES

There were eighty-five works of art on display in *Visual Art and the American Experience* when the NMAAHC opened its doors to the public. Our goal was to provide a platform through which visitors can access on multiple levels—aesthetically, historically, intellectually, and emotionally. I have selected three artworks to illustrate the levels of engagement provided along these lines: Robert S. Duncanson's *Garden of Eden*, 1852; David Driskell's *Behold Thy Son*, 1956; and Jefferson Pinder's *Mothership (Capsule)*, 2009. Like the other artworks displayed in *Visual Art and the American Experience*, these three examples connect directly with themes, stories, and objects that visitors encounter in other parts of the museum.

ROBERT S. DUNCANSON, *THE GARDEN OF EDEN*, 1852

The first example, *The Garden of Eden*, 1952, was created by nineteenth-century Ohio River Valley landscape painter Robert S. Duncanson. Located in the exhibition's section, *Religion and Spirituality*, *The Garden of Eden* is a quintessential example of an elevated landscape painting. The subject and composition of this painting was inspired by Thomas Cole's earlier work, *The Garden of Eden*, 1828, an artist whose style Duncanson greatly admired. Duncanson's interpretation of the Garden of Eden is considered a tour de force in his oeuvre that helped to propel him into the national spotlight. It also

reflects his role in America's abolitionist movement as well as his position as a free person of color living during the antebellum era.

In many respects, Duncanson's career as an Ohio Valley landscape painter was comparable to his white colleagues. Although he was largely self-taught, he traveled to Europe to study the great masters, was influenced by the work of the Hudson River Landscape School, and was able to support himself and receive notable recognition as a professional artist. In other respects, his life dramatically differed from his peers.

Duncanson was a man of mixed race living during the era of slavery. As a light-skinned black American living in Cincinnati, Ohio, he was accorded rights and privileges withheld from his darker-skinned brethren. These privileges enabled him to move in wider social circles and provided him with a degree of entrée into an elite art world generally not afforded to other African Americans living during the era. From the very beginning of his career, Duncanson's talent was nurtured by a variety of white abolitionist patrons through commissions (primarily portraits), purchases, and by financially supporting his study and travels abroad. His first art commission came from Charles Avery—a

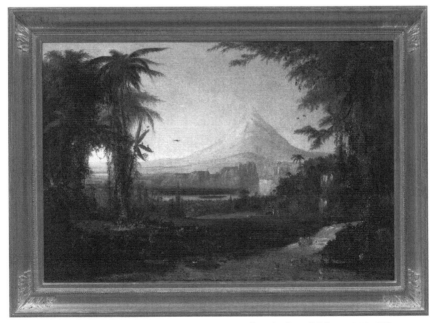

Figure 1.1. Robert S. Duncanson (1821–1872), *The Garden of Eden*, 1852. Oil on canvas, 3½ × 48½ in. (82.6 × 123.2 cm). Collection of the Smithsonian National Museum of African American History and Culture. Gift of Louis Moore Bacon. Collection of the Smithsonian National Museum of African American History and Culture, Gift of Louis Moore Bacon.

noted abolitionist and minister who requested that Duncanson paint *Cliff Mine, Lake Superior*, 1848. Around 1850 to 1852, Cincinnati abolitionist and art patron Nicholas Longworth also commissioned him to paint a series of eight large-scale murals (9 ½ x 6 ft.) for his home.

The NMAAHC's *The Garden of Eden* is a smaller version of a painting Duncanson presented to Charles Avery to commemorate his work as an abolitionist and his support of free people of color. This generous and thoughtful gift was considered an important event and was covered by several newspapers, including the *Frederick Douglass' Paper* and the *Daily Cincinnati Gazette*, which described the painting as his "chef d'oeuvre."[3] Even though *The Garden of Eden* can be appreciated solely on its merits as an elevated narrative/religious landscape painting, we felt it was also important to call attention to its important connection to the antislavery movement and its proponents, particularly as they relate to the stories of free people of color and the abolitionist movement in the museum's *Slavery and Freedom* exhibition.

One of the key sections in *Slavery and Freedom* is titled "Anti-Slavery: A Movement in Black and White, 1820–1861." In this area of the exhibition, visitors learn about how black and white abolitionists worked together in an effort to eradicate slavery, despite the violent backlash many experienced as a result. This section also reveals the complexity of these partnerships, as blacks and whites often had divergent opinions with regard to the role of free people of color in American society. Many objects featured in this exhibition are particularly relevant to *The Garden of Eden* and its abolitionist context, such as the American Anti-Slavery Society collection box, ca. 1850, used by the family of abolitionist William Lloyd Garrison to raise money for the abolitionist movement; an enameled beauty-patch box with an antislavery slogan; and a first edition copy of *Uncle Tom's Cabin*, 1852, by writer and abolitionist Harriet Beecher Stowe.

The other area of the *Slavery and Freedom* exhibition with compelling connections to Duncanson is "The Limits of Freedom." This section focuses on the limitations of freedom and equality for free people of color and the ways that they worked to secure their own rights as well as the rights and freedoms for those that remained enslaved. Additionally, "The Limits of Freedom" explores how, despite the challenges of restrictive codes and discriminatory practice, many free people of color were able to become entrepreneurs, philanthropists, and community leaders. One object in this exhibition segment that speaks most eloquently to this point is a silver teapot (ca. 1817–1829) created by Peter Bentzon.

Peter Bentzon (ca. 1783 to after 1850) is considered the earliest known black silversmith to be recognized as a master craftsman in the United States. Bentzon was of mixed racial heritage; he was born on the island of St. Thomas to a free white father and a mulatto mother. Around 1791, he was

Order ID: 111-8229115-4608257

Thank you for buying from CRC Family Books on Amazon Marketplace.

Shipping Address:

Dixie Norwood	Order Date: Sun, Jul 7, 2019
PO BOX 544	Shipping Service: Standard
BUTLER, AL 36904-0541	Buyer Name: Dixie Norwood
	Seller Name: CRC Family Books

Quantity	Product Details
1	**Art and Public History (American Association for State and Local History) [Paperback] [2017] Bush, Rebecca** **SKU:** RH-XDHZ-81XO **ASIN:** 1442268441 **Condition:** Used - Very Good **Listing ID:** 0205VKOWGMX **Order Item ID:** 20545678548218 **Condition note:** PAGES ARE CLEAN. COVER HAS MINOR WEAR. 100% GUARANTEE. 28

Returning your item:

Go to "Your Account" on Amazon.com, click "Your Orders" and then click the "seller profile" link for this order to get information about the return and refund policies that apply.

Visit https://www.amazon.com/returns to print a return shipping label. Please have your order ID ready.

Thanks for buying on Amazon Marketplace. To provide feedback for the seller please visit www.amazon.com/feedback. To contact the seller, go to Your Orders in Your Account. Click the seller's name under the appropriate product. Then, in the

sent to Philadelphia to be educated, and from 1799 to 1806 he trained as a silversmith. Like Duncanson, Bentzon's free-born status and fair complexion afforded him opportunities to move in a wider variety of social circles, sometimes passing for white during his time in the United States. He was an independent business owner who achieved a level of success that allowed him to be the sole financial provider for his wife and six children.

The important relationship between Duncanson, *The Garden of Eden*, and the abolitionist movement is clearly stated in the object label and gallery interactive, although the painting's connection to the work of Peter Bentzon is not directly referenced. However, we hope that visitors who visit the *Slavery and Freedom* exhibition will link what they learn about Bentzon and free people of color in "The Limits of Freedom" section to the story of Duncanson's life and work. In the future, we will be able to make these connections more explicitly through the visual art component of the museum's website.

DAVID DRISKELL, *BEHOLD THY SON*, 1956

When I first began acquiring art for the museum's permanent collection in 2008, I knew that I wanted to collect pieces that engaged themes of religion, activism, struggle, loss, and resilience. That year, I encountered a work of art that incorporated all of these subjects in one powerful image, *Behold Thy Son*, 1956, by David C. Driskell.

David Driskell is a renowned art historian, curator, professor, and artist. He is often referred to as the "godfather" of African American art history in honor of his many contributions to the field as well as his generosity in guiding and mentoring generations of young artists and art historians. While reading Driskell's biography, *David Driskell: Artist and Scholar*, I encountered an image of *Behold Thy Son*, a painting that struck me as a perfect fit for our museum. The style, subject matter, and coloring of *Behold Thy Son* represents a radical departure for the artist, who is best known for his colorful semi-abstracted landscapes, still life, religious, and African-inspired imagery. It is also one of the few politically motivated paintings in his oeuvre and, by far, his most significant. An allegorical modern-day pieta, *Behold Thy Son* is an important and thought-provoking tribute to the life and death of Emmett Till.

Till was a fourteen-year-old Chicago native whose mother sent him to visit their family in Money, Mississippi, during the summer of 1955. In late August, Till and his cousins visited a local grocery store where he was accused of disrespecting Carolyn Bryant, wife of Roy Bryant, the store's owner, who was away on a trip at the time. Several days later, upon Bryant's return (August 28), he and J. W. Milam kidnapped Till, brutally beat and then shot him in the head before tying him with barbed wire to an eighty-pound fan

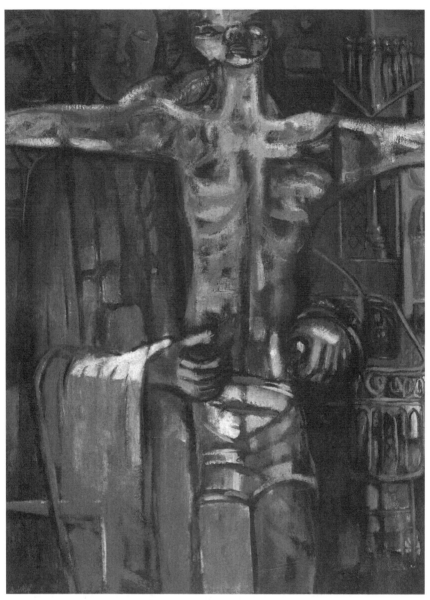

Figure 1.2. David C. Driskell (b. 1931), *Behold Thy Son*, 1956. Oil on canvas, 40 x 30 in. (101.6 x 76.2 cm). Collection of the Smithsonian National Museum of African American History and Culture. © David C. Driskell.

and dumping his body in the Tallahatchie River. When Till's body was found three days later, his body and face were mutilated beyond recognition. Mamie Till brought her son back to Chicago for burial and insisted that the casket remain open to allow "the world to see" the hate and barbarism brought to bear upon her child as well as other African Americans living under the yoke of racial violence and intimidation.[4]

Roy Bryant and J. W. Milam were tried before an all-white jury in September 1955. Although both men were found not guilty, they later admitted to the murder during an interview with *Look* magazine in 1956.

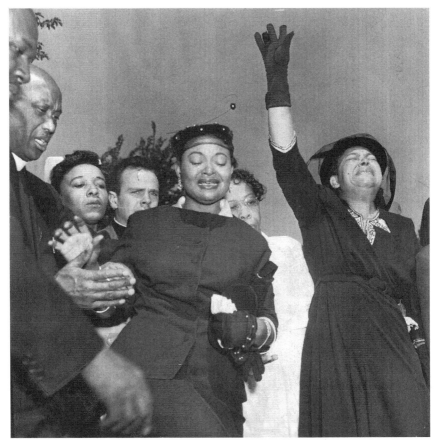

Figure 1.3. Dave Mann, *Till Boy's Funeral, Burr Oaks Cemetary* [sic], September 6, 1955. Silver and photographic gelatin on photographic paper. 81⁵/₁₆ X 9¹/₁₆ in. (22.7 x 23 cm). Collection of the Smithsonian National Museum of African American History and Culture. Gift of Lauren and Michael Lee. Photo courtesy of the *Chicago Sun Times.*

The story of Till's brutal murder and funeral received widespread coverage by the press. Images of his mangled face and body, published in *Jet Magazine* in 1955, mobilized many individuals to actively take part in America's burgeoning civil rights movement. David Driskell, who had just moved his family from Washington, D.C., to Alabama for a teaching position at Talladega College, was deeply moved by this tragedy and felt compelled to express his feelings though his art.

The painting's title, *Behold Thy Son*, is taken from a biblical verse in John 19:26: "When Jesus therefore saw his mother, and the disciple standing by, whom he loved, he saith unto his mother, Woman, behold thy son!" Driskell meant for the image and the title to evoke a symbolic connection between Till's lynching and the crucifixion of Christ. For example, Driskell employed broad, aggressively applied brushstrokes to render Till's body to signify the horrific injuries inflicted upon him prior to his death and the subsequent mutilation that continued after he was cast into the Tallahatchie River. He also painted a seven-branch Jewish menorah, placed right of the figure, to represent the seven spirits of God. And Till's casket, located in the bottom right of the image, is decorated using a rinceau design signifying, in Driskell's words, Till's "royal and dignified burial in spite of the violence perpetrated on [him] by barbaric people."

The thematic and historical link between Driskell's painting and the history exhibition, *Defending Freedom, Defining Freedom: Era of Segregation 1876–1968*, is undeniable, as one of the most powerful segments of that exhibition is a section dedicated to the murder and legacy of Emmett Till. A few months after the NMAAHC acquired *Behold Thy Son*, we also were entrusted with Till's casket, a sacred object donated to the museum with the approval of Till's family.

The casket on display in the museum was the one that held Till's body when thousands of visitors paid their last respects during his wake. In 2005, Till's body was exhumed for DNA tests to confirm that it was Mamie Till's son. Till was reburied in a new casket, and the old one was saved with the intention of its possibly being used for a Till memorial museum. Although the memorial museum never materialized, we were entrusted to share his story so that his life would never be forgotten. Many of the images, objects, quotes, and statements contained within this section would have been seen by Driskell prior to and during the creation of his painting. These include several issues of *Jet Magazine*; quotes by Mamie Till and by Rosa Parks; images of Till as a young boy, Mamie Till, the Tallahatchie River, and the fan used to weigh Till's body in the water; and a film documenting how Till's death affected a wide array of people as events unfolded and later on in time.

Behold Thy Son is exhibited in the section titled *Religion and Spirituality*, on a wall dedicated to the artistic expression of religion, political activism, and personal struggle during the civil rights movement. We see this work as both an expression of the themes elucidated in *Defending Freedom, Defining Freedom* as well as a historical testament to that era. Driskell's visual tribute to the life, death, and historical legacy of Emmett Till serves as a poignant reminder that even though many people in our society view art as an elitist pursuit, far removed from everyday life and struggles, it is an integral component of our world and a potent lens through which the personal and the historical can be experienced over time.

Although we believe that visitors will not have any problems linking *Behold Thy Son* to the section on Emmett Till in *Defending Freedom, Defining Freedom: Era of Segregation 1876–1968*, we briefly touch on the history of Emmett Till in the object label. We also have a more detailed discussion of Emmett Till, his murder, and the funeral in the "Historic Context" section of the gallery interactive. In addition to the text, the interactive also includes two photographs from the era—one of Emmett Till with his mother and the other of Mamie Till weeping over her son's casket.

JEFFERSON PINDER, *MOTHERSHIP (CAPSULE)*, 2009

Jefferson Pinder's sound sculpture, *Mothership (Capsule)*, is located in the gallery titled *New Materials, New Worlds*. Named after George Clinton's famous stage prop, The Mothership, Pinder's sculpture is a present-day space vehicle modeled after NASA's Mercury space capsule *Liberty Bell 7*. Pinder constructed his sculpture with wood salvaged from President Obama's 2009 inaugural platform and ceiling tin from a gutted Baltimore house. His goal was to create a provocative artwork that evokes both the past and the present, science fiction and space, hope for the future, and the promise of racial equality. He states, "We grew up when NASA was in its golden age. Remember, the first interracial kiss on television was in outer space on Star Trek. Space is an idealized entity. Science fiction fantasy is something that has not been figured out. . . . We see this relationship between escapism and identity. It is, in part, a spiritual place that African Americans have always inhabited. Ingrained in popular culture, it is a utopian idea that other places could be better."[5]

Pinder's *Mothership* embodies a myriad of interrelated themes and discourses found throughout the museum. The most obvious feature of this sculpture is its physical resemblance to the Mercury space capsule. Project Mercury (1958–1963) was America's first manned space program, marking a pivotal moment in American history and space exploration. For a few African

Figure 1.4. Jefferson Pinder (b. 1970), *Mothership (Capsule)*, 2009. Mixed media: tin, wood, chrome, bass speaker, audio. Audio: Sun Ra, *Space Is the Place* and Stevie Wonder, *Living for the City*. 92½ x 75 x 86 in. (235 x 190.5 x 218.4 cm). Collection of the Smithsonian National Museum of African American History and Culture. Gift of Henry Thaggert III in memory of Burnell P. Thaggert. © Jefferson Pinder.

Figure 1.5. Designed by Jules Fisher and George Clinton (b. 1941). *The Mothership*, 1990s. Metal, plastic, glass. 120 x 250 x 113 in. (304.8 x 635 x 287 cm). Collection of the Smithsonian National Museum of African American History and Culture. Gift of Love to the planet.

Americans, the advent of space travel beyond the accomplishments of American scientific exceptionalism, it was also a symbol of hope, progress, and the potential of a new and better world.

Within the museum, there are several exhibition areas that underscore the connection between Pinder's sculpture and the influence of space travel in African American history and culture. The most immediate of these is the cross-exhibition dialogue between *Mothership (Capsule)* and the stage prop The Mothership, located in the *Musical Crossroads* exhibition. The original version of The Mothership was used between 1976 and 1981 as a theatrical live-concert centerpiece designed by George Clinton and Jules Fisher. It served as a visual allegory of the transformative and transcendent power of music to transport listeners to a utopian cosmic universe—free of racism, segregation, and earthly constraints. The Mothership in the museum's collection is not the original version but a replica created to replace the first version that was destroyed in the 1980s. The newer version was created in the 1990s and was used during Parliament-Funkadelic's Mothership Reconnection Tour.

Another connection linking Pinder's sculpture and Afrofuturist philosophy to other areas of the museum relates to television's cult classic series, *Star Trek* (1966–1969). When *Star Trek* debuted in 1966, it was revolutionary for

its incorporation of multiracial actors and characters—most notably Nichelle Nichols, who played Lieutenant Uhura; Japanese American actor George Takei, who played Lieutenant Sulu; and Leonard Nimoy, who played the half-human/half-Vulcan Lieutenant Commander Mr. Spock. For African Africans, the inclusion of Nichols in a nonstereotypical, albeit secondary role, was a major source of pride. So much so that when Nichols contemplated resigning to pursue a role on Broadway, she was encouraged to remain by Dr. Martin Luther King Jr., whom she met during a fundraiser. According to Nichols, King (a self-professed fan of the show and her character) counseled her to stay with the series. She recalled, "Dr. Martin Luther King . . . approached me and said something along the lines of 'Nichelle, whether you like it or not, you have become a symbol. If you leave, they can replace you with a blonde haired white girl, and it will be like you were never there. What you've accomplished, for all of us, will only be real if you stay.' That got me thinking about how it would look for fans of color around the country if they saw me leave. I saw that this was bigger than just me."[6]

Like Martin Luther King Jr., the presence of a black woman in space who was an officer and an integral member of the crew was meaningful to Pinder. When describing the influence of *Star Trek* and the relationship it has to the evolution of his work, he states, "Besides *Star Trek* being a cultural Phenom, it represented society being pushed and tugged in many ways. *Star Trek* featured civil warriors exploring new frontiers, pushing our understanding of societal relations and norms. I loved that space exploration represented an escapist journey in which viewers are seemingly transported to another world. *Star Trek* allowed for us to look at ourselves again. If a black man exists in outer space, is he black? Can we break free of the gravitational forces that keep us down?"[7]

In 2016, the NMAAHC acquired one of Nichelle Nichols's "Lt. Uhura" Starfleet uniforms worn in the first season of the *Star Trek* series (1966). The uniform is slated for display in the *Taking the Stage* exhibition in the section "TV Pioneers." Although it was not on view at the time of opening, an image of the uniform, along with an explanation of its significance in relation to popular culture and Pinder's sculpture, will be incorporated in *Visual Art and the American Experience*'s gallery interactive.

The final link between the *Mothership (Capsule)* and other museum themes relates to the 2008 inauguration and legacy of President Barack Obama, a subject covered in *A Changing America: 1968 and Beyond*. For many African Americans, including Pinder, the prospect of living to see an African American occupy the greatest office in the United States was something of the stuff of dreams. He states, "Like most of the free-world I was ecstatic at the election of Obama. I think most every artist I know made an

Obama piece of work following his election. This was mine. I think a generation of dreamers were inspired."[8]

The influence of NASA's space program, science fiction, *Star Trek*, President Obama, Afrofuturism, *The Mothership*, and George Clinton on the aesthetic design and theoretical concept of Pinder's sculpture is explained in the object label. In the future, we will be able to delve even deeper into these connections through text and images when we add *Mothership (Capsule)* to our gallery interactive. However, for the present time, we are confident that our audience will be able to understand how the subject and theme of the artwork relates to other areas of the museum.

PRESS AND VISITOR RESPONSE

Reaction to our exhibition from visitors and critics alike has been overwhelmingly positive. Vinson Cunningham of *The New Yorker* described the exhibition as the "triumph of the building's interior."[9] He also referenced the connection between Duncanson's *Garden of Eden* and relevance within a preemancipation era. He states, "Painted thirteen years before emancipation, [the painting] depicts a paradise, leafy and mountainous but also unsettling dark. . . . The painting conveys a post-Fall America, tinged with menace, in which sin and grace manage a dissonant coexistence."[10] *New York Times* critic Holland Cotter stated that the exhibition's mix of well-known and little-known artists "usefully confuse any pigeonholing definition of what 'African-American art'—and by extension, identity—means." Cotter also made the connection between our exhibition and other exhibitions in the museum, stating, "If you could crawl under the witty, jazzy sculpture 'Mothership (Capsule),' by the Washington artist Jefferson Pinder, you'd find supports made of wood salvaged from President Obama's 2009 Inauguration Day platform." He adds, "There's another Mothership on view for the opening, too, this one a 1,200-pound aluminum stage prop with flashing lights once used in the 1990s by the Afro-Futurist musician George Clinton and his Parliament-Funkadelic band. It's in the 'Music' galleries, which are pure heaven."[11]

CONCLUSION

The process of creating the exhibition *Visual Art and the American Experience* was a labor of love, a journey into uncharted territory, and a dream fulfilled. Dr. Jacquelyn Serwer and I set out to change the perspective of how art created by African Americans is interpreted and to illustrate its essential

connection to our history and our world. Through the immense efforts of our staff, the generosity of our donors, and the indispensable advice from members of our curatorial team, we were able to create an exhibition that can be experienced and enjoyed on a variety of levels—aesthetically, intellectually, and thematically.

When I began writing this chapter, the museum had yet to be opened. Now, as I write my final words, we have been open for ten days, and I have just celebrated my nine-year anniversary as a NMAAHC curator. The experience of building an art collection from scratch, mounting a traditional art gallery in a museum of history and culture, and creating a new narrative framework through which visitors can experience art has proven to be a daunting, exciting, scary, and fulfilling experience.

During my research for this chapter, I came across a statement by President Obama that resonated with my sentiments about this stage in the museum's existence. The speech outlined his vision for the future of NASA's space program, and described how the innovations and accomplishments achieved through the program inspired him and captured the essence of what it means to be an American. In reference to the lunar landing, its importance to the history of mankind, and what it means for us today, he stated, "The question for us now is whether that was the beginning of something or the end of something. I choose to believe it was only the beginning."[12] Even though our museum is open and our exhibition complete, we choose to believe that this is only the beginning for the exhibition and interpretation of art by Americans of African descent—a foundation from which future curators will build and expand upon long after we have departed.

NOTES

1. David C. Driskell, email message to the author, August 30, 2016.

2. Grace Glueck, "The Best Painter I Can Possibly Be," *New York Times*, December 8, 1969.

3. *Frederick Douglass' Paper* ran the story on Duncanson's gift of *The Garden of Eden* on August 6, 1852. The *Daily Cincinnati Gazette*'s article appeared on October 15, 1852. Joseph Ketner, *The Emergence of the African-American Artist: Robert S. Duncanson, 1821–1872* (Columbia and London: University of Missouri Press, 1993), 44–45, 212.

4. S. Booker, "Nation Horrified by Murder of Kidnaped Chicago Youth," *Jet Magazine*, September 15, 1955, 9.

5. A. M. Weaver, "In the Studio: Jefferson Pinder, From Cosmonaut to Escape Artist," *Artvoices Magazine*, November 6, 2012.

6. Abby Ohlheiser, "How Martin Luther King Jr. Convinced 'Star Trek's' Lt. Uhura to Stay on the Show," *Washington Post*, July 31, 2015, https://www.washingtonpost.com/news/arts-and-entertainment/wp/2015/07/31/how-martin-luther-king-jr-convinced-star-treks-uhura-to-stay-on-the-show/.

7. Email communication with Jefferson Pinder (October 3, 2016).

8. Ibid.

9. Vinson Cunningham, "A Darker Presence: A Museum of African-American History Finally Comes to the Mall," *The New Yorker*, August 29, 2016, 39.

10. Ibid.

11. Holland Cotter, "Review: The Smithsonian African American Museum Is Here at Last. And It Uplifts and Upsets," *New York Times*, September 15, 2016.

12. President Barack Obama, "Remarks by the President on Space Exploration in the 21st Century," John F. Kennedy Space Center, Merritt Island, Florida, April 15, 2010, http://www.nasa.gov/news/media/trans/obama_ksc_trans.html (accessed October 6, 2016).

Chapter Two

Citizenship and Caricature

Teaching the American Past with Images[1]

Jennifer M. Black

In 2013, I began an undergraduate lecture by projecting an old photograph and asking my students to describe what they saw. I gave no context or attribution information, save the date and place of production (US, 1864). Peering at the small, sepia-toned oval portrait, the students described a young girl, perhaps five or six, with pretty brown hair that had been curled and styled, falling softly in ringlets around her face. Scrutinizing her white billowy dress and the carved wooden chair supporting her, the students speculated that she might be from a middle-class family—the girl's clothing appeared clean and in good shape; surely only a moderately wealthy family could afford to photograph their children. Some students saw a sad look in her eyes; others caught a glimpse of anger or frustration. After a few minutes of pointing out the details in the image, they all agreed that she was likely the daughter of a member of the middle class, for she appeared well fed, well clothed, and white. The students were shocked to then learn that the photograph's caption reads "Rosa, a slave girl from New Orleans" (figure 2.1).

Though Mary Niall Mitchell wrote a decisive article examining this image in 2002—and the impact of her work continues to shape scholarship on the history of photography, race, and the Civil War in the United States—Rosa's photograph still shocks students because of its incongruity with the public's predominant understanding of the racial identity of slaves in the United States.[2] Every semester I deploy the same image, ask the same questions, and experience the same results: students are incredulous at the sight of the caption, their disbelief registering in dumbfounded stares as I explain that Rosa was likely the child of a white man and a light-skinned slave woman, who passed on her slave status to all of her children, regardless of their father's racial or social standing. Like much of the American public, my students continue to inhibit deep preconceived notions about slavery and whiteness in US

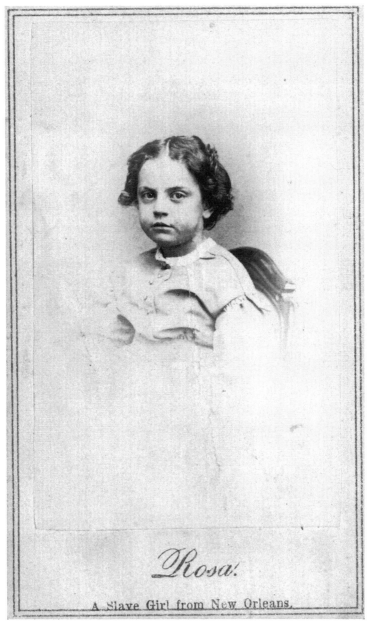

Rosa.

A Slave Girl from New Orleans.

Figure 2.1. Charles Paxson, "Rosa, a Slave Girl from New Orleans," albumen photographic print on carte de visite mount, 10 x 6 cm (New York, 1864). William Gladstone Collection of African American Photographs, Library of Congress, Prints & Photographs Division [Reproduction number LC-DIG-ppmsca-11240].

history; they assume that all slaves were black, and that blackness and slavery was visible on the body. Though this assumption fails to take into account gray areas—like Rosa's situation—it illustrates a key aspect of visuality that continues to impair us today, much as it did our nineteenth-century predecessors. Vision is not always indexical; that is, appearances can be deceiving. This exercise illustrates the difficulty historians often face when attempting to counter dominant narratives that structure public understandings of the past. Visual culture can serve an important function in aiding such counternarratives by evidencing the ways that American society and culture historically recognized belonging as a visible, bodily attribute.

In many ways, therefore, Rosa's portrait provides compelling evidence of the visual construction of Otherness throughout American history, even if it only serves as a reminder of the tension between vision and our assumptions about belonging in the past. History reminds us that free blacks were not always welcomed in the North, femininity was not a privilege available to all women, slaves were not always "black," and the Irish were not always "white." While the historical profession has long since accepted such claims, public historians and teachers still face the difficult task of arguing and proving these points for the many audiences we encounter through our work. Images, I argue, can help us interrogate and explicate the history of citizenship and belonging in the United States, demonstrating both how past individuals understood cultural norms and how those same individuals ridiculed others for their deviation from established norms.

SEEING IMAGES AS OBJECTS

Following the 1972 publication of John Berger's highly influential study *Ways of Seeing*, a small yet vocal group of historians called for the increased use of images as primary sources in the classroom. Berger's work introduced a generation of historians interested in cultural history to the myriad ways that images could be useful in understanding the past.[3] The following year, Thomas Milton Kemnitz argued that political cartoons could reveal past public opinions and culture, and provided some methodological suggestions for historians to consider.[4] Though the field of material culture studies grew in the 1980s (predominantly through the work of Thomas Schlereth and Jules Prown), urgent calls for using visual culture as a primary medium for historical study did not come until the 1990s.[5] Here, Katharine Martinez and Louis Masur each beckoned historians to consider using visual culture as primary sources for research, suggesting that beyond providing simple illustration of past events, images could "illuminate" latent cultural values in the past.[6] In so doing, Martinez and Masur gestured to an emerging body of historical scholarship that demonstrated

the power of visual culture in history—scholarship that used images as primary sources to reveal hitherto unknown narratives, and that pointed to their agency in precipitating change.[7] Soon after, history educators began echoing the same calls for including images in both classroom lessons and assignments, most recently advocating an image-centered approach to teaching historical content.[8]

In short, the value of teaching with images is well documented. Many advocates of an image-centered approach note that because students generally assume they understand how to read images, the sources become that much more important for the contradictory narratives they potentially offer. Pointed discussions thus hold the power to reveal "competing truths" that can reshape students' interpretation of the past.[9] Moreover, as a recent psychological study demonstrated, provoking a surprising and emotional response in the viewer triggers memory and promotes learning. This effect can be heightened when using images that invite an identification between the student and the subjects depicted, as in my use of the photograph of "Rosa" to challenge white students' understandings of race and slavery in the American past.[10]

Historians' use of images as meaningful primary sources builds upon the theoretical treatises offered by art historians and semioticians, most notably in the work of Erwin Panofsky and Roland Barthes. In 1955, Panofsky outlined a method for visual analysis rooted in discovering three levels of meaning in an image: the literal meaning of details, the conventional meaning of the same, and the symbolic meaning.[11] The first two levels make up the "iconographic" meaning of the image—that is, the viewer's interpretation of the details based upon literal or factual knowledge combined with learned or conventional understanding. The third level of meaning, the symbolic (which Panofsky called the "iconologic"), comes from "a unifying principle which underlies and explains both the visible event and its intelligible significance."[12] In other words, knowledge of the prevailing cultural worldview and context for the image's creation will shed light on the iconologic meaning of the image.

Panofsky's theories of the iconographic and iconologic meanings inherent in art were later expanded and explained by semiotician Roland Barthes in his essays on photography. Barthes also theorized three levels of meaning: the "denoted" or literal meaning of the subjects depicted, the "connoted" or symbolic meaning behind the image's content, and "anchored" meanings that come from texts (captions) positioned alongside the image.[13] Like Panofsky, Barthes noted that symbolic meaning stemmed from understanding context— the system of cultural signs that constitute a code of symbolic meanings ("signifiers") that could be read into the image. Thus, embedded within every image is a "rhetoric": a code of ideologies that give meaning to the signs/ symbols within the image, which together make up the plurality of meanings associated with the different possible interpretations of the image itself.[14]

The important points to take from both Panofsky and Barthes lay in their theorization of varied levels of meaning within the image, and their emphasis

on the ways that cultural (and historical) context and the positional standpoint of the viewer—including unspoken or expressed biases—can structure the meaning of an image. Both theoreticians stress that images cannot be taken at face value: assumptions of the perceived indexical (or documentary) value of images are patently false. Artists work within existing cultural codes to determine the inherent and symbolic meanings embedded in their visual creations. They make decisions to structure the image in ways consistent with their intended messages and their specified audiences. Thus, through an internal "rhetoric" (to borrow Barthes's phrase), images make visual arguments that combine cultural conventions, symbols, and evidence to persuade the viewer. In assessing these arguments, historians can uncover the agency that images had in shifting past cultural behaviors. In the history of citizenship and belonging in particular, political cartoons played an important role in *visually* marking distinct groups as unfit for inclusion in the citizenry.

Thus, my pedagogy begins from the assumption that images can, and should, be treated as objects—objects with a history—whose deconstructed meanings can divulge important stories about past society and culture. I first introduce the compositional elements of the image (line, proportion, perspective, contrast/shading, etc.) and its symbolism (color, weather, body language, clothing, etc.) to enable students to verbalize what they see.[15] Once students have a firm grounding in methods of visual analysis, we can move on to careful *ekphrasis*—a pointed description of the image through a close reading of its details.[16] This process involves asking them leading questions to substantiate the details, and active listening on the part of the instructor to reiterate what students have said, to rephrase their descriptions as needed, and to summarize as we move through the parts of the image. The instructor's role in this process is both to reflect and redirect student descriptions while offering important contextual information as needed to augment their reading of the image. Context is key here, because it enables us—as contemporary viewers divorced from the cultural norms of the past—to attempt to understand how and why past society might have viewed the image in a particular way. In this stage, the process mimics a conversation between the group and the instructor, which results in an organic revelation of the image's symbolic meaning. I allow students to offer preliminary interpretations of each area of detail in turn before moving onto another component. Once we've deconstructed the image, I then push the group to consider potential audiences, their responses, and the artist's intent. I ask questions of the students and interject important contextual notes that will help shape the students' speculations as to potential audience reactions. Again, I use this context to provoke a connection between my contemporary students and historical publics. In this step, it is also important to push students to consider alternative audiences and intentions behind the image—for example, "we've assumed thus far that the artist's audience was x, but what if it were y?" Asking deliberately

argumentative questions reinforces the point that there is no single hegemonic interpretation in considering images from the past. Only after discussing each of these elements can we then step back and consider the overall meaning(s) and significance of the image itself.

In what follows below, I will model this method of immersive image analysis, interspersed with contextual information, to reveal the ways that nineteenth-century American visual culture provides an exemplary source for understanding the history of citizenship and belonging in the United States. This model is based upon an interactive-lecture approach to the classroom, using images to guide discussion and interpretation of the course content. I've found that students need some priming before they are comfortable dissecting images on their own, thus I recommend an introductory lecture that firmly grounds the students in the terms used to talk about the formal qualities of an image. In our first analysis discussion, I use a fairly transparent image—such as the Currier example below—to warm up the students. "Describe what you see," I ask, reminding them that I'm only looking for the literal details, not interpretation. For many students, simply verbalizing what they see is a great way to begin discussion; others may have trouble limiting their contributions to simple description without interpretation. With encouragement and leading questions, students gradually become more comfortable vocalizing their thoughts and ideas, which eventually lead to interpretation. To reinforce the concepts we discuss in class, I ask students to demonstrate visual analysis on written work, including short essay exams and longer analytical assignments, disbursed throughout the semester. Through this written work, students gain the opportunity to demonstrate the analysis modeled for them in our classroom discussions while working directly with primary sources to interpret the past. About halfway through the semester, they begin to "get it" and can offer fairly sophisticated analyses of historical images, both in discussion and in written work.

To understand citizenship and belonging in the past, it is important to look at model citizens and the qualities that made them ideal. Nathaniel Currier's 1848 print *The Fruits of Temperance* demonstrates how antebellum artists translated middle-class ideologies into visual form and distributed them for public consumption (figure 2.2). In this print, we see five figures standing on either side of the image: a young woman and infant on the right, and a young man with two children walking toward her from the left. Currier used several compositional elements to demonstrate the relationship of this group as a close-knit family. The triangular gaze created by the figures links the group together despite their physical separation: the figures all turn toward the center of image, indicating that this is a nuclear family with strong emotional ties to one another. Their smiling faces and pleasant expressions, along with their physical gestures toward each other, strengthen our impression of their bond as a family. Currier creates visual stability by using multiple perpendicular lines in the im-

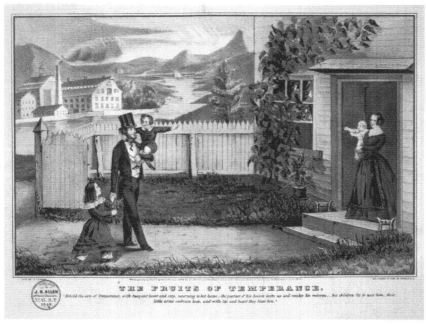

Figure 2.2. Nathaniel Currier, *The Fruits of Temperance*, hand-colored lithographic print, approx. 11 x 14 in. (New York: J. B. Allen, 1848). Library of Congress, Prints & Photographs Division [Reproduction number LC-USZC2-2380].

age—the vertical lines of the house, window, doorway, and step intersect with the horizontal lines of the white fence, the sandy pathway, and the green grass. These perpendicular lines firmly ground the image, giving it a sense of order that separates it from the space outside the fence, which Currier contrasts with the jagged diagonal lines of the river and mountains. The varied terrain outside the fence mimics the chaotic character of the public sphere, while the stability of the space inside the fence signifies the domestic sphere. In this way, Currier visualized the emphasis that the antebellum middle class placed on the home as a haven away from the boom and bust of the public sphere. He placed the family at the center of this haven to emphasize the importance of familial unity for success and happiness—just as the antebellum middle class did in numerous etiquette books and treatises on manners.

After 1815, the Northern middle classes struggled to cope with their own tenuous social standing, as the Market Revolution destabilized existing social orders. Cultivating an ideal of respectable and restrained self-display, a socially mobile group of merchants and industrialists increasingly sought to differentiate themselves from the lower classes by emulating the genteel manners of high society. They institutionalized strict codes of dress, conduct, and cor-

respondence that underscored their preferred separation of public and private space along gendered lines. As men controlled the public sphere of politics and industry, women's place became the home—a refuge from the harsh disorder of public life.[17] Through carefully selected fashions and learned behaviors, men and women of the Northern middle classes practiced restraint and demonstrated refinement. In so doing, they reflected their anxieties about their own tenuous place in the emerging social hierarchy in the United States—a hierarchy that these middling sorts desperately attempted to preserve despite the prevailing myth of America's "classless" democracy. Publically displaying one's status (and knowledge of prescribed rules) was therefore essential to belonging for the antebellum middle class, in many ways because of the seemingly unstable boundaries between social classes in this fluid, young society.[18]

Following these maxims, Currier visualized the class status of this family through the costumes and appearance of the figures and their environment. Each figure wears clean, pressed, and tailored garments, suggesting the group has enough expendable income to afford such goods and maintain them. The children appear not in play clothes but in navy satin outfits, their hair delicately styled to match their clean hands and faces. The little girl presents a freshly picked flower to her father, who dotingly clutches his son in his arms. The boy's blue romper matches the satin of his sister's dress, as well as the apron worn by the mother, whose bold red gown provides a stark contrast from the baby's white lace dressing gown. These blue color blocks unify the figures on either side of the image, bringing them together as a family unit. The sheen of the father's black patent leather top hat, alongside his crisp white shirt and pressed three-piece suit, indicate his status as a clerk or manager. These are not a workingman's clothes; they are the marks of a gentleman. Were this family poor, we might see dirty, ragged clothes, and a decrepit home; were they unhappy, we would see their gazes diverge from one another. Instead, we see smiling faces and a pristine, well-maintained, single-family home in the country. The siding and shingles of the white house are neither neglected nor in need of repair, and we even spot potted plants in the well-groomed yard. This family is decidedly middle class: their unblemished, manicured appearance separates them from the working class, yet their modest country home tempers their wealthy appearance as different from the lavish estates of the elite.

Further, Currier's positioning of the man and woman underscores the gendered separation of private and public spheres. Beyond the borders of the white picket fence lies a path to the outside world. Behind the man sits a factory, visually detached from the home space by the fence. The winding river bisects the image, marking the left side as the public sphere of factory life—the sphere for men working outside the home—while the right side signifies the domestic or private sphere: Currier plants the woman firmly in the doorway of the home, as if to note that her gender requires her confinement to the private sphere. Notice that she does not step out to meet her husband,

as the children do, but remains calmly (even contently) within the confines of the tranquil domestic space.

Finally, Currier's caption for the image, *The Fruits of Temperance*, concretizes his visual argument, and provides a clue that identifies his audience. Here, Currier stresses that the key to happiness—as well as the sanctity and stability of the home and family—lies in abstention from alcohol and following the middle-class ideal of separate spheres for men and women. In the antebellum period, temperance emerged as a social strategy to combat urban poverty, crime, prostitution, and other vices thought to destroy the family.[19] Currier links the problems of alcohol use to their perceived effects on the family by representing the opposite—a happy, stable family that is thriving because the father refrains from drinking alcohol. He anchors his visual argument with a clear political statement: true family happiness can only be had by living the temperate lifestyle.

Currier's political argument becomes more evident when considering his 1870 print *The Bad Husband: The Fruits of Intemperance and Idleness* (figure 2.3). In remarkable contrast to the 1848 image, this piece demonstrates what happens when the middle-class father falls prey to alcohol consumption. Instead of a happy, stable family, we see one marked by discord and homelessness. The winds of change are rough and difficult, as this family toils onward down their

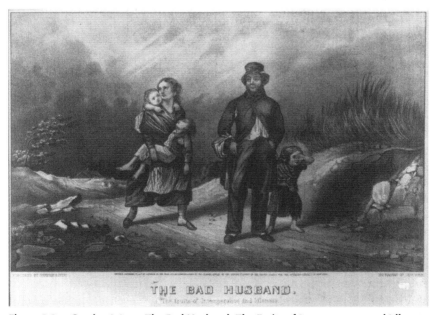

Figure 2.3. Currier & Ives, *The Bad Husband: The Fruits of Intemperance and Idleness*, lithographic print, approx. 11 x 14 in. (New York, 1870). Library of Congress, Prints & Photographs Division [Reproduction number LC-USZ62-699].

rocky path. The mother struggles to carry the limp body of her young boy, look-ing to the heavens for relief, while the little girl shields her face from the strong winds confronting her. The group's poverty is visible in their torn, ill-fitting clothes and in the children's bare feet; their diverging gazes reinforce the fam-ily's disunity and unhappiness. They've left behind a homestead, carrying their meager possessions in a small kerchief sack. Moreover, the multiple diagonal lines and the dark, winding landscape underscore the distraught emotions em-bedded in the scene. The deleterious effects of alcohol use fall heavily on the family, while the husband stands leisurely at the center of the image. He needs a tailor and a shave, but his blasé expression suggests that he remains aloof to the cause of his family's troubles. Only the cherubic baby, clinging precari-ously to her mother's back, offers him any sign of redemption. He has failed in his manly obligation to provide for his family, and thus Currier reminds the audience that the man's intemperance and idleness have made him the quintes-sential "Bad Husband." Again, Currier's visual argument arises through the details, creating an iconographic program that both ridicules the subject and cautions the viewer to steer clear of these dastardly behaviors. While in the 1848 image Currier represented the model of middle-class identity, here he strikingly marginalizes those who deviate from the ideal. Together, these two images provide a fruitful backdrop for understanding how artists marginalized various groups for their deviance from middle-class norms.

In order to understand the ways that images culturally constructed values that worked to include or marginalize particular groups throughout American history, students first need a firm grounding in the methodological consid-erations outlined here. Following a clear discussion of how to deconstruct images—including the language and terms historians use to conduct such analyses—I use images like the Currier examples above to demonstrate the ways that visual culture reinforced the dominant cultural values of the nine-teenth-century American middle class. At each juncture historical context is the key to ensuring that students can appropriately interpret the images and forge connections with the historical actors who might have viewed or been depicted in the images. Once students have this foundational understand-ing of the value of images as primary sources, we can move on to explore the ways that historical images elaborated a visual system of signifiers that worked to exclude various groups from the American citizenry.

CITIZENSHIP AND OTHERNESS

Citizenship in the United States has often been defined as much by those who do not fit inside its coffers as by those who do.[20] In the early American

republic, the dominant definition of political citizenship as a quintessentially white male privilege grew out of lingering British Common Law regulations, coupled with military service, property ownership, and taxpayer status. Indeed, the nation's first naturalization law of 1790 declared that "all free white persons" who could swear an oath of residence would be entitled to the privileges of citizenship. By definition, this clause excluded women (who could not, under prevailing laws of coverture, swear an oath in court), Native Americans, and African Americans regardless of slave status.[21] The 1790 law developed precisely in response to the growing visibility of both Native Americans and free African Americans in the new republic, whose ability to own property and pay taxes might have otherwise made them eligible for political rights. Thus, despite initial declarations of equality and self-determination by the Founding Fathers, the Constitution severely limited the US citizenry to purposefully exclude free blacks and Native Americans and preserve the political power of white men over nonwhites.[22]

The visual culture of the antebellum period reinforced these dominant ideals, as it did for those of the middle class and separate spheres, by ridiculing groups who could not (or would not) adhere to prevailing norms. Through caricature and like imagery, artists helped to reify such norms by marking those who deviated as abnormal and unworthy of inclusion by the dominant group (in this case the white middle classes). In a broad sense, such images provided an "inversion of the viewer's (or dominant culture's) self-image, and thus help the viewer self-identify by acknowledging that which he/she is not."[23] In the American past, caricatured subjects became visible proof of the naturalness of the values they failed to uphold, as artists depicted them as infantile, brutish, uncouth, oversexualized, and generally opposite from everything that "civilized" culture demanded. Public and visual mockery of the marginalized group served to remind dominant audiences of what not to do, while mutually reinforcing their own sense of superiority over the parodied subjects. In this way, caricature has historically worked to police deviant behavior by adding the stigma of public humiliation.[24] Throughout the nineteenth century, the lines of citizenship were drawn around middle-class white men of Anglo-Saxon lineage, leaving free blacks, female reformers, and many immigrants outside the boundaries of the citizenry. Caricatures mocked these groups for their supposed inability to adhere to norms dictated by the white middle class.

The free black communities of the antebellum North provided a ripe repository for social mockery, both for their determined attempts to perform as members of the middle class and for their supposed failures at doing so. Working- and middle-class whites defined themselves in opposition to blackness—where members of the white middle class claimed decorum and

self-restraint, in blacks they only saw a "lack of power, lack of decorum, lack of self-restraint, [and] lack of humanity."[25] This resulted in a myriad of caricatures depicting free blacks as childlike and poorly educated in their mannerisms and speech, as apelike and vulgar in their appearance, and as wholly ill fitted for inclusion in the American citizenry. Many leaders in the African American community sought to counter these dismissive portrayals by urging constituents to invest in education and to maintain the highest standards of virtue and decorum in public in order to strengthen arguments for full black citizenship.[26] In Philadelphia, the large and visible presence of a modestly wealthy free black community forced whites to reconsider their own definitions of citizenship and belonging, and precipitated a backlash from working-class whites who viewed the socially mobile African Americans as arrogant in their aspirations for middle-class virtue, taste, and education.[27] Caricatures of free blacks in Philadelphia, particularly those by the noted caricaturist Edward William Clay, demonstrated the anxieties whites felt over this upwardly mobile group of African Americans, and their fears that blacks might supplant them on the class hierarchy. The caricatures point to the ways that middle-class whites used notions of taste, virtue, and education to police the boundaries of belonging in antebellum Philadelphia. Finally, by painting free blacks as distasteful, self-important, and unrefined, Clay's caricatures helped to teach white Philadelphians how to interpret the increasing presence of African Americans in their city. In the wake of gradual emancipation programs in the North, free blacks seemed to threaten the privileged positions that Northern whites formerly held as slave owners. Clay's caricatures sought to reassert this privilege by diminishing the ability of free blacks to conform to the cultural standards of the white middle class.[28]

When compared to the restrained appearances of the middle-class family in Currier's *Fruits of Temperance* image, the couple in Clay's *Miss Chloe* (1830) stands out for all the wrong reasons (figure 2.4). A young man, "Mr. Cesar," has had a chance meeting with the young woman, "Miss Chloe." The darkened skin and exaggerated facial features dehumanize the African American couple, rendering them grotesque. Cesar's pink cravat and pants clash with his blue jacket, though not as horribly as Chloe's ensemble. Here, we see the ideal of self-restraint failing miserably, in Chloe's billowy dress that doesn't quite hit the ground (her slippers peer from beneath its hem), revealing her sexual faux pas in failing to cover her ankles. She's accessorized her dress with a pink shawl, purse, and umbrella, a gray fan, and a very large, overdecorated hat (complete with pink ribbons, flowers, and a lace veil). Beneath her hat we see a gold barrette and earrings, which dangle so unfashionably low they almost touch the lacy collar of her gaudy dress. A mockery of prevailing fashion standards for women, Chloe appears short and bulbous instead of elongated and delicate, as the ideal woman should (figure 2.2).

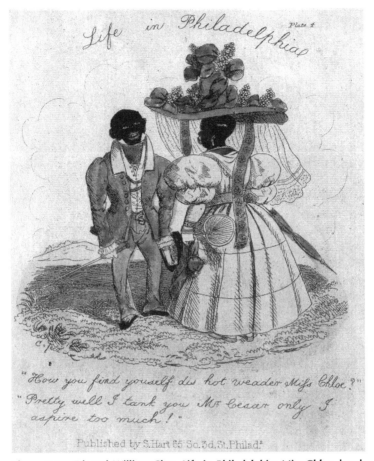

Figure 2.4. Edward William Clay, *Life in Philadelphia: Miss Chloe,* hand-colored lithograph, 21 x 16 cm (New York, 1830). Courtesy of The Library Company of Philadelphia.

The overdressed couple departs from the restrained archetypes that structured antebellum culture, having flamboyantly selected mismatched colors for their outfits. Chloe's attempt to be prepared for whatever the weather might bring—indicated by her umbrella, fan, shawl, and hat—serves as a euphemistic reminder of her childlike interpretation of social norms and incredibly poor taste.[29] In this way, Clay's image demonstrates free blacks' awareness of social codes, yet denies them the ability to adequately practice and adhere to them. They try too hard to meet middle-class standards, and in the process they reveal only their inadequacy and lack of self-restraint, and thus become a mockery of the ideals they hoped to portray. As one historian notes, "Viewers are reminded that [skin] color renders some aspirations ludicrous."[30]

Clay's ridicule of this couple extends to their use of language, shown in the caption for the image. Social guidebooks stressed the importance of formality in addressing acquaintances by "Mr./Miss/Mrs.," adding that proper salutations included the individual's *last name.* Thus, the proper mode of address would be "Mr. Jones" or "Miss Smith."[31] In Clay's image, however, our well-intentioned couple fails again, by pairing the formal prefix "Mr./Miss" with the informal first name of the addressee. The couple perverts the rules for proper address between acquaintances, displaying their clumsy application of social codes. Clay concretizes his mockery of this couple (and the entire demographic they represent) in the verbal exchange between Cesar and Chloe, jabbing at their language skills through a truncated dialect that mocks black attempts at education and proper speech.[32] When Cesar greets Chloe with a friendly question about the weather, she replies, "Pretty well I tank you Mr. Cesar, only I aspire too much!" Using the dialect to create a play on words here, Clay suggests that Chloe's social aspirations are too high for her station, and with this pun Clay's message becomes entirely clear. The image as a whole ridicules free blacks in the antebellum North, whose aspirations for social betterment and equality fail hopelessly despite all of their efforts. Ill informed and ill equipped to manage middle-class life, African Americans are doomed to failure and thus could never be considered for true citizenship in the United States. Clay's images thus help to reassure white viewers of their own superiority by dismissing free black attempts at middle-class status as impossible to achieve and entirely unnatural.[33]

Deviance from middle-class ideals for proper public behavior also structured visual caricatures of female reformers in the antebellum period—particularly those who agitated for women's rights and abolition. Following the emergence of a women's rights movement in the 1840s, caricatures of female activists increased in the 1850s as it became more public.[34] Defying the gendered rules for restrained behavior, female activists sparked fears of social disorder. Such women appeared to threaten the purity of political activity by introducing sexual desire into the public sphere, and thus artists visualized female deviance from prescribed gender norms in sexual terms. Women who exercised independence to speak out in public were caricatured as sexual deviants: whores who lacked propriety, miscegenationists who lacked racial decorum, masculine brutes who lacked feminine delicacy, or shameless spinsters lacking tact and looking for a husband to nab. Like the white anxieties that spawned caricatures of free blacks, antebellum caricatures of female reformers likely stemmed from male anxieties over their own displaced power should women gain suffrage and full citizenship.[35]

David Claypoole Johnston deftly illustrates the ways that female activists were ridiculed for their public behavior. In *Women's Rights at the Polls* (1849), the viewer catches a glimpse of a future defined by women's political participation (figure 2.5). A group of women campaign for their two presidential

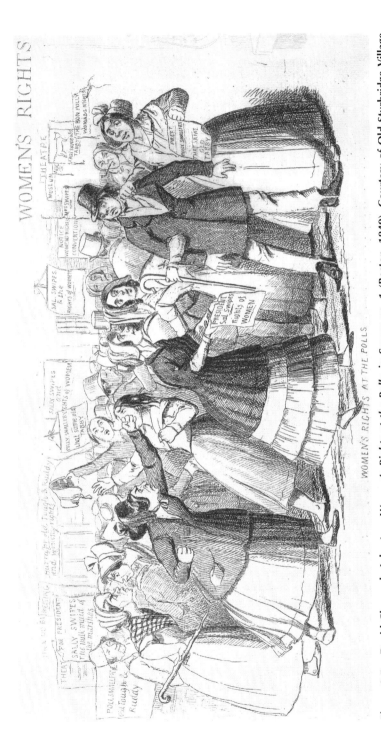

Figure 2.5. David Claypoole Johnston, *Women's Rights at the Polls*, in *Scraps* no. 1 (Boston, 1849). Courtesy of Old Sturbridge Village Research Library.

candidates, Polly Smallfry (known variously as "Old Tough & Ruddy" and "That Old Tabby") and Sally Swipes ("The Milk Maid of the Marshes"). The women engage in active (and sometimes physical) debate, and can be seen variously smoking pipes, cheering, and waving banners overhead—behaviors that diverge from the ideal of female restraint. To the right, three women accost a young man, whose stunned expression invites the viewer to identify with his fear of female aggression: they thrust posters in his face and tug him every which way. To the right, a group of women engage in a fistfight with the crowd. Their angry scowls, sturdy builds, and prominent features masculinize their appearance—a marked contrast to the dainty and delicate woman idealized by Currier (figure 2.2). Johnston defines women's independence in masculine terms in order to render it absurd in the viewer's mind. He illustrates a world turned upside down, where the unladylike presence of women in politics has resulted in their inability to maintain any form of decorum, which, in turn, threatens the sanctity of the polling place for men.

Notably, Johnston and others also portrayed female reformers as sexual deviants. *Women's Rights at the Polls* depicts women with dresses hemmed too short, revealing bare ankles, and in one case, a midcalf. Like Clay's *Miss Chloe*, these women fail to demonstrate sexual decorum as dictated by prevailing fashion standards. Political critiques of women's inability to perform the duties required by public life thus take the form of sexual criticism: jabs at reformers' propriety and immodesty. Likewise, Clay also attempted to deride female activism by painting abolitionist women as engaging in sexual congress with free black men. In a series of prints on "amalgamation," Clay depicted white women dancing, kissing, and otherwise socializing with black men out of a seeming lust for black bodies that defied the dominant standards of courtship and marriage. These images formed a political argument against abolition, suggesting that cooperation between white women and black men in the movement would lead to interracial marriage and a complete reversal of the dominant racial order. While scholars such as Elise Lemire have examined these images for their derisive representations of free blacks in the antebellum North, few note that the images also worked to discredit women's involvement in the abolitionist movement.[36] In particular, promiscuous images of white female reformers further marked them as sexual deviants who refused to adhere to middle-class codes of respectability, especially in public. An affront to both their class and their race, such women presumably sacrificed their suitability for citizenship through their aberrant sexual behavior and choices. By depicting these women as subversives, both Johnston and Clay suggested that their potential for maintaining virtue in public (and thus, in politics) was suspect.[37]

Finally, Irish immigrants to the United States faced intense discrimination in the nineteenth century, which manifested in visual stereotypes that dehumanized

and excluded them from the citizenry. Irish caricatures first emerged in Britain in the early modern period and migrated to the North American colonies along with other British ideals and customs. Like their American counterparts did with free blacks, the British ridiculed the Irish as lazy and immoral, in opposition to the proper behavior supposedly exhibited by the British middle classes.[38] Across the Atlantic, Irish Catholics leaving Europe's peasantry faced considerable prejudice from wealthy American Protestants who looked down upon their lack of skills, lowly status, and "superstitious" religious beliefs. Moreover, the immigrants tended to reside in the poorest areas of the antebellum city—often alongside free African Americans—and thus the two groups grew to share a "common culture of the lowly" in the eyes of the American middle classes.[39] With the emergence of the popular science of physiognomy at midcentury— which proposed a racial hierarchy linking skull shapes and facial characteristics with intellectual abilities—caricatures that condemned Irish social habits, cleanliness, and predilection toward vice (such as alcoholism) proliferated.[40]

By distorting and exaggerating popular conceptions linking the Irish to apes, caricatures reinforced the apparent visual and social differences that separated white, middle-class Protestants from the working-class Irish. One prominent example comes from Samuel Wells's 1866 publication, *The New Physiognomy*, which juxtaposed the portrait bust of Florence Nightingale with an Irish "type," "Bridget McBruiser" (figure 2.6).[41] The text describes these two individuals as

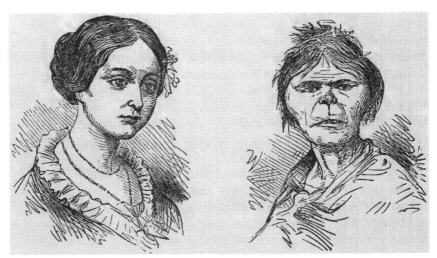

Figure 2.6. Unknown artist, *Florence Nightingale vs. Bridget McBruiser* (1866). Reprinted from Samuel R. Wells, *New Physiognomy: Or, Signs of Character, as Manifested through Temperament and External Forms, and Especially in "the Human Face Divine"* (New York: Fowler & Wells, 1875 [1866]), 537. Available online at http://archive.org/details/newphysiognomyor00well.

contrasting in every way. Nightingale, the famed English social reformer who publicized nursing during the Crimean War, is held up as the quintessentially pure and cultivated woman, while the lowly McBruiser is "rude, rough, unpolished, ignorant, and brutish."[42] The pair of images mirror these opposing descriptions in the text, painting the lowly McBruiser as haggard. Her crude expression and furrowed brow bear a marked contrast to the clean and demure appearance of Nightingale, whose gaze turns appropriately away from the viewer to demonstrate her refinement and propriety. McBruiser stares bluntly and expectantly at the viewer, confronting us with her beady eyes and broad upper lip, giving her an apelike appearance meant to provoke disgust. Her clothes and hair are dirty and disheveled, while the jagged wrinkles across her face betray, for Wells, her ignorance and predilection toward crime and vice. In contrast, the smooth lines of Nightingale's hair, face, and clothes appear to indicate her civilized, refined countenance—she is a model of middle-class propriety.

Though the text notes that McBruiser's only real crime is ignorance, her appearance as a racial Other marks her, permanently, as ineligible for inclusion in the white middle class. Like the cartoons of Thomas Nast, which consistently portrayed Irish immigrants in simian and animalistic poses, this image distills Irish identity into a set of legible, undesirable features that can be read on the body and generalized to apply to all Irish immigrants in the United States. These caricatures worked to exclude Irish immigrants from the citizenry on the basis of their inability to adhere to middle-class codes of conduct, which demanded sobriety, virtue, education, taste, and a measure of expendable income. Caricatures translated the working-class status of the Irish into a visual representation of racial difference, which marked them as subordinate, and provided a ready reference for Nativists' arguments against extending the franchise to immigrants.

What each of these examples show is that character and fitness for citizenship in the nineteenth century were thought to be *visible* on the body and in the behaviors of the individual. Shawn Michelle Smith, in examining photographic collections compiled in the nineteenth century, suggests that the processes whereby identity was envisioned produced a model of subjectivity in which exterior appearance was imagined to reflect interior essence.[43] Morally and intellectually, free blacks, white female reformers, and Irish immigrants appeared to deviate from the dominant codes of respectable public behavior as prescribed by the antebellum middle class. In their public flamboyance and ostentatious attempts to display status, free blacks demonstrated their cultural clumsiness and their inability to behave in the proper middle-class way. Likewise, female activists betrayed the prescribed ideals for their gender by speaking out in public, and in turn faced derisive visual critiques that ridiculed these women's sexual impropriety and masculine tendencies. Finally, visual caricatures that dehumanized the Irish barred them from middle-class respectability for their low

economic status. Through pointed caricatures that reified middle-class norms in their representations of deviance, the white middle-class media Otherized these groups, marking them unfit for citizenship and inclusion. Yet the paradox of this model of belonging was that the categories were not always neat; vision could be deceiving. Amalgamation led to mixed bodies, whose appearance contradicted their political status (figure 2.1). When considering the tenuous foundation of this way of knowing and belonging, the images discussed here represent the anxiety of individuals such as Currier, Clay, Johnson, and Nast about their own fragile place on the social hierarchy.

Each of the above examples demonstrates a discreet lesson about the intersections of race, gender, class, and citizenship in US history, modeling a method of visual analysis that has proven results in the undergraduate classroom. In a survey administered anonymously to my students in 2015 and 2016, 94 percent of participants found this method effective for demonstrating gendered cultural ideals for men and women, while 97 percent found the method effective for demonstrating concepts of racial inclusion and exclusion in the United States. Importantly, students overwhelmingly commented on the positive value that images added to the classroom—89 percent found them "very beneficial" in demonstrating course content—and anecdotal comments suggest that the image analyses provided the most memorable components of the course experience.[44] Moreover, in their written essays and exams, students overwhelmingly achieved the highest scores on areas that required demonstration of historical content through image analysis. Not only did the images provide the most memorable and enjoyable components of the classroom experience but also they provoked students' highest intellectual achievements on written evaluations. Finally, integrating visual analysis into written evaluations challenged my assumptions about what types of questions might be "easy" for students to complete: I soon learned that my students much preferred engaging in visual analysis on exams (even when the images might be selected at random from the pool shown in class) than complete short answer or multiple-choice questions.

Challenging students through close visual analysis of political cartoons thus provides a meaningful way to interrogate difficult concepts, such as citizenship and belonging, in American history. After a foundational understanding in the methodologies of visual analysis has been planted, students will be primed to use appropriate language in conducting their own analyses of historical images as primary sources. Carefully chosen images, such as the Currier examples above, can illuminate the ways that visual culture reinforced the dominant cultural values of the American middle class in the nineteenth century; then the real work of interrogating the ways that historical images also worked to marginalize and exclude particular groups can begin. Contextualizing these images—including their production and potential reception—provides the

key to unlocking the value that such images can lend as primary sources. Immersing students in the cultural contexts that made these images powerful and meaningful allows them to better understand the human experience of visual culture, while repeatedly asking students to practice such analysis in written work and exams helps to solidify their grasp of past events and peoples. As I have shown, these images can, perhaps if only for a moment, push students to know how and why people in the past saw citizenship as a visual quality they might identify on the bodies of Others.

NOTES

1. This chapter benefited from generous comments provided by Tawny Paul, Ryan Watson, Elisa Korb, and the audience who attended my panel at the 2015 National Council on Public History conference in Nashville, Tennessee. I also owe a debt of gratitude to Misericordia University for funding my research, and to my current and former students at MU and College of the Canyons (Valencia, California), whose feedback helped me refine my pedagogy. Finally, my method for treating images as objects developed, in part, through the course of many conversations with faculty and graduate students at the University of Southern California, especially Vanessa Schwartz, Catherine Clark, Matt Amato, and Sarah Fried-Gintis. I owe a special debt to Diana Williams for introducing me to the work of Edward William Clay.

2. Mary Niall Mitchell, "'Rosebloom and Pure White,' Or So It Seemed," *American Quarterly* 54, no. 3 (2002): 369–410.

3. John Berger, *Ways of Seeing* (London: Penguin Books, 1972).

4. Thomas Milton Kemnitz, "The Cartoon as a Historical Source," *Journal of Interdisciplinary History* 4, no. 1 (1973): 81–93.

5. See, for example, Thomas J. Schlereth, ed., *Material Culture Studies in America* (Nashville: American Association for State and Local History, 1982); and Jules David Prown, "Mind in Matter: An Introduction to Material Culture Theory and Method," *Winterthur Portfolio* 17, no. 1 (1982): 1–19.

6. Katharine Martinez, "Imaging the Past: Historians, Visual Images and the Contested Definition of History," *Visual Resources* 11, no. 1 (1995): 21–45; and Louis P. Masur, "'Pictures Have Now Become a Necessity': The Use of Images in American History Textbooks," *Journal of American History* 84, no. 4 (1998): 1409–24.

7. Martinez particularly notes several examples that use images to reveal potent "cultural values," naming Stuart Blumin's *The Emergence of the Middle Class: Social Experience in the American City, 1760–1900* (New York: Cambridge University Press, 1989) as one prominent example (ibid., 29). Other noteworthy examples of scholarship demonstrating the historical agency of images include Paul Staiti, "Character and Class," in *John Singleton Copley in America*, ed. Carrie Rebora (New York: Metropolitan Museum of Art, 1995), 53–78; Vanessa R. Schwartz, *Spectacular Realities: Early Mass Culture in Fin-de-Siècle Paris* (Berkeley: University of California Press, 1998); David M. Henkin, *City Reading: Written Words and Public Spaces*

in Antebellum New York (New York: Columbia University Press, 1998); and Anna Pegler-Gordon, *In Sight of America: Photography and the Development of U.S. Immigration Policy* (Berkeley: University of California Press, 2009).

8. Notable examples include Samuel J. Thomas, "Teaching America's GAPE (or Any Other Period) with Political Cartoons: A Systematic Approach to Primary Source Analysis," *The History Teacher* 37, no. 4 (2004): 425–46; Anna Pegler-Gordon, "Seeing Images in History," *Perspectives on History* (February 2006): 28–32; Chad Berry, Lori A. Schmied, and Josef Chad Schrock, "The Role of Emotion in Teaching and Learning History," *The History Teacher* 41, no. 4 (2008): 437–52; Barbara Ormond, "Enabling Students to Read Historical Images: The Value of the Three-Level Guide for Historical Inquiry," *The History Teacher* 44, no. 2 (2011): 179–90; Dominique Padurano, "'Isn't That a Dude?': Using Images to Teach Gender and Ethnic Diversity in the US History Classroom—Pocahontas: A Case Study," *The History Teacher* 44, no. 2 (2011): 191–208; and Jessica B. Schocker, "A Case for Using Images to Teach Women's History," *The History Teacher* 47, no. 3 (2014): 421–50.

9. Pegler-Gordon, "Seeing Images," 28, 30.

10. Berry et al., "Emotion," 445–46.

11. Erwin Panofsky, *Meaning in the Visual Arts: Papers in and on Art History* (Garden City, NY: Doubleday, 1955), 27–28.

12. Ibid., 30.

13. Roland Barthes, *Image, Music, Text*, trans. Stephen Heath (New York: Hill and Wang, 1977), 27–29, 37.

14. Ibid., 41, 49.

15. Useful methodological texts include: Molly Bang, *Picture This: How Pictures Work* (New York: SeaStar Books, 2000); Peter Burke, *Eyewitnessing: The Uses of Images as Historical Evidence* (Ithaca, NY: Cornell University Press, 2001); and Joshua Taylor, *Learning to Look: A Handbook for the Visual Arts* (Chicago: University of Chicago Press, 1957). For the purposes of this chapter, I take figurative images with human subjects as my focus. Methodological considerations for interpreting nonfigurative images appear in Henry M. Sayre, *Writing about Art* (Upper Saddle River, NJ: Prentice Hall, 2009); and Gillian Rose, *Visual Methodologies: An Introduction Researching with Visual Materials* (London; Thousand Oaks, CA: Sage, 2001).

16. A useful outline for this method, whose name derives from the Greek word for describing works of art, can be found in Sayre, *Writing about Art*, chapter 2.

17. For a detailed discussion of the antebellum middle class' views on home life, the family, and separate spheres, see Barbara Welter, "The Cult of True Womanhood: 1820–1860," *American Quarterly* 18, no. 2 (1966): 151–74; Linda K. Kerber, "Separate Spheres, Female Worlds, Woman's Place: The Rhetoric of Women's History," *Journal of American History* 75, no. 1 (1988): 9–39; and Karen Halttunen, *Confidence Men and Painted Women: A Study of Middle-Class Culture in America, 1830–1870* (New Haven: Yale University Press, 1982).

18. Linzy Brekke-Aloise, "'A Very Pretty Business': Fashion and Consumer Culture in Antebellum American Prints," *Winterthur Portfolio* 48, no. 2–3 (2014): 192–93; Halttunen, *Confidence Men*.

19. Frances Willard, *Women and Temperance* (Hartford, CT: By the Park Publishing, 1883), 43–48.

20. Barbara Young Welke, *Law and the Borders of Belonging in the Long Nineteenth Century United States* (New York: Cambridge University Press, 2010), 34.

21. For a discussion of the laws of coverture and women's exclusion from the citizenry, see Nancy Isenberg, *Sex and Citizenship in Antebellum America* (Chapel Hill: University of North Carolina Press, 1998).

22. Matthew Frye Jacobson, *Whiteness of a Different Color: European Immigrants and the Alchemy of Race* (Cambridge, MA: Harvard University Press, 1998), 30 and 22. See also Rogers M. Smith, *Civic Ideals: Conflicting Visions of Citizenship in U.S. History* (New Haven: Yale University Press, 1997), 1; and Gregory T. Knouff, "White Men in Arms: Concepts of Citizenship and Masculinity in Revolutionary America," in *Representing Masculinity: Male Citizenship in Modern Western Culture*, eds. Stefan Dudink et al. (New York: Palgrave Macmillan, 2007), 26.

23. Burke, *Eyewitnessing*, 126. Such theories were first developed by Edward W. Said in *Orientalism* (New York: Vintage Books, 1979).

24. John Morreall, *The Philosophy of Laughter and Humor* (Albany, NY: State University of New York Press, 1987), 188, citing Thomas Hobbes (*The Elements of Law, Natural and Politic* [London: 1650–1651], chapter 9, part 13); and Henri Bergson (*Laughter: An Essay on the Meaning of the Comic* [1901]). See also Michel Foucault, *The History of Sexuality Vol. 1: Introduction*, trans. Robert Hurley (New York: Pantheon Books, 1978); and Martha Banta, *Barbaric Intercourse: Caricature and the Culture of Conduct, 1841–1936* (Chicago: University of Chicago Press, 2003), 4. By 1900, the photography of the eugenics movement would seek to exclude various immigrant groups because of their deviance from prescribed cultural norms. See, for example, Elena Tajima Creef, *Imaging Japanese America: The Visual Construction of Citizenship, Nation, and the Body* (New York: New York University Press, 2004); and Anna Pegler-Gordon, "Chinese Exclusion, Photography, and the Development of US Immigration Policy," *American Quarterly* 58, no. 1 (2006): 51–77.

25. Kirk Savage, *Standing Soldiers, Kneeling Slaves: Race, War, and Monument in Nineteenth-Century America* (Princeton: Princeton University Press, 1999), 15; also David R. Roediger, *The Wages of Whiteness: Race and the Making of the American Working Class* (New York: Verso, 1991), 13.

26. Jeffrey A. Mullins, "Race, Place and African-American Disenfranchisement in the Early Nineteenth-Century American North," *Citizenship Studies* 10, no. 1 (2006): 84; Emma Jones Lapsansky, "'Since They Got Those Separate Churches': Afro-Americans and Racism in Jacksonian Philadelphia," *American Quarterly* 32, no. 1 (1980): 69; and Samuel Otter, *Philadelphia Stories: America's Literature of Race and Freedom* (New York: Oxford University Press, 2013), 117, 10.

27. Jasmine Nichole Cobb, *Picture Freedom: Remaking Black Visuality in the Early Nineteenth Century* (New York: New York University Press, 2015), 18; Lapsansky, "Separate Churches," 63–67; and Brekke-Aloise, "Pretty Business," 209.

28. Cobb, *Picture Freedom*, 113.

29. Brekke-Aloise, "Pretty Business," 211.

30. Otter, *Philadelphia Stories*, 86. See also Elise Lemire, *"Miscegenation"*: *Making Race in America* (Philadelphia: University of Pennsylvania Press, 2011), 92.

31. For example, see Arthur Martine, *Martine's Sensible Letter-Writer* (New York: Dick & Fitzgerald, 1866), 97–140.

32. Cobb argues that antebellum caricatures ridiculed black speech to elide differences between antebellum free black communities. See *Picture Freedom*, 153, 185.

33. Otter, *Philadelphia Stories*, 82; Cobb, *Picture Freedom*, 113–17; and Lemire, *"Miscegenation,"* 92.

34. Gary L. Bunker, "Antebellum Caricature and Women's Sphere," *Journal of Women's History* 3, no. 3 (1992): 7.

35. Isenberg, *Sex and Citizenship*, 42–43, 45–46.

36. Lemire, *Miscegenation*, 97, pointing to Clay's *Amalgamation Waltz* (New York, 1839). Diana Williams explores the connection between sexual practice and citizenship fully in *"They Call It Marriage": Law, Race, and Domestic Partnerships in the Nineteenth-Century U.S.* (unpublished manuscript forthcoming from Oxford University Press).

37. This is not unlike the pornographic literatures that emerged during the French Revolution as political critiques of Marie Antoinette. See Lynn Hunt, *The Family Romance of the French Revolution* (Berkeley: University of California Press, 1992), chapter 4.

38. Martin Forker, "The Use of the 'Cartoonist's Armoury' in Manipulating Public Opinion: Anti-Irish Imagery in Nineteenth-Century British and American Periodicals," *Journal of Irish Studies* 27 (2012): 60. See also John J. Appel, "From Shanties to Lace Curtains: The Irish Image in Puck, 1876–1910," *Comparative Studies in Society and History* 13, no. 4 (1971): 372; and Susan Dente Ross, "Images of Irish Americans: Invisible, Inebriated, or Irascible," in *Images That Injure: Pictorial Stereotypes in the Media* (Westport, CT: Praeger, 2003), 133.

39. Noel Ignatiev, *How the Irish Became White* (New York: Routledge, 1995), 2.

40. L. Perry Curtis, *Apes and Angels: The Irishman in Victorian Caricature* (Washington, DC: Smithsonian Institution Press, 1971), 84. See also Ross, "Images," 134; and Ignatiev, *Irish*, 61.

41. Samuel R. Wells, *New Physiognomy: Or Signs of Character, as Manifested through Temperament and External Forms* (New York: Fowler & Wells, 1875 [1866]), 537.

42. Ibid., 538.

43. See *American Archives: Gender, Race, and Class in Visual Culture* (Princeton, NJ: Princeton University Press, 1999), 4.

44. I offered the survey to approximately 225 students in 2015 and 2016. Of these, 132 completed the survey.

Chapter Three

Investigating the Past through Art

Opportunities for Museum Education

Megan Clark and Heidi Moisan

As educators at the Chicago History Museum, our first opportunity to create a student experience with American art as the focal point presented exciting challenges and opportunities. We considered how we could best use art to engage elementary-age students in public history, and what special facets using art would bring to interpreting the past. We wondered how to use art to facilitate active learning strategies for students that involved their imaginations and incorporated discussion, physical movement, reading, creating, and collaborating. In developing a workshop program, we eventually focused on a piece of art related to the Great Chicago Fire. This led to the question of how this particular work of art could help us explore a much-loved and very familiar story in a fresh approach. Finally, we considered how art could help us incorporate the new Common Core State Standards (CCSS) and support CCSS teaching and learning.

This chapter will reflect on our development of a new workshop program called *Painted Memories*, in which we used a painting as a means of engaging third- and fourth-grade students in the examination of Chicago's history. We share our design and implementation process, and examine key outcomes of the project, including how using a painting as a focal point resonated with our students during the program and back at school. The development of this new programing yielded both benefits and challenges, requiring us to develop new instructional skills as well as a comfort level with visual art. In developing, implementing, and evaluating the workshop, we faced institutional challenges, including advocating for a new programing approach with a focus on a painting rather than on three-dimensional objects, involving colleagues in the design and evaluation process, training volunteers, and ultimately, taking stock of our effort and reflecting on the implications for our practice. In developing the program as part of the new CCSS, we needed to become fluent

in the standards in order to determine which ones were a best match for our mission-based programing and to this specific student experience. Our evaluation approach necessitated working "in the open" with colleagues, which led to frank conversations and greater visibility for student programs. In the pages that follow, we will explore our findings regarding student interactions with art and history during the workshop, use of CCSS skills, and the "staying power" of the artwork within students' memories.

CHICAGO HISTORY MUSEUM ELEMENTARY FIELD TRIP FRAMEWORK

The Chicago History Museum's mission is to "share Chicago's stories, serving as a hub of scholarship and learning, inspiration and civic engagement."[1] In the Education Department we strive to live the mission through a range of experiences with our visitors that provide opportunities to explore the city's past, reflect on how history impacts our experiences in the present, and consider future choices. Our approach to the museum field trip visit has evolved over time, moving from a passive guided-tour experience to an active-learning model consistent with Constructivist theory that provides students with opportunities to engage in historical interpretation.[2] The backbone of the school visit experience at the Chicago History Museum is our History à la Cart program, which provides student visitors the opportunity to engage in inquiry, sensory, and kinesthetic learning experiences in the museum galleries during twenty-minute facilitated activities. Our fleet of six carts invites children to design and build bridges over the Chicago River; pair up to act features of the John Hancock building for classmates; use a compass to find artifacts in the gallery and then mark their original location on a map of the city; touch, analyze, draw, and write about objects; map the path of the Great Chicago Fire; and measure and mark the height and depth of prairie plants.

Building on the success of the History à la Cart program, which debuted in 2006, over the last few years we have added new fee-based field trip options in the form of student workshops. Workshops are designed around object-based learning experiences, and since they last forty-five minutes we are able to go deeper into themes and topics than the History à la Cart experiences. The first elementary workshop we introduced, "The Wonderful World's Fair," takes students on an imaginary visit to the World's Fair of 1893. During the program, students use historic sources including images, documents, and actual souvenirs to become knowledgeable of one of the buildings at the fair. Then, during the "tour" conducted using maps and projected photographs of the fairgrounds, they share their findings with classmates and

make recommendations about what to see and do in that place at the fair. The workshop proved to be extremely popular, with nearly all the available slots filling up. We realized that enough audience demand existed to expand this program category.

EMBRACING OPPORTUNITY AND CHALLENGE

Any endeavor presents both opportunities and challenges. In our case, we were working within some unfamiliar contexts to launch this new student program. The most complex was mastering the Common Core State Standards (CCSS) and understanding the implications they posed for our work with the school audience. Applying for funding was a wonderful opportunity, but it also posed a challenge as the funding possibility came from an American-art-centered organization, which meant we needed to leave our comfort zone and learn how to make art central to the student experience. Another challenge we faced was to find a novel interpretive approach to the Great Chicago Fire that met the curricular needs of elementary students and the instructional goals of their teachers.

As we were contemplating how to grow our elementary school workshop program, the CCSS were adopted in our state of Illinois in 2010, with full implementation during the 2013 to 2014 school year.[3] The CCSS are Math and English Language Arts standards that define what a student should know and be able to do at each grade level from kindergarten through twelfth grade. The standards represent a major shift from content-focused to skill-focused standards, and have sparked a vigorous national debate over the standards themselves and their influence on standardized testing and teacher evaluation. While the CCSS landscape is seemingly constantly shifting—for example, with some states adopting the standards and then opting out of them, and states implementing the standards but dropping from the two national testing consortia—the CCSS have impacted education across the country. At the time of this writing, forty-two states and the District of Columbia have adopted the standards. Working in a state that has implemented the standards, we realized that any new school programs and resources we developed would need to align to them. Fortunately, in 2012 the Terra Foundation for American Art launched a multiyear initiative: American Art at the Core of Learning. This initiative was designed to serve the education staff of local cultural institutions by providing professional development on integrating Common Core standards with American art instruction. Through this initiative we had the opportunity to acquire funding to implement an art-focused project that aligned to the new standards.

In thinking about the target audience for our new workshop, we identified third- and fourth-grade students. In these years, students typically study state and local history, and these grade levels make up 49 percent of all student field trip visitors to the Chicago History Museum. The workshop format is especially effective for these students who enjoy socializing, working in small groups, and are enthusiastic and willing to try new things. Students at these grade levels are very verbal and can grasp abstract concepts through learning experiences that involve movement and making things, and they enjoy non-fiction, especially when it involves drama and binary opposites such as good and bad, right and wrong. These grade levels also respond well to hands-on experiential learning and keeping direct teaching lessons short.[4]

A key component of every on-site student workshop we offer is that a part of the experience takes place in a museum exhibition space. We strive to utilize our museum's unique resources, the collection and exhibition environments, in the experiences we provide. With that goal in mind, education staff spent time in our signature exhibition on Chicago history, *Chicago: Crossroads of America*. For the purpose of creating this new program, we analyzed the exhibition through new lenses, first identifying works of American art on display and assessing their suitability for our audience; and second, evaluating the feasibility of using the space for a student program. Ultimately, we found that the strongest artwork was an oil-on-canvas painting titled *Memories of the Chicago Fire, 1871* by Julia Lemos. This piece is visually striking, with bold colors we believed would catch students' attention. It also conveys a powerful narrative and includes many children in the composition, which we knew would draw students' interest. The choice of the Great Chicago Fire as the workshop topic fits well into the state/local history focus of third- and fourth-grade curricula. We examined the spaces near the Lemos painting and determined that although they contained potential noise and traffic challenges, the area could work for use with thirty students if our program design addressed these issues.

A NEW APPROACH—*PAINTED MEMORIES: THE GREAT CHICAGO FIRE*

In order to create the best program possible, we committed to a new approach: a full year of pilot testing and refining program design during a reflective evaluation process, to address issues of proper scaffolding of art interactions to yield the most meaningful investigation possible, and ensuring the opportunity for student creativity during the experience, program sequencing and timing, and space constraints. Our goals with this approach

were to end with the fullest understanding of the program's impact on our audience, the extent of CCSS integration, and information we could apply to the design of volunteer facilitator training and future student experiences.

The experience we created, *Painted Memories: The Great Chicago Fire*, begins in the exhibition *Chicago: Crossroads of America*, in the section City in Crisis, which examines how the city has responded to various calamities including the Great Chicago Fire. We start the program in front of a painting by Norman Rockwell called *Mrs. Catherine O'Leary Milking Daisy*. Rockwell created this oil-on-canvas work in 1935, and it depicts the popular legend of how the fire started: that a cow in Mrs. O'Leary's barn kicked over a lantern and ignited the conflagration. We use this painting to have a brief conversation with students that allows workshop facilitators to gauge their knowledge about the fire and as a "warm up" to looking at and discussing a work of art. This large painting (37 in. by 30 in.) is the only image on the wall on which it is hung, and there is plenty of floor space in front of it. Even in a busy, noisy gallery, this space works well for group conversation. We discuss the origins of the fire, which began in or near the O'Leary barn. However, it is unlikely that Catherine O'Leary was milking her cow. All these years later, how the fire began remains a mystery. The conversation here also introduces the idea of considering multiple perspectives. Norman Rockwell was not alive at the time of the fire and never lived in Chicago. Yet the cow-kicking-over-the-lantern story became so familiar that he was able to depict it in his painting. The painting the students examine next was created by a woman with a different experience. At this point, we hand out a simple gallery worksheet to students, and we ask them what they can tell about the artist just by the title she gave her painting. Students recognize the importance of the word *memories* and have rich discussions around the idea that the artist lived through the fire and can provide the perspective of an eyewitness.

After discussing the title, the students move around the corner and gather in front of the actual Lemos painting. We treat the painting as a written text, asking students to identify a detail in the work that they find interesting and how that detail supports the main idea: what it was like to live through the Chicago fire. During pilot testing, the directions and design of this worksheet evolved. The area where the original painting is displayed is not ideal for gathering students as the floor space is obstructed in the middle by a large display case. Having a full-color image of the painting on the worksheet allows students to see details up close that they may be too far away to notice in the original. Instructing students to circle the detail they choose in the painting and then complete the boxes below also came with experience. We noticed that often students were overwhelmed with detail choices. Spending a few minutes looking, then circling one detail and making an

Name _____

Memories of the Chicago Fire in 1871 • Artist: Julia Lemos

1. Choose a detail. Circle it.

2. Write your detail. Draw it.

3. Act it out!
How can you use your body to act-out your detail?

I would...

ChicagoHistoryMuseum www.chicagohistory.org

Figure 3.1. This worksheet allows students to view a color version of the painting up close and helps them record initial thoughts and ideas. It then serves as a reference tool throughout the rest of the workshop as they engage in more in-depth interpretations of the work. Chicago History Museum Education Department. Chicago History Museum Education Department.

explicit choice, helped students with the rest of the exercise of drawing, writing, and planning acting. As with many institutions, our busiest field trip season is in the spring, and we definitely noticed a difference between fall and spring gallery conditions. There were a few instances during pilot testing when we faced the possibility of not being able to gather in front

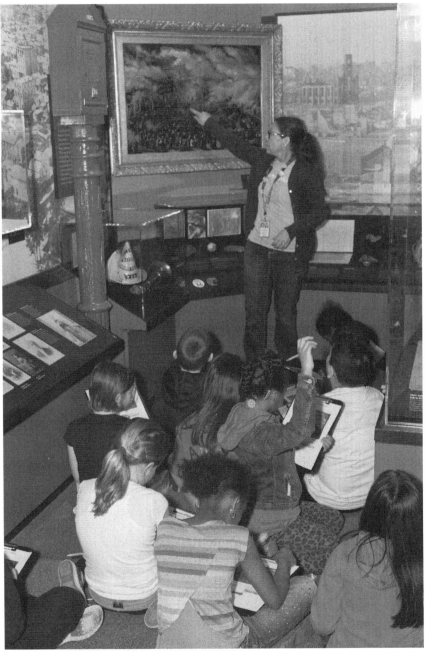

Figure 3.2. In the gallery, students view and discuss the original artwork during a conversation driven by the details they found in the painting. Photograph by Stephen Jensen for the Chicago History Museum.

of the Lemos painting because another visitor group was in that part of the gallery. We contemplated several solutions, including trying to reserve that section of the gallery for the exclusive use of workshop students, but we decided against doing that as we felt it could lead to customer service issues with other visitors. Ultimately, we had a large canvas print of the painting made that can be displayed in the gallery on an easel next to the Rockwell painting. Students can use the canvas print to choose their detail and have the initial discussion of the work if absolutely necessary. Then they can go around the corner to see the original work of art and the rest of the fire section of the exhibition. This is definitely "Plan B"; we have found that almost always, gallery conditions can be mitigated and worked through, but it is good to have this option for exceedingly busy times.

In the workshop, students have a few minutes to choose and record a detail, and then we use their details to frame a discussion of the painting. Students volunteer what they noticed in the painting, and typically conversations cover people: how they are dressed, what they are doing, animals, the fire and smoke depicted in the scene, and buildings that are on fire. The narrative nature of this work seems to make it very accessible to students, and the conversations around the work show the empathy students have for the situation and figures depicted in the painting. Woven into the conversation are principles of art such as line, shape, composition, and color and how the artist's choices shape our perceptions. Observation data showed that during the busy spring season, facilitators spent less time using art-rich vocabulary and encouraging discussion of the principles of art and fell back on more familiar conversations with students around historic interpretation.[5] This finding was important to the design of volunteer training and led us to emphasize the development of their skills in facilitating art-focused conversations.

In order to understand what details resonated most with students, we analyzed a random sample of forty gallery worksheets. We found that in the first box, in which students write and sketch their detail, the choices broke down as follows: 24 percent people, 23 percent animals, 21 percent objects/things, 21 percent environment/setting, and 12 percent made an inference based on a detail. In the sample, 85 percent of students both wrote and drew in the detail box. It is important to note that student details could be assigned to multiple categories. For example, if a child drew a wagon with a person holding the reins of a horse, then that worksheet counted in three categories: people, animals, and object/things.[6]

After our gallery discussion concludes, students have a few minutes to look around the fire section of the exhibition. Here they can see additional artifacts, documents, and images that lend more context to the Lemos painting.

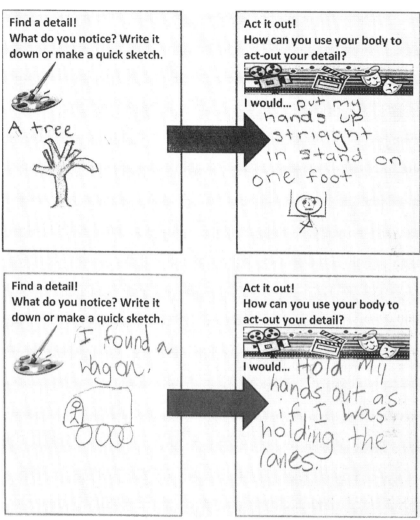

Figure 3.3. The language and visual cues on the gallery worksheet evolved throughout pilot testing. Analysis of gallery worksheets showed that nearly a quarter of student samples depicted the environmental elements in the painting. In these examples, the first student noticed a tree and described a creative way to express this inanimate object through movement. The second student noticed the covered wagon and drew a person inside. Likewise, the action description focuses on how people would interact with the wagon. Chicago History Museum Education Department.

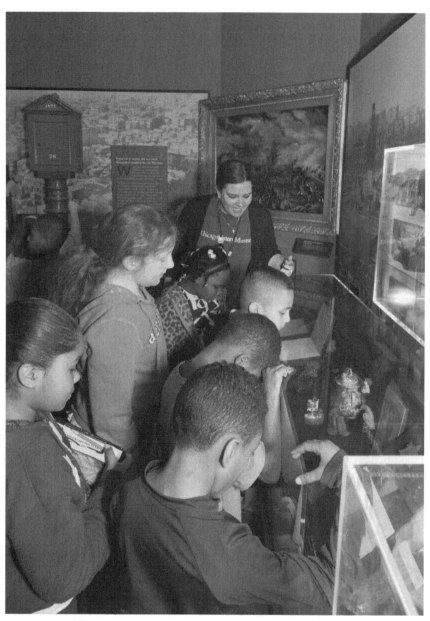

Figure 3.4. While the workshop focuses on Julia Lemos and her painting, it sparks student curiosity about the Great Chicago Fire, and they enjoy the opportunity to see additional artifacts related to the fire up close. Photograph by Stephen Jensen for the Chicago History Museum.

When gallery exploration time is up, we gather together in a classroom space in the museum. Students sit in collaborative groups to share their details and acting notes, building on one another's ideas and offering acting suggestions if a classmate is stuck. This short step in the process came directly from pilot testing. When we first facilitated the program, we tried to start the acting as soon as we had students settled in the classroom. But we found that moving to acting that quickly was too abrupt. Giving students a short time to collaborate boosted their confidence and the participation in and enthusiasm for "bringing the painting to life" through acting. This time also allows facilitators to visit and check in on each group to get a sense of how they are doing and assist if needed.

After a few minutes collaborating, we all stand up and face an image of the Lemos painting enlarged on a Smartboard. This is an interactive touchscreen that functions as a regular computer monitor but allows the user to write on and annotate images and documents using specially designed digital pens and erasers. We ask student volunteers to share their detail and how to act it out. Details are circled on the Smartboard, and this begins the process of student annotation of the painting. We compile a list of the five to six details. Then, we act out the details all together. One facilitator serves as the stage manager, calling out details and weaving them together into a narrative. The second facilitator faces the audience and acts out the detail as each is called, so students have a "guide" to look to if they forget what actions were determined for that detail. Acting out the painting brings it to life for students, making their interpretation memorable. According to Lengel and Kuczala in *The Kinesthetic Classroom: Teaching and Learning through Movement*, the most effective movement means that educators must "think deeper; this refers to actually experiencing the academic concepts by using the body."[7] To meet this standard, educators must do more than simply have students move into groups or approach the white board. Role-play and representing physical objects and concepts with body movement as students do in the *Painted Memories* workshop allows them to increase understanding and retention of the new information. The acting portion of the workshop provides another facet of interpretation, as one teacher noted: "I appreciate how the students made inferences based on the Chicago Fire [painting] . . . They were also engaged in this activity by making motions to their ideas."[8] We saw the power of the painting in student conversations, in their acting, and in their own artwork.

We were curious to learn more about the details students volunteer to act. In looking at the notes from twenty workshop sessions, we found that people account for 30 percent, with descriptors such as "people comforting each other" and "people in smoke—cover mouth and cough." Animals represent 16 percent with actions such as a "dog pulling on its leash." The fire in the painting was acted 12 percent of the time—one memorable description was

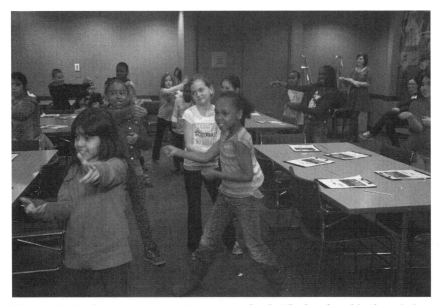

Figure 3.5. Students use movement to express the details they found in the painting. These motions combined with the facilitator weaving the details into a short narrative create a fun and memorable interpretation of the painting. Photograph by Joseph Aaron Campbell for the Chicago History Museum.

"crouching and growing"—while smoke and wind were part of the acting 9 percent of time. Wagons (often interpreted in conjunction with the actions of people) occurred 12 percent of the time, with acting notes such as "hold reins and say 'Giddy-up'" or notes about how it would feel to be in the wagon during a "bumpy ride." Setting elements such as burning trees occurred 9 percent of the time, such as "[use] arms as branches and fall over," and structures including buildings, a tower (church steeple), and a fence were included 11 percent of the time.[9] In their drawings, notes, and the physical movement of their bodies, students were able to make connections to details of the painting and the emotions and actions of people. One Chicago History Museum staff observer noted, "Through movement students were incredibly creative and expressive when choosing details to act out from Lemos's painting. They chose aspects that I didn't even notice."[10]

We are fortunate to have not only the painting by Julia Lemos in our collection but also her written account of her experience in the fire. The dramatic story of her escape with five children and two elderly parents engages students and adds another historic source for them to analyze as they explore the Great Chicago Fire. Use of multiple nonfiction sources, such as the painting

and written account, aligns with the reading and speaking and listening goals of the Common Core standards. A student volunteer reads an excerpt from the Lemos account aloud, and then as a whole group we have a discussion comparing her writing to her painting. This allows students to understand portions of the painting in a new way, such as realizing the "tower" in the painting is likely the church steeple she wrote about or adding context to the observation that there are many children depicted in the painting when students learn from her writing that Julia was a mother to five children. Students learn additional details that the painting doesn't provide, such as what alerted her to the fire in the first place. During this discussion we continue to annotate the painting on the Smartboard, noting new findings in the painting from the artists' writing.

The workshop concludes with students expressing their ideas about the fire in writing and through images as Julia Lemos did, by creating Great Chicago Fire book covers in a collaging art-making activity. We send the teacher home with the pages for students to complete and to assemble as graphic-novel-style books. The pages give students the opportunity to respond to additional visual images from our collection, with their own writing and drawings representing different portions of the fire story.

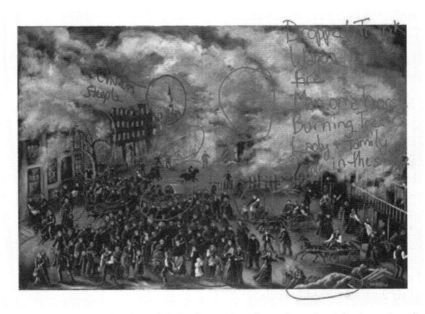

Figure 3.6. Student details and their observations from discussing Julia Lemos's written account are annotated on a projection of the Lemos painting. Using a Smartboard creates a visual record of the layers of their analysis. Chicago History Museum Education Department.

MAKING IT HAPPEN

Implementing *Painted Memories* presented a number of challenges from utilizing art as the program medium to involving colleagues in the evaluation process and designing around new learning standards. While we have a combined thirty years' experience with museum theory and education programs, our approach to this workshop required careful coordination of stakeholders, research, and an approach to evaluation that necessitated a significant investment of staff time throughout the process but that enabled us to make real-time changes to the program and to better "own" and understand the findings and implications.

To prepare for the new workshop approach, we researched art programs and consulted with colleagues from art museums. Both provided invaluable insights into developing programs around a work of art. One key phrase that kept coming up throughout this process was "reading the painting" just as you would read a text. Through this process, we recognized the strength of the historical paintings in our collection. Many of these are narrative in nature and contain rich imagery to support a main idea and enable the viewer to interpret the story. To evaluate the workshop, we worked with a professional firm, MEM & Associates, in a developmental evaluation approach. Developmental evaluation involves long-term partnering relationships between evaluators, and in our case, we the museum educators. It integrates the evaluator into a team of collaborators who conceptualize, design, and test new approaches. Developmental evaluation emphasizes asking evaluative questions and gathering information to provide feedback during development and testing to support decision making and changes during the process, rather than issuing a final report with recommendations at the end of an initiative. We were drawn to this approach because it gave us the ability to try a variety of facilitation techniques, edit the workshop outline, incorporate new research, and make changes throughout the pilot year, adjusting the program on an ongoing basis.[11]

The implementation of the *Painted Memories* workshop took place in three logistical phases: (1) research, program design, and pilot testing all led by us (museum educators) and evaluation led by us in collaboration with our professional evaluator and involving our colleagues; (2) a combination of museum educator/volunteer–led workshop sessions; and (3) volunteer-led workshops. This progression allowed us time to perfect program sequencing, design workshop materials, and create facilitator manuals, all informed by our pilot-testing experiences and discoveries made during the evaluation process.

In addition to researching the use of art in a workshop such as this, we also looked into other works related to the Great Chicago Fire held by the museum. We found a series of compelling sketches by Alfred R. Waud, a

Civil War illustrator, who came to Chicago in the midst of the fire to capture the events. His sketches are included in both the pre- and postvisit classroom activities. The previsit activity, in which students read a nonfiction article "Chicago Burns!" which is illustrated with images from the museum's collection, helps to set a baseline of knowledge for students prior to their visit, and it enables facilitators to do a quick overview of the fire and jump right into working with the Lemos painting. The postvisit book activity allows students to create their own interpretations of the Waud sketches and other visual works related to the Great Chicago Fire. Together, the previsit activity, onsite workshop, and postvisit activity provide students with a comprehensive experience using artwork to investigate the Great Chicago Fire.

While the workshop can stand alone, we recognize that a field trip is a much richer experience when it connects back to classroom instruction. We felt it was important to provide teachers with additional resources to frame the workshop experience. Of the responses from a teacher survey that we conducted, all the teachers acknowledged use of the previsit materials, and 67 percent of the teachers said they also used the postvisit. One teacher noted about the previsit, "Having read the article that was sent beforehand really helped to prepare my students for the activities and gave them plenty of background knowledge."[12] Incorporating added mediums of art, including sketches and lithographs, took better advantage of our collection and exposed students to a greater variety of historical sources and aligned with the goals of our funder to provide rich learning opportunities rooted in American art.

Pilot testing for the workshop began in the fall of 2013 and continued through the end of the school year in 2014. The ability to pilot test over a full school year enabled us to experience the workshop under a variety of circumstances, including slower fall and busy spring gallery conditions, working with student groups with prior knowledge and those without it, and a myriad of other situations that arise in fluid program settings. We were able to address and make suggestions for many of these variables when writing the facilitator manual and training the volunteer facilitators. Additionally, pilot testing for an entire school year gave us plenty of time to schedule the workshop observations included in the evaluation design, which relied on a cross-departmental team to carve out time in their schedule of approximately one-and-a-half hours per workshop observation.

To enroll participants, the workshop was first promoted in our annual Field Trip Brochure. As part of the promotion we were able to offer reimbursement for transportation to and from the museum in return for copies of pre- and postvisit student work. These student work samples and those students created on site were critical for evaluation of the workshop.

In our original grant proposal we anticipated conducting the workshop two days per week, reaching a year-end total of twenty workshops for six hundred students. Our time commitment expanded beyond our original estimation, which required some reprioritizing of our workflow. During the pilot testing year, we actually led seventy-six workshops for 1,871 students. We quickly realized that two facilitators were needed for this high-energy program, as well as to keep the workshop on time, moving students quickly and easily around gallery spaces and to the museum classroom. The reason that pilot-testing numbers were so much higher than what we predicted was that we began offering the workshop on additional days based on teacher requests and our availability. We knew the more instances we could offer the workshop the more data could be collected, as well as more experience with a wide variety of schools and gallery conditions. Offering the workshop more frequently also enabled us to grow our data pool of student work samples and teacher surveys and ultimately to pull more random samples for analysis.

The second phase, museum educator/volunteer–led workshops, began during the 2014 to 2015 school year. CHM has a strong core of gallery volunteers who facilitate the twenty-minute History à la Cart stations, and some had already begun working with the Wonderful World's Fair elementary workshop. Many of these volunteers are former classroom educators and had long expressed the desire to work with students in a more in-depth way.

We realized with the novel approach of the *Painted Memories* workshop that we faced a challenge in training our volunteers to master and feel comfortable facilitating these new approaches. We worked with our colleague who manages the volunteer program to develop a process that included attending three training sessions, observing museum staff facilitate the workshop, and finally, coteaching with education staff to become eligible to facilitate the workshop. The three training sessions began with experiencing the workshop as a participant. Modeling the activity demonstrated and emphasized the importance of the students "doing the work" and making their own connections, with the volunteer serving as a facilitator as opposed to a tour guide or lecturer. Other training sessions included a presentation on the historical background of the Great Chicago Fire by a Chicago History Museum curator and an art interpretation experience led by a colleague from an art museum to help volunteers learn to find and discuss details in a painting and identify principles of art—all of which contribute to a meaningful discussion of a work of art. During training, volunteers were given a variety of resources that included art analysis techniques, background information on the Great Chicago Fire, the workshop outline, and samples of the materials used during the workshop.

One test we faced was in training our volunteer facilitators in a way that ensured consistency of program delivery. In order to achieve that goal, fol-

lowing the training sessions, volunteers were required to observe museum educators facilitate the workshop. This served to model best practices, reminded them of the program sequence, and most importantly provided the opportunity to see the workshop with an elementary audience. Following the observation, we met with volunteers to answer their questions and deconstruct the program, including any deviations that were made to meet the needs of that particular group. The next step for the volunteer was to cofacilitate with a museum educator. This was a mutually beneficial process; we were able to watch and give constructive feedback as well as step in and redirect if the facilitator ran into difficulty, and we gained insight on their readiness and the effectiveness of our training design. This gradual release model assured the volunteers that they were fully supported as they mastered facilitating *Painted Memories*. Following the workshop, the volunteer and museum educator met again to discuss the experience. In a few cases, after observation and cofacilitation, we determined that the volunteer needed to gain facilitation skills or confidence. In those instances, volunteers were required to complete another coteaching or observation session. In all cases, volunteers were receptive to this direction, as they felt the need for more time and experience before cofacilitating with a fellow volunteer.

With all the momentum we had gained from launching a new program and training our volunteers, we hit an unexpected bump in the road with the challenge of audience retention. During the 2014 to 2015 school year, portions of our building, affecting the classroom space we use, were under construction. This necessitated utilizing alternative locations that lacked the Smartboard capabilities. We could still carry out the program, but some of the qualities were lost, especially being able to mark up the painting to show students' ideas and reflections. Additionally, to accommodate volunteer training and staff schedules, we offered the workshop only two days a week. Overall, we were able to manage these circumstances and saw only a slight dip in the number of student participants and a corresponding decrease in the number of workshop instances.

We completed the final phase of implementation during the 2015 to 2016 school year. In this final phase the workshops are entirely volunteer led, which with our limited staff resources is a critical milestone to achieve and a sign of a successful program. Professional graphic design of the previsit, onsite, and postvisit materials also debuted this year. We offered an additional round of volunteer training, which increased our pool of facilitators and enabled us to offer the workshops five days a week.

The popularity of the program continued to grow; during the 2015 to 2016 school year we served 2,886 students in 116 workshops. We are still very involved in the administrative aspects of the workshop, including scheduling

and advance correspondence with the classroom teachers. As special requests are made, or in a scheduling pinch, one or both of the education staff members still serve as facilitators. This enables us to continue to model facilitation techniques for our volunteers and helps us to maintain high-quality program implementation.

PAINTED MEMORIES BY THE NUMBERS

As previously mentioned, developmental evaluation was the best match for the *Painted Memories* workshop. Although developmental evaluation is an iterative process, it was important to frame our efforts with clear objectives in order to produce the best program possible. We established two overarching goals: "for CHM staff to more fully understand (1) how best to work with art in a history museum context and (2) what students understand and focus on when asked to analyze and produce works of art that contain history messages."[13] These goals were supported by more detailed evaluation questions that looked at the nature of discussion and interaction during the three distinct parts of the workshop, understanding how teachers assess the ways the workshop experience links to their curriculum and how it supports the CCSS and capturing student learning about history and analysis of works of art.[14]

As part of the developmental evaluation's collaborative approach, we assembled a cross-departmental team of thirteen staff members who were trained in workshop observation and data collection. We used the fall semester of 2013 to work out the major features of the workshop and to involve this cross-departmental team in giving feedback to our program design. We collected data for a period of five months (February through June 2014). Data came from three main sources: workshop observations, analysis of student work (on-site products, as well as the postvisit book activity), and teacher surveys. Observations of twenty-three workshops (out of the seventy-six conducted) were completed. Members of our Teacher Advisory Board were trained in using specific protocols to analyze student work samples. Teachers analyzed random samples of forty gallery worksheets, and twenty postvisit books were analyzed. Finally, twenty-one completed teacher surveys were returned and analyzed.

Workshop observers were tasked with collecting data on student interactions with art, student interactions with history, and use of Common Core standards. Observers were asked to rank specific behaviors on a four-point scale, with four being the most descriptive. Three key student interactions with art emerged: spending time looking at art and pointing out details (3.8), referencing the art work in discussions (3.26), and interpreting conditions,

characteristics, feelings, and emotions based on features of the art work (2.96). Observations also showed that students cited details and evidence in the painting and the artists' written account (3.65). Timing and tracking data indicated that, on average, students spent about thirty minutes looking at and discussing artwork, which accounts for 58 percent of the workshop time.[15]

We designed the *Painted Memories* workshop to provide students with an active inquiry experience utilizing Common Core English Language Arts skills in reading, speaking, and listening around art to develop an understanding of a key event in Chicago's history. The evaluation found that "students were on task in practicing essential reading and writing skills such as finding details, drawing inferences, and providing evidence for their interpretations of artworks and history." Furthermore, we concluded that "there is evidence that access to the learning environment provided by the Museum and engaging in collaborative, social learning that is a feature of museum education resulted in students who were highly engaged and on task."[16]

Twenty postvisit books were chosen. In ten books, one page was analyzed for student writing. In the other ten books, two pages were analyzed for student drawing. We found that on the writing page, students were able to compose contextually appropriate copy in response to a sketch of the fire done by artist Alfred Waud. Evaluators found that in the ten books analyzed on a four-point scale students were able to refer to evidence (3.0), describe feelings and emotions (3.8), and express logical reasoning (3.8). Results for the drawing pages showed that nearly all—nine out of ten of the books—contained a representation of elements similar to the Julia Lemos painting. Of the eleven "Lemos" features listed in the protocol, thirty-nine examples of them were found within the student drawings.[17] We were excited to see that students' art was informed by exposure to the Lemos painting days and weeks after the workshop experience.

Both students and teachers felt the connection of using art to understand the past. On teacher surveys, we asked what students most enjoyed about the workshop. One teacher shared "Nico—he liked seeing a painting from someone in the fire [Julia Lemos] . . . Mezhtli—she liked finding details from the painting then acting them out."[18] Many teachers commented that their students appreciated the close looking experience: "They really enjoyed seeing the Julia Lemos painting and finding small details within the painting," and another wrote "being able to look analytically at a painting." The previsit activity first introduces Julia Lemos to the students, and one teacher noted that this heighted their excitement for the workshop. "They really wanted to see the painting!"[19] On the teacher survey, we also asked educators what they as teachers most appreciated about the workshop experience their students had. One teacher commented, "I really appreciate the in-depth explanation of

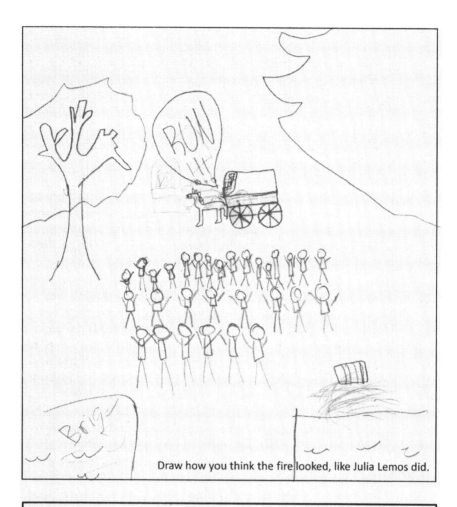

Draw how you think the fire looked, like Julia Lemos did.

The fire moved fast, spreading north and east throughout the city. Hotels, businesses, stores, and the Courthouse were destroyed. The fire jumped the Chicago River and began to burn down people's homes.

Figure 3.7. On average, students include interpretations of four "Lemos" details in their book drawings. This particular student included seven. Other than fire and smoke, the most common "Lemos" detail was people. Students' drawings often echoed the composition of Julia Lemos's painting. In this drawing, the tree, wagon, and people are placed similarly to where they are in Lemos's work. These books were done back at school in the days and weeks following the workshop. This indicates the "staying power" of the artwork and the workshop experience. Chicago History Museum Education Department.

art work. It was a great connection to what the kids already learned,"[20] while another shared, "I like that they looked at artwork and thought about how the artist told the story with a picture."[21] Finding details and the critical-thinking opportunities in the experience were evident to teachers, as one wrote, "I really enjoyed looking at two different paintings and picking out details. Often students are asked for details from a story, but his gave a new perspective."[22]

Through observation data, examination of student work, and teacher surveys, the evaluation concluded, "There is substantial evidence to support a claim that the innovation embedded in the design of *Painted Memories* was a success in its implementation and resulting outcomes. The careful examination of a work of art in a history museum did capture students' attention; students actively participated in the learning experience; and samples of student work demonstrate a vividness and depth of understanding of the Chicago fire and its effects on people and the city."[23]

REFLECTIONS ON DEVELOPMENTAL EVALUATION

The Developmental Evaluation approach was a new process for us, and we quickly saw its benefits. Unlike other evaluative approaches, we were involved from the beginning in the development of the evaluation questions, goals, and protocols. This helped us to stay focused on stated outcomes and refer back to them as we made changes and refinements to the program. The ability to reflect, make changes, and gauge their effectiveness throughout the process is a huge benefit of the developmental approach versus a traditional summative evaluation.

Cocreation of evaluative tools is also a key component of the developmental approach. MEM and Associates led a series of meetings with the Education Department and our colleagues as well as a separate series with members of our Teacher Advisory Board who helped to evaluate student work samples. The cocreation of the protocols gave everyone a deeper understanding of the questions and goals of the evaluation. This process enabled colleagues to conduct more accurate observations and teachers to assess student work for the purpose of the workshop evaluation, rather than grading a classroom assignment.

We were also heavily involved in the analysis of the data collected. Through a series of conference calls and emails with the professional evaluator, we were instructed on how to run reports on the different types of data that gave us a better understanding of what those numbers truly meant and the methodology behind them. We also analyzed the open-ended teacher survey questions for patterns and trends that were emerging so that we could interpret them in relation to the data.

Once all the reports were run, we met with the evaluator to discuss the data in depth and begin the process of identifying its implications. Due to our extensive involvement in all phases of the evaluation from data collection to design to computing and interpreting findings, we had a deeper understanding of and familiarity with the data and could be more confident in the conclusions we were drawing. Following these meetings, the evaluator wrote a final memo summarizing our collective findings.

The developmental approach challenged us to take a more active role in the evaluation process; refining objectives and goals, creating protocols, and working on data analysis under the supervision of a trained evaluator. By truly acting as cocreators throughout, we gained a different perspective on the evaluation process and can represent the program more fluently to stakeholders.

LASTING IMPACTS

As we began to reflect on the *Painted Memories* workshop, we identified a number of benefits for both the education staff and the institution. Each of us brought our own ideas and strengths to the development, implementation, and evaluation processes that made for a fruitful partnership. Additionally, we worked "in the open," bringing in the voices of colleagues during the program design and evaluation phases. Asking colleagues from across the museum who had varying degrees of familiarity with the school audience and the types of experiences we create for them was daunting and a little scary. In the end, we are truly glad we did work "in the open" because their expertise and support contributed immensely to the quality of the program. Our co-workers assisted us in solidifying historical content, helped consider potential improvements to the exhibition environment, and became advocates for updating and enhancing the museum classroom space used for student programs.

We, as museum educators, benefitted greatly from this program. Participation in the Terra Foundation for American Art's initiative helped us consider new ways to incorporate and interpret art within our student programming. It also helped to expand our professional network to institutions across the city and enabled us to call on those external colleagues' expertise during workshop development. Involving internal colleagues in the process of creating *Painted Memories* has raised awareness of the school audience within our organization. The staff members of our cross-departmental team now have a better understanding of school programs and our audience, and have a stake in the programming we create. This awareness has become a conversation

starter and led to other collaborations with colleagues from around the building. For example, we work more closely with our colleagues in collections on programming, and our development colleagues have commented that they are better able to describe our work to potential funders.

The financial benefits of the workshop are not limited to the one-time grant funds we received. Basic field trips to the Chicago History Museum, which include visiting the exhibitions and participating in the History à la Cart program, are free for Illinois students, but the workshops carry a $3 per student fee. This price was determined based on the fees charged by area museums for programs of a similar style and length. The ongoing revenue generated from student workshop fees contributes to the general operating budget of the museum, which was something the school programs side of education was rarely able to support prior to developing this program category. While fiscal benefits are important, the fulfillment of our mission is even more crucial. The *Painted Memories* workshop experience enables students to interact with one of Chicago's most famous stories in a unique way that provides multiple points of entry through Julia Lemos's art and writing.

As schools become more critical field trip consumers, opportunities such as *Painted Memories* that provide an in-depth, interdisciplinary approach are more attractive and better attended, as shown by the continued growth we have seen in workshop registration. During the 2015 to 2016 school year, we were able to work with classroom teachers to modify the *Painted Memories* workshop to meet the needs of diverse learners. We have found that it is a good fit for this audience because the workshop content is directly generated through student voices and observations. This enables all students to contribute to the conversation and workshop experience. Museum educators have facilitated the workshop for two high school–aged groups of diverse learners, and the students enjoyed the experience. One student was so excited he volunteered to read even though, as the teacher later mentioned, he had one of the lower reading levels in his class. As the student and two other classmates read Julia Lemos's words aloud, the teacher and the museum staff beamed with pride that this student had made a connection with a work of art and writing that he would not have made without seeing and interpreting the art in the workshop format. As one teacher noted on her survey, "I appreciated the differentiation I saw in the strategies used to meet the various needs of my students."[24]

The *Painted Memories* workshop has also raised awareness of the Lemos painting itself. The painting has been on display for many years in various locations throughout our building. In its current location, the painting hangs among many artifacts related to the Great Chicago Fire, including a model of the Water Tower, everyday belongings that were melted by the heat of the

fire, firefighting equipment, and various documents related to the rebuilding of the city following the disaster. Many teachers have commented that they never noticed the painting before, and some have even asked how long it has been there. Following the workshop facilitator training, our volunteers have begun to incorporate the Lemos painting and art analysis techniques into their public tours as well.

As much staying power as Julia Lemos's painting has had for student visitors, the process of developing *Painted Memories* has had a profound staying power for us. We now have a template for program development and implementation that increases collaboration between departments. We have a deeper understanding of the characteristics of artwork that resonate with students, allowing us to consider incorporating the paintings and sculpture pieces in our collection in new ways. Learning the principles of art interpretation has informed volunteer training for upcoming temporary exhibitions. We are happy to report that integrating art more explicitly into our history museum context has created richer experiences for students, staff, volunteers, and visitors of all ages.

NOTES

1. "About the Organization," Chicago History Museum, accessed March 31, 2016, http://www.chicagohistory.org/aboutus/organization.

2. Anita Woolfolk, "Constructivism and Constructivist Theories Express the Idea That Learners Construct Their Own Knowledge through Active Learning Experiences and Social Interactions," *Educational Psychology* (New York: Pearson, 2015), 373.

3. "Standards in Your State" Infographic, Common Core State Standards Initiative, accessed March 21, 2016, http://www.corestandards.org/standards-in-your-state/.

4. Chicago History Museum Education Department, "Developmental Characteristics of Pre-K through 4th Grade" (October 28, 2013), 5–6.

5. MEM & Associates, "Painted Memories Evaluation: Data Analysis Book" (August 21, 2014), 70.

6. Chicago History Museum Education Department, "Analyzing the Painted Memories: The Great Chicago Fire Workshop" (September 4, 2014).

7. Traci Lengel and Mike Kuczala, *The Kinesthetic Classroom: Teaching and Learning Through Movement* (Thousand Oaks, CA: Corwin, 2010), 11.

8. MEM & Associates, "Teachers Survey: Patterns and Themes" (August 25, 2014), 2.

9. Chicago History Museum Education Department, "Analyzing the Painted Memories: The Great Chicago Fire Workshop" (September 4, 2014).

10. Chicago History Museum Education Department, "Final Grant Report to the Terra Foundation for American Art" (October 1, 2014), 5.

11. MEM & Associates, "Introduction to Developmental Evaluation" (August 2, 2013).

12. MEM & Associates, "Teachers Survey: Patterns and Themes" (August 25, 2014), 2.

13. MEM & Associates, "Terra Grant Proposal: Evaluation Plan Description" (April 9, 2013).

14. MEM & Associates, "Terra Grant Proposal: Evaluation Plan Description" (April 9, 2013).

15. MEM & Associates, "Painted Memories Evaluation: Data Analysis Book" (August 21, 2014), 84. Note: during pilot testing, workshops averaged fifty-one minutes in length.

16. MEM & Associates, "Development Evaluation Memo #4" (September 28, 2014), 3.

17. MEM & Associates, "Painted Memories Evaluation: Data Analysis Book" (August 21, 2014), 50–56.

18. MEM & Associates, "Teachers Survey: Patterns and Themes" (August 25, 2014), 1.

19. MEM & Associates, "Teachers Survey: Patterns and Themes" (August 25, 2014), 1.

20. MEM & Associates, "Teachers Survey: Patterns and Themes" (August 25, 2014), 2.

21. MEM & Associates, "Teachers Survey: Patterns and Themes" (August 25, 2014), 2.

22. MEM & Associates, "Teachers Survey: Patterns and Themes" (August 25, 2014), 2.

23. MEM & Associates, "Developmental Evaluation Memo #4" (September 28, 2014), 2.

24. MEM & Associates, "Teachers Survey: Patterns and Themes" (August 25, 2014), 2.

Part II

CONTEMPORARY ART AND ARTIST COLLABORATIONS

Chapter Four

"The Art Museum Does History?"

Building Connections and Relevancy within Multidisciplinary Museums

Rebecca Bush

When public historians enter the job market, they confront a dizzying array of potential employment possibilities. Historic house museums, traditional brick-and-mortar institutions, historic sites and battlefields, archives and libraries, historical consulting and architectural firms, even some government agencies: all of these settings offer opportunities for historians to spread the gospel of the significance of history within organizations set up expressly for that purpose. The American Association for State and Local History recorded about 5,500 members, both institutional and individual, in its most recent count.[1] In these spaces, it is rare for history professionals to be questioned about their purpose within the broader organizational structure. Corporate historians may occasionally face questions of this nature, as the general public does not immediately associate Wells Fargo, Coca-Cola, Walt Disney, or any number of massive American corporations with a directive to preserve and interpret history. When the connection to a corporate mission is less clear, those people filling the role of historian or archivist in such a company might expect to explain their goals as they meet new people and fulfill the functions of their job. It's much more unusual, I suspect, for a curator to be questioned about their role in a local museum that is not only well known but also generously supported by its community. Perhaps it happens more than I realize, but I was not prepared for that reaction in 2011 when I arrived in Columbus, Georgia, the state's second-largest city.

"Oh, I didn't know the art museum did history, too!" For years, this was the response I received when I told local residents that my job title was curator of history at the Columbus Museum (CM), an institution with a dual mission of American art and regional history of the Chattahoochee Valley of Georgia and Alabama. Though the museum has included historical artifacts and exhibitions since its opening in 1953, the public perception of it in the

ensuing decades has been largely one of the supposedly rarified air occupied by a fine art museum and its patrons. This perception was partially reinforced by early board members and directors, understandably excited about opening a fine art museum in west-central Georgia that could accommodate exhibitions of paintings, drawings, sculptures, and other artworks previously only available in Atlanta, nearly two hours away. The museum shifted its focus a few times over the years, including a stint as a natural history museum and having a naturalist for director; and for several years it focused on regional folk art and folkways, with a riverside folk festival as the annual highlight.[2] Through it all, though, two constants remained: art of the fine and decorative varieties, as well as a random assortment of historical artifacts with a special focus on the Muscogee (Creek) Indians and their ancestors who lived in the area for thousands of years. The museum employed various staff members through the years who focused on history, including a "curator of Indian arts" and an archaeologist with nearly forty years' experience, but an official curator of history was not hired until 2001. When I arrived ten years later as the third employee to hold that title, I was deeply grateful to my predecessors, but I immediately realized that more work needed to be done to impress upon the local community that the Columbus Museum did value regional history beyond just lip service.

Out of more than thirty-five thousand museums in the United States, data compiled in 2015 by the Institute of Museum and Library Services counts 2,284 history museums and a whopping 14,861 historical societies in the country, as compared to 3,241 art museums and 8,699 general museums, an inexact term that includes multidisciplinary museums as well as those organizations without a precise collections focus.[3] Still, the cultural footprint of art museums looms large in the public imagination. Beyond the Smithsonian, few history museums carry the name recognition and cachet of the Metropolitan Museum of Art and the Museum of Modern Art in New York, the Louvre in Paris, or the Victoria & Albert and the Tate Modern in London. Most Americans have an idea of what awaits them in art museums, even if it's a phrase as general as "nude sculptures" or "fancy paintings." In Columbus, people knew that the museum contained paintings, sculptures, and drawings from both regionally and nationally known artists. However, identification of particular artifacts in the permanent history gallery was generally limited to "Indian pots," "guns," or the ever fashionable "old stuff."

Despite these differences in visitor perception, existing interpretation in art and history museums borrows more from each other than visitors might realize. A careful examination of many art museums' object labels will reveal a dash of historical context, and history museums have long used portraits to illustrate historical figures. (It is important to note that this chapter only

considers brick-and-mortar, purpose-built museums and not historic house museums, where furniture, ceramics, and artwork have long straddled the line between decorative arts and historical artifacts.) Making a more purposeful effort toward multidisciplinary interpretation begins with an understanding of what has already been done, whether intentional or accidental, and planning toward future efforts. This chapter primarily discusses collaborations with contemporary artists and the institutional framework necessary to make such projects successful.

PLANNING FOR RELEVANCY

Institutional anniversaries often inspire reflection as well as celebration—a chance to chart a course for the future while contemplating past successes and failures. As part of the CM's sixtieth anniversary in 2013, the board of trustees commissioned a strategic planning study led by Lord Cultural Resources, an international cultural resources consulting firm led by Gail Dexter Lord and Barry Lord. Representatives of the firm conducted a number of interviews with museum board and senior staff members, as well as several community leaders in the Chattahoochee Valley. Focus groups were also assembled, representing young professionals, African Americans, and leaders of other cultural organizations in the region. Since the Museum's building and grounds are owned by the county school district, making it part of the public school system, educators and parents active in local family groups also participated in discussions. The Lord team then compiled an informal summary of results, which was presented to board and staff members at an off-site meeting. Though the final data contained a few surprises, as well as information many staff members had heard anecdotally or knew instinctively, the most striking fact was that the community as a whole felt that the museum's perception as an elitist organization by many was directly tied to what was seen as an overwhelming focus on art. Quite simply, art exhibitions were described as "intimidating" or "not for everyone." Those asked said they felt they needed prior art knowledge to truly enjoy or understand the museum's art exhibitions. Conversely, history exhibitions were seen by most as more engaging and accessible, not requiring specialized knowledge to be enjoyed. Some respondents indicated they regularly made special trips to the museum to see history exhibitions but only did so for art exhibitions if they were interested in a particular artist or topic.

For an institution with sixty years of art collections and exhibitions, but fewer than fifteen years of employing a history curator and using a focused regional history collecting plan, the challenge was clear: how to increase

public awareness of history exhibitions while simultaneously creating art exhibitions that general audiences found more accessible or "friendly." After decades of unequal footing for the two disciplines, one avenue that board and staff members chose to pursue was greater mission integration, making a conscious effort to include historical context in exhibitions of artwork while also incorporating more pieces traditionally seen as fine and decorative art in artifact-heavy history installations. An ongoing reinstallation of the permanent history gallery would be adjusted to fulfill this new directive, while a future reinstallation of the permanent art galleries would be designed with this new theme in mind from the start. Additionally, curators would make a point of developing more exhibitions that could be described as both art *and* history, instead of just one or the other. This would have to be done carefully, however, as no one was interested in diluting the quality of exhibitions in the service of forcing connections. Curatorial and education staff members reiterated their commitment to producing quality exhibitions and programming that focused exclusively on American art or regional history, while seeking out opportunities to highlight interdisciplinary themes that were often readily apparent. In addition, these themes would be made more explicit, occasionally making subtext into text in order to draw clearer connections and interest visitors who might otherwise perceive an exhibition as being "not for them."

It's worth noting that this type of mission integration was not a new concept to Museum staff. In 2009, the curatorial team produced *The Way We Lived: Residential Architecture and Life in the 19th Century*, a major exhibition that explored the furnishings of historic homes in the Chattahoochee Valley. While rooms of the home and each house's life cycle was interpreted through a traditional historical lens, other text panels focused on the decorative arts pieces that furnished each home, evaluating chairs, tables, desks, mirrors, and other furnishings with an eye to major movements in American art. To staff, this was a clear example of an exhibition that married both parts of the Museum's mission, but this was largely an internal distinction, as mission-related discussions often are in cultural nonprofits.

When I arrived for my interview in 2011, the Museum's premier gallery space was divided between two related but separately curated exhibitions. *Likenesses in the Latest Style: Historical Portrait Photography* featured a staggering array of daguerreotypes, ambrotypes, cabinet cards, and other objects exhibiting historical styles and methods of photography, selected by the history curator. This exhibit complemented *Soldier Portraits: Contemporary Wet Plate Photography by Ellen Susan*, which featured the work of a Savannah artist who used wet plate collodion photography to capture US Army soldiers, using the same technology available during the Civil War. The Museum commissioned the works on the recommendation of the art curator

after she visited with the artist in the latter's studio. Together, these exhibitions offered visitors a contemporary artist using historical methods to create portraits in styles exemplified by dozens of historical portraits of regional subjects. As we discussed next steps for the strategic plan in 2013, this project seemed a clear example of how the museum's art and history focuses could be combined into one experience that presented a variety of insights for the visiting public.

ART IN THE HISTORY GALLERY

One of the first consciously mission-integrated exhibitions to open after the strategic planning process was *Leaving Mississippi—Reflections on Heroes and Folklore: Works by Najee Dorsey*. Already in the works before strategic planning had even begun, the exhibit showcased the work of a contemporary African American artist who creates three-dimensional and digital collages to examine both historic and present-day southern life. Lesser-known historical figures and legends of folklore mingle in his work, along with commentary on modern economic and social conditions. Nineteenth-century outlaws, civil rights pioneers, and Occupy movement protestors were all fair game. To better accommodate the artwork, much of which had three-dimensional elements that required additional cases instead of just being hung on the wall, we presented this exhibit in a gallery traditionally used for history content. In explaining this decision to other staff members, the curatorial team emphasized that the subject matter focused heavily on southern themes and historical figures that were appropriate for a gallery focused on regional history. To contextualize the work for visitors, but also to make the historical connections more explicit, director of collections and exhibitions Kristen Miller Zohn wrote labels and a long-form gallery guide that provided both aesthetic and historical context. The longer guide, offered for free, also included commentary from a professor of African American studies at Emory University in Atlanta, who further examined the work in the realm of both cultural and historical inquiry.[4]

One of the primary tasks of the guide's text was to provide factual historical information to help viewers interpret the work. Though Dorsey demonstrates great interest in making known the lives and contributions of little-known Americans of color, these are not biographical portraits, created in the school of either classical or contemporary realism. Instead, his works seek to capture the essence or spirit of these figures as seen by the artist himself. Dorsey looks online and in thrift shops and junkyards for faces and figures that speak to him; these individuals then take on new life as representations

of historical figures.[5] Often this artistic license is a necessity since there are no known pictures or portraits of these figures. In these cases, the new representational image is not in conflict with the historical record because the latter does not exist. However, historians could reasonably be expected to note to visitors that this, in fact, is not reality—the face you see did belong to a specific person, but his identity was lost long ago. In a field that focuses heavily on accuracy while also letting audiences find their own meaning, this offers an interesting juxtaposition: you (the viewer) should know this is not a true likeness, but in truth, it's as valid as any other interpretation I (the artist) can offer because this person's face was not considered important enough to record. Since these found photographs frequently include white borders, Dorsey often incorporates a rectangular shape around the heads of these figures, further emphasizing the disparate collage elements that combine to create a composite image. In one work, *Dear Dangerfield*, the imagined and known intermingle in depicting the wife of Dangerfield Newby, a free African American who participated in John Brown's raid on Harpers Ferry because he could not obtain his family's freedom. As Harriet composes her letter, the text of which serves as a border for the image, a picture of the actual Dangerfield Newby can be seen on the wall behind her, lending verisimilitude to a speculative scene.

Dorsey sometimes uses his work to tweak established narratives, such as in the CM's recent acquisition *B4 Rosa—Here I Stand*. The mixed media work features teenaged Claudette Colvin, the first person arrested for violating Montgomery, Alabama's segregation policy on city buses. Colvin's story has garnered more attention in recent years, as scholars' examination of the long civil rights movement have brought her actions back to public attention. At the time of her arrest, though local NAACP leaders had begun planning such an action, they chose not to widely publicize her arrest, choosing to continue working toward a campaign with another to-be-determined activist. Colvin's youth and darker skin complexion have been cited by some as factors in this decision, and Dorsey engages with the controversial topic of colorism within the black community by purposely darkening Colvin's face. She holds a sign with "B4" written before Rosa Parks's prison number of 7053, signaling her place in history.

For the historian, Dorsey's work and those similar to it invite questions of interpretation and the appropriate roles of artist and curator. Few people would suggest that cultural institutions should be in the business of censoring artists, and "taking artistic license" is a well-known cultural phrase that applies to more than just visual arts—filmmakers, musicians, and a host of other creative types are generally understood to have some liberty to embellish or adapt real-life events in order to better serve the goals of their craft.

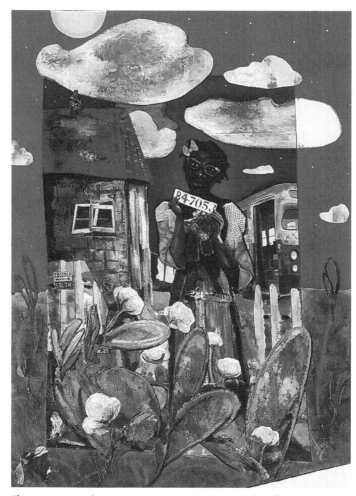

Figure 4.1. Najee Dorsey, *B4 Rosa—Here I Stand*, 2014, mixed media, 47 in. x 36 in. Collection of the Columbus Museum, Georgia. Museum purchase made possible by the Edward Swift Shorter Bequest Fund, G.2015.1.

Art museums contain many works that depict historical figures and events with varying degrees of accuracy, and it's widely understood that portraitists might paint their patrons in a particularly flattering way to ensure future commissions. Why, then, did I spend so much time thinking about this particular exhibition? In large part, I kept mulling over this show because the gallery selected was the temporary exhibition section of the Chattahoochee Legacy history gallery, which primarily contains permanent chronological displays

detailing the region's history. For more than twenty-five years, this space has presented exhibitions detailing the history of the Chattahoochee Valley, carefully researched and presented with traditional interpretive methods of didactic panels, historic images, and authentic artifacts. The voice adopted for these presentations has been that of the omnipotent, third-person narrator—the typical museum "voice of authority" that rings through so many exhibits. In this case, though didactic panels written by the art curator and fact checked by me still helped interpret the work, someone else (the artist) was presenting the primary interpretation. The artwork on the wall confronted viewers with historical subject matter of lesser-known people, presenting Dorsey's own interpretations before visitors read the label text, if they did so at all. Sharing authority in this way, though increasing in popularity throughout the museum world, still offered a chance for additional reflection, as we sought to ensure the exhibit content met our standards for accuracy.

Ultimately, it is likely that many more people connected with the subject matter in this way rather than simply viewing traditional artifacts and descriptive text. In many cases, the titles of Dorsey's work—*B4 Rosa* and *Google Robert Charles*—directly challenge the viewer to seek more information on their own, sparking curiosity that may not be satisfied by only seeing the works themselves. In this sense, *Leaving Mississippi* sparked the exact visitor response all curators and other museum professionals strive for: a desire to learn more after leaving the museum, and engaging critical-thinking skills to form their own opinions on what they had seen, learned, and discussed. In its ability to carry the conversation outside of the walls of the museum, then, the exhibition could be deemed a success. The Museum's acquisition of *B4 Rosa*, which joins a collection with works by renowned contemporary African American artists Benny Andrews, Radcliffe Bailey, and Kara Walker, among others, also signals an interest and willingness in continuing the conversation beyond the run of the exhibition. Though our efforts at times may be imperfect, the museum is now committed to reaching the local African American community through art that often examines a difficult history. One of the most noticeable effects of this exhibit was the more diverse audience that immediately came through our doors. Like many other museums founded by white elites, the Columbus Museum has challenges with reaching out to minority audiences. This exhibit in particular generated attention from the very start, with more than four hundred people arriving for the opening reception and artist talk in an auditorium with only 298 seats.

When considering this response, it's important to note that the Museum's permanent collection is not devoid of African American art and history. Most significantly, Columbus is the birthplace of Alma Thomas, a noted Expressionist artist and the first African American woman to have a solo show at

the Whitney Museum of American Art in New York City. The CM has more than sixty works by Thomas in the collection, many of them small watercolor sketches, as well as a staggering amount of archival papers and photographs that document the history of her family and her own career as a teacher. The permanent history gallery, installed twenty-six years ago and currently undergoing renovation, includes some references to African American history, mostly in regard to slavery, the Civil War, and the civil rights movement. Most notably, among the life-size "habitats" or vignettes is a simply furnished urban slave house, a somewhat unusual choice for a southern museum in a smaller city to include in the 1980s. This is in addition to the habitat and copious archaeological objects devoted to the Muscogee (Creek) peoples and their ancestors. People of color have had a presence, albeit an imperfect one, in the galleries of the Columbus Museum for more than thirty years now. Still, something about *Leaving Mississippi* undoubtedly struck a chord. Was it the undeniable aesthetic pull of the work itself, made in colorful collages and three-dimensional and digital assemblages? Or was it the chance to see African American history makers whose names aren't in the headlines, with titles like *B4 Rosa* and *Google Robert Charles* that directly reference the subject's anonymity? Was it simply because Dorsey, a savvy entrepreneur, leveraged his own numerous digital platforms to promote the exhibit of his work, expanding awareness of the museum beyond our own audience of the usual suspects? Whatever led to this perfect storm, staff members took away several lessons from the exhibition's success, not the least of which was the hunger for something different.

TATTOOS: CHALLENGING STEREOTYPES THROUGH HISTORICAL CONTEXT AND ARTISTIC EXPRESSION

Continuing to tap into the enthusiasm for this type of nontraditional subject matter and programming has become a priority for the museum as we move forward. To this end, I chose to develop an exhibition on a topic I had little prior knowledge of: tattoos. As someone who has to turn her head away when getting a vaccine, the mere thought of sitting still for hours of intricate application by a needle, all accompanied by a whirring buzz, pains me. However, a board member who was intrigued by full-body Japanese tattoos and a sign he'd seen in front of a local tattoo parlor—"We Tattooed Your Father"—brought the idea to me, and I began considering for the project as a fusion of art and history. Once I finally came around to the idea, I became intrigued by the curatorial possibilities. Since tattooing is an artistic practice with non-Western origins, exploring its history would necessitate engaging with non-American art and history,

something that is unusual, though not unheard of, for our institution. Though I was most interested in this migration from Pacific islands to the United States via British and American merchant ships and the subsequent development of a tattoo industry, I also recognized that it would be disingenuous to advertise a "tattoo exhibit" without including contemporary examples and discussing its modern-day influence, which led me to borrow electric needles and contemporary designs from two local tattoo shops. Finally, I knew that this was a chance to connect with new visitors who might see the museum as stuffy but appreciated tattoos on an aesthetic or deeply personal level. I also knew that there would be some long-time visitors who would find the concept inappropriate or unworthy for a museum. To both attract new audiences and attempt to mitigate outrage, it became clear that there had to be a personal "hook"—something that captured the feelings and stories that often inspire people to permanently decorate their bodies, something that went beyond mere ink on skin and could counter negative stereotypes.

This hook for *We Tattooed Your Father: The Global Art of Tattoos* was delivered to me, again, by museum patrons who were willing to stretch boundaries. They brought to my attention the work of Ronie Dalton, a woman from California whose son had served in the US Army in Iraq and later committed suicide at Fort Benning, the massive post adjacent to south Columbus. As a way of coping with her grief, Dalton moved to the area and began talking to several of her son's fellow soldiers, many of whom had shared his affinity for tattoos. In 2009, Dalton documented several of these soldiers and their stories, working with a local photographer and graphic designer to capture images of soldiers' faces and their tattoos while asking them to write down their tattoos' meaning on an index card. These images and stories were then grafted onto 5-feet-by-10-feet canvas banners, creating larger-than-life works that confront the viewer. The entire series of forty-three images was initially shown at a small downtown studio, with subsequent installations at the Columbus airport and select venues in California once Dalton returned there, but it had never been shown as part of a larger exhibition. The time seemed right for these works to be seen again.

Given space constraints, only thirteen were used in the final exhibit, but they immediately proved to be significant, both visually and emotionally. Dalton selected the images for this exhibit with a special eye toward service members who were still in the Columbus area, and several attended the opening reception. As the artist walked around the space, speaking about each face and tattoo, her emotion was palpable. When she spoke directly to the soldiers (most now retired) and their family members who attended, and when one soldier came to the microphone at her invitation to give a powerful discussion of his own feelings and impressions, the event suddenly became special and memorable beyond an ordinary reception. No longer was the discussion about

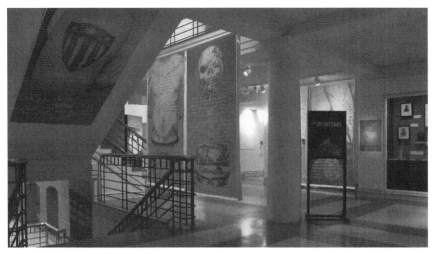

Figure 4.2. Images from artist Ronie Dalton's *A Break in the Battle: Tattoo Project/ Fort Benning* fill the Galleria of the Columbus Museum in 2016. Courtesy of the Columbus Museum, Georgia.

the historical movement of tattooing practices, or innovations in electric needles, or current trends in tattoos and the art world's assessment of them, all topics I had attempted to highlight through artifacts and text. Suddenly this was a moment of real human connection, a crowd of friends and strangers witnessing (and in many cases sharing in) an emotional response to the harsh toll of war, the therapeutic ability of art, and the redemptive power of shared grief. This is the sort of connection twenty-first-century museums often strive for, to provide more than just historical facts or artists in the canon and encourage audiences to think and feel. This exhibit had done just that, and in a way I never would have arrived at on my own. Through the images and words of an artist and her subject, the objects on display took on new meaning, creating an evocative experience shared only by those in attendance that day.

In the coming weeks, as I walked past the cases each day, I did see many visitors lingering at the cases containing the exhibit's traditional historical artifacts—Polynesian tattooing patterns, early twentieth-century flash patterns, images of sailors receiving tattoos on ships and in ports. As anticipated, a few longtime museum patrons found the exhibit offensive, suggesting that it glorified tattoos to impressionable young children on school field trips. On social media and in the comments section of a newspaper column that criticized the exhibit on these grounds, many people defended tattoos on a basic level as art and not something dirty to be censured. However, some respondents specifically addressed the exhibit's historical content as reason to be included in an educational institution. One commentator reasoned that

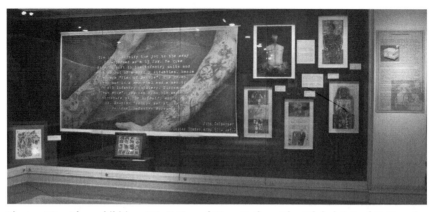

Figure 4.3. The exhibition *We Tattooed Your Father: The Global Art of Tattoos* included designs by local tattoo artists and contemporary artists' own interpretations of tattooed bodies. Courtesy of the Columbus Museum, Georgia.

since the exhibit drew connections between the tattoos of native peoples of the Pacific islands and the Muscogee (Creek) and their ancestors who had lived for so long in the Chattahoochee Valley, the content fit within our existing mission and was therefore completely appropriate: "I saw the . . . exhibit last week but did not find it out of place. Native Americans used tattoos as did the Aztecs, Mayans, and Incas. Much of the museum is dedicated to the Mississippian Indians . . . That is why I did not think the display is out of place, if taught in context with history."[6] In this instance, both art and history proved to be key components of connecting with multiple different audiences. Native peoples around the world, non-Western art, rowdy sailors in port, contemporary art, modern warfare, and patriotism—in the end, there was seemingly a theme or hook for everyone.

INTERSECTING LINES OF INQUIRY

One of the biggest benefits to these types of interdisciplinary exhibitions is, in fact, the diversity of viewpoints and ideas that can be incorporated into the final product. As someone with scant art history knowledge, I've found it incredibly stimulating to work with people from different academic backgrounds who share my commitment to museums and the power of objects. My use of the word *objects* is deliberate, as even the terminology we use can have different meanings. As an historian, I often look at an object and interpret it first as an artifact—a relic of the past that can be used to teach or inform about that past. I ask practical, almost journalistic questions: Who used it? For what purpose? When and how was it made or used? And most importantly in a museum setting, why should anyone care about it today? Why is it worthy of being preserved and

exhibited? Art historians also use questions when engaging with an object, but their line of questioning owes more to aesthetic and contextual concerns than to traditional historical inquiry. What is aesthetically distinctive or pleasing about this work? Who made it, and why? (Does the "why" even matter?) What historical or contemporaneous artists and movements influenced the creation of this piece? What events, on a macro or micro scale, might also have influenced the artist and led to this particular work? This last question is one that truly lends itself to cross-disciplinary discussions, as the art historian contemplates the world surrounding the creation of an object, much as a traditional historian does. The work's subject matter may have little to do with outside forces, but often it does, encouraging viewers to engage with the external as well as internal thoughts and feelings. In the Columbus Museum's own collection, a pair of Rembrandt Peale portraits depicting George and Martha Washington, executed in the 1820s, reflect the growing trend toward American nationalism and early veneration of the forefathers. This fact is hammered home by the portraits' installation near nineteenth-century lithographs, porcelain dolls, and currency issued by a local bank, all featuring the nation's first president. The David Gilmour Blythe work *Land of Liberty*, painted in 1840, includes subtle visual clues mocking new Irish immigrants who streamed into the country, seeking freedom and liberty but often finding discrimination and hardship in equal measure. In these cases, a thorough discussion of the painting's meaning and context must necessarily include a heavy dose of American history.

Conversely, this approach works on the local scale as well. One of the American Indians featured prominently in both the museum's permanent art and history galleries is Opothle-Yoholo, an Upper Creek leader who had a fascinating relationship with the US government. Initially willing to work with federal soldiers and agents to accommodate Euro-American settlers on traditional Creek lands, Opothle-Yoholo later became a leader of the Creek resistance movement. Ultimately, even guerilla tactics could not hold back the tribal group's own Trail of Tears and forced migration. In 1832, before relations soured, Opothle-Yoholo was in a delegation of southeastern native leaders that traveled to Washington, D.C., for treaty negotiations. On this trip, federal official Thomas McKenney took several members of the traveling party to the studio of Charles Bird King, a portraitist who McKenney commissioned to paint the likeness of many American Indian leaders of the early nineteenth century. McKenney occupied several positions in the Bureau of Indian Affairs for more than a decade and saw these portraits as a way to record and preserve the culture of these tribes who came to the nation's capital to negotiate for their futures. To further his goal, McKenney hired Henry Inman to paint copies of Bird's 150 originals (on display in the War Department), which then became the basis for an "encyclopedia" McKenney compiled with author James Hall. Several lithographers, working for different publishers, created prints that depict several prominent American Indians of the 1820s and 1830s.[7]

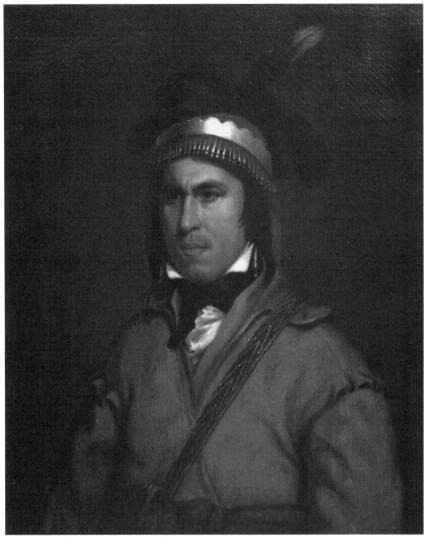

Figure 4.4. Henry Inman, *Opothle-Yoholo (Creek Chief)*, 1831–1832, oil on canvas, 30 in. x 25 in. Collection of the Columbus Museum, Georgia. Museum purchase made possible in part by the Ella E. Kirven Charitable Lead Trust for Acquisitions, The Crowley Foundation Acquisition Fund, and a gift of Robert M. and Jane D. Hicklin in memory of Mr. and Mrs. Robert M. Hicklin Sr., G.2011.3.

The Columbus Museum owns several of these prints, depicting important Muscogee (Creek), Seminole, and Cherokee leaders in what is now west Georgia, east Alabama, and the Florida panhandle. Many of these works came to the Museum in its first five years, reflecting the interest of two prominent donors. In recent years, the Museum also acquired Inman's painting of

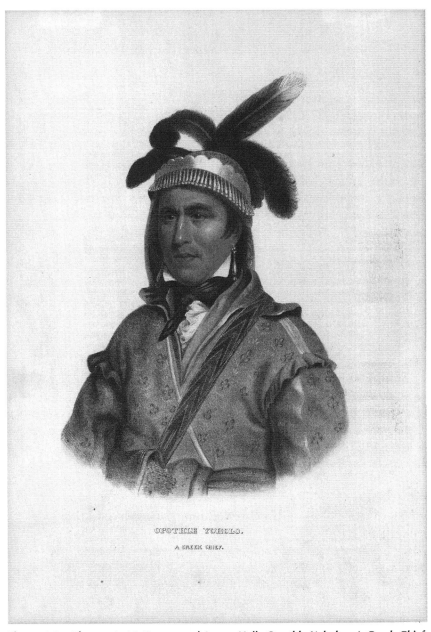

Figure 4.5. Thomas L. McKenney and James Hall, *Opothle-Yoholo—A Creek Chief,* 1836–1844, lithograph, colored and published, 15 in. x 10.5 in. Collection of the Columbus Museum, Georgia. Gift of C. Dexter Jordan, G.1954.80.

Opothle-Yoholo, which now hangs in the Museum's permanent art galleries. The corresponding McKenney and Hall print can be found in the permanent history gallery, with a label that also directs visitors to the full-size Inman painting. Visitors can thus view this complex leader through two lenses, drawing meanings in multiple ways and through multiple media. It also opens a discussion about the very nature of record keeping. When McKenney sought a way to record the traditions and appearance of American Indian leaders, he turned to a portrait painter—not to ensure the memory of himself or his family, but to leave an impression of the non-Anglo-Americans he knew through his profession. The McKenney and Hall three-volume set *The History of the Indian Tribes of North America* provides a plethora of observations and information about these leaders, but the general public's encounters with these works today comes through artistic renderings, not lengthy paragraphs. The Smithsonian's National Portrait Gallery took this approach a step further in 2015, exhibiting McKenney and Hall lithographs next to presidential treaty peace medals similar or identical to those worn by the sitters in the selected portraits. Simultaneously placing the focus on portraits and historical artifacts found in those portraits, *From Token to Ornament: Indian Peace Medals and the McKenney-Hall Portraits* encouraged visitors to "read" the art more closely, while still providing ample historical facts and context about the creation and purpose of such medals, which feature the profiles of America's first eight presidents. This nontraditional portrait even further stretches the definition of a portrait for visitors while enriching the exhibit experience. Cocurators Brandon Brame Fortune and Wendy Wick Reaves noted in the exhibition text that these objects "are only one aspect of the complex stories of diplomatic exchange between Euro-Americans and Native Americans," encouraging visitors to investigate further, perhaps through more traditional methods of historical research and interpretation.[8]

PAST LESSONS, NEW CHALLENGES, AND NEXT STEPS

As I and other Columbus Museum staff members continue our quest for greater mission integration, there are some insights we have gained along the way that will affect our future course. Just as it is true that not every exhibition or collections object cries out for multidisciplinary interpretation, not every visitor or patron will enjoy this comprehensive focus. Some will decry the inclusion of lengthy historical information on panels for art objects, insisting that the aesthetics of a work of art should be appreciated for its own sake. Others will breeze right past those same art objects, never stopping to read the labels that we've so carefully crafted to include historical context. Not even

multidisciplinary museums can please everyone, and though we'd like to think that we offer something for everyone, logistical and budgetary restraints mean there is a limit to that goal. And ultimately, that's just fine. Subject purists will continue seeking out objects and exhibitions that appeal to them. When we install one exhibition or thematic section with lengthy explanatory labels, and another with simple tombstone labels (artist, title, medium, date), we acknowledge this difference and offer visitors more choices.

As several mentors have told me over the years, I've rediscovered the simple truth that words matter. When a fundraiser, affinity group, special trip, or programming continually privilege one part of the mission over the other, especially in written descriptions, the cumulative effect is the undervaluation of the forgotten portion of the mission. Contemporary society has more ways than ever to show that you "like" something or someone, but it still comes down to repetition: number of page views or location check-ins, repeating key phrases in political rhetoric, purchasing the same brand. Much like studying for a test, the more we review or repeat something, the more ingrained it becomes in our brains. True integration of art and history, then, requires commitment and buy-in across the entire institution at the board and staff levels. Both internal and external communication should reflect this goal. As we discovered as a result of the strategic planning process, visitors did not always recognize or respond to the combination of art and history, even when staff thought the effort was obvious. We learned to think more purposefully about how we were presenting our message and our story. Stating in an interview or press release that "this exhibition strategically integrates our dual mission of art and history" is not only jargon, it's boring and dull. However, talking about the aesthetic and historical highlights of an exhibition, drawing attention to both while talking about one or two examples, provides a more natural way to present content with more than one interpretative viewpoint.

As I continue to grow in my career, I find that several of my own biases, not just as a museum professional but also as a museum visitor, have been challenged by my work in a multidisciplinary museum. Whereas I rarely would have sought out an art museum when visiting another city, I now include them in my planning of special events or exhibitions. I find myself lingering and enjoying works I would barely have glanced at ten years ago, and though I still gravitate toward photography and away from abstraction, I'm comfortable with that. Most importantly, inspiration for a new exhibition can strike anywhere. My world of artifacts and objects to interpret has grown exponentially, and that has made me a more imaginative curator. Though I still grit my teeth every time someone references "The Columbus Museum of Art" as being in Georgia and not Ohio, I can see the fruits of my colleagues' and my efforts in a growing awareness of our history program throughout the

Chattahoochee Valley. In features in national magazines and public affairs television, in regional media outlets, and in conversations with community members, I find more and more people attuned to the history side of our mission. I see couples and families coming to receptions and exhibitions, with one person leaning in close to examine the complexities of a historical map while another stands back to absorb the breathtaking whole of a work of art, and I am thrilled. Most rewarding of all, it has been a couple years now since I encountered someone who was surprised by the presence of a history curator at "the art museum." Greater relevancy for all comes not with the relentless promotion of one discipline over another, it seems, but in blending multiple perspectives, objects, and experiences into a space open to everyone. Public historians may find this recipe for success to be a familiar one, but it's worth remembering that these tools are available in all sorts of settings, whether you're breaking new ground in a corporate office, a brand-new historical park, or, yes, the local art museum.

NOTES

1. "Meet a Member," American Association for State and Local History, last modified July 12, 2016, http://blogs.aaslh.org/tag/meet-a-member/.

2. William Winn, *Building on a Legacy: The Columbus Museum* (Columbus, GA: The Columbus Museum, 1996), 69–70.

3. "Museum Universe Data File," Institute of Museum and Library Services, last modified November 2015, https://www.imls.gov/research-evaluation/data-collection/museum-universe-data-file.

4. Pellom McDaniels III, "Arias for the Discontented: An Homage to Black Masculinity and Manhood," in Kristen Miller Zohn, gallery guide for *Leaving Mississippi: Reflections on Heroes and Folklore—Works by Najee Dorsey* (Columbus, GA: The Columbus Museum, 2014).

5. Ibid.

6. Joseph C. Leuer, February 28, 2016 (9:22 a.m.), comment on Richard Hyatt, "Bringing Body Art to Galleries," *Ledger-Enquirer*, February 27, 2016, http://www.ledger-enquirer.com/news/local/news-columns-blogs/article62966782.html. "Mississippian" in this instance refers to the Mississippian prehistoric cultural period, which is discussed at length in the museum's permanent galleries, and not a designation of tribal affiliation.

7. Christopher W. Lane, "A History of McKenney and Hall's *History of the Indian Tribes of North America*," from *Imprint: Journal of the American Historical Print Collectors Society* 27, no. 2 (Autumn 2002).

8. "From Token to Ornament: Indian Peace Medals and the McKenney-Hall Portraits," National Portrait Gallery, accessed June 25, 2016, http://npg.si.edu/exhibition/token-ornament-indian-peace-medals-and-mckenney-hall-portraits.

Chapter Five

Coming Face to Face with the Past

Exploring Scottish History and
National Identity through Portraiture

Tawny Paul

There is a long-held understanding within academic study that museums play a fundamental role in shaping identities. Museum scholars suggest that "museums are important because they serve to remind us of who we are and what our place is in the world."[1] Museums possess a power to "shape collective values and social understandings in a decisively important fashion," and national museums are seen as active agents in the process of imagining national histories, cultures, and identities.[2] The portrayal of national identity within museums often relies on a sense of history. Our understandings of the past inform us about who we are. As Benedict Anderson explained, national identities claim historical longevity and authenticity in order to give themselves authority, legitimacy, and credibility.[3] Museums form collections of objects, artworks, and stories in which history is reflected. Thus, material collections and displays articulate and represent national histories, values, and realities, helping to create and communicate a sense of collective heritage.

Representing history and identity in the museum is a complex endeavor. First, museums are not monolithic institutions. They will (and should) include diverse and potentially competing narratives. They also represent diverse populations, and have often been enlisted in an effort to promote cultural and social inclusivity. In Britain, for example, museums are seen as essential to helping to create "greater intercultural understanding and community cohesion."[4] Further, a museum's message or meaning is created by an encounter with the history of the institution itself. The material presented and the ideas communicated in museums are built upon the material collections that curators have to work with, which can be inherited and accidental. Museum collections, often shaped by the concerns and tastes of people of the past, can obscure some voices from history. Minority and marginalized groups might not be well represented by traditional collections of material

culture. Finally, while the relationship between representations and identity might seem purely theoretical, museums are not insular spaces. Museum representations identity have political ramifications. Perhaps nowhere is this better demonstrated than in Scotland, a small nation whose identity politics are of current global interest. A recent independence referendum and the UK's Brexit vote (in which Scotland dissented from the majority decision to leave the EU) mean that current debates about Scottish and British nationalism, feelings toward immigrants, and attitudes about who belongs in the nation and who doesn't are hugely relevant beyond the museum walls.

In facing the challenges presented by the need to represent diverse perspectives and diverse populations, the limitations of inherited collections, and the politicization of identities, museums might see collaborations with contemporary artists as providing great potential. Art lends imaginative potential to the process of history making. It can move us beyond the certainties of evidence-based historical research, providing other ways of "knowing" and understanding the past.[5] This might include embodied knowledge or emotional intelligence. Art has the power to convey intangible human emotional responses, which are seen as important especially when dealing with difficult histories. But while the potential of art has been greatly applauded, the ways in which visitors interact with this art might be more problematic. A museum's message is not only created by its collection but by its encounters with its audiences. Meaning in museums is coproduced, and this is reflected in the audience-centered approach that is now widely adopted in museums. Whatever the agendas or intended messages developed by curators, visitors bring their own diverse perceptions, knowledges, and experiences to bear on what they encounter in displays. They will interpret what they see in light of their own background, their own sense of identity, their motivations, and the nature of their visit.

How, then, do visitors respond to and engage with artistic interventions? Do they "get it"? What kind of potential does art have to interpret history and engage audiences, and what are its limitations? These questions seem especially relevant to representations of identity and nationhood, issues that are often socially and politically fraught. In probing these questions, this chapter focuses on the potential of portraiture as a specific art form. It draws on a case study of the Scottish National Portrait Gallery (hereafter SNPG), a museum that reopened in 2011 after major renovations and that now seeks to present a "portrait of the nation." In particular, it focuses on an artistic collaboration in one of the opening exhibitions, *Migration Stories*, which, in an effort to represent an inclusive nation, involved commissioning photographs of Scotland's Pakistani community.

THE NATION'S PORTRAITS:
A HISTORY OF THE GALLERY

The SNPG, opened in July 1889, was one of the first purpose-built portrait galleries in the world. When it was built, the Gallery reflected a particular way of seeing the nation's past, its people, and its identity by collecting and displaying portraits that celebrated the achievements of so-called great men (and a few great women) who were largely white, wealthy, and successful. The SNPG intended to inspire and educate its visitors and encourage good citizenship. It was nationalistic in tone, and brought together people who made and were making a vital contribution to the development of Scotland's identity and history.

Not only was the museum a means of explaining the nation's history to the public but also in the nineteenth-century context of empire and industrial development the study of history and of historical characters was used to justify British success. People and their achievements were were seen as a nation's greatest assets. As one Scottish historian wrote in 1854, "It has always struck me that Historical Portrait Galleries far transcend in worth all other kinds of National Collections of Pictures whatever; that in fact they ought to exist . . . in every country, as among the most popular and cherished National Possessions." Even the Gallery's building itself was a representation of the way that history was presented through portraiture. The notion of national and individual character permeated the fabric of the building as well as constituted the material that adorned its walls. Built in a gothic style of distinctive red stone, the building was covered with statues of historical figures and intended by its architect to reflect "the spirit of the native architecture."[6]

Though the SNPG was one of the first, it shared its purpose and ambitions with other portrait galleries around the world. Portrait galleries in London and the United States were and continue to be integrally involved with telling the story of the nation by celebrating the achievements of its people. For example, in justifying the establishment of an English National Portrait Gallery in London in 1856, Lord Stanhope argued before Parliament for the establishment of a collection of portraits "to consist as far as possible of those persons who are most honourably commemorated in British history as warriors or as statesmen, or in arts, in literature or in science."[7] The Smithsonian National Portrait Gallery proclaims, "Our collections present people of remarkable character and achievement. These Americans—artists, politicians, scientists, inventors, activists, and performers—form our national identity. They help us understand who we are and remind us of what we can aspire to be." Visiting the portrait gallery brings visitors "face to face with America."[8]

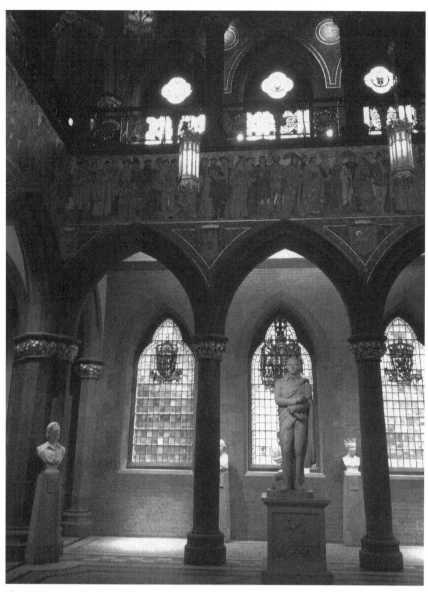

Figure 5.1. Portraiture is woven into the fabric of the SNPG building. Upon entering the gallery on the ground floor, visitors are greeted by a frieze of Scottish notables and historical figures in a chronological order. Photography by Tawny Paul, reproduced with permission from the National Galleries of Scotland.

Today, the function of the SNPG is still to represent the nation to itself. However, the means of fulfilling this purpose have changed considerably. Though the Portrait Gallery perfectly suited nineteenth-century understandings of history, citizenship, and the nation, it was becoming clear by the twenty-first century that the gallery felt out of date. It needed to be refashioned to suit a contemporary audience. Representing the nation now required attention to diversity. If it was going to represent Scotland, it needed to represent an inclusive Scotland. This is something that museums can do quite well. As Rhiannon Mason argues, museums have "the potential to demonstrate the contingent and constructed nature of contemporary nations."[9] Furthermore, in line with new ideas about museology and museum learning, the SNPG needed to communicate with its audiences in more dynamic ways. While nineteenth-century visitors came to be told what constituted good citizenship, the modern gallery needed to engage in dialog.

In order to modernize and animate its collection, the Gallery underwent a major refurbishment called *Portrait of the Nation*. Its new vision was to reinvent the SNPG for the twenty-first century, and to be "a true portrait of the nation—a unique, responsive and essential portrayal of Scotland" that would "fascinate, stimulate and engage."[10] In order to achieve this ambition, the Gallery transformed how it collected and represented portraiture to the public. National identity and its connection to history would remain central to the collection. As the director general of the Scottish National Galleries, John Leighton, told the press, "We would surely expect our Portrait Gallery to be a visual history of Scotland, combining our fascination with people, art and stories." This historical identity, however, would now be more inclusive. As Leighton explained, "We mean portraits in the widest sense. The search for identity, personal, collective, national and global, has become a preoccupation of contemporary society."[11]

Creating a gallery that would be a space for debate was particularly relevant because at the time of the SNPG transformation, the issue of national identity had particular resonance in Scotland. The Gallery reopened in the period leading up to the 2014 Scottish Independence Referendum. The Scottish nation's identity and relationship to the UK and to Europe was therefore an issue at the forefront of many visitors' minds, and would color their responses to representations in the museum. In the wake of 2016's Brexit vote, these issues of identity continue to be politically relevant, and history becomes a political resource. The British historian John Tosh sees history as "a citizen's resource, essential to social awareness and political choice."[12] While the SNPG deliberately did not engage in the politics of the Referendum, its collection was certainly relevant to the decisions and debates facing Scotland.

FROM THE NATION'S
PORTRAITS TO *PORTRAIT OF THE NATION*

Representing national identity is a challenge. Though Scotland is a diverse nation, the stereotypical image of the Scot, both at home and abroad, is a kilted white man. He is probably standing in a rural landscape, wind rustling his hair, as he gestures at a castle or estate. Perhaps he is a warrior, holding a shield and poised to defend his native land.[13] Some of the gallery's displays might seem to bolster this stereotype (figure 5.2). Though the gallery's collection was of course much more diverse than images of kilted men, the collections made representations of racial, cultural, and social diversity difficult. Historically, given the expense of commissioning a portrait, those who were depicted in Europe were male, wealthy, and white. The Gallery's collection included only a handful of individuals of African descent. Migration was largely underrepresented. The Gallery faced a challenge that confronts many museums: our collections are inherited, and these collections can limit the stories that we wish to tell.

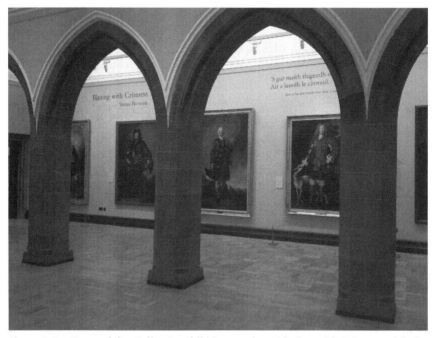

Figure 5.2. Some of the Gallery's exhibitions such as *Blazing with Crimson* might be seen to uphold more traditional images of Scots. Photography by Tawny Paul, reproduced with permission from the National Galleries of Scotland.

The Gallery's approach to an inclusive Scottish identity involved creatively redefining "portraiture." Traditionally, a portrait is understood as a visual representation of a person. However, under the conceptual framework, this definition was expanded. The Gallery would now be a portrait of the *Nation*. This might on the surface seem like a small semantic change. However, it allowed the gallery to transform its approach to collecting, display, and audience engagement in key ways. First, this conceptual shift allowed the gallery to diversify its collections and exhibition practices. By representing a place rather than just people, the Gallery could now collect and display more diverse forms of art. "Portraiture" could include not only individuals but also landscapes, portraits of the times, or portraits of particular concerns. Diversifying the types of material that it included was seen as a way of better engaging audiences. As the Gallery's director of new media explained, "People can make their own connections with the people, places and history of Scotland, from Bonnie Prince Charlie to King Creosote [a popular Scottish musician]. There's something for everyone, however they want to make connections—personal, geographical, historical."[14] The new conceptual framework facilitated more flexibility around how the collection was interpreted and displayed.

Under the new *Portrait of the Nation* framework, the Gallery was organized around a thematic and chronological account of the social, economic, political, and cultural history of Scotland. The four floors of the building were supported by a chronological backbone, with major exhibitions in five key areas: Reformation, Enlightenment, Empire, Modernity, and Contemporary. These key areas seemed to resonate with current debates about the nation and its identity, which would engage visitors in a dynamic sense of history. Alongside the Gallery's chronological focus around the key areas, five themes cut across the entire space: Power, History, Identity, Representation, and Memory. This offered visitors an alternative, nonchronological way of accessing the collections. The gallery offered multiple forms of interpretation to suit different audiences and layered interpretation, including multimedia stations, more traditional labels, and education programs designed for particular audiences. It sought to equip visitors with the tools to critically view and interpret the portraits.

Using the key areas and themes, Gallery curators sought to represent a nuanced and diverse vision of Scotland and its past. This included images that celebrated the achievements of the nation and those who lived within it. Enlightenment galleries, for example, touched upon technological breakthroughs and exhibited the portraits of Scotland's well-known scholars, philosophers, and artists. Space was also devoted to representations of ordinary people and diverse themes. For example, one exhibition focused on sports and the pastimes enjoyed by Scots, from golf, to curling, to rock climbing.

The gallery also gave space to darker and less celebrated aspects of the nation's history and culture. In 2012, the gallery had a temporary contemporary exhibition called *Legacy*, which focused on videos of two sectarian flute bands. It explored the identities of Loyalist and Republican communities, and tapped into a history of social division and violence that many Scots prefer to forget. Another new work in the collection was a video installation by the contemporary artist Graham Fagen called *Missing*, about those who have disappeared. The installation made references to notorious serial killers, and it dealt with themes of absence, loss, and the impact of the missing on those who remain. In a slightly unusual way, this piece encapsulated the Gallery's vision of inclusivity by explicitly addressing the condition of vanishing from history, literally and figuratively. As the Gallery director reflected, "I like very much the idea that one of our first exhibitions is about people who have fallen off the map. It gives the idea that we have changed, that the Gallery embraces the whole of Scotland, whether you're world famous or are on the outskirts of society."[15]

Representing an inclusive and diverse Scotland meant reinterpreting and reorganizing the historic collection. Working with contemporary artists and commissioning new works offered promising possibilities. One of the areas that the Gallery prioritized was the theme of migration. A new program of exhibitions titled *Migration Stories* was established, exploring the visual culture of Scotland's migration history. Migration is central to Scotland's popular history and its sense of identity. A series of events in the eighteenth and nineteenth centuries, including Highland Clearances (a contested term), changes in land holding, the allure of economic opportunities elsewhere, and participation in the British empire drew a steady stream of Scots away from their homeland.[16] The legacy of this flow of migrants means that Scotland now claims a connection with a global community of some forty-five to fifty million people who claim Scottish ancestry. The notion of a small nation populating the globe and making a disproportionate contribution to the modern world pervades popular memory.[17]

Migration history is a theme addressed by many museums, galleries, and visitor centers around Scotland. However, in the complex story of migration, most histories, both popular and academic, focus on the flow of people out of Scotland. Much less studied, remembered, and celebrated is the story of those who migrated into Scotland, including Italian, Pakistani, and Polish communities who made Scotland their home. Portrayals of Scottish migration also tend to be celebratory, neglecting, for example, its role in enforced mobility. In the words of one historian, Scotland has experienced a "collective amnesia" about its participation in the Atlantic slave trade.[18] Following the blind spots of academic and popular histories, museums and visitor centers

that address Scottish migration tend to focus on Scots going abroad rather than immigrants coming to Scotland. Thus, one of the challenges faced by the *Migration Stories* curators was to represent how "migrants both into and out of Scotland continue to shape the nation."[19]

The inaugural exhibition of the *Migration Stories* series was a photography exhibition titled *Migration Stories: Pakistan*, which explored Scotland's links with Pakistan through three contrasting displays: *A Scottish Family Portrait*, featuring photographs of prominent Scots of Pakistani heritage; *Fragments of a Love Story*, a personal film by a Pakistani-born filmmaker; and *Isabella T. McNair*, a snapshot of the life of a Scottish teacher in Lahore. The largest of the three displays, and that which occupied my research, was the photography exhibition *A Scottish Family Portrait*.

For *A Scottish Family Portrait*, the SNPG commissioned the German photographer Verena Jaekel, who focuses on portraiture and whose work has explored themes of migration, religion, and generations. Jaekel was given a list of individuals by the SNPG to photograph, and she chose how to compose the portraits. Because most of the sitters, chosen by the gallery in consultation with the Pakistani community, were successful and prominent individuals, Jaekel chose to photograph them with their families. According to Jaekel, this decision was made in order to broaden the scope of people involved in the portraits, including different generations and those who supported the chosen sitter. She also hoped that including families would show the sitters in their diverse public and private roles, making the portraits more accessible to viewers. As she explained, "I had chosen family portraits because visitors would be able to relate better to the portraits because everyone has a family. Family shows them in a different role rather than the role they represent in public. . . . it is possible to see these successful people in a different way."[20]

The resulting photographs, which Jaekel composed using a large-format camera, show the families in their own homes. Sitters face the camera head-on, relaxed, most unsmiling. Produced in a large color format (each measured 43 x 33 inches), the images convey a kind of intimacy between sitter and viewer, almost as if the viewer is able to enter into the subject's domestic space. The sitters chose who they would be pictured with, and thus the definition of "family" in the exhibition was diverse. Some assembled small, nuclear families. For example, the lawyer Aamer Anwar chose to be photographed with his wife and son; actor Atta Yaqub with his brother. Others chose to include multiple generations. The politician Bashir Ahmed Maan chose to be photographed with four generations of family.[21] Sitters also chose what to wear. Some chose traditional Pakistani dress. Anwar and his wife were photographed in traditional Pakistani wedding attire, while others chose western clothing. In some cases, families (often divided by generation) wore both tra-

ditional and modern attire. These might seem like small choices, but clothing, setting, and the inclusion of others are a means of communicating biography. According to Jaekel, these decisions invested the photographs with meaning. As she explained, "The constellations are interesting and show different generations doing their own things."[22] Exhibition labels focused heavily each sitter's sartorial decisions and his or her own sense of national identity. By giving them decision-making power over how they would be represented, and making these choices prominent, Pakistani-Scots were brought into the exhibition not only as subjects but also as collaborators.

THE AUDIENCE RESPONSE

The SNPG, in the new *Portrait of the Nation* gallery, and in working with contemporary artists like Jaekel, was deliberately aiming to convey a sense of Scottish identity that was diverse, inclusive, and that would encourage debate. A number of recent studies, however, question the museum's ability to effect attitudinal changes to cultural difference.[23] In order to address these questions, I conducted a survey in the Gallery during August 2012, in which I spoke with 130 randomly selected and anonymous visitors. This group was in many ways typical of the visitor population we would expect to see in an art gallery. It was just under 60 percent female and slanted toward an older population of visitors (75 percent of visitors were over the age of thirty-five). Visitors had an overwhelming personal connection to Scotland, either through Scottish residence or heritage. Some 64 percent considered themselves to be Scottish or of Scottish heritage, and 45 percent lived in Scotland. Of those who did not live in Scotland, most visitors were British. About 36 percent lived in England, Wales, or Northern Ireland, 11 percent came from other parts of Europe, and 8 percent were international visitors from outside of Europe. Only 4 percent of visitors in my survey self-identified as being nonwhite.

The overwhelming Scottish and British residence patterns and cultural and ethnic identifications of survey participants were important, because this background would help shape how they responded to the images of Scotland in the Gallery. The survey, which lasted about five minutes per participant, contained a mixture of multiple choice and open-ended questions. My questions intended to better understand how visitors interacted with the history of Scotland through portraits; how they reacted to portrayals of Scotland and Scottish identity in *Portrait of the Nation*; and where they found points of personal identification or connection in the collection. I was interested in whether they were challenged by their visits to the Gallery, and to what extent they engaged with ambitions of diversity and inclusion.

So, what did they have to say? One of the questions that I asked reflected on the gallery's ambition to portray the nation. I asked how, after seeing the gallery, visitors might describe Scotland, and what really stood out to them. There were a number of different answers, but what really tied them all together was a celebratory tone, a very positive portrayal of the nation, and for Scots, national pride. One respondent described how "the content displays the growing confidence of a small nation." Others emphasized Scotland's influence on the world. Many visitors, especially after visiting a gallery called *Pioneers of Science*, focused on Scotland's medical innovation. One participant reflected that a painting portraying three oncologists "highlights how much innovation has come out of Scotland." Others focused on cultural achievements. One woman described her impression that "[w]hat [Scotland] has given to the world stood out, especially in terms of literature."

Celebratory comments do not seem unfair, given that the gallery historically collected images of Scots who have achieved and who have shaped the nation, and much of the gallery reflects that inheritance. However, the political context of the moment was palpable. Many visitors answered my question by referencing Scotland's relationship with England, or its achievements despite its small size. Some comments suggested the possibility of culturally celebrating Scotland within a British framework. As one visitor explained, "It establishes that this is a nation in its own right. But also it ties Scotland into the history of Great Britain, the empire and industry." Many referenced Scotland's small size, clearly in relation to England. One participant felt that the gallery showed Scotland "consistently punching above its weight. A concentration of interesting things and achievements, despite its small size." Others saw in the gallery evidence of Scotland's continuing repression by England with comments such as, "We're still struggling under the yoke of English imperialism." Others wanted to clearly delineate Scotland's cultural identity from England's. As one participant suggested, "It's Scottish art, not British art."

There were more diverse and contradictory audience responses about the degree to which the Portrait Gallery should be a space for celebrating positive aspects of Scotland, or whether it should provide space for diverse and potentially less flattering aspects of Scottish identity. Responses to the exhibition *Legacy*, about sectarian marching bands, encapsulated this issue. The common response by most participants who visited this exhibition was surprise. In some cases, this feeling of surprise led visitors to an experience of challenge in which they were encouraged to rethink how they understood Scottish identity. As one visitor told me, "The rest of it is a very conventional portrayal of Scotland, but that exhibition makes you think. It wasn't the Scotland that I expected." For others, seeing a dark side of Scotland's culture

given space on the gallery walls was not a welcomed experience. As one couple told me, "We were surprised at the prominence given to flute bands. It isn't a thing about Scotland that I admire." Another visitor explained, "I was surprised at the marching bands. I didn't know why they didn't portray Scotland in the best way they could have. In other spaces we portray ingenuity and philanthropy. But we have some aspects of society that we describe as negative. To put that in a portrait gallery—I question it." For this last visitor, the Gallery was a space of public, international representation, and she felt that it had a responsibility to represent Scotland in the best light possible. The comment gets to the very heart of debates around the purpose of the museum. In this case, the visitor's vision for the SNPG might have conflicted with the institution's own vision for itself as a forum for debate.

Responses to *Migration Stories* were similarly varied, and the presence of this exhibition offered the opportunity to observe how audiences responded to representations of a multicultural Scotland, and whether this enabled discussions of identity. It must be noted that the overwhelming majority of visitors surveyed responded positively to the exhibition. Over 70 percent responded with positive comments. Some 15 percent responded negatively, and 12 percent didn't give particularly positive or negative responses but told me that they had learned something. When confronted with images that seemed to challenge standard or inherited representations of Scotland, audience responses seemed to take one of three paths. First, when asked what they thought about the exhibition, many used the experience of talking to me to "perform" a standard narrative, or to perform societal expectations regarding acceptable discourses around diversity, a feature of audience responses described by scholars elsewhere. I got a lot of very uniform and quite generic responses, where visitors suggested that it was good to see a minority community represented. Here, I think a lot of people were "performing" what they thought the institution was trying to say, or what a young woman with a clipboard standing at the museum exit would want to hear. One visitor responded that she thought *Migration Stories* "says [Scotland] is cosmopolitan and welcoming to different ethnic backgrounds. It's a culture that embraces other cultures." Others described the exhibition as a means of celebrating Scotland, noting how inclusive the nation is: "The exhibition told me that Scotland makes people feel welcome and allows them to achieve." Another told me that "it is so wonderful to see the gallery portraying the Asian community so beautifully . . . they have much to give to our British Community." Sometimes these sentiments were couched in terms of Scotland's relationship with England. One person told me that the exhibition was proof that Scotland is more welcoming than England. I do not intend to suggest that these celebratory responses were not genuine or were somehow inauthentic, but rather than

the uniformity of comments across the sample suggest adherence to some sort of standard narrative. As Lloyd suggests, when negotiating national identity and cultural diversity, individuals might "adopt narrative strategies to accommodate new information without necessarily changing their own definitions of national heritage or attitudes towards minority groups."[24]

A second type of response was what Laurajane Smith has identified as "strategies of disengagement and avoidance," distancing themselves from the subject matter by relating it to their own experience.[25] According to Smith, visitors use museums in strategic ways to navigate social debate. She explains that "visitors seek to use museums to reinforce their emotional and intellectual commitment to certain forms of knowledge and the values they underpin."[26] These can include things like nationalism, class solidarity, ethnic identities, and political ideologies. According to Poria, museum visitors tend to fall into two groups: knowledge seekers and identity reinforcers.[27] Those in the second group, when confronted with exhibitions or images that do not accord with their knowledge or values, use emotional or intellectual strategies to disengage or distance these from their own reality. As one couple told me after viewing *Migration Stories*, "it was good to incorporate it but it didn't really affect us." Another described the sitters as "not Scottish." As the visitor explained, "They're not my perception of Scots. I only read one of the stories, but he said he was Pakistani sometimes and Scottish sometimes. In other words, he would be Pakistani when it suited him to be Pakistani and Scottish when it suited him to be Scottish. That was a depiction of what I expected an Asian immigrant to say. It didn't represent Scotland in any way."

For many, the distancing of the exhibition from their own experience was explained in terms of place. Visitors reflected on the images as not part of their own social reality by placing them in a different geographical setting, noting, for example, that Pakistani communities in Scotland tend to be concentrated in particular cities; cities that they do not inhabit. As one couple explained, "The town we live in is quite small. It's all white." They might therefore appreciate the images but feel they did not represent the Scotland that they knew. A handful of visitors responded negatively, suggesting that this image of diversity was manufactured by a liberal museum, and that it was not representative of the nation to which they belonged. One man told me, "It's not representative. They should not have been allocated as much space. Because I live in the Borders and it's not the same as in cities." Here, place and the local experience play an important role in mediating responses to inclusiveness and national identity. The local, personal experience is one of Smith's strategies of "avoidance."

There were also some concerns about whether the images were representative of the migration experience. Some visitors felt that it was not fair to

focus on just one immigrant group, with several suggesting that Italian migrants ought to be represented. Others were concerned that it might reinforce stereotypes that we have of Asian migration; for example, large families. In many cases these comments seemed to reflect visitors' appreciation for the nuances of migration. It was also clear, however, that visitors projected their perceptions of migration onto the photographs. The exhibition text focused on the prominence of the individuals depicted, their contributions, and also focused on issues of clothing choice, and on how they described their own sense of identity. In dealing with a minority group often stereotyped as poor, the gallery was arguably seeking to provide an alternative representation. Visitor responses emphasized just how entrenched the narrative of immigration as a struggle and experience of longing is, and how compelling the story of rags to riches. As one visitor commented, "I would have liked to hear about the struggles of moving to a new place." Another reflected that "it was very interesting to see how people have come over with nothing and made a lot of themselves." Even reviews criticized the images of success. As one local magazine commented, sitters were depicted in their middle-class homes with supportive families, "while the struggling door to door salesmen of today are notable by their absence from this collection. With Pakistanis being among the poorest racial groups in the UK, this can't really be described as an accurate portrait of our nation."[28] Arguably, these comments could reflect the attitude that everyone deserves representation, not just the successful. However, they also speak to both the entrenched nature of some cultural stereotypes, and to the importance of visitors' own backgrounds and perspectives, which shape how they interpret what they see. As Rhiannon Mason argues, communities and visitors exert their "own forces upon the museum."[29]

In these examples, visitors seem to have avoided or rejected the "intended" message of the exhibition. What happens when visitors refuse to engage? A growing academic literature explores this problem, raising questions about the potential of museums to change minds. As Lloyd suggests, attempts to reimagine the nation in "inclusive" terms may only be successful if individuals are already inclined to identify with plural conceptualizations. Similarly, Mason contends that the challenge facing museums lies in the degree to which visitors seek out museum representations that reaffirm rather than challenge or disrupt their identities and preconceived ideas about nationality and belonging, while Jay Rounds contends that an individual's capacity for change is mediated by the degree to which he or she is prepared to engage with alternative viewpoints in the first place.[30] While art contains great potential to foster visitor engagement, we have to remember that it also has limitations. In the context of historical interpretation, we need to keep in mind what art *doesn't* do as well as what it *does*.

ART AND EMOTION

Some audience responses to *Migration Stories*, supported by the theoretical perspectives of Rounds, Lloyd, and Mason, suggest that visitors might come to museums to reaffirm what they already know and believe. This calls into question the potential of art to challenge the entrenched historical narratives that inform both museum collections and wider societal attitudes. However, we also need to consider what kinds of environments we are creating in order for these challenges to take place. Describing visitor responses through languages of avoidance, performance, or disengagement places a lot of onus on the viewer. I wonder, however, whether we create spaces that encourage visitors to respond in these ways. Museums are often conceptualized as cultural "contact" zones; in other words, spaces of encounter, exchange, and connection.[31] However, as Bernadette Lynch, former deputy director at the Manchester Museum contends, the ways in which museums address current issues and foster interactions of "contact" can be conservative. There is a disjuncture between the role that museums might play in society and internal practices in terms of how institutions deal with cultural conflict. Museums serve as "crucibles of conceptual, ethical, and aesthetic confrontation," but museum boards, curators, and patrons avoid what Lynch calls "clash" or "agonistic energy," instead encouraging consensus and perhaps shaping or even limiting the ways in which individuals might respond to challenge. Lynch therefore calls for us to "envision the museum as a vibrant public sphere of contestations where different views can be usefully confronted," and where we encourage "dicensus."[32]

In seeking dialog, debate, and changes in social attitudes, we might also be looking for impact in the wrong places and failing to recognize more subtle responses to art. *Migration Stories* did not seem to provide major challenges or change minds, at least at the museum door. However, it did allow visitors to connect with exhibition themes on an emotional level. Audience responses to *Migration Stories* emphasized the emotive power of art as a tool for interpretation and audience engagement. Allowing visitors to have an empathetic or emotional experience can help to foster the sense of connection, and making connections is one of the cornerstones of interpretation. Though emotional responses to public history have been traditionally interpreted in terms of nostalgia, the field of heritage studies is beginning to recognize how central emotions are to the visitor experience, and that these emotions are incredibly varied and complex. For example, Laurajane Smith describes heritage as an embodied cultural performance of meaning making, which has important consequences for social recognition, and relies on claims to "emotional authenticity."[33] As interest in the "affective museum" becomes increasingly popular, art has the potential to play a central role.

Visitors expressed a range of different emotional responses to *Portrait of the Nation*. One was nostalgia. This seemed to occur especially in images of places that visitors knew. One participant, for example, upon seeing the place where she lived exclaimed: "That's where I was brought up." Others expressed feeling surprised. One visitor described *Migration Stories* as "not the kind of stories I would expect . . . I find it interesting." Others experienced feelings of pride. Another commented, "It made me feel that Scotland was welcoming. People are proud of their history but seem to be proud to be Scottish as well. You get that positive image in the photographs." Others felt a sense of belonging. One English visitor explained, "Sometimes I feel very foreign here. Scotland can be very homogenous, but the gallery disperses that." For others, paintings could evoke discomfort. Upon seeing the images of pipe bands, one visitor responded, "I didn't feel comfortable with that. It was not a positive image, but it's good for people to know about that aspect." Emotionally engaged visitors tend to define a site or exhibition as part of their personal or cultural heritage, or as related to their own experience.[34]

Though emotional responses can vary, and often depend upon each individual's personal experience in relating to a place, person, or theme depicted, one of the most common and compelling emotional responses was empathy. Portraits, by their very nature, allowed visitors to make connections in emotional and empathetic ways. As defined by Alison Landsberg, empathy is a feeling "connected to but different from some other person or historical situation . . . empathy requires the person to imagine the other's situation and what it *might* feel like while simultaneously recognizing her difference from the other."[35] Visitors seemed to connect especially to themes of family and person. One commented of *Migration Stories*, "I was impressed that the sitters chose to show their family life." Another "liked that they were with families. It's not just a single man or woman, compared with the dusty old portraits of men." Another told me that she "liked the portraits where the kids had blurry faces. They looked relaxed, happy and proud." Another described the exhibition as "nice, and very personal."

Throughout the gallery, visitors expressed the powerful experience of coming "face to face" with historical characters. One young woman described seeing a portrait of Robert Burns: "It was kind of indescribable. Especially from that far in the past because there are no photographs. Knowing the history, you have all these other images that come to mind and so to be able to be face-to-face with the man, it was really amazing, it was incredible." Another commented, "It's interesting to see what the artist gets out of the person." Even for visitors who knew a lot about the characters they saw depicted, portraits seemed to allow them to know these figures in a new way. As one visitor commented, "Through a museum like this I feel like I'm getting

a more intimate side." Previous studies have underlined the importance of personal stories and spotlights on people in exhibitions—a central feature of portraiture. Focusing on people allows visitors to make "humanistic connections"—to empathize with the subjects on display and to make personal and emotional connections with what they are seeing.[36]

Empathy can facilitate viewers' ability to build connections to historical contexts that lie beyond their own experiences. As Zuckerman has suggested, the power of history is that it addresses "what is beyond immediate experience." It "offers us a prospect of enlarging our experience and opening out upon wonder."[37] In other words, history allows us to consider other possibilities, and to have the experience of understanding and empathizing with actors different than ourselves. According to theorists, empathy is key to triggering audience responses that engage the imagination. Emotions can be used to destabilize received narratives and understandings, leading to greater engagement with hidden or marginalized histories. In other words, deep empathy can allow visitors to question what they know and understand, though this might happen on a level more subtle than intellectual engagement with notions of nationality or citizenship.[38] As Landsberg suggests, having an empathetic relationship to the past can be a constructive mode of engagement because it "creates a sense of emotional investment, and it will stay with the viewer, affecting and perhaps even orienting his or her future ideas and beliefs."[39]

Emotions, whether they be surprise, empathy, or discomfort, seem to trigger curiosity and the willingness or desire to consider a topic further, even if, in the case of images of an inclusive Scottish identity, the emotional response only leads to ambivalent acceptance. As one visitor commented on *Migration Stories*, "I didn't like it. I suppose that now it is part of our culture . . . There always has been migration in Scotland, but it takes time to digest it." For others, however, emotion can lead to learning. Emotions seem most "useful" in this way when they are coupled with knowledge, and art has particular potential to tap into this kind of emotional work. As Jill Bennett suggests, art "by virtue of its specific affective capacities, is able to exploit forms of embodied perception," creating what she calls "critical awareness."[40] As one visitor told me, "I was surprised at the number of diverse Scottish Asian families. . . . It was neat to see the different generations."

Emotional engagement, of course, provides challenges. One of these is that emotional responses are not always positive in the sense of encouraging active engagement, or encouraging visitors to think in new and deeper ways. One of the common emotional engagements with the past comes in the form of nostalgia. As numerous studies have noted, this emotional response can involve a reactionary backward glance to the past and can bolster notions of

triumphant nationalism. David Lowenthal has recently argued that empathy replaces rigorous understanding with a potentially more shallow emotional engagement. Emotional engagement, he argues, can occur to the "detriment of historical understanding. Empathetic concerns have their place. But they should not be allowed to overshadow the detached distancing that enables museums uniquely to serve, and to be widely seen, as reliable vehicles of public illumination."[41]

CONCLUSION

Representing the history and identity of a nation in a museum is a complicated task. However, it is a task aided by the use of art. Portraiture has particular potential. Coming face to face with historic characters allows visitors to connect with a past often distant from their own experience. In the case of the SNPG, using portraiture to its full advantage involved expanding the definition of this genre, allowing visitors to connect with place, theme, and topic rather than just person.

As we explore art's potential to represent new stories and to engage visitors, it is important that we consider both what art does and what it doesn't do. In terms of representing an inclusive national identity, looking at portraiture in the SNPG might not be changing people's minds about social inclusivity, at least not immediately after the visit. However, it seems to me that the Portrait Gallery is a space where imagination and a trying on of empathetic historical identities is occurring, where subtle emotional connections through character and place can happen, subtle understandings that there are multiple ways of inhabiting a place and emotive response to the characters of the past. This is what Pierre Bourdieu calls a "naïve" reaction—"horror at the horrible, desire for the desirable, pious reverence for the sacred."[42] Experiences of intimacy and empathy that seem to constitute part of the experience of looking at portraiture, when applied to images of migration, a politically charged and controversial topic, are arguably quite powerful.

NOTES

1. Peter Davis, *Ecomuseums: A Sense of Place* (Leicester: Leicester University Press, 1999), 24.

2. Timothy Luke, *Museum Politics: Power Plays at the Exhibition* (Minneapolis: University of Minnesota Press, 2002), xiii; Rhiannon Mason, *Museums, Nations, Identities: Wales and Its National Museums* (Cardiff: University of Wales Press, 2007), 267.

3. Benedict Anderson, *Imagined Communities: Reflections on the Origin and Spread of Nationalism* (London: Verso, 1991).

4. Museums Galleries Scotland, *National Strategy Consultation—Working towards a National Strategy for Scotland's Museums and Galleries: Your Chance to Shape Your Future* (Edinburgh: Museums Galleries Scotland, 2011), 6.

5. Karen Harvey, "Envisioning the Past: Art, Historiography and Public History," *Cultural and Social History* 12, no. 4 (2015): 528.

6. Helen Smailes, *A Portrait Gallery for Scotland: The Foundation, Architecture and Mural Decoration of the Scottish National Portrait Gallery 1882–1906* (Edinburgh: National Galleries of Scotland, 1985), 18, 19, 81.

7. National Portrait Gallery, http://www.npg.org.uk/about/history.php, accessed September 1, 2016.

8. National Portrait Gallery, http://npg.si.edu/about-us; http://npg.si.edu/visit; http://npg.si.edu/portraits, accessed September 1, 2016.

9. Rhiannon Mason, "National Museums, Globalisation and Postnationalism: Imagining a Cosmopolitan Museology," *Advances in Research: Museum Worlds* 1, no. 1 (2013): 43.

10. National Galleries of Scotland, *Annual Review, 2011–12* (Edinburgh: National Galleries of Scotland, 2012), 5.

11. "Scottish National Portrait Gallery Ready to Reopen," *The Scotsman*, Supplement, November 29, 2011, 2–3.

12. John Tosh, "Citizen Scholars," *History Today* 62, no. 7 (2012): 44.

13. For the contemporary appeal of the warrior Scot, see David Hesse, *Warrior Dreams: Playing Scotsmen in Mainland Europe* (Manchester: Manchester University Press, 2014).

14. "Scottish National Portrait Gallery, Ready to Reopen," 6.

15. "Scottish National Portrait Gallery, Ready to Reopen," 7.

16. Tom Devine, *To the Ends of the Earth: Scotland's Global Diaspora, 1750–2010* (London: Penguin, 2011).

17. See for example Arthur Herman, *How Scots Invented the Modern World* (New York: Crown, 2001).

18. Tom Devine, "Did Slavery make Scotia Great?" *Britain and the World* 4, no. 1 (2011): 40–64.

19. National Galleries of Scotland, https://www.nationalgalleries.org/whatson/exhibitions/migration-stories-pakistan, accessed September 1, 2016.

20. Author interview with the artist, June 19, 2012, Edinburgh.

21. For images of the photographs, see https://www.nationalgalleries.org/object/PGP 779.1; https://www.nationalgalleries.org/object/PGP 779.4.

22. Author interview with the artist, June 19, 2012, Edinburgh.

23. Katherine Lloyd, "Beyond the Rhetoric of an 'Inclusive National Identity': Understanding the Potential Impact of Scottish Museums on Public Attitudes to Issues of Identity, Citizenship and Belonging in an Age of Migrations," *Cultural Trends* 23, no. 3 (2014): 148–58; Mason, "National Museums"; Jay Rounds, "Doing Identity Work in Museums," *Curator* 49, no. 2 (2006): 133–50.

24. Lloyd, "Identity, Citizenship and Belonging," 148.

25. Laurajane Smith, "'Man's Inhumanity to Man' and Other Platitudes of Avoidance and Misrecognition: An Analysis of Visitor Responses to Exhibitions Marking the 1807 Bicentenary," *Museum and Society* 8, no. 3 (2010): 209.

26. Laurajane Smith, "Affect and Registers of Engagement: Navigating Emotional Responses to Dissonant Heritages," in *Representing Enslavement and Abolition in Museums: Ambiguous Engagements*, eds. Laurajane Smith et al. (London: Routledge, 2012), 260.

27. Yaniv Poria et al., "Visitors' Preferences for Interpretation at Heritage Sites," *Journal of Travel Research* 48, no. 1 (2009): 92–105.

28. Tom Freeman, "Art Review: Missing and Migration Stories," *Buzz Magazine*, February 25, 2012, http://www.buzzmag.org/2012/02/art-review-missing-and-migration-stories/, accessed September 1, 2016.

29. Rhiannon Mason, "Cultural Theory and Museum Studies," in *A Companion to Museum Studies*, ed. Sharon MacDonald (Malden, MA: Blackwell, 2010), 25.

30. Lloyd, "Beyond the Rhetoric"; Mason, "National Museums"; Rounds, "Doing Identity Work."

31. James Clifford, "Museums as Contact Zones," in *Routes: Travel and Translation in the Late Twentieth Century*, ed. J. Clifford (Cambridge, MA and London: Harvard University Press, 1997), 188–219.

32. Bernadette Lynch, "Challenging Ourselves: Uncomfortable Histories and Current Museum Practices," in *Challenging History in the Museum: International Perspectives*, eds. Jenny Kidd et al. (Oxford: Routledge, 2014), 92, 97–98.

33. Laurajane Smith, *Uses of Heritage* (Oxford: Routledge, 2006).

34. Yaniv Poria et al., "The Core of Heritage Tourism," *Annals of Tourism Research* 30, no. 1 (2003): 238–54.

35. Alison Landsberg, *Engaging the Past: Mass Culture and the Production of Historical Knowledge* (New York: Columbia University Press, 2015), 65.

36. R. Sandell, *Museums, Prejudice and the Reframing of Difference* (Oxford: Routledge, 2007), 114; Harriet Purkis, "Making Contact in an Exhibition Zone: Displaying Contemporary Cultural Diversity in Donegal, Ireland, Through an Installation of Visual and Material Portraits" *Museum and Society* 11, no. 1 (2013): 50–67.

37. Michael Zuckerman, "The Presence of the Present, the End of History," *The Public Historian* 22, no. 1 (2000): 19–22.

38. Andrea Witcomb, "Understanding the Role of Affect in Producing a Critical Pedagogy for History Museums," *Museum Management and Curatorship* 28, no. 3 (2013): 255–71.

39. Landsberg, *Engaging the Past*, 66.

40. Jill Bennett, *Empathetic Vision: Affect, Trauma, and Contemporary Art* (Redwood City, CA: Stanford University Press, 2005), 10.

41. David Lowenthal, "Patrons, Populists, Apologists: Crises in Museum Stewardship," in *Valuing Historic Environments*, eds. L. Gibson and J. Pendleburry (Farnham: Ashgate, 2009), 19–31. Quote at pp. 29–30.

42. Pierre Bourdieu, *Distinction: A Social Critique of the Judgment of Taste* (Cambridge, MA: Harvard University Press, 1984), 54.

Chapter Six

Framing the Collaborative Process

Teresa Bramlette Reeves,
Julia Brock, and Kirstie Tepper

INTRODUCTION, BY KIRSTIE TEPPER

As this volume attests, public historians and artists are forging substantive work in a variety of venues. Each chapter focuses on the production that comes from such collaboration, and this chapter, in some ways, is no different in its presentation of case studies. But as the members of a curatorial collective that has worked together for more than two years, the authors of this chapter hope to offer a meditation on the process of collaboration, infused with a commitment to the audience. Selvage is a curatorial collective that reveals and visualizes alternative narratives and histories. With a strong commitment to service, we work with our partners (individuals, community groups, institutions) to identify a particular need and research focus that allows for discovery on both sides of the partnership. We approach an examination of the past through multiple lenses, incorporating our backgrounds as curators, artists, museum professionals, and public historians. In examining the past we ultimately aim to rewrite future understanding of a time and place and embrace nostalgia as a form of knowledge rather than as sentimental longing.

We often work in the borderland of fact, hearsay, and fiction, wherein one finds multiple voices and stories to share. Our backgrounds include training in fine arts, curatorial studies, and public history, and we draw upon a variety of methodologies and theories in support of our practice. At the center of our mutual work is a concern for audience engagement—we are interested in how our multidisciplinary backgrounds can produce work that has broad appeal.

We draw upon theory to aid us in our work with audiences, and two conceptual frameworks outlined in this chapter are presented in conjunction with case studies of our work. The projects are situated within narrative theory (narratology) and relational art or relational aesthetics. We focus on these two

theoretical priorities as a response to the prevalence of narrative media in our lives (through television, film, and fiction), the audience-driven desire for experiential learning and spectacle, and the ever increasing "curated" selections that are made for us across many aspects of our digital lives (through preferences recorded from our activity on web browsers and social media, for example).

Selvage was formalized in 2014 after several years of close collaboration between our three members. Teresa Bramlette Reeves, Julia Brock, and I (Kirstie Tepper)[1] found that we held shared interests. We wanted to explore interdisciplinary approaches to scholarship that entered into the physical world through aesthetically considered presentations—hence our interest in exhibitions. We are also committed to projects that served some kind of social purpose (unveiling hidden histories and perhaps providing a corrective to the historical record, for example) and would be approachable to neophytes and experts alike. We came together as the curatorial team for *Hearsay*, an exhibition that was on view at the Zuckerman Museum of Art from July 26 to October 25, 2014. Since then, we continue work that explores the boundaries of art and history: a digitally based project dedicated to uncovering the role of women artists in the creation of the heady 1970s Atlanta art scene (*Forget Me Not*); an exhibition that connected the lives and work of current seminal artists to the broader political and economic structures of the art world that produced them (*Narratology*); and an ongoing collaboration with the Carson McCullers Center in Columbus, Georgia, that explores the liminal role of the alley in southern cities and in McCullers's fiction.[2]

Figure 6.1. Installation view, *Forget Me Not*. Zuckerman Museum of Art, August 22–December 6, 2015. Photograph by Mike Jensen. Courtesy of the Zuckerman Museum of Art.

Figure 6.2. Installation view, *Forget Me Not*. Zuckerman Museum of Art, August 22–December 6, 2015. Photograph by Mike Jensen. Courtesy of the Zuckerman Museum of Art.

We describe our work as reflexive when it comes to collaboration, whether it be with other artists, audience members, or communities. We actively incorporate other voices into our work. For example, in our project *Hearsay*, we knew we wanted to tell forgotten, ignored, or hidden southern narratives. We talked with artists and community groups about our ideas and, if they were willing, invited them to create an installation. We ended with a show that told disparate stories: of black Muslims in Atlanta; of refugee experiences in Clarkston, Georgia; of queer migration from the South; and of the Cherokee syllabary. After the exhibition was over, we met with partners again to ask them how the process might have been different, how we could have been more effective in our collaboration, and what they ultimately gained from the experience. This approach—one that invites feedback and input—is fundamental to our work as a collective.

As museum and academic professionals, our interests lie in the potential for research, scholarship, and narrative to lead to visualizations based in a site or place. We have a formal relationship to collections: we organize; assign intellectual, historic, and artistic value to; care for and conserve; interpret; and display objects as part of our work. As artists, we are makers of objects and use materials of all kinds to visualize ideas, help answer questions, and satisfy our innate love of the tactile. Within our practice we allow space for understanding objects in an intensely personal way—as relics, even, that we imbue with meaning and that we keep and display (or don't) in order to tell personal

narratives. We also consider the influence of nostalgia on our research by welcoming content associated with this kind of response to memories and histories of place. We recognize the nostalgic object's or relic's ability to transcend or alter historical factuality and garner importance for its symbolic function. Collectively, we benefit from the depth of our training and heightened sensitivity to material culture and ephemera. Our work relies on site, narrative, and objects, and therefore directly responds to ideas of place. In our projects we acknowledge our status as outsiders, and employ the philosophy of shared authority. Recognizing a range of physical, psychological, and emotional associations to objects and their environments, we also privilege the resonance of the absent object or the empty space; the provocative oddity; the clue; the inappropriate; the utilitarian, and the outlier. All serve as vehicles for imagination and repositories of history.

RELATIONAL ART, BY TERESA BRAMLETTE REEVES

In our curatorial work, Selvage privileges ideas of social engagement, user friendliness, and visceral or physical immersion in the space and/or the experience. Located within this approach is a desire to reach multiple audiences—from those with specialized knowledge to newcomers—and to create a type of collaborative environment that isn't reliant on participant authorship. This democratic methodology is informed by Nicolas Bourriaud's idea of relational aesthetics. In 1995, the French art critic and curator Bourriaud organized the exhibition *Traffic* for the CAPC Museum of Contemporary Art in Bourdeaux. The focus of this group show was to highlight a trend that Bourriaud identified in the practice of a group of young artists—a movement he dubbed "relational art." By "relational" he meant artwork that is interactive, social, and experiential. In this form, the artist serves as a catalyst for creating an environment in which people come together to participate in a shared activity. Rather than the traditional experience of a singular encounter between a viewer and a still object, relational work creates an arena of exchange.[3] Bourriaud later formalized his thoughts about this contemporary artistic methodology in the book *Esthetique relationnelle (Relational Aesthetics)*, published in French in 1998 and translated into English in 2002.

In order to more fully understand Bourriaud's idea of an "arena of exchange," it is perhaps most useful to look at artistic examples before moving onto analogues in history museums and other audience-focused installations. Among the artists who appeared in *Traffic* and continue to be championed by Bourriaud are Carsten Höller, Rikrit Tiravanija, and Vanessa Beecroft. Born in 1961, Carsten Höller is a Belgian artist who now lives and works in Stock-

holm and Ghana. Höller earned a PhD in agricultural science and worked as a research entomologist until 1994. His installations or environments are often conceived of as experiments and range from the hallucinogenic (*Upside Down Mushroom Room*, *SOMA*, *Light Wall*), to social establishment (*The Double Club*), to funhouse (*Mirror Carousel*, *Test Site*). *Test Site* was built in the Turbine Hall at the Tate Modern in London in 2006.[4] Essentially, it was a series of tubular slides that crisscrossed the vast reaches of the multistoried space. In an interview, the artist explained that the work was based on two questions: What if sliding was part of the daily routine? (and) Can slides become part of our experiential and architectural life? He goes on to explain:

> From an architectural and practical perspective, the slides are one of the build-ing's means of transporting people, equivalent to the escalators, elevators or stairs. Slides deliver people quickly, safely and elegantly to their destinations, they're inexpensive to construct and energy-efficient. They're also a device for experiencing an emotional state that is a unique condition somewhere between delight and madness. The slide is an object that we associate with playgrounds, amusement parks and emergency exits. . . . The performers become specta-tors (of their own inner spectacle) while going down the slides, and are being watched at the same time by those outside the slides. All these works . . . are exploratory sculptures. They offer the possibility of unique inner experiences that can be used for the exploration of the self.[5]

Like Höller, Rirkrit Tiravanija is multinational and was born in 1961. He currently divides his time between New York City, Berlin, Bangkok, and Chiang Mai, Thailand. He initially studied history but later went on to focus on art at the Ontario College of Art, the Banff Center School of Fine Arts, the Art Institute of Chicago, and the Whitney Independent Studies Program. His work is often centered around making and serving food, and in so doing, bringing groups of strangers together for a shared meal. Early versions of this participatory practice were staged at galleries in New York City, where he cooked and served pad Thai. The communal aspect of these meals underlies the artist's desire to create both a lived experience and an opportunity for un-expected exchange as strangers gather around a table to share food. Tiravanija continues his work on an international stage, fostering increasingly political and ecological projects, such as The Land Foundation. This initiative is cen-tered on a small parcel of land in rural Thailand in which invited guests utilize the area as a laboratory for developing rice cultivars, sustainable housing, and other models for an improved future.

Vanessa Beecroft, who now lives and works in Los Angeles, was born in Italy in 1969 and studied architecture, painting, and stage design. Much of her best-known work involves arrangements of live female models, which

serve as visual fodder for the audience. Each performance is site-specific and typically references some aspect of the location's social and/or political history. The scantily clad women (usually fashion models of a particular height and weight) are often dressed in a similar fashion and wear matching wigs that serve to erode their individuality. The women's stillness, silence, and unapproachability create an intentional sense of discomfort in the audience, suggesting ideas of voyeurism and shifting the power between viewer and the object/model. The spectator's uneasiness is central in experiencing Beecroft's work, begging as it does questions of identity, normative beauty, and authority.[6]

In each of the three artists discussed, Beecroft, Tiravanaji, and Höller, one can easily see how they engage an audience in an active way—through confrontation, hospitality, and play. Their work provokes a physical response as a result of the lived experience. Also critical within this approach is the move from a singular to a shared event or spectacle. Bourriaud suggests that the contemporary desire for a collective experience stems, in part, from the emergence of technologies that encourage a democratized interactivity. Rather than working within the strict confines of the art world, the emphasis in relational art shifts to a broader cultural context toward a group of viewers who do not need to be specialists or versed in art in order to understand and enjoy it. Terms such as *user friendly* are often applied to this kind of art experience, a descriptor also commonly found in the tech arena. Borrowing from the contemporary mandate to make the interface with personal devices and other technologies easy for all to learn and use, relational aesthetics emphasizes this friendly approach. In addition to the utilitarian function there is an explicit desire to emphasize egalitarianism. Millennials and younger audiences expect instant access to information, a predisposition that informs their relationship to all forms of entertainment, including the art or history exhibition (which is why many museums have moved—or are being advised to move—toward inclusion of digital technologies).[7] If we accept received wisdom that audiences now expect to be engaged in a more direct way, it is incumbent upon those of us who shape these encounters to think in those terms ourselves and provide a platform that encourages multiple avenues of entry and experience.

It is important to note that Bourriaud sees the relational approach as differing from participatory art. Participatory art directly engages the audience in the creative process, allowing visitors to complete the work by becoming coauthors and editors, as well as observers. This term is most often used in the context of happenings, performance-based presentations common in avant-garde circles in the 1950s and 1960s.[8] An example of this kind of work can be seen in Yoko Ono's *Cut Piece* (1964), in which the conceptual artist

invited members of the audience to cut off her garments. One by one, using a pair of scissors placed on the floor beside the seated Ono, participants came forward. It was an exercise in vulnerability, as she did nothing to stop their progress in baring her body. Even now, the video documentation of this performance is extremely uncomfortable to watch.

The differentiation that Bourriaud asserts may simply be part of a larger debate on nomenclature—on assigning the appropriate label or terminology to interactive art. I would argue that the designation of relational art is best understood as a continuation of the twentieth-century impulse to define a public and more performative practice of artistic engagement. It speaks to a particular time period (the 1990s and early 2000s) and place (western Europe), and thus is reflective of both.

Visitors to history museums and exhibitions may be familiar with strategies that seek to convey a particular narrative by offering a physical experience of some kind. Designed to evoke an empathetic response to a person or situation in the past, these vehicles for engagement come in various forms. For example, a recent and impressive exhibition at the High Museum of Art in Atlanta, *Iris van Herpen: Transforming Fashion* (November 7, 2015–May 15, 2016), featured the innovative work of a fashion designer who blends craftsmanship with technology. Herpen routinely collaborates with other artists or scientists to create new materials for her designs; for instance, an iron-filled polyurethane resin that can be manipulated by magnets. Within the exhibition, samples of some of her most inventive creations were made available for viewers to touch, thus providing a much richer understanding of the work. Similarly, in *Bodies: The Exhibition*, a touch booth allows access to the materials used in preserving the human bodies on display. Dioramas, actors in historical settings (such as Williamsburg), opportunities to perform simple experiments, interactive maps, and opportunities for feedback are all forms of audience engagement that emphasize the senses. Opportunities to touch an object, or experience confinement or scale in relationship to your own body exemplify the transfer of visceral knowledge. The chance to "feel" or get a sense of an earlier circumstance or individual creates a connection between the present and the past that is important in terms of education but also in the way it can prompt genuine curiosity and compassion.

Typically, these strategies of engagement in history and science museums are geared toward an individual experience. The social aspect of Bourriaud's proposal is less common. So how then does one create an "arena of exchange"? How can Bourriaud's ideas of relational aesthetics best be applied or utilized within the context and focus of this book?

In partial answer, I would like to describe a recent experience at the Museum of Modern Art in New York City when my colleague and I visited the

Björk retrospective (*Björk*) in spring 2015. The Icelandic composer, musician, and singer was represented by her instruments, costumes, music videos, and the commissioned sound and video installation, *Black Lake*. Her selection for this prestigious venue was an extension of the museum's curatorial efforts to collapse the boundaries between high and low art (elitism and popular culture) as well as extend the notion of artistic media as being relatively boundless. Described in a review in *The Guardian* as being "one part Rock and Roll Hall of Fame exercise, one part science lab, one part synesthesia experiment, one part Madame Tussaud's parody,"[9] the show was extraordinarily successful in terms of attendance. It was, in fact, the large crowd we experienced that lent the occasion its true punch and power. In two separate viewing rooms, one designed for *Black Lake* and the other for a rotating schedule of music videos, we were seated on cushioned floors and surrounded, shoulder to shoulder, by other people. The effect was of being at a small concert hall or club. It was dark, the music was throbbing from multiple speakers, and our bodies were packed together for maximum density. Presumably intentional, this aura of club-ness heightened the elation of the shared experience. The formula here appears to be pop culture + crowd = fun and excitement. Does the entertainment quotient add to the meaning of the work itself? I suppose that is debatable, but it does increase the sense of personal involvement—the "we were there" immersive memory.

In work produced by Selvage, we are planning to utilize a similar strategy of immersion in regard to a project at the Carson McCullers Center for Writers and Musicians during the centennial celebration of her birthday in 2017. The Center is located in Columbus, Georgia, in the Smith family's former home (Smith was McCullers's maiden name). While in residence at the Center in 2015, we became acquainted with the immediate neighborhood, Wildwood Circle, now a designated historic district. Early plans for this Columbus suburb reveal an organic grid of blocks. Within the layout, alleys bisected two blocks. One of these ran north/south through the block in which the McCullers home is located between Stark and Wildwood avenues. The other nearby alley disappears from city maps fairly early, but the alley in the McCullers block remains on maps through at least 1956, though former residents we've talked to don't remember its existence. We see the mystery of the Stark/Wildwood Alley as a perfect metaphor for public and private life (front door/back door—visible/hidden) as well as a signifier of race and class in its use as a service entrance. These themes are also readily present in McCullers's work. Her preoccupation with boundaries, the attention she gave to race and class, and her own love of place and space (and her characters' mobile propensities) all inform our interest in the alley.

John F. Flournoy platted the Wildwood Circle development in 1911. At the time residential alleys were understood as signifiers of wealth—necessary pathways for servants and deliveries. Carriage houses that would have once occupied a back-alley site were all but gone due to the advent of automobiles.

The McCullers home, one of the earliest residences built on the block, had a driveway off Stark Avenue. The area also had plumbing, thus eliminating the need for an outhouse (which, historically, would have also been located at the back edge of the property). Thus the alley served an entirely different purpose by 1926 when the Smiths, the original occupants of the home, moved in. For this project, we want to pinpoint when the alley disappears off city maps and locate information regarding use patterns over the years. We have already begun this work by conducting informal interviews, gathering archival data, and consulting period deeds and maps. We are hopeful that this historical data and the collected narratives will provide a fresh perspective on McCullers and point to a larger pattern of migration and integration in Columbus in the first half of the twentieth century.

In addition to this research, we are erecting a textile-based fence that marks the McCullers's side of the Stark Alley. We will produce interpretive labels and signage to detail the project and the revealed histories of the alley, and install these text- and image-based elements in a small room on the back of the existing carport, thus creating a mini-museum space adjacent to the textile fence. Visitors will be able to investigate the vestiges of the Stark/Wildwood alley firsthand and to contribute stories about their own knowledge of this or similar alleys they have experienced. In this modest way, we hope to encourage an ownership of this place and a greater understanding of the histories that resonate from a once common feature of the urban landscape.

Is our small intervention in Columbus as entertaining as Höller's slides in the Tate Modern or the arrangements of scantily dressed models that Beecroft puts on display? No is the quick answer—this project does not rise to the level of a spectacle, which is okay. But it is also acceptable to harness the power of sensationalism on occasion. Art21, the nonprofit organization that created the PBS broadcast television series on contemporary art and ideas, also maintains a blog, the *Art21 Magazine*. In a post about interactive and participatory art, writer Meg Floryan writes:

> The explicit parallels between participatory art and entertainment also do nothing to detract from quality . . . After all, "popular" doesn't necessarily translate to "uninspiring" or "trivial" . . . Art is no longer [just] a spectator sport.[10]

I bring this point of view to light in order to quell the sometimes negative associations connected to the idea of popular entertainment. Museums, in particular, are often accused of "selling out" or "dumbing down" the content when they host a show with widespread appeal. This was apparent in the hubbub around the Guggenheim Museum's 1998 exhibition *The Art of the Motorcycle* or their later, even more contentious presentation *Norman Rockwell: Pictures for the American People* (2002). One critical review of this later show was titled "Norman Rockwell at the Guggenheim, for the Shallow and Jug-Stupid."[11] Despite theoretical arguments to the contrary, many academics and art world

denizens still look askance if something is too popular or entertaining. We tread a fine line between wanting to attract and educate a wider audience and secretly addressing a narrower like-minded constituency. This truth is but one of the reasons that the perception that contemporary art is an insider's game remains intact.

For this writer, it is especially important to continue to break down these walls. Thus the strategies inherent in participatory and experiential approaches are particularly useful in addressing questions of access and the communication of a complex idea or history. Popular culture becomes the bridge or hook, the way into the material on display. Creating a community or social event in concert with an exhibition project encourages dialogue and a sense of involvement or ownership. Considering entertainment as critical to your goals rather than a happy coincidence becomes standard practice in this mode of working. It is incumbent upon curators to be inclusive, building partnerships that allow for diverse stakeholders to help shape the story. It is equally important to help viewers relate—to feel, to learn, to partake.

NARRATOLOGY, BY JULIA BROCK

Selvage Collective is informed by relational art practice as well as a blended approach to the use of narrative in exhibition. The satisfaction of our collaborative work comes from combining training and sensibilities about how narrative and storytelling inform interpretive practice. With training in history and historiography, for example, my approach to exhibit structure leans toward the linear. The others in the group, perhaps due to the primarily visual language of studio arts, do not feel as compelled to situate narrative in a timeline or bookend a story with a clear start and finish. Our work is shaped by bringing these approaches into conversation and takes inspiration from theories of narrative. This section offers a brief meditation on discipline-bounded narrative production; a look at the conclusions of museum practitioners who draw upon narrative theory; and examination of one Selvage Collective project, *Hearsay*, that attempted to put theory into practice.

Narratives are "stories that both explain and construct the ways in which the world is experienced."[12] The study of narrative theory, sometimes referred to as narratology, has less to do with a specific narrative or story than "how narrative operates."[13] Narratology is rooted in the idea that all narratives consist of internal structures that give narrative its meaning as a form. Narrative, for example, is driven by story and plot. The story, or what occurs in any given narrative, is emplotted in a specific sequence of events. That sequence

does not have to match the temporal unfolding of the story; in other words, the plot does not have to begin at the beginning and end at the end.[14] Authors employ narrative techniques of prolepsis and analepsis, for instance, which flash forward and backward in time, respectively, and that interrupt an otherwise linear story.[15]

Narrative theorists generally work with literary texts. By the 1970s and 1980s, as the idea of a "text" was construed more broadly, scholars began to consider how narrative differed depending on the medium (film, for example). They also moved narratology into conversation with other theoretical developments—with poststructuralism, for instance, and with feminism or postcolonialism.[16] Scholars here challenged the "classical" understanding of narrative reception, wherein an author transmitted a story to a passive reader.[17] Many gave renewed emphasis to the theories of Mikhail Bakhtin, who argued that the discourse contained in a novel creates a dialogue between characters in the text but also between author and reader, and that the novel itself is situated within a broader social context that shapes its meaning.[18]

Historians do not often deeply engage with theories of narrative; many take for granted that use of narrative to make arguments about the past is a specific methodological choice. As the philosopher of history David Carr notes, narrative explication is but one option among other forms of explanation: the "problem-oriented" explanations, for example, of the *Annales* school historians who relied on quantifiable models to explain past human behavior.[19] At this point, however, the idea that historical analysis is a scientific exercise is largely outmoded, and most historical works are narrative in form. That is, generally speaking, they offer an explanation of human action that is placed in a temporal and spatial context, and they relate individual and group actions to broader historical conclusions about an event or period in history.

Public historians who work in history museums are often trained in historical methodology and exposed to narrative as employed by historians. Thus, history-based exhibitions often (not always!) follow a linear narrative. As Nina Simon notes, since the 1990s and 2000s especially, history exhibits tend to put visitors on a "forced march" through content, aligning a structured pathway with, for example, a chronological narrative.[20] Museum educators have suggested that this kind of guided experience suits visitor needs for organized and unidirectional passage. Visitors seem less likely to retrace steps through an exhibit space in order to return to missed content.[21] But Simon wonders why, with the narrative revolution promised by hypertext, that museum professionals have not adopted wholesale explorations in nonlinearity from the web.[22] Is it simply that most of us think in a linear way, or need a hierarchical structure to process story?

For their part, art exhibitions in the modern and contemporary eras have generally eschewed a narrative structure and instead explored concept, abstraction, and form. In a recent exhibit, *Storybook: Narrative in Contemporary Art*, curators at the Madison Museum of Contemporary Art reclaim storytelling in some twentieth- and twenty-first-century art, acknowledging that artists tended to embrace narrative in the 1980s when artistic practice became more centrally concerned with critiques of identity, culture, and politics.[23] In addition, the Guggenheim's recent installation, *Storylines*, refocused attention on the storytelling by artists of the 1990s and 2000s. The show's curators argue that a recent "narrative turn" has taken hold in contemporary art, one that shifts curatorial strategy to consider story.[24] Not only have the social sciences and humanities taken a "narrative turn," but so too has the art and museum world.

Narrative theory has supported this turn, with some museum practitioners explicitly drawing from the rich literature base to inform their work. In a thesis devoted to applying narrative theory to museum exhibition practice, Stephanie Lambert contends that curators and exhibit designers continue to adopt a "classical" approach to narrative. That is, museum professionals create narratives that they then transmit to audiences via a curated layout of objects and interpretive text. Whether or not the narrative can be read in a linear or nonlinear way, the emphasis of this practice lies in the assumption that the exhibit will communicate a story that viewers receive.[25] Lambert is one of many museum practitioners to lament this staid approach to narrative. She is not alone; museum practitioners have for years urged that museums take a more creative and collaborative approach to narrative practice in the museum exhibit—one that is, as the title of Simon's work suggests, more participatory.[26] Public historians and those trained in contemporary curatorial practice will be familiar with this move to audience-centered work. Lambert and other museum professionals draw especially from more recent literature on narrative and meaning-making among readers (or, in the case of other types of media, audiences).[27]

What are the conclusions to be drawn from practice that critically engages narrative and its possibility for dialogue? Lambert, in a study that focuses on the Museum of New Zealand Te Papa Tongarewa, postulates that five "features" of narrative exhibition have emerged. All of these characteristics, which define narrative exhibition practice, are medium specific; that is, they emerge from the modes and materials we use to create interpretive exhibits:

> The first is that a narrative exhibition is a fixed configuration of exhibition components through which a visitor is free to plot a variable path; the second is that objects are a core component that museums use to support their story-telling in

exhibitions and stimulate narrative meaning-making among their audiences; the third that visitors participate with each other in socially-based meaning-making processes; the fourth that an interpretive framework support linkage between the narrative exhibition and the different communities interfacing with it; and the fifth is that narrative exhibitions afford meaning-making by different interpretive communities who engage with exhibition components and the narrative, in different ways.[28]

As with later works of narratology, Lambert asserts the need to examine narrative in its medium-specific context and, in this case, with an eye toward the broader ethical priorities of the museum field (which now certainly include audience engagement). Narrative production, in the context of exhibitions, includes the added three-dimensional layer of objects as well as the explicit inclusions of a variety of audiences, or "interpretive communities." Perhaps Lambert's framework provides a new model for assessing an exhibit's narrative success; she uses it in her work to explore the Museum of New Zealand Te Papa Tongarewa's exhibition practice.

Selvage Collective attempted to experiment with narrative exhibition form in its first show, *Hearsay*. We presented *Hearsay* with significant contributions from artists, archivists, historians, and community members, offering stories that illuminate the history of the US South. Inclusion of multiple partners allowed for a polyphonic exploration of the region's history; we prioritized these stories at the outset because they connected with themes of hearsay or secondhand information, undervalued or underrepresented histories, or marginalized voices. Projects included *Take Me with You*, a two-channel video installation by idea collective John Q, which explored the rural-to-urban migration of a young gay artist in the 1970s; *After Malcolm: Islam and the Black Freedom Struggle*, a presentation of African American Muslim experiences in Atlanta, organized by Abbas Barzegar (Georgia State University), Bilal King (Morehouse College), and Tom LaPorte (Chattahoochee Technical College); oral histories from the diverse community of Clarkston, Georgia, a refugee resettlement area; a photovoice project on Clarkston facilitated by Birthe Reimers, in which native and new Georgians told stories about their communities with photography; *Cherokee Phoenix: The Birth and Revival of Cherokee Printing in the Southeast*, a collaborative project by Adam Doskey and Frank Brannon on the revival of the Cherokee-language printing press; and solo projects by visual artists Nikita Gale, Robert Sherer, Carolyn Carr, and George Long, all of which explored collective and individual southern histories.[29]

These projects were installed in two separate galleries at the Zuckerman Museum of Art, Kennesaw State University, in a way that did not require a "forced march" through content. Organization of the solo projects was set

Figure 6.3. Installation view, *Hearsay*. Zuckerman Museum of Art, July 26–October 25, 2014. Photograph by Mike Jensen. Courtesy of the Zuckerman Museum of Art.

according to spatial needs of the contributors and not necessarily by any kind of temporal or thematic overlay imposed by us as curators. The end result was that audience members encountered disparate but self-contained histories as they moved through the exhibition. Finally, at the center of the larger gallery visitors could write their own (real or fictional) narratives and affix them to a wall, creating a cacophony of stories. We hoped visitors would rethink their own relationship to gossip, hearsay, and secondhand information, remembering that, as forms of knowledge, these retain primacy in our everyday lives.

Storytelling was central to *Hearsay*, and we were interested in engaging with a number of methods in order to add further depth, including components of narrative exhibition as conceptualized by Lambert. John Q, for example, employed different narrative techniques in order to convey the full meaning of their installation, which focused on the films created by Crawford Barton, a young gay man, en route from rural Georgia to San Francisco.[30] *Take Me with You* included a two-channel video projection—one channel screening Barton's films, the other footage captured by members of John Q as they made a reverse trek of a part of Barton's journey—that intersected at the inside corner of a room. In the opposite corner was a museum case that held a reproduction document. John Q describes the work as follows:

Well-known for photo-documenting queer life in San Francisco's Castro district through the 1970s and '80s, Barton is also a native of Resaca, a rural town in northwest Georgia. The [projected] films include a record of an early-70s road trip with a friend, presumably from rural Georgia to San Francisco, in an era of gay liberation. Driving from Atlanta to Barton's hometown, [John Q] reversed the first leg of Barton's migration and his film of it, in a sense passing each other on I-75. Footage from both cars (1970s and 2013) is intercut alongside other imagery from Barton's films.

A vitrine in the center of the installation displays a parallel re-enactment: John Q's redesign of an undated flier found in the Crawford Barton papers at the Gay, Lesbian, Bisexual, Transgender Historical Society. This quotidian and seemingly trivial object becomes an important evidentiary document, in part since it evokes the sexual ethos of a pre-AIDS gay male culture in San Francisco, but also because it is one of the few traces left of social networks that operated underneath the historical radar, a communication as fleeting and ephemeral, perhaps, as the ride itself.[31]

Barton's road trip scenes from the 1970s serves as backstory in some parts and flashback in others and is intermixed with other footage, presumably taken on the same journey. Much of the intercut footage is shot through a car window, adding a second framing device from the camera lens. The

Figure 6.4. Installation view, *Hearsay*. Zuckerman Museum of Art, July 26–October 25, 2014. Photograph by Mike Jensen. Courtesy of the Zuckerman Museum of Art.

reproduction document serves as a kind of foreshadowing for the AIDS epidemic of the 1980s and 1990s:

TAKE ME
WITH YOU

I'M LOOKING
FOR A RIDE
I CAN NOT AFFORD
GAS EXPENSES, HOW
EVER I'M YOUNG,
GOOD LOOKING AND
ALWAYS HORNY

CALL 863-7136

Lambert's components of a narrative exhibit form a central part of the installation. The objects, framed by John Q's interpretive text (offered above), guided the visitor's entry into narrative in a way that created space for provocation and meaning-making. The story provided by film and the archival clue was not a complete one, which required the visitors to imagine the world of Crawford Barton, his migration from rural South to urban West, and the desire or longing (for community, for love and sex, for escape) that propelled him.

We can draw a few conclusions from our exploration of dispensing with a nonlinear narrative overlay. We realized, for example, that visitors needed some kind of introductory text placed in both galleries that wove the projects into the larger theme of hearsay; otherwise, the solo installations might have seemed haphazard and without connection. Museum educators reported back that, because of the multitude of content from the solo projects, they had to spend much more time orienting tour groups from a variety of age ranges. The show was a lot to process, they told us. While the exhibition's nonlinear presentation was difficult in terms of navigating between projects, within each work or installation an accessible narrative layer provided an entry point for audiences. Artists and researchers employed narrative techniques that then provoked further investigation. We think the exhibition was successful in creating conversation among and meaning-making within visitors. Their imaginative and creative responses to the show were apparent in the narratives they posted on the wall.

CONCLUSION

Our experience with collaboration has thus far been satisfying and (we feel) successful, and we believe strongly that public historians and artists can inform

each other's perspectives in a way that enriches practice, particularly if focused on engaged art practice and narrative experimentation. As with most collaborative processes, there is the potential for added workload in terms of coordinating with more partners, though we have found that the gains far outweigh the costs. Conversations and visioning that is based in theoretical texts can provide the opportunity for collaborations across institutional boundaries and/or disciplines. We encourage inviting the unaffiliated into the project space either through partnership or as an audience. By uniting the communities we serve with institutions, researchers, and scholars, we believe that the outreach that is naturally part of the discipline of Public History can be furthered with the visual tools of artistic practice. For us, looking to theoretical frameworks informs this collaborative work, and, by doing so, allows us to reach beyond the boundaries of discipline in ways that seem more common, particularly in public history practice. We also feel that theoretically informed practice offers a ballast for working with and for public audiences. The result is work that is multivocal and that moves across disciplines. Here, we hope to have offered thoughts that might catalyze alternative explorations and experimental work elsewhere.

NOTES

1. Teresa Bramlette Reeves is a practicing studio artist, art historian, and curator based at Kennesaw State University near Atlanta, Georgia; Julia Brock is a public historian who specializes in the US South and is based at the University of West Georgia; and Kirstie Tepper is a practicing studio artist and curator based at Georgia State University.

2. For more about these projects please see our website, http://selvagecollective.org.

3. Nicolas Bourriaud, *Relational Aesthetics* (Dijon, France: Les Presses Du Reel Edition, 2002), 18.

4. To view images of this installation, see http://www.tate.org.uk/whats-on/tate-modern/exhibition/unilever-series-carsten-holler-test-site/carsten-holler-interview.

5. "Carsten Holler: Interview," Tate Modern, accessed September 18, 2016, http://www.tate.org.uk/whats-on/tate-modern/exhibition/unilever-series-carsten-holler-test-site/carsten-holler-interview.

6. To view images of Beecroft installations see https://www.youtube.com/watch?v=TkVFm0pvPmA.

7. See, for example, B. Wyman, S. Smith, D. Meyers, and M. Godfrey, "Digital Storytelling in Museums: Observations and Best Practices," *Curator: The Museum Journal* 54, no. 4 (October 2011): 461–68.

8. Tracy DiTolla, "Happenings," *The Art Story: Modern Art Insight*, accessed September 18, 2016, www.theartstory.org/movement-happenings.htm.

9. Jason Farago, "Björk Review: A Strangely Unambitious Hotchpotch," *The Guardian*, March 4, 2015, http://www.theguardian.com/music/2015/mar/04/bjork-moma-review-strangely-unambitious-hotchpotch.

10. Meg Floryan, "Interactive and Participatory Art," *Art21 Magazine*, June 3, 2010, http://blog.art21.org/2010/06/03/interactive-and-participatory-art/#.VtiS6MArJz8.

11. Christian Viveros-Faune, "Norman Rockwell at the Guggenheim, for the Shallow and Jug-Stupid," *New York Press*, June 16, 2002.

12. Paul Wake, "Narrative and Narratology," in *The Routledge Companion to Critical Theory*, eds. Simon Malpas and Paul Wake (London: Routledge, 2006), 14.

13. Ibid.

14. Mieke Bal, *Narratology: Introduction to the Theory of Narrative*, 2nd ed. (Toronto: University of Toronto Press, 1997), 5–6.

15. Wake, "Narrative and Narratology," 17. These are very cursory thoughts about narrative theory, and in no way stand in for the body of literature that exists on narrative deconstruction.

16. See, for example, Susan S. Lanser, "Towards a Feminist Narratology," *Style* 20, no. 3 (Fall 1986): 341–63; and Ngũgĩ wa Thiong'o, *Decolonising the Mind: The Politics of Language in African Literature* (Portsmouth, NH: Heinemann, 1986).

17. See Stanley Fish, *Is There a Text in This Class? The Authority of Interpretive Communities* (Cambridge: Harvard University Press, 1981).

18. For an brief overview of Bakhtin's thought and the "Bakhtin industry" that appeared after his works were translated anew in the 1980s, see Lynne Pearce, "Bakhtin and the Dialogic Principle," in *Literary Theory and Criticism: An Oxford Guide*, ed. Patricia Waugh (London: Oxford University Press, 2007), 223–32.

19. David Carr, *Experience and History: Phenomenological Perspectives on the Historical World* (London: Oxford University Press, 2014), 88.

20. Nina Simon, "Should Museum Exhibitions Be More Linear? Exploring the Power of the Fixed March in Digital and Physical Environments," *Museum 2.0*, January 9, 2013, http://museumtwo.blogspot.com/2013/01/should-museum-exhibitions-be-more.html.

21. Stephen Bitgood, "An Analysis of Visitor Circulation: Movement Patterns and the General Value Principle," *Curator* 49, no. 4 (October 2006), 463–75.

22. The classic work on the effect of the Internet on narrative is Janet H. Murray, *Hamlet on the Holodeck: The Future of Narrative in Cyberspace* (Cambridge: MIT Press, 1997).

23. See *Storybook: Narrative in Contemporary Art*, Madison Museum of Contemporary Art, http://www.mmoca.org/exhibitions-collection/exhibits/storybook-narrative-contemporary-art.

24. *Storylines: Contemporary Art at the Guggenheim*, Guggenheim Museum, http://www.guggenheim.org/new-york/exhibitions/past/exhibit/6252.

25. Stephanie Jane McKinnon Lambert, "Engaging Practices: Re-Thinking Narrative Exhibition Development in Light of Narrative Scholarship," MA thesis, Massey University, Palmerston North, New Zealand (2009), 7.

26. See Nina Simon, *The Participatory Museum*, Santa Cruz: Museum 2.0, 2010; and Simon's blog *Museum 2.0*, http://museumtwo.blogspot.com/.

27. See also David Francis, who draws upon the work of Mikhail Bakhtin in "'An Arena Where Meaning and Identity Are Debated and Contested on a Global Scale': Narrative Discourses in British Museum Exhibitions, 1972–2013," *Curator: The Museum Journal* 58, no. 1 (January 2015): 41–58.

28. Lambert, "Engaging Practices," 35.

29. To a view a catalog of the show visit http://selvagecollective.org/wp-content/uploads/2014/12/ZMA-Excerpts-catalogue-X.pdf.

30. John Q is "an idea collective interested in public scholarship, interventions, and memory" and consists of Joey Orr, Wesley Chenault, and Andy Ditzler. More information on the work of John Q can be found at http://www.johnq.org.

31. Ibid.

Part III

PUBLIC ART AND THE BUILT ENVIORNMENT

Chapter Seven

A Call for Proactive Public Historians

Nancy Dallett

This chapter is a call for public historians to proactively engage in new arenas. It's based on the premise that it's not enough to rely on where we have practiced in the past—it's important to explore processes that are currently going on in our communities without the participation of public historians. It's not enough for the field to be primarily focused on training good historians and giving them the skills to serve only in the usual places: in museums, historic preservation, archival repositories, and on digital platforms, traveling exhibits and programming, documentary film and other media productions. It's not enough to rely on being *invited* to participate in projects because we reliably provide historic context, are good collaborators, and are sensitive to communicating with diverse public audiences. It's on us to knock on doors and create new arenas. One relatively new direction is to insert public historians as digital storytellers, which is becoming a popular pathway for those public historians who want their projects primarily to live online.

For historians who want their collaborative projects to have a broad public reach that does not require people to enter a building or go online, this chapter suggests finding the ability to reach people informally as they walk, drive, relax in parks, and engage in the fabric of their communities. It traces one public historian's journey and gradual building of expertise in creating a relatively untapped arena for public historians in the ultimate public landscape: as partners in public art.

To begin to see how public historians can add value to public art, let's start with a definition. Simply stated, public art is art in a public place. Historically it took the form of freestanding sculptures and memorials. Over time it has evolved to be more subtly integrated into how a city builds its infrastructure and its identity. Municipal public art programs put public artists on design teams with architects, engineers, and others to create public spaces that use creativity,

stories, and visual enhancements on a large scale. Public art can be perceived and funded to raise the creative capital for a city, to make more vibrant places, and to express unique history and collective spirit neighborhood by neighborhood or for a whole city. Public art can be temporary or permanent but, "always it is about engaging the public in envisioning and creating an aesthetically enhanced environment that is filled with shared meaning. Public art, when it is done well, helps to engender pride in place, add meaning and a sense of history to the public realm, and bond people together around a common goal."[1] In doing so it can often be mired in controversy and contentious public discourse, depending on who is in a position to commission the art, who considers the history or ground where the art will be placed as "sacred," what past grievances bubble up, and whose history is being represented and whose is being silenced. Where better to insert public historians in the process?

Public historians can add value in a variety of ways. It may take the form of helping to interpret the public art that was created long ago to express a communal commemoration or aspiration. It may take the form of being part of a team to decipher how to reflect a community's current or future reification of its communal commemoration or aspiration. It may take the form of advising on archival resources, organizational partnerships, and community experts. Either way, public historians can play a vital role, but they will not necessarily be invited to the planning and design table on their own. They need to investigate where these important conversations are being held and where decisions are made in their cities and introduce themselves to public artists, public art commissions, and public art consultants so that they can become known within the public art field. There they could well become entwined in the goals of both good public art and history and be part of the process to create reflective communities.

SOME PARALLELS OF PUBLIC HISTORIANS AND PUBLIC ARTISTS

During 2013 to 2014 attendees at several national conferences for museum professionals, historic preservationists, traditional and public historians, and others framed seven principles for the *History Relevance Campaign.* In their statement on the value of history they put forth seven ways it is essential: to ourselves, in building identity through stories and in developing critical skills and independent thinking; to our communities in creating vital places to live and work and for cultural heritage to serve as a catalyst for economic growth; to our future by engaging citizens to craft better solutions, to inspire local and global leadership to confront challenges; and to preserve the legacy of authentic and meaningful places and things through preservation.[2] The group calls on organizations to

endorse, share, and use this statement on the value of history in contemporary life to change the common perception that "history is nice, but not essential."

If you substitute the word *history* with the word *public art* in the relevance campaign, we see overlapping essentialist arguments for public art. Public art is also slighted by the notion that it is nice but not essential, and much public art is perceived by cities to be a wise investment only because it can be an economic engine. However, I contend that public art planning is becoming more sensitive to a city's particular history and becoming more invested in getting at what distinguishes their particular historical and cultural landscapes.

Let's explore some of the similarities among public historians and public artists. Most public historians are used to explaining what public history is. Once we explain our ability to ferret out and rely on the best current scholarship available and then to communicate good history with wide public audiences in mostly informal learning settings—such as museums, films, and web-based projects—people are generally intrigued and appreciative of our training and skills. We might then go on to say that one characteristic that distinguishes us from many academically based scholars is that they often pursue their research and writing with a relatively small number of academics interested in precisely the same specialty. In contrast, a public historian's interest, ability, and fundamental purpose is to work collaboratively with many disciplines and to relish, rely on, and respect public input on our projects so that we are certain to be communicating clearly and efficiently and in an engaging way with as many people as possible in our target audiences. The National Council on Public History serves as an umbrella organization that "inspires public engagement with the past and serves the needs of practitioners in putting history to work in the world by building community among historians, expanding professional skills and tools, fostering critical reflection on historical practice, and publicly advocating for history and historians."[3]

Public artists are similar to public historians in this way and differ from studio artists who work in solitude. They welcome and must embrace the public arena in which they develop their projects. Since 1959, when Philadelphia created the country's first municipal public art ordinance, hundreds of communities across the country have adopted them, and public artists are thriving on commissions from public art funding. Public art programs offer training for public art, and a national organization, the Americans for the Arts' Public Art Network, is dedicated to "advancing public art programs and projects through advocacy, policy, and information resources to further art and design in our built environment."[4]

Public historians and public artists work for specific clients. They compete for funding and are commissioned in a very formal public process. While artists are stereotypically perceived as temperamentally unfit to solicit ideas and feedback, public artists must work collaboratively with city departments, business leaders, community organizations and partners, funders, and fabricators so they

must be inclined toward patience, multiple iterations, delays, approvals, and fundraising to accomplish success. As public historians on a public art project, we can provide a steady influence and anchoring in the soil that nurtures distinct and accurate historical information as well as legitimate competing narratives. Public historians and artists must both receive final approval from the client and can sometimes see their efforts diminished or their projects moved or removed, blunting our efforts toward academic and artistic freedoms.

Public historians and public artists have usually not structured their practices to stay focused on one particular subject, nor to practice in one place. Almost by definition, they differ from academic and studio-based practitioners because they are called upon to investigate different topics and to continuously shift focus from place to place, to physically investigate new landscapes and cultural contexts, to shift to accommodate large and small budgets, and to constantly be working in the public realm. This requires a certain type of expertise to be built over time. It requires a willingness to go into situations not knowing anything about the history, or the people who will be shaping the history and art, or the power structures that put them in that position. It requires a type of intellectual and personal flexibility to become the student: to listen and learn, to observe and question, to refrain from seeing oneself as the immediate expert, but rather to serve as an outsider, relying on drawing together people in a community who are strangers and then using expertise to allow a new vision to emerge based on how they are bound to one another. It takes a special kind of practitioner to engage in what are extremely ambiguous situations at the start of a project; to build trust in the initial process of gathering information and to find and include many perspectives of on-the-ground experts, whether they are fellow historians and other experts in academic disciplines or city staff and interested residents. Then the public historian must serve as a sort of channeling device to synthesize and communicate the findings. Finally, the public historian must be ready to know when they have investigated enough to know it is time to begin to fashion recommendations for short- and long-term strategies for public history to support public art.

Timing is key for both public historians and public artists: the earlier they can be brought in to a project, the better the outcome. If historians are part of the process for a public art master plan from the start, the planning process will undoubtedly have a stronger sense of a city's past and the legacies of that past in the present. If artists are brought in to a project late in the process their work is often, at best, a lovely adornment, and at worst, a plopped-down piece that neither sits well on the site nor with the residents who then have to live with it. Public artists need to become familiar with the physical site, and the residents of a community need to become familiar with the artist. Ideally the artist is responsive to a community as well as able to bring something the community could not imagine or fabricate and install without the creativity

and expertise of the artist. A good public artist has the ability to get the scale of an installation or project right: from creating the idea to envisioning how the form fits in the landscape, their expertise is a combination of having their work be inspired by a unique place and offering a physical embodiment of a narrative that residents and visitors recognize, relate to, and take ownership of. This is similar to public historians, who need time to identify the resources of a community, and to listen, learn, help shape shared narratives, and include multiple perspectives. Public art administrators should not rely on artists to do their own historical research. Public artists may well be inclined to enter the archive, and they should be encouraged to conduct interviews and create narratives as an important part of their process. However, they should always be supported by people who have the skills to research history and have access to diverse experts in the field, including academic historians, beloved residents with long associations with a community, and others who serve as the community's collective memory keepers.

While the shared approaches and goals of public artists and historians are often complementary, it's important to point out that significant differences can also emerge. History and art are not the same thing and their aims and methods are not identical, so there can be pitfalls to this kind of collaboration. For instance, historical rigor can constrict as well as inform art. Art's desire to push, pull, evade, and shatter boundaries can risk dragging history away from its (admittedly problematic) goals of objectivity. Traditionally, history attempts to obscure its practitioners' subjectivity while art is defined by it. Public artists and historians must learn to communicate and find the right balance.

PUBLIC ART AND ITS ENVIABLE
PERCENT FOR ART FUNDING

Public art often deals with historical narratives, commemorating and memorializing as it pushes communities to tackle difficult and complex histories on local, regional, national, and international scales. Why aren't public historians across the country working hand in hand with urban planners and others on the very public process of developing public art? How might we train a new generation of public historians to insert themselves in this process?

First let's understand how it gets paid for. Public Art Ordinances set up a funding mechanism for public art by determining criteria by which a city's Capital Improvement Plan (CIP) includes a set-aside for between ½ and 2 percent of a project's budget for public art. CIPs might include the construction of new schools, fire stations, police stations, water treatment plants and sewers, parks, low-income housing, and the purchase of land for public use. So, for instance, let's assume a city's ordinance requires construction projects over

$250,000 to have 1 percent of the budget set aside for public art. A $100,000 construction project will spin off $1,000, but city construction budgets are often more in the realm of millions of dollars, and those projects spin off considerable funds for public art. Look up your city's budget and you might find that 30 to 40 percent is made up of a CIP budget. Depending on the city's capital improvement construction rate and whether public art funding applies to transportation and infrastructure projects, a fund can either grow steadily or in spurts over the years. Some city ordinances require that the public art funding generated by a specific construction budget stay with the site, so if a school or police headquarters or fire station is constructed the public art funding generated must be spent at those locations. Other ordinances allow a city to pool the public art funding, and administrators can use funds for projects not connected to the particular construction site that generated the funds. Either way, construction budgets spin off millions of dollars for public art. Some public art projects can be massive in scale, while others can be woven in to smaller infrastructure such as pedestrian and vehicular bridges and can even take the form of smaller functional objects such as benches, manhole covers, and tree guards. In addition to city-based percent for art programs there are also federal, state, and transportation agency programs for public art.

Once a percent for art ordinance is in place a strategic plan is required to define the specific policies and procedures, the appointment and structure of the commission that will oversee the percent for art program, how artists will be evaluated and commissioned, how general and specific sites in a city where public art should be determined, the public engagement and outreach that needs to be followed, and other relevant issues.

GETTING SPECIFIC: SEVEN LESSONS FOR PUBLIC HISTORY COLLABORATION IN ACTION

I have collaborated on public art master planning over the last ten years in many cities across the country and one in Canada. I've had the pleasure, challenge, and honor to work with public art consultants who were hired through a competitive process, usually in response to a Request for Proposal (RFP), Request for Qualifications (RFQ), or both. They included me on their proposal in places where history is seen to be an important component for the development of a public art plan. On more than one occasion I've been told that having a public historian on their team has either helped them to get the contract or, once the team is working, that the role of the public historian has been recognized as a vital and important component of the team's work. What puzzles me is why more historians aren't involving themselves in their city public art plans. Without exception, when I have come from outside the city and reached out to the

history community its members have been extremely responsive and apprecia-
tive to be included in a process that they've never been invited to participate in
before. Practitioners and mentors should be proactive and train public history
graduate students to knock on those doors and take seats at the table.

My experience in working on teams as a public historian to create pub-
lic art master plans has taught me several lessons. While not all public art
projects require a public historian in helping an artist to conceive an artistic
response, when the siting and content of a project can benefit from infusing
public history with public art there are seven significant overarching results:

- Artists do not solely bear the burden for researching, understanding, and
 interpreting the past.
- When public artists collaborate with public historians, archivists, and other
 humanities professionals, they combine their knowledge and expertise to
 help understand the underlying layers of urban form and urban life upon
 which new public spaces are being built. Together they may dare to find
 and sometimes express wisdom about a certain time and place.
- Communities are rewarded with new dimensions of a city's past, which
 helps to open them up to new ways of seeing and engaging.
- Residents and tourists are invited to be part of a strategic remembering that
 is based on authenticity.
- Public art projects become more nuanced and transparent and approachable
 because public history and public art teams are sensitive to matters of scale.
- Public art programs are assured of wrestling with new ideas about contem-
 porary place making, creating manageable social processes, and construct-
 ing a "public" in public art.
- Public art programs can become bolder and begin to pose vital questions
 about their city's public art program: How are we pushing public art to be
 a tool for creative understanding of difficult histories, to open up new ways
 to learn about the past? Are we promoting unquestioned nostalgia for what
 might not have ever been, or are we using history to see how we got here
 and inspire us to meet what challenges us today?

I've been privileged to work with public art master planners Deborah
Whitehurst, Gretchen Freeman, and Gail Goldman. They have all designed
and run public art programs in their own cities, and as public art master plan-
ning consultants they bring special talents to cities across the country, skills
that are essential for any public art consultant. Deborah Whitehurst has the
uncanny ability to understand city governments to such an extent that within
a short period of time she can see where power is held, the obstacles to cre-
ating or implementing public art programs, and how shifts in structure can
accommodate and support the best municipal government environments for

collaborative, meaningful, and adequately funded public art. Gretchen Free-man understands the landscape of public art on a national scale and has the uncanny ability to quickly map and evaluate the strengths and weaknesses of a city's art and design community, and she knows how best to propose training and mentoring public artists. She was a maverick at inserting public artists into the city of Phoenix's infrastructure when she served as public art coordinator there. With the knowledge of how public art can strengthen en-gineering visions and implementation, she knows how to work through city engineers to devise and revise policies and procedures to build and maintain public art collections. Gail Goldman shares some of Freeman's and White-hurst's experiences and expertise and in addition has the ability to work with private developers and corporations. She engages them in discussions about incorporating public art in their projects, offering options for either hiring artists to do work on site or contribute money to a fund that can be used by a city's public art program. Public art consultants, public art commissions, and public artists can include public historians on their teams, but they must be introduced to the value we can bring to the process and products.

THE UNIVERSITY CAMPUS AS HISTORY
AND ART CANVAS TO EMPHASIZE IDENTITY

The first opportunity came in 1999 to develop a public art master plan with Freeman and Whitehurst for Arizona State University (ASU) in Tempe, Arizona. Freeman/Whitehurst Group subcontracted with Projects in the Public Interest for me to provide public history consulting. ASU recognized the wisdom in building on the original layout of the university campus as an arboretum and investing in public art as part of its creative capital. The public art consultants took charge of interviewing university administrators, financial officers, facilities maintenance and engineering staff, and professors in design, art, and architecture. Fortunately for me, this was an easier place to begin collaborating on public art: a university campus is a small city in some respects, with its internal police and infrastructure, but with only seven hundred acres within discrete boundaries, it is a manageable size. As a team of a public historian coupled with public art planners, we envisioned informal learning experiences within the university's formal learning environment. The art master plan, titled *Emphasizing Identity*, recommended creating threshold experiences at campus entrances that demarcated the university boundaries from the surrounding city and campus wayfinding devices to in-crease cohesiveness, legibility, and to welcome everyone.[5] Mirroring the pro-cess of learning and acquiring an education, we proposed providing a sense of discovery and surprise. We suggested that when public history and public

art can be married to curriculum there could be opportunities for interdisciplinary learning; that when dedicated to aesthetics the public art could emphasize identity through artfully designed avenues to interpret the university historically, thematically, and spatially; and that public history and public art needed to be integrated into the total life of the university rather than just as decorative additions. We recommended that public art could be a tool to unify and acknowledge the university's history and to unlock classroom doors so that education, arts, design, and aesthetics would permeate the campus.

Upon completion of the first art master plan there were two important consequences that became apparent over time. The public history program at ASU developed a course where the campus was the landscape of study and each year new students built on the collective repository of information. Students researched and mapped different quadrants and interpreted the growth of the university over time, each semester compiling more documentation on physical growth, student demographics, the influence of different presidents on the university, as well as student activities, including protests that marked the struggle for civil rights legislation. Consequently, the university's preservation officer and the university collection librarians began to collaborate on many projects using public history students to research, create archival resources, and be part of educational outreach efforts. This is an easy target for public history programs everywhere: be proactively involved in creating self-reflective campuses. Meet the public art planners if there are some, and if not, be part of the creation of a public history planning effort. Public historians can offer their services to campus initiatives for walking tours, interpreting the campus history and change over time, emphasizing the campus art and architecture, and making the campus accessible and legible to everyone.

RAILS TO TRAILS AS CANVAS: GETTING BACK ON TRACK WITH A RESONANT JOURNEY

After successfully completing a university public art plan as a public history consultant, I had the chance to work on a larger project in 2000 to 2001 with Freeman and Whitehurst: to identify the potential for art in and around a 5.5-mile-long industrial freight corridor, the Midtown Greenway Corridor in Minneapolis, Minnesota. The hope for the rails-to-trails conversion was to help South Minneapolis get "back on track" with a new corridor conceived to do more than provide bicycle and pedestrian transportation. Residents envisioned it as a ribbon of ideas to tie people to place. After years of neglect and indifference, the long, idle freight corridor was perceived as a thoroughfare to recapture lost ground and to create new common ground. The long, linear freight track was an artifact of the glamour industry of late nineteenth- and twentieth-century

Minneapolis, once forested, and where lumber was cut, steel was forged, and immigrant laborers laid the rails. This all became food for thought and inspiration for art as the Midtown Community Works Partnership, which contracted for the public art master plan, was envisioning a new relationship with the corridor. From a dark trench to a place featuring public art, planners wanted to make it visible, to create connections among adjacent communities that were sliced through in the past. We created a connection with a Macalester College professor who agreed to have his students devote a semester to researching and compiling the history of the industrial corridor. They documented the death and destruction in South Minneapolis created by the original railroad tracks, the history of the struggle to prevent loss of life at rail crossings, and the eventual decision to lower the tracks. The activists who fought for depressing the tracks took the case all the way to the Minnesota Supreme Court, arguing against the power and actions of the state railroad commission and the owners of the railroads. This was the first time a city was granted the right to act on its own behalf to determine its landscape, transportation corridors, and character. The students made presentations of their research, and it became important for the contemporary corridor activists to learn that they were following in a tradition to use the linear line landscape to the best advantage of current residents. Students also documented the twenty-first-century changing demographics of businesses and nearby neighborhoods. Community members engaged in character-mapping exercises to identify landmarks, anchors, building materials, people, and stories of the site, this crevice that allowed them to see back in time and to envision its future. With participation and expertise from the Heritage Preservation Commission, the Minnesota Historical Society, and the Minneapolis Public Library, we documented ways to "restory" the railroad ties and recommended envisioning the corridor as a *Resonant Journey* with a one-hundred-year history, a sort of museum of urban life.[6] Public historians should look for opportunities in their communities when rails are being converted to trails, canal towpaths are restoried as connections among communities, and any other infrastructure is being repurposed.

CITIES AS CANVASES

Indianapolis: A Heritage of Nineteenth-Century Public Art Reenvisioned for the Twenty-First Century

The next opportunity came in 2002 to 2003, when the Freeman/Whitehurst group subcontracted with Projects in the Public Interest for the Arts Council of Indianapolis to create the city's first formal public art master plan. Over time, Indianapolis had distinguished itself from other Midwest places by

promoting various identities: "Railroad City," the "Crossroads of America," the "100 Percent American City," "Toolmaker to the Nation," and the "Amateur Sports Capital." Fortunately, Indianapolis also already had a remarkable tradition of monument building and civic architecture. Alexander Ralston, who worked under L'Enfant to plan Washington, D.C., was commissioned to devise a layout for Indianapolis in the 1820s. He envisioned Mile Square, which determined the location of buildings for courts and religious and market purposes, and continues to be at the heart of the city. George Kessler devised a Boulevard and Park System from 1908 to 1915, which still defines the city. The Soldiers and Sailors Monument of 1887 and the Indiana World War Memorial Plaza of 1923 both brought high-quality public art to the city on a human scale with delightful details. Luckily for Indianapolis, part of the public art planning process was about reenvisioning that bold identity of a city that invested in high-quality aesthetics.

As part of the *Indianapolis Public Art Master Plan*, I interviewed people who would not normally be involved in the creation of a public art plan: Indianapolis Historic Preservation staff and commission members; members of the War Memorials Commission; staff at the Indiana Historical Society, the Historic Landmarks Foundation, and the Polis Center; public historians at Indiana University/Purdue University Indianapolis (IUPUI), Ball State and Butler University historians; staff at the Eiteljorg Museum; the editors of the *Encyclopedia of Indianapolis*; people who wrote nominations for the National Register of Historic Places in Indianapolis, and others.[7] They told us they wanted the city to do something it had already done: build on its long tradition of planning, memorializing, and creating public spaces. While they honored the cultural capital built on the tradition of public architecture and art, they were keenly aware of those expressions commemorating national military conflicts and that it was now time for reflecting upon the diverse regional history including its agricultural and industrial labor force; its multifaceted transportation/crossroads infrastructure, including canals; its National Road connection and relationship to the auto and auto parts and avionics industry; its powerful pharmaceutical production; its dynamic duet of jazz and landscape painting history; its highly successful historic preservation force that has protected the city's architectural assets; and its immigrant groups, who engage in complex yet fairly stable race relations. They wanted to be involved in telling new stories in new ways and cautioned against allowing places to suffer from erasing their distinctiveness. The history community was so strong in Indianapolis that one of the recommendations was to increase the percent for art so a portion could be set aside for public history. While not adopted at the time, it was a confirmation of the sometimes perfectly entwined goals of both public art and public history.

El Paso's Artes Civicas: Complex Reactions to Colossal Sculpture

In 2004 to 2005, Freeman/Whitehurst Group was again awarded a commis-
sion to create a public art master plan with Projects in the Public Interest, this
time for the city of El Paso, Texas. *Civic Arts/Artes Civicas* built on El Paso's
natural and cultural heritage, including its ancient petroglyphs at Hueco Tanks,
an enviable collection of landmark historic architecture in its downtown, and a
tradition of muralist paintings in public places.[8] The city's imagery for attract-
ing tourists generally relied on the story of conquistadores and the Wild West,
both stories of armed conquest. Narratives often positioned 1880 to 1920 as
the city's "best days" with shootouts and "saucy" women. For this project,
people were brought in to the public art planning process who would not nor-
mally have been included: representatives of the history department and oral
history institute at the University of Texas at El Paso, El Paso Community
College Valle Verde Campus, El Paso Public Library, the Camino Real Trail
Association, the El Paso County Historical Society, and Fort Bliss. Along with
community meeting participants, El Pasoans argued that they now deserved
a rich, inclusive, complicated array of competing histories. Once a place to
simply pass through, they saw their city as a place to stay; they wanted to high-
light their links with Ciudad Juárez, Mexico, and border life. The US-Mexico
border is marked with obelisks every thirty to two hundred miles, steel cur-
tains, and concrete ditches. Residents asked how public art and history could
bridge twin-city communication, fluid identity, immigration, interdependence,
integration, and interaction in the "Ellis Island of the Southwest." The public
art planning was created in consultation with exhibit design underway at the
time at the El Paso Museum of History. The plan recommended highlighting
themes and topics that had receded from public view, such as artisans in trap-
pings and leatherwork, manufacturing of clothing (especially blue jeans), a
tradition of neon arts, and El Paso's agricultural production of corn, cattle, cot-
ton, fruits, and brandy. It recommended public artists interpret the centennial
of the Mexican Revolution when it became the site of international attention
in 2010. Rather than continue to feature static identities, fixed nationalities,
and "pure" languages, public artists and performers were to "elaborate a new
set of myths, metaphors, and symbols that will locate us within all of these
fluctuating cartographies."[9] They suggested a focus on Pachuco, Spanglish,
and El Paso's distinctive style of dress.

The irony was that the public art planning for El Paso began in the midst
of the creation of the world's largest equestrian statue of Don Juan de Oñate.
The sculptor, John Houser, came by his fascination and predilection with
colossal works quite naturally: he was the son of one of the first assistants to
Gutzon Borglum's carving of the American presidents at Mount Rushmore.
First proposed in the 1990s, the statue of epic proportions was conceived to

signify the first wave of emigrants to come from New Spain to what is now New Mexico and to honor the contributions Hispanics made to build the American Southwest. Ten years in the making, it was scheduled to be unveiled in 2006, but by that time more people gave voice to their pent-up anger and objected to the thirty-six-foot-tall Oñate atop a rearing Andalusian horse, seeing it as a symbol for colonization and brutality. No longer willing to defer to or publicly ignore the glorification of Oñate, who killed hundreds of men, women, and children and ordered the severing of one foot of surviving adult males, they questioned why the city should allow the statue, especially one on such a massive scale, of a foreigner who ordered those atrocities. The sculptor and his supporters countered, arguing that the statue was just making people aware of a certain stage in Southwestern history. Unfortunately in the decade it took to complete the statue (during which time other statues of Oñate on horseback had one foot amputated in retaliation), the city was unaware of the velocity of public dissonance and unwittingly became the perpetrator of discord between Native Americans and Hispanics. The city brokered a compromise: to remove Oñate's name from the piece and to simply assign it the name "The Equestrian." The original intent to bind communities together had devolved into a colossal spectacle that did quite the opposite. Such is the power of public art when it is out of touch with prevailing and emerging sentiments and sensitivities of a city. To eliminate further rancor and controversy the statue was moved beyond the city limits, and the nameless horse and rider now stands at the entrance to the El Paso International Airport. Perhaps if historians and public historians had been more involved in the process this whole episode would have been avoided. In general, academic scholarship is twenty-five years ahead of what results in museums and public art. Public historians must insert themselves in that process to avoid these long gaps between what is already explored and documented in academia and when new information seeps in to common perception and understanding of a place.

A Line of Inquiry Developed for San Antonio, Calgary, and Richmond for Public Historians to Use in Public Art Projects

Public art planning in 2008 in San Antonio, Texas, resulted in *PASA, Public Art San Antonio*, and in 2009 in Calgary resulted in *Regarding Calgary: Public Art in Context*. San Antonio offered an opportunity to bring historians into the process of examining the roots of the city's rich and diverse cultures, how to nourish it, and to go beyond the historic preservation ethic and a River Walk that had become the envy of the nation and copied worldwide. It offered a map for publicly exploring its Mexican roots grafted to a Texan spirit, while asking how to keep it real and alive and not fossilized by its success. Calgary offered an opportunity to bring historians into the process of examining the wider consequences of being

subject to boom-and-bust economies. In both these cities a similar line of inquiry was posed that serves as a good starting point for historians involved in public art planning. The questions follow this general track:

- What are the most influential sources of information about the city's history, cultures, characteristics, and uniqueness?
- What are some of the most influential images, icons, stories, histories, folk legends? Are they intertwined?
- Who "owns" the history of the city?
- Who usually gets to tell the history?
- What buildings, public art, television, radio, tourism brochures, and others are most responsible, now, for telling the city's history? What is left out? Why?
- Does the city support its history, and if so, how and for whom? For residents or tourists primarily? Is it mostly through support for historic preservation?
- Have historians, other than preservationists, been seen as a resource for the city? If so, which? If not, why? If some, why not others?
- What are the meta-narratives for the city?
- How do newcomers get their understanding of the city?
- What are the resources of this institution/organization for public artists who will get commissions here?
- Would you be interested/willing to be involved in public art projects?
- Who else do you suggest be involved in the process?

NEW OPPORTUNITIES

For a public art master plan commission in Richmond, Virginia, I'm once again working with Freeman and Goldman. When we began the public art planning process in Richmond it seemed as if it would unfold like others before it, but that quickly changed after the June 25, 2015, racially motivated murders at the Emanuel AME Church in Charleston, South Carolina. Nothing could have fully prepared anyone for the situation the city faces in the wake of the wounds of the Civil War that are coming into twenty-first-century focus. With a new populist era giving voice to dissonance, there is much discussion and decision making on the lowering of Confederate flags and removal of Confederate monuments across the South. Richmond's Monument Avenue, with its Confederate generals astride horses, lines one of the city's most remarkable expressions of what one historian characterizes as the North having won the war and the South having won the peace, the narrative, the history.[10] Richmond's reification of Lost Cause mythology was created in a time when a small elite could erect their preferred narratives, and generations

have lived under the physical and emotional weight of monuments meant to maintain power structures and prevent opposition and change.

Now, more than ever, public historians should become involved in the changes in the public art landscapes across the South. As Civil War tourism continues and civil rights tourism expands and changes over time, public historians have many opportunities to be part of the reinterpretation of public landscapes, memorials, and commemorations. They can volunteer or be hired to work in southern cities to deal with their hidden and visible dominant narratives of the past, to encourage truthful accountings, to de-mythify, to become aware of new "heritage preservation" legislation that might protect historic architecture, and to become an important voice in cities moving toward understanding their obligations to see the generational and current legacies of past injustices. Public historians and public artists together have opportunities to coax cities into creating more inclusive narratives and places. They can collaborate by offering dialogue techniques to find common ground. They can fashion activist histories in the search for challenging outdated identities.

The National Park Service is making bold moves with its various new Heritage Initiatives: the Lesbian, Gay, Bisexual, and Transgender Initiative; the Latino Initiative; the Asian American Pacific Islander Initiative; and the Women Initiative. With its centennial anniversary this year, its new partnerships with the National Endowment for the Humanities for art in the parks, and its urban agenda that calls for the parks to be relevant to all Americans and to work in collaboration to better serve communities, public historians have much work to do. Finally, as more colleges and universities are starting to offer public history courses and public history certificates and degrees, one overlooked place for collaboration is with their cities' municipal and regional airports. In addition to many cities that have a percent for art, most airports have a public art component. They are developing ways to welcome residents and tourists with various mechanisms to define the unique aspects of what makes their cities and regions distinct, special, and often how their history is notable. This presents opportunities for public history programs to work with municipal airport public art planning. The budgets for new airport terminals can reach into the billions, and designers of new terminals look to find ways to entertain and enhance the passenger experience, which has become increasingly stressful since 9/11. While much of public art in airport terminals seeks to provide beauty and comfort and distraction, perhaps in the form of dazzling terrazzo floors and light-infused walkways, many also feature an introduction to a region's landscape, demography, culinary specialty, and sometimes an introduction to its past. Imagine what would happen if public historians were part of the planning teams. Imagine if history professionals and politicians could argue successfully for a "percent for public history." When projects include a historic component, a team including a public historian could manage the public process. The only formal attempt

to propose a city percent for public history was not adopted, but that was years ago. Perhaps it's time for another run at it.[11]

There is no blueprint for public art and public history planning, and every city is different and context is different. However, we have learned some things along the way, all of which point to the need for fruitful collaboration of public historians in public art and socially engaged art practices. To my fellow public historians, I urge you to overcome any sense of outsider status: meet public artists, introduce yourselves to public art commissions, serve on commissions. Help them become aware of your historic preservation commissions, your archival resources, and your community experts. With often perfectly entwined goals and audiences, let's encourage new generations to fuse public history and socially engaged art practices for the wider public understanding of history and art.

NOTES

1. From a definition crafted for *PASA Public Art San Antonio* 2008. Freeman-Whitehurst Group and Gail M. Goldman Associates, 5.

2. The *History Relevance Campaign* was created by attendees at these national conferences: American Alliance of Museums (2013), National Council on Public History (2013), American Association for State and Local History (2013 and 2014), American Historical Association (2014), Idaho Heritage Conference (2013), the New Jersey History and Historic Preservation Conference (2014), State Historical Administrators Meeting (2013), and the Smithsonian Affiliates Conference (2014). http://www.historyrelevance.com/#!value-statement/ca2m.

3. http://ncph.org.

4. http://www.americansforthearts.org/by-program/networks-and-councils/public-art-network.

5. *Emphasizing Identity, Public Art Master Plan for Arizona State University*, n.d.

6. *Resonant Journey, The Public Art Master Plan for the Midtown Greenway Corridor*, 2001.

7. *Indianapolis Public Art Master Plan*, 2003.

8. *Civic Art/Artes Civicas, A Public Art Master Plan for the City of El Paso*, 2005.

9. Ibid., Guillermo Gomez-Pena, page 10.

10. See David W. Blight, *Beyond the Battlefield: Race, Memory, & the American Civil War* (Amherst: University of Massachusetts Press, 2012) and *Race and Reunion: The Civil War in American Memory* (Cambridge: Harvard University Press, 2002).

11. The only attempt I am aware of to create a percent for history was proposed in Indianapolis. If anyone knows of another please inform the author. In 1999, the City of Chandler, Arizona, adopted a Chandler Public History Master Plan and subsequently created a formal municipal position for a public historian, the first in the country. That is another route to explore in your community.

Chapter Eight

Savannah's Hidden Histories

Using Art and Historical Markers to Explore Local History

Holly Goldstein and Christy Crisp

Savannah, Georgia, is a city that takes its history seriously. Georgia's first city and colonial capital boasts lovely public squares, streets, and parks in a nearly picture-perfect downtown historic district that attracts millions of visitors each year. The Savannah College of Art and Design (SCAD), located in Savannah, Georgia, offers an ample roster of creative people and projects to benefit the historically rich city. Also headquartered in Savannah, the Georgia Historical Society (GHS) is one of the oldest historical organizations in the nation. In recent years, these seemingly unlikely partners have worked together in a collaborative endeavor using student research and artwork to enhance existing historical markers. This SCAD/GHS collaboration reveals how students at an arts university both learn about history through public art projects and work to create a rich public historical record through their aesthetic engagement with historical research. In the SCAD Art History course Recording Local Histories, students study the conventional tourist-driven history of Savannah and then conduct research to uncover untold, omitted, and underrepresented narratives. The course begins with the question: How is Savannah's history typically recorded, and whose histories have been forgotten? Utilizing one of the most traditional historical resources—roadside historical markers—each student identifies a topic (represented on an existing local marker) and then conducts research to investigate and represent the "hidden" histories missing from their public marker text. GHS, who erects and maintains Georgia's historical markers, works closely with SCAD to identify potential topics and facilitate student research. Published on the GHS website, the resulting student-made materials enhance the available historical content on the chosen topics through the creation of an online exhibit that includes new supplemental text along with the student-curated exhibition of existing archival resources (such as historical photographs or documents) and

175

of new original student artwork intended to complicate the histories of their chosen marker sites.[1] The projects not only expose students to the process of historical research but also to methods of curation, providing insight into the choices that are made by both artists and public historians in interpreting our community histories. This chapter presents the SCAD/GHS collaboration as a model for how students, tourists, and residents can employ the arts toward a deeper appreciation of complex regional histories.

The Savannah College of Art and Design, founded in 1978, offers a rigorous arts-centered education for undergraduates and graduate students. Billed as the "University for Creative Careers," SCAD encourages students to tailor their education toward refining professional practices, and students consistently emerge ready to compete in the workplace.[2] The institution grew over time by reclaiming and rehabilitating old and unused buildings, and SCAD classrooms, offices, studios, and workplaces now occupy more than sixty facilities across Savannah. As a result of SCAD's career-focused mission and sprawling physical urban layout, students are driven to integrate their classwork and professional goals, and the city of Savannah itself becomes their campus and territory of learning. Despite their constant navigation of Savannah's streets, squares, and buildings, students seldom learn more about their adopted home than is visible on the surface. This surface-level engagement with place is indicative of Savannah's larger resident and tourist population, most of whom walk, drive, and bike easily through the close-knit historic district yet rarely pause to think critically about Savannah's complicated visible and intangible histories.

Tourism—and specifically heritage tourism—is one of Savannah's leading industries; more than thirteen million tourists visited Savannah in 2014, with more expected each year.[3] While the population of Savannah is comparatively small, at just under 150,000 residents in the metropolitan area, year-round tourism and the student population help to drive a constant demand for the public interpretation of history.[4] In the historic district, visitors can choose from theme-oriented tours ("foodie" and ghost tours are especially popular), and a burgeoning tourism infrastructure seeks to cater to every taste and interest. Despite the overwhelming amount of ways to experience Savannah, many visitors spend only one day in the area, and most tours neglect to mention the challenging and problematic narratives lining Savannah's complicated past, omitting a probing discussion of contested issues surrounding race, class, and gender. Savannah is a city built on the legacy of the slave trade and plantation system, yet many civic tours overlook even a mention of slavery. It is common for locals to walk on streets and inhabit buildings constructed of bricks made by slaves, with little knowledge or public recognition of Savannah's slave history. Interestingly, despite the abundance of new, ac-

cessible, and mobile tourism resources, perhaps one of the most widely used and readily available methods for conveying historical information to a busy, overstimulated, and distracted public (particularly in a concentrated urban setting) remains traditional metal historical markers. Standing tall in a public space boasting a short paragraph of text, historical markers present quick, authoritative, location-specific fragments of history. Dozens of historical markers punctuate the streets and squares of Savannah's historic district, offering visitors a glimpse of the region's noteworthy sites, stories, and residents. Yet because the vast majority of these markers were erected during the 1950s and 1960s, they rarely reflect the broader and more inclusive topics of cultural history that have been brought to the forefront in more recent years. Generally, these existing markers focus on stories related to military and political history—specifically as they involve the wealthy, white, male population. As a result, there are significant gaps in the historical record as represented through historical markers.

Since 1998, the Georgia Historical Society has administered the historical marker program for the state of Georgia. As an educational and research institution, GHS has worked since that time to create a more complete record of Georgia's past through these roadside historical markers. Specifically, since taking over responsibility for Georgia's markers, topics discussed have broadened to include stories related not only to other groups such as women and African Americans but also to other aspects of history such as business and popular culture. Another goal of the statewide historical marker program is to reflect new historical scholarship through marker text and provide context to the marker's story, giving readers a sense of not only what happened in a particular place and time but also why it was important—how the events of that place fit into the larger story of Georgia and American history. Despite these efforts, however, the limitations of 130 words on a marker plaque significantly restrict the content and force difficult decisions about what to include and omit in each project. Further, while these newer markers may help provide a broader view of Savannah's past, they represent only about 30 percent of the total historical markers in Chatham County, home to both the Georgia Historical Society and the Savannah College of Art and Design, leaving numerous stories still untold through traditional markers.

The "Recording Local Histories" course at SCAD, taught in the Art History Department, aims to address and remedy gaps in Savannah's visible historical record and inspires students to engage deeply with Savannah's contested past to consider how both mainstream and underrepresented historical narratives have shaped our present. Savannah serves as a case study for a deeper consideration of how cities tell their stories, and how residents and tourists can engage with, learn from, and continue to examine our complex

past. Because SCAD is an arts-centered university, students learn about and respond to history from an aesthetic, creative vantage point. By both learning about other artists who have successfully combined artistic creation with historical reinterpretation and also by crafting their own aesthetic responses to historical research, SCAD students capitalize on the arts' ability to address historical complexity in innovative, emotionally, and visually compelling ways. In turn, their contributions provide additional content for the GHS website and enhance user experiences with the more traditional historical marker information. This then furthers the work of GHS to make historical markers more accessible and relevant to wider audiences.

COURSE LAYOUT, GUIDING
QUESTIONS, AND GOALS

Recording Local Histories was designed in 2014 as an opportunity for SCAD students to engage thoughtfully and critically with Savannah's historical legacy, public interpretation of history, and contemporary community. Taught as a "visiting scholar" course featuring numerous guest speakers and including field trips to various local museums, exhibitions, and historic sites, the course immerses students in Savannah's rich fabric. Recording Local Histories encourages SCAD students to think critically about both the mainstream and lesser-known histories of the Lowcountry region. Using the city of Savannah as an urban model, the course deconstructs the history of place. The syllabus is organized both chronologically and thematically: first, a brief history of Savannah prompts students to question which stories, sites, and events have been omitted from conventional tourist-driven narratives, and then students select individual research projects to study and write about an overlooked aspect of local history. The "visiting scholar" format combines the professor's expertise in the critical analysis of place, cultural geography, and cartographic theory with the regionally specific knowledge of scholars in a variety of disciplines. Drawing together experts in fields as diverse as archaeology, urban slavery, and colonial history, this course forges significant links with community leaders and offers a rich spectrum of voices.

Course development addressed several guiding questions and goals, including:

How can SCAD professors inspire students to engage critically with Savannah's history? How can public history be conveyed in a complicated and critical way for a diverse population of students, residents, and tourists? How can scholars utilize the existing historical marker infrastructure to expand on and enhance Savannah's public history? How should we integrate art view-

ing, art making, and an engagement with history? How can Savannah serve as a case study to ponder deeper questions about place and humanity? How can students gain professional experience and feel empowered not only to learn about but also to shape and rethink public history?

In ten weeks, students progress through a deeply critical investigation of Savannah as a model for understanding how places are created and remembered. The course is structured in cooperation with the GHS, where students conduct research on a historical marker topic of their choosing. By writing a scholarly text, selecting representative archival images, and creating contemporary visual representations of their marker topic, each student curates an online exhibition ultimately published by the GHS. This publication opportunity offers valuable professional experience for students and expands available marker content for the GHS program.

Covering topics including Savannah's chronological history, urban planning, and architectural record, Recording Local Histories prompts students to question how history is recorded, and students work to fill in missing pieces toward the goal of creating a more complete record of local history. Recording Local Histories offers a space for students of all disciplines to engage critically with the historical and contemporary stories of Savannah and the South. By writing and publishing a research project on a local site, each student expands and enriches the public record of Savannah, casting light on underrepresented people and places. Additionally, students assess the aesthetic and cultural significance of art objects. As an art history course focused on visual study, this course highlights how local works of public art, temporary exhibitions, visual culture, and archives preserve and construct history.

The course begins with a discussion of Savannah's public historical interpretation. Guest lecturers Christy Crisp and Elyse Butler from the GHS present the history of the historical marker program, introduce case studies of controversial marker sites and topics, and address the challenges of writing marker texts. An article by GHS historian Stan Deaton further complicates the task of contemporary historians presenting public history.[5] Course readings introduce students to a brief regional history, highlighting Savannah's chronological background focusing first on its establishment as a British colony.[6] In addition to studying historical accounts, students also read contemporary reflections on Savannah's current community, including editorials on race relations, political achievements and challenges, and tourism in order to consider how Savannah's historical legacy complicates today's municipal makeup.[7]

Students visit the Georgia Historical Society where Lynette Stoudt, the director of the research center, presents an overview of GHS collections, and students consider questions of how we collect, store, and access information.

Readings that highlight research from historical archival collections model for the students the potential benefits and pitfalls of primary historical research, and demonstrate how visually rich ephemera such as postcards, bills of sale, or periodical advertisements can enhance traditional textual research to give a more nuanced understanding of how we interpret the past and share it with the public.[8] By conducting primary research in the GHS Research Center, students become acquainted not only with the processes of archival research but also with the evolution of collecting practices over the last two centuries. Specifically, they learn that many of their topics are underrepresented by the GHS collections due to the liminal and marginalized nature of their chosen subject areas. Using writings from theoreticians such as Michel Foucault, John Tagg, and Alan Sekula as a guide, students study the "archive" as an authoritative structure that wields power to shape and legitimize history through institutional biases in collection, storage, and access.[9] This understanding encourages students to explore the idea that—as with historical markers being representative of the times in which they were written—collections reflect the values and priorities of the collectors and, further, that those priorities can and do change over time. Students are therefore encouraged to extend their research to utilize alternative methods and sources, including city archives, oral histories, and community networking.

One of the first class meetings is spent riding a "Trolley Tour" in downtown Savannah. This exposes students to a popular, quick method through which most tourists view Savannah and learn about its history. While trolley tour drivers offer numerous tips on where to eat and shop and recount jokes and tales about pirates and ghosts, they rarely mention Savannah's Native American, enslaved, immigrant, military, and lower socioeconomic status populations. The tour route bypasses the historic district's physical fringes and omits mention of the region's historically impoverished and marginalized communities. After the trolley tour, in subsequent class meetings and in their research projects, students attempt to fill in the gaps missing from Savannah's mainstream tourist interpretation.

Visiting scholars include Paul M. Pressly, director emeritus of the Ossabaw Island Education Alliance, Ossabaw Island Foundation, who lectures on Savannah's colonial history and examines the Atlantic and Caribbean slave trade; and Vaughnette Goode-Walker, who guides the students on an "Urban Slavery Walking Tour" highlighting unmarked locations from the urban slave trade. Readings by Pressly and Goode-Walker deepen the students' knowledge of Savannah's mainstream and lesser-known histories from the colonial through Civil War eras.[10] Students examine the Revolutionary era through the lens of archaeology, where presentations by Rita Elliott (archaeologist, education coordinator, and research associate at The LAMAR Institute) at loca-

tions including the Revolutionary War–era Savannah Battlefield, old Jewish Cemetery, and Davenport House reveal the personal and political histories gleaned from archaeological excavation.[11]

In addition to the many historical markers, Savannah's cityscape is festooned with a plethora of public monuments and memorials. Students learn the differences between marker and memorial, and consider questions of who is remembered and how and why people are commemorated. Lectures on memorialization and public commemoration by guest speakers Stan Deaton (GHS senior historian) and Michael Freeman (independent scholar) introduce students to questions and controversies surrounding the public memory of such contested topics as Confederate history and religious tolerance.[12]

Additional field trips include the Massie School, where students view a three-dimensional model depicting Savannah's city plan, exhibits on Native American history, and examples of architectural period styles, as well as various site visits relating to the students' chosen research project locations, which vary from year to year. Sites have included Laurel Grove Cemetery South (an African American burial ground), Pin Point (a community established by former slaves and their descendants), and Ossabaw and Sapelo Islands (sea islands historically home to plantations). A field trip to the Ralph Mark Gilbert Civil Rights Museum illuminates Savannah's public presentation of its civil rights–era history and offers students the opportunity to speak with docents who were personally active in the civil rights movement.

Students engage with both vernacular art and fine art in Savannah, studying local murals, public sculptures, and hand-painted signs as well as visiting museum and gallery exhibitions and artist studios. In accordance with the shifting exhibition schedules at local arts institutions, students have viewed installations at the Telfair Academy and Jepson Center, and at the SCAD Museum of Art, both discussed in more detail below. Visiting Artist Amiri Farris has spoken about his paintings depicting themes of Gullah and Geechee culture, which combine an aesthetic celebration of Gullah and Geechee heritage with historical initiatives and political activism. Course readings accompany the museum and studio visits, including Gullah and Geechee oral histories as well as exhibition catalogue essays.[13]

A professor-led seminar on theories of cartography and cultural geography introduces students to questions of how geographers map space, and examines how we afford maps authority and power. Using antique and contemporary Savannah maps as models, students come to understand maps as both useful and flawed documents. Maps are inherently biased texts created to serve individual values. Like photographs, they miniaturize and represent the world in a seemingly factual way, transforming lived experience into tangible, possessable objects that both reflect and construct place. Readings by scholars

including J. B. Jackson, Mark Monmonier, J. B. Harley, and others introduce historical and contemporary theories of cartography and cultural geography.[14]

Recording Local Histories aims to integrate as many mainstream and underrepresented, past, and present stories and voices as possible in sketching a rich history of Savannah. This prepares the students to add their own words and images to Savannah's public historical interpretation. To complement the weekly lessons on Savannah history, imparted through the lectures, field trips, and discussions, students select a local historical marker for their personal research topic. After reading the existing marker text and studying the topic and location, students choose an untold aspect of the marker topic or site to research, write about, and respond to artistically. Outcomes of specific research projects are examined below. The syllabus is constructed to offer a varied experience of place. The diversity in site visits, guest lecturer professions, and formats of assigned readings compels students to question the hierarchies of how and why some stories are told, how they are recorded, and how they themselves possess agency to shape a fuller public interpretation of place. By writing "thank you" notes to guest speakers, conducting oral history research with a variety of local sources, and selecting personally appealing research topics, students develop an intimate, emotional relationship with Savannah's past and present.

LEARNING ABOUT HISTORY
AND PLACE THROUGH ART

Art is an inspiration for and product of the SCAD course. Throughout the course, students view images and installations created by locally and internationally known artists who use creative means and innovative curation to respond to and shape public history. Noteworthy examples of Savannah-based exhibitions visited by the students include SCAD Museum of Art exhibitions *Fred Wilson: Life's Link*, *Tim Rollins and KOS: Rivers*, and *Jack Leigh: Full Circle, Low Country Photographs, 1972–2004*, as well as Telfair Museum's exhibitions *Slavery and Freedom in Savannah* and *Whitfield Lovell: Deep River* at the Jepson Center and *Women Artists in Savannah, 1920–1960* and *Cheers* (a history of drinking vessels) at the Telfair Academy. These exhibitions, discussed below, exemplify how the shrewd placement and juxtaposition of objects can narrate alternative histories.

Fred Wilson's installation inside the SCAD Museum of Art capitalized on the museum building's previous history as a railroad depot. Constructed of "Savannah gray" bricks, materials originally fashioned by the hands of slaves on the nearby Hermitage Plantation, the museum building represents both Sa-

vannah's complicated past as a city built and enriched by slave labor and its contemporary circumstances as a city struggling to find balance in evolving race relations.[15] In the gallery *Life's Link* are integrated locally sourced Savannah gray bricks with objects celebrating Savannah's African American legacy selected from the Georgia Historical Society as well as artwork celebrating African American accomplishments in art and literature from the Walter O. Evans Collection of African American Art.[16] Also at the SCAD Museum of Art, *Rivers* by Tim Rollins and KOS offered students an aesthetically innovative way to rethink our assumed knowledge of southern history.[17] Rollins and his collaborators translated images from canonical southern narratives, including a speech by Martin Luther King Jr., Harriet Jacobs's *Incidents in the Life of a Slave Girl*, and Mark Twain's *Adventures of Huckleberry Finn* into large-format, indigo watercolor mixed-media paintings. Rollins also collaborated with students from the nearby Esther F. Garrison School of Visual and Performing Arts to respond aesthetically to Duke Ellington's ballet score for *The River*, also using the historically significant medium of indigo. The paintings transformed authority into uncertainty and power and oppression into acceptance and celebration. Likewise, *Full Circle, Low Country Photographs, 1972–2004* demonstrated how Savannah photographer Jack Leigh's lifelong documentation of Lowcountry people, places, and traditions both confirm and critique complicated stereotypes of the coastal South.[18]

Several installations presented by the Telfair Museums illuminated underrepresented artworks and makers rarely seen in mainstream exhibitions.[19] *Slavery and Freedom in Savannah* brought together images and objects offering a glimpse of the lives of the many enslaved people whose unrelenting labor made Savannah's opulent history possible.[20] In *Deep River* Whitfield Lovell used multimedia narrative tableaux, reconstituted found photographs, and used sound projections to pay tribute to anonymous African American ancestors who paved the way to "freedom" for today's generation of southern residents, evoking an emotionally wrenching exploration of time, memory, and racial oppression. *Women Artists in Savannah, 1920–1960* brought scholarly attention to the work of female artists including Emma Cheves, Anna Hunter, Virginia Jackson Kiah, and Myrtle Jones as well as the contributions of local amateur organizations such as the Savannah Art Association, the Southern States Art League, and the Association of Georgia Artists.

Viewing *Cheers*," an exhibition designed to demonstrate how decorative arts shed light on social practices and cultural customs, became a critical exercise as students were encouraged to look beyond the museum presentation and consider other aspects of the stories being shared and what the objects and their provenance revealed about museum collection priorities

over time. Whereas the exhibition primarily displayed flamboyant luxury items used by (and donated to the museum by) wealthy white landowners, the professor prompted SCAD students to consider who had originally created, cleaned, and served from the silver and glass goblets, punch bowls, and decanters, as well as to reflect on who had initially harvested the sugar cane and grain to eventually create the sugary and alcoholic drinks that sweetened the ruling class's daily lives. Through these innovative and bold exhibitions, students encountered topics of race, class, and gender rarely included in mainstream, tourist-driven presentations of local and regional history, and gained exposure to the various ways in which artists and curators can use aesthetic objects and installations to complicate regional history. These experiences provided the foundation for students to consider how to see beyond the story on the surface and ask the questions that would result in their own individual projects.

The classroom also offers the opportunity for students to learn about additional artists who are using aesthetic means to rethink and expand on conventional history; Carrie Mae Weems and Michael Mergen are two exemplary influences. First, Carrie Mae Weems is a photographer and multimedia artist who uses archival and contemporary photographs and installations to reveal how history—a seemingly infallible "truth"—is a flexible, moldable and ever-changing text.[21] In particular, SCAD students are introduced to Weems's *Sea Island Series* (1991–2003) in which the artist photographically explores the heritage and contemporary circumstances of Gullah people, descendants of former slaves, residing on sea islands not far from Savannah. Weems visited SCAD Savannah in February 2016 for a series of lectures, exhibitions, and studio visits as a part of the DeFINE ART Festival. Her exhibition *Carrie Mae Weems: Considered* at the SCAD Museum of Art included images from her *Constructed History* series, created as a collaboration with SCAD students in 2008.[22] Second, an emerging artist who offers a noteworthy model for the students in the practice of conflating past and present voices, texts, and images toward the goal of visually and conceptually enriching our relationship with the past is photographer Michael Mergen.[23] Mergen, currently based in Farmville, Virginia, uses a combination of contemporary photographs layered with rubbings of historical texts to conflate and question past and present accounts of history in the post–Civil War South. According to the artist, the 2015 series *After Lee's Retreat*

documents the landscape and history of the final days of the American Civil War. Through direct, wax rubbings, the large-scale, mixed media photographic prints physically imbue the language of the historical markers that chronicle and memorialize the historic sites. This binary layering of past and present considers the history, location, and the contemporary landscape of rural Virginia.[24]

Using crayon to rub words onto a landscape photograph depicting the site, Mergen layers historical marker text over image to meld disparate media and voices into an amalgam of conflicting data. Bold capital letters describing battle configurations, attacks, and surrenders overlay serene images of bucolic farmland, country roads, and clapboard farmhouses. The clash of violent past and seemingly tranquil present, words and images, and "official" and "neutral" voices presents a dizzying metaphor for the impossibility of a "correct" or unbiased historical interpretation.[25] Both Weems and Mergen, artist-scholars who rethink and retell history using visually and emotionally compelling aesthetics, inspire SCAD students to seek diverse visual formats with which to express unconventional histories of place.

In *Lee's Retreat, M-11* (2015) and *The Last Fight, K-156* (2015), for example, Mergen collapses marker text over photographs, flattening words and images into a single shadowy surface where past and present compete for our understanding and attention. *Lee's Retreat* recounts the sad story of a starving and undersupplied army troop. Famished Civil War soldiers were forced to forage for food in this location, and the gloomy, barren landscape photograph underscores the futility of both this specific search for food in particular and of war in general. Similarly, text in *The Last Fight* recounts a violent military encounter, and the photograph presents a solitary car abandoned on a lonely highway. Electrical wires, the road, and its painted dividers traverse the image horizontally, moving from left to right like the lines of text. Thus text and image are both harmonious and in competition, as the image obscures the words and renders them partially indecipherable. Together, the text and image are desolate and ghostly; time and history become both continuously seamless and forever unknowable. The transferred text, rubbed as a wax impression, is a metaphor for both photography and memory itself. A rubbing, like a photograph, represents a literal indexical impression of a place, both stopping time and rendering history timeless.

Physically interwoven with Savannah's downtown, SCAD is an institution engaged with rethinking how to use public art to present Savannah's diverse history. Two recent initiatives reveal how SCAD's administration is continually expanding the university's visual presentation of public history. First, in the SCAD Museum of Art, located on the site of the historic Central of Georgia Railroad, a medallion was permanently installed into the floor commemorating the lives of Ellen and William Craft, two escaped slaves who boarded the railroad in Savannah bound for freedom in the North. The Crafts' legacy embodies the condemnation of slavery and quest for equality, offering a poignant lesson for SCAD students in their halls of learning. Second, the Savannah Women of Vision project in SCAD's Arnold Hall auditorium erected a public artistic monument to ten noteworthy women who have benevolently shaped Savannah's civic story.[26]

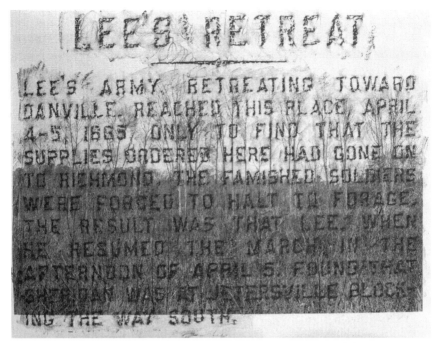

Figure 8.1. Michael Mergen, *Lee's Retreat, M-11*, 2015. Courtesy of the artist.

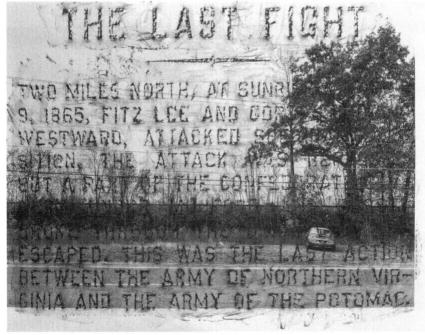

Figure 8.2. Michael Mergen, *The Last Fight, K-156*, 2015. Courtesy of the artist.

STUDENT HISTORICAL MARKER RESEARCH PROJECTS: SCHOLARSHIP, ARTWORK, AND PUBLICATION

Recording Local Histories inspires students not only to learn about Savannah's history from a variety of voices and methods but also to contribute to enhancing and enriching the city's public presentation of the past. Historical markers, easily viewed and quickly read, are seemingly infallible and authoritative records of a person, place, or event, yet like all histories they are carefully crafted texts that bear the biases of their makers. Upon selecting their historical marker, students conduct research to uncover aspects of their chosen topic that are not currently represented publicly. The following examples of student research projects highlight the types of texts and images that students create to transform the markers' current "master narrative" of the past into a multivalenced fabric of history woven from diverse threads.

Each student produces a new historical document to accompany, enhance, and challenge the existing plaque's text. Students also curate a series of archival and contemporary images to reenvision their site's visual history. To accompany their written record, the students' chosen archival images highlight selections from the GHS archives and complement their words with historical photographs and ephemera. The students' contemporary artwork further allows each individual to engage with history in a personal, intimate, and creative manner. Inspired by the examples of Fred Wilson, Carrie Mae Weems, Michael Mergen, and others, students produce photographs, paintings, illustrations, and multimedia installations to document place and respond to history in a complex, multifaceted visual way. The projects of students Dylan Wilson, Charlie Swerdlow, Erica Corso, and Elizabeth Cara offer four examples of how an arts-centered rethinking and retelling of history contributes fresh visual and textual information to public history.

Dylan Wilson presents a photographic and mixed-media installation in response to Sapelo Island's history of land ownership.[27] A barrier island off the Georgia coast, Sapelo has been home over the years to plantation owners, slaves, wealthy white landowners, and currently a dwindling population of former slaves' descendants and a state-run scientific research facility. Sapelo is also a popular, if relatively inaccessible, tourist destination. Noting that Sapelo's existing marker text offers little recognition of the island's enslaved population or their current descendants, Wilson crafted a research and art project to resurrect those underrepresented narratives.[28] For his GHS marker site project, Wilson contributed his own contemporary photographs of Sapelo today along with lesser-known images of documents including historic land deeds, soil maps, slave list rosters, and an Arabic document created by slave ancestor Bilali Mohammet. Wilson's photographs, including *Former Site of Lucy Robert's House in Raccoon Bluff* and *South End House* (both 2014) offer balanced, picturesque, and nostalgic contemporary depictions of historically

contested sites on Sapelo. While the Racoon Bluff house site appears peaceful today, this empty "stage set" of grass in front of tall trees represents years of struggle for slave descendants to claim their own property despite continual resettlement and displacement. *The South End house*, formerly tobacco heir R. J. Reynolds's estate built on the foundations of plantation (and slave) owner Thomas Spalding's main house, presents an ostentatious neoclassical mansion façade and reflecting pool hiding behind moss-laden oak trees, representing the clash over competing interests on Sapelo throughout time.

Wilson's project for Recording Local Histories eventually turned into his master's thesis for his MFA degree in the SCAD Photography Department: *Missing Voices: Field Notes and Photographs from Sapelo Island*. According to the artist statement:

> *Missing Voices: Field Notes and Photographs from Sapelo Island* re-presents Sapelo's complicated and often contradictory history through my own interpretation and foregrounding of the perspective of the island's marginalized peoples. The work utilizes multiple media to stimulate the viewer's senses by using photographs, sculptures, mixed media pieces that incorporate 3-D prints, video,

Figure 8.3. Dylan Wilson, *Former Site of Lucy Robert's House in Raccoon Bluff*, 2014. Courtesy of the artist.

Figure 8.4. Dylan Wilson, *South End House*, 2014. Courtesy of the artist.

audio, and light boxes. These mediums create a fully immersive environment that allow for a rich understanding of place. It is my hope that by examining these unrecognized places, they will be reinvested with the stories and memories of the people who once lived there and expand the definition of the document from "words and pictures" to a more faceted means of communication.[29]

Wilson states, "By presenting information about the marginalized descendants of slaves who have lived on Sapelo Island since the early 19th century, this project reflects on historical blank spots, and expands the definition of the document."[30] Wilson's Sapelo project expands the original marker focus and introduces audiences of the GHS Hidden Histories website to a wide variety of images and documents created by and giving voice to some of the most historically overlooked of Sapelo's inhabitants from the 1800s through the present.

For his project on the "Jonathan Bryan" historical marker, Charlie Swerdlow created a historically researched imaginative illustration of the region's Yamacraw Creek settlement.[31] Swerdlow noticed that while several of Savannah's downtown historical markers were located on the site of former Native American land, none of them mentioned the indigenous history of the region.

The Jonathan Bryan marker sits atop Yamacraw bluff, named for the region's original residents who predated Savannah's colonial history. By expanding the focus of the chosen historical marker from the marker *topic* to the marker *site*, Swerdlow's project helps provide context and depth to the historic location referenced in the text. In it he highlights aspects of Yamacraw building practices, culture, and customs, and his meticulously researched illustration depicts how the historic settlement might have originally appeared before the arrival of European colonists. *Reconstruction of the Yamacraw's Village* (2014) offers a historically probable illustration of the Yamacraw village as it would have been situated along the original layout of the Savannah River, with a map to orient contemporary viewers. Today, the only local landmark acknowledging the bluff's indigenous residents is a low-income housing community named Yamacraw Village, included in Swerdlow's subtly ironic documentary photograph.

For the "History of Emancipation: Gen. David Hunter and General Orders No. 7" historical marker, Erica Corso enhanced her chosen historical marker by creating paintings inspired by archival photographs of emancipated slaves joining the US Army.[32] The existing marker text explains the 1862 decree that offered the promise of freedom to those in bondage in exchange for service in the US Army. Inspired by the harrowing tales and wrenching life decisions of these first black soldiers, Corso included personal primary-source

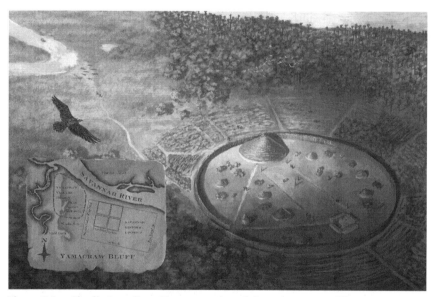

Figure 8.5. Charlie Swerdlow, *Reconstruction of the Yamacraw's Village*, 2014. Courtesy of the artist.

Figure 8.6. Charlie Swerdlow, *Yamacraw Village Housing Community*, 2014. Courtesy of the artist.

accounts in her written text, such as the observations of Susie King Taylor who wrote about the 33rd US Colored Troops in *A Black Woman's Civil War Memoirs.*[33] Likewise, Corso's own paintings depicting emancipated soldiers at Fort Pulaski (situated just outside downtown Savannah) continue this personal, emotional response to history. *Slaves on Fort Pulaski Wearing Old Union Uniforms, Living in Outbuilding Around the Fort* (2015) depicts soldiers and their families uncomfortably adjusting to a new way of life in front of makeshift homes. *Some of the First Black Soldiers* (2015) offers somber compassion and grave dignity to the new soldiers in uniform, who had traded one form of servitude for another. Corso's paintings, influenced by documentary photographs of historic people and places, endow a shadowy, emotional humanity to an otherwise abstract military footnote.

Among the most common and traditional of marker topics, the "Savannah High School" historical marker gives a chronological narrative of the imposing brick structure's nearly one-hundred-year history. Included in the text is a reference to the school's integration in 1963. Inspired by the lives of the twelve African American students first chosen by the NAACP to attend Savannah High School, Elizabeth Cara used her research project to assemble a larger history of public school integration and the civil rights movement.[34]

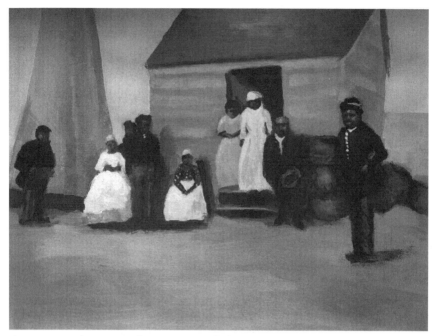

Figure 8.7. Erica Corso, *Slaves on Fort Pulaski Wearing Old Union Uniforms, Living in Outbuilding Around the Fort*, 2015. Courtesy of the artist.

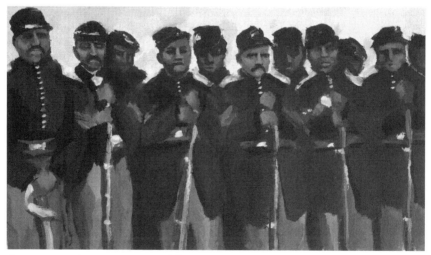

Figure 8.8. Erica Corso, *Some of the First Black Soldiers*, 2015. Courtesy of the artist.

An architectural photographer by training, Cara created photographs depicting Savannah High School today (still in use and now called Savannah Arts Academy); its shadowy halls, neatly organized desks, and imposing façade physically link contemporary schoolchildren to the brave activists who paved the way for integrated education. In *Savannah Arts Academy Hallway* (2015), tidy rows of lockers and institutional school desks stand in for the countless young bodies who have raced back and forth along this passage talking, laughing, fighting, idling, and learning. We imagine students navigating their school hallways as they navigated the fraught passage from childhood to maturity. Similarly, *Savannah Arts Academy Original Wooden Chairs* (2015) depicts empty seats in an auditorium, facing a stage that has hosted countless lectures, performances, demonstrations, and events. Names furtively scratched into desktops and elegant but worn scrolling metal seat supports reveal the marks of time and carry the memories of all students who have occupied this shared space, past and present. In documenting the historic building, Cara's haunting photographs pay homage to the people—students, teachers, administrators, and staff—who have filled these spaces with noisy human history.

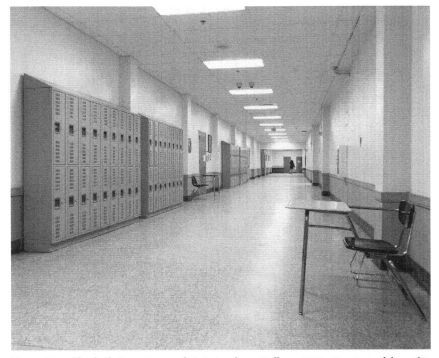

Figure 8.9. Elizabeth Cara, *Savannah Arts Academy Hallway*, 2015. Courtesy of the artist.

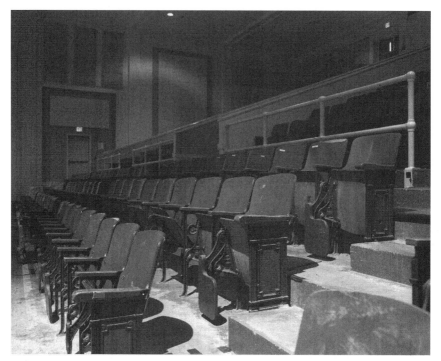

**Figure 8.10. Elizabeth Cara, *Savannah Arts Academy Original Wooden Chairs*, 2015.
Courtesy of the artist.**

These student projects and many others are displayed on the GHS website in the "Hidden Histories Online Exhibit."[35] As a web-based exhibition space, "Hidden Histories" expands the traditional historical narrative of the staid roadside marker and becomes another facet of public art, offering searchable, clickable public histories to complement and enhance the physical historical markers tourists encounter. Also, because the exhibit is linked through the online database of historical markers across Georgia, users searching for traditional markers can access the new material. Further, a mobile app allows travelers and residents alike to explore the content as an added feature in their search for markers near their current location or in preparation for coming travel to the area.

COLLABORATION OF TWO INSTITUTIONS

The Recording Local Histories project exemplifies the benefits of seemingly dissimilar institutions offering a diversity of perspectives and resources working together toward a common goal of increasing public knowledge of—and

connection with—our shared past. Further, while this project has been successful in addressing the goals noted earlier, SCAD and GHS have lately found common purpose in other related projects. As an example, GHS efforts to identify an appropriate place to locate a new historical marker highlighting local activities during the civil rights movement met with SCAD's related interest in recognizing a historic sit-in that occurred in what is now the College's main library. The result was a new historical marker located at the library's main entrance and a dedication ceremony that included selections of visual and performance art by SCAD alumni and students inspired by the story captured in the marker.[36]

Projects such as Recording Local Histories and the new Savannah Protest Movement historical marker demonstrate the value of collaboration in creating vibrant and lasting contributions to the historical record. By partnering with SCAD, GHS taps into a rich resource of artists and art historians who think critically about and create art as a way to understand place and culture. Further, the insight and creativity of the SCAD students provide new opportunities to expand both the more traditional historical narrative and the impact of the very traditional historical resource of the roadside historical marker. In turn, students are exposed to primary source material through archival research and gain a better understanding of how the documentary record can give life and context to our knowledge of the past and insight into the present. Finally, the inclusion of those archival materials in the online exhibit, a project intended to show the ongoing significance and inspiration of the past in our modern communities, underscores the value of those materials in understanding the development of communities and their identities.

CONCLUSIONS AND RECOMMENDATIONS

While GHS originally struggled with the best format for sharing the student projects, the current use of the online exhibit seems to allow for the most flexibility and best presentation for the created materials given the constraints of the overall institutional website. Projects are displayed as a type of gallery, giving primary focus to the newly created student materials but providing easy links to the original marker database. The inclusion of endnotes and suggested readings on the topics encourage users to extend their explorations into these stories even more deeply, while image credits and citations allow for later research using the highlighted archival materials. The online exhibit format also helps establish a distinction between institutionally created content and the student projects. The exhibit also provides students a more manageable way to access their work when referencing the project to others.

The digital format of this project also allows for the expansion and enhancement of marker content without actually replacing or modifying the existing structure. While in an ideal world, perhaps, the content and text of historical markers could be updated and expanded to include information gathered as a result of this project (and/or new scholarship), there are, of course, logistical and financial limitations on our ability to modify the physical markers. Naturally, there will always be the limitations on space that require the distillation of any story told through the medium of the historical marker into approximately 130 words. In this regard, markers will always act as a starting point for further exploration as opposed to a final and complete discussion of the topic. Further, at a cost of several thousand dollars per marker for replacement, the financial challenge of updating, revising, or expanding the text on existing markers (over two thousand in the state of Georgia alone) is a daunting task indeed.[37] In the end, it is the responsibility of those who craft modern marker text to encourage these tangential explorations by introducing a broad and inclusive narrative through the few lines available in this traditional medium. Hopefully the development of projects like the one explored here can actually encourage those who craft these texts to look broadly at topics with the goal of telling the most inclusive story possible.

After two years of coursework, preliminary conclusions suggest that the students' published projects have enriched the region's public history not only for the SCAD community but also for Savannah's residents and tourists as well as the broader online audience through a growing digital exhibition that explores, enhances, and critiques a portion of the local public historical record. Expanded further, Recording Local Histories positions Savannah as a case study for a larger critical reinterpretation of the history of place, one historical marker at a time.

While intended as a way for students to connect with their current community, the project has undoubtedly also given these students the tools to look more deeply at the ways that all communities present themselves, and to understand better the development of community and cultural identity based on the stories we share (and omit) in constructing the historical record. The project also furthers the goal of expanding available content for Georgia's historical markers while simultaneously increasing awareness of the GHS collections and encouraging new and innovative uses for those materials.

As a collaboration, this project highlights the value of combining the distinct yet complementary approaches of narrative storytelling and artistic response. Our shared past is rich with complicated and multilayered stories that inspire, sadden, outrage, and intrigue. While the topics explored through historical markers have certainly evolved and expanded over the past half-century, the presentation of information is still very straightforward and,

hopefully, objective. By contrast, the student projects examined here are designed to focus attention on a related yet distinct aspect of the marker story in order to help audiences better understand the complexity of each event, person, or place explored through the marker text and do so through the more subjective though often more personally affecting medium of visual art. Therefore, while the approaches may differ, the combined effect ideally shows the value of both in encouraging a connection with past. In this case, the markers—or more correctly the stories they either tell or omit—provide the inspiration, and the students through their energy and creativity encourage us to go beyond the presented narrative and consider the hidden histories that might lie just outside the boundaries of the written text.

NOTES

1. Student research projects can be viewed at: Georgia Historical Society, "Hidden Histories Online Exhibit," accessed December 14, 2015, http://georgiahistory.com/education-outreach/online-exhibits/online-exhibits/hidden-histories/. See also: Georgia Historical Society, "Georgia Historical Markers," accessed December 14, 2015, http://georgiahistory.com/education-outreach/historical-markers/.

2. Savannah College of Art and Design, "SCAD, The University for Creative Careers," "Georgia Historical Markers," http://www.scad.edu/.

3. Savannah Chamber of Commerce, "Economic Development," accessed December 14, 2015, http://www.savannahchamber.com/economic-development/tourism.

4. United States Census Bureau, "Quick Facts," accessed December 14, 2015, http://quickfacts.census.gov/qfd/states/13/1369000.html.

5. Stan Deaton, "The Past Never Changes But History Does," *Georgia History Today* 7, no. 1–2 (2013): 1–2.

6. Preston Russell and Barbara Hines, *Savannah: A History of Her People Since 1733* (Savannah, GA: Frederic C. Biel, 1992); Thomas D. Wilson, *The Oglethorpe Plan: Enlightenment Design in Savannah and Beyond* (Charlottesville, VA: University of Virginia Press, 2012).

7. Ron Stodghill, "Savannah: Both Sides," *New York Times*, October 3, 2014, accessed December 15, 2015, http://www.nytimes.com/2014/10/05/travel/savannah-both-sides.html?_r=0; Jim Morekis, "Two Savannahs: Further Apart Than Ever," *Connect Savannah*, October 7, 2014, accessed December 15, 2015, http://www.connectsavannah.com/savannah/editors-note-two-savannahs-further-apart-than-ever/Content?oid=2491716.

8. Holly Goldstein, "St. Augustine's Slave Market: A Visual History," *Southern Spaces* 28, September, 2012, accessed December 14, 2015, http://www.southernspaces.org/2012/st-augustines-slave-market-visual-history; Kwesi DeGraft-Hanson, "Unearthing the Weeping Time: Savannah's Ten Broeck Race Course and 1859 Slave Sale," *Southern Spaces*, February 18, 2010, accessed December 15, 2015,

http://southernspaces.org/2010/unearthing-weeping-time-savannahs-ten-broeck-race-course-and-1859-slave-sale.

9. See, for example, Michel Foucault, *The Archaeology of Knowledge* (Paris: Éditions Gallimard, 1969). See Also John Tagg, *The Burden of Representation: Essays on Photographies and Histories* (Minneapolis, MN: University of Minnesota Press, 1988); and Alan Sekula, "The Body and the Archive" in *The Contest of Meaning: Critical Histories of Photography*, ed. Richard Bolton (Cambridge, MA: MIT Press, 1989).

10. Paul M. Pressly, *On the Rim of the Caribbean: Colonial Georgia and the British Atlantic World* (Athens, GA: University of Georgia Press, 2013); Barry Sheehy, Cindy Wallace, and Vaughnette Goode-Walker, *Savannah: Immortal City* (Austin, TX: Emerald Book Co., 2011).

11. LAMAR Institute, "Reports on Savannah Archaeology," accessed December 17, 2015, http://www.thelamarinstitute.org/index.php?option=com_content&view=article&id=48&Itemid=58.

12. Michael Freeman, *Savannah's Monuments, The Untold Stories* (Atglen, PA: Schiffer, 2015).

13. Philip Morgan, ed., *African American Life in the Georgia Lowcountry: The Atlantic World and the Gullah Geechee* (Athens, GA: University of Georgia Press, 2010); Leslie Harris and D. M. Berry, *Slavery and Freedom in Savannah* (Athens, GA: University of Georgia Press, 2014); Charles Joyner and Georgia Writer's Project, *Drums and Shadows: Survival Studies Among the Georgia Coastal Negroes* (Athens, GA: University of Georgia Press, 2012).

14. See, for example, Denis Cosgrove, *Social Formation and Symbolic Landscape* (Totowa, NJ: Barnes & Noble Books, 1985); William Cronon, *Uncommon Ground: Toward Reinventing Nature* (New York, W. W. Norton, 1995); J. B. Jackson, *Vernacular Landscapes* (New Haven, CT: Yale University Press, 1984); J. B. Jackson, *A Sense of Place, A Sense of Time* (New Haven, CT: Yale University Press, 1994); D. W. Meinig, ed., *The Interpretation of Ordinary Landscapes* (Oxford: Oxford University Press, 1979); Paul Groth and Todd Bressi, eds., *Understanding Ordinary Landscapes* (New Haven, CT: Yale University Press, 1997); Yi-Fu Tuan, *Space and Place: The Perspective of Experience* (Minneapolis, MN: University of Minnesota Press, 1977).

15. SCAD Museum of Art, "About the Museum," accessed December 14, 2015, http://www.scadmoa.org/about/about-museum.

16. SCAD Museum of Art, "Permanent Collection," accessed December 14, 2015, http://www.scadmoa.org/art/collections/walter-evans-african-american-art; SCAD Museum of Art, "Exhibitions," accessed December 14, 2015, http://www.scadmoa.org/art/exhibitions/2012/fred-wilson.

17. SCAD Museum of Art, "Exhibitions," accessed December 14, 2015, http://www.scadmoa.org/art/exhibitions/2014/tim-rollins-KOS-painting.

18. SCAD Museum of Art, "Exhibitions," accessed December 14, 2015, http://www.scadmoa.org/art/2014/jack-leigh-low-country-photography-exhibition.

19. Telfair Museums, *Women Artists in Savannah, 1920–1960*, Telfair Museums Past Exhibitions," accessed December 14, 2015, http://www.telfair.org/womenartists;

Whitfield Lovell: Deep River, "Telfair Museums Past Exhibitions," accessed December 14, 2015, http://www.telfair.org/deepriver/; *Slavery and Freedom in Savannah*, "Telfair Museums Past Exhibitions," accessed December 14, 2015, http://www. telfair.org/slavery-and-freedom-in-savannah/; *Cheers*, "Telfair Museums Past Exhibitions," accessed December 14, 2015, http://www.telfair.org/cheers/.

20. Harris and Berry, *Slavery and Freedom in Savannah*.

21. Carrie Mae Weems, "Timeline," accessed December 14, 2015, http://carriemaeweems.net/.

22. SCAD Museum of Art, "Carrie Mae Weems Exhibition," accessed April 30, 2016, https://www.scad.edu/event/2016-02-16-carrie-mae-weems-exhibition-carrie-mae-weems-considered.

23. Michael Mergen, "Projects," accessed December 14, 2015, http://mimages.com/.

24. Ibid.

25. Mergen's series *After Selma-to-Montgomery* similarly depicts rubbings of historical signs that mark the civil rights route through Alabama layered over contemporary landscape photographs. For a discussion of Mergen's recent portraits of Confederate monuments, see Jack Hitt, "Stone-Faced Ghosts of the Confederacy," *New York Times*, October 16, 2015, accessed December 14, 2015, http://www.nytimes.com/2015/10/18/magazine/stone-faced-ghosts-of-the-confederacy.html?r=0.

26. More information on the Craft medallion and commemoration and the Savannah Women of Vision initiative can be found at: Barbara McCaskill, *Love, Liberation, and Escaping Slavery, William and Ellen Craft in Cultural Memory* (Athens, GA: University of Georgia Press, 2015); Savannah College of Art and Design, "SCAD Celebrates the Valor of William and Ellen Craft," accessed March 23, 2014, https://www.scad.edu/about/news-press-and-recognition/2016-02-12-scad-celebrates-valor-william-and-ellen-craft; Savannah College of Art and Design, "Savannah Women of Vision, Recognition Ceremony," accessed March 23, 2016, https://www.scad.edu/event/2016-02-12-savannah-women-vision-recognition-ceremony.

27. Dylan Wilson, "Projects," accessed December 14, 2015, http://dylanwilsonphotography.com/.

28. Dylan Wilson, "Sapelo Island, Hidden Histories Online Exhibit," accessed December 14, 2015, http://georgiahistory.com/education-outreach/online-exhibits/online-exhibits/hidden-histories/sapelo-island/.

29. Dylan Wilson, master's thesis text, and interview with Holly Goldstein, December 14, 2015.

30. Ibid.

31. Charlie Swerdlow, "History Depicted," accessed December 14, 2015, http://historydepicted.com/.

32. Erica Corso, "Paintings," accessed December 14, 2015, http://www.ericacorso.com/.

33. Susie King Taylor, *A Black Woman's Civil War Memoirs: Reminiscences of My Life in Camp with the 33rd U.S. Colored Troops, Late 1st South Carolina Volunteers,* edited by Patricia W. Romero (New York: Markus Wiener Pub, 1988), 9.

34. Elizabeth Cara, "Photography and Written Work," accessed December 14, 2015, http://www.elizabethcara.com/.

35. Georgia Historical Society, "Hidden Histories Online Exhibit," accessed December 14, 2015, http://georgiahistory.com/education-outreach/online-exhibits/online-exhibits/hidden-histories/.

36. More information on this project can be found at: *Savannah Morning News*, "State Historical Marker to Commemorate Savannah Civil Rights Struggle," accessed October 10, 2016, http://savannahnow.com/news/2016-09-21/state-historical-marker-commemorate-savannah-civil-rights-struggle; Savannah College of Art and Design, "SCAD Hosts Visionary Voices Tribute to Savannah's Civil Rights Movement," accessed September 24, 2016, http://www.scad.edu/about/news-press-and-recognition/2016-09-16-scad-hosts-visionary-voices-tribute-savannah-s-civil.

37. In July 2015 the Georgia Historical Society took the lead on statewide efforts not only to erect new historical markers but also to repair and replace the two-thousand-plus existing markers installed throughout Georgia since the early 1950s. Part of that project has been to establish a thorough process of review for all markers to be replaced that includes the review of marker text by independent scholars, ensuring that these state-owned historical resources remain an accurate representation of current knowledge on the topics they discuss.

Chapter Nine

Travelers, Tale-Telling, Truth, and Time

Rebecca Keller

Historic houses, public historic sites, archives, collections, museums, and similar and institutions represent methods of ordering knowledge. They are places where the world's cultural memory and visual production are organized and interpreted. These places make claims about what is important, and assert that certain values, narratives, images, and understandings deserve our attention and support. Such assertions about a place's importance or meaning are always subject to redefinition and renegotiation over time, and given to exceptions and generalizations.

As an artist, I am interested in the social structures that give context and meaning to my work and that of my fellow artists, and other creative practitioners. We obviously have a stake in the frameworks and institutions that support and expand the role that art plays in our culture. The opportunity to interact with historic sites, to respond to a particular historic context or collection, or to make work that engages evocative buildings and landscapes can be both enormously challenging and creatively satisfying.

In addition to the opportunities these sites offer artists, artists likewise offer historic sites and museums fresh ways of thinking about their collections, of expanding their reach and exploring new territories. An artist working in a historic site might suggest additional or alternative "readings" or create engagements with aspects of the narrative that have gone unexamined or unexplored. An artist may deploy their creative freedom to foreground stories or meanings suggested by the research but not firmly documented; evoke a sensory and alternative way of experiencing the space very different from the established approach; or uncover new connections to contemporary life. As art practice has become more open, contemporary artists are increasingly interested in deploying their skills and experience in new realms and in seeking dialogue with new audiences.

The idea of an artist working across disciplines, with a variety of contexts and in diverse venues, can be traced to the very beginnings of art as a profession. During the Medieval period, in the age of craft guilds, artists who were learning their trade would travel from town to town, working with different masters. These journeymen (and occasionally journeywomen) became the conduit through which the ideas from one place transformed the practices of another, and established the tradition of the artist as someone who can move between areas of expertise and social groups. A contemporary parallel to this is the capacity for artists to transmit the knowledge from one domain so it can resonate in another, working across disciplinary boundaries (like history and art). For me the idea of an artist as traveler—taking unexpected pathways through our cultural landscape and drawing on disparate bodies of knowledge—is a useful metaphor.

So when an institution invites an artist to use historical or archival research to create a new work, or use their art to create a new framework for experiencing a historic site, it is participating in a long history of inviting artists to introduce new ideas and "build linkages" between different areas of knowledge and interests and audiences. The resulting artworks can enlarge the symbolic, aesthetic, and educational possibilities of museums and historic sites. At a moment when historic sites and museums are seeking greater relevancy and social purpose, these projects demonstrate the potential of collaborating with artists as a means to engage with new audiences and broader, more surprising, relevant, or complex conversations.

For me, the practice of creating artworks in dialogue with a historic site—a place that is already generating multiple meanings—poses an exciting set of challenges and opportunities. I have been doing such projects for ten years now, in sites that have ranged from an 1801 anatomy theater in Estonia to a historic forest in Germany to a medical history museum housed in a mansion that is a reproduction of the *petit palais* in Versailles. Done under the umbrella title *Excavating History*, these exhibitions unfold in places that are charged with preserving, presenting, and interpreting our cultural legacies.

Several of these projects are described below, but before I discuss each specific project in detail, I would like to begin with a description of the kind of creative brainstorming I pursue when I am developing my work. I also list some analogies/metaphors and prompts, often drawn from other disciplines and areas of study, that spark my imagination and have proven useful in thinking about making and teaching the processes I have been engaged in for the last decade.

My practice in working in historic places is driven by the conviction that meanings buried in these sites can be connected to contemporary social issues. They acknowledge that history is:

- Shaped by the narrator
- Has a point of view

- Always leaves some things out
- Might have an agenda (consciously or unconsciously held)
- Makes assertions that are sometimes accepted without question
- Can reveal different truths depending on who is doing the telling
- Can be expanded or challenged
- Can spark an imaginative leap
- Can find expression in material and metaphor
- Expresses cultural values

MOST HISTORIC SITES OFFER A NARRATIVE

I sometimes think about the historic site or landscape I will be working in as a text. A book is obviously a text, but so too can be an oral tradition, a photograph or photo album, a movie. Basically anything that houses narrative—the container for a story or set of stories—can be thought of as a text. Historic sites act as containers for the stories the exhibitions and tour guides tell visitors about events that happened or ideas that came into existence in a given place, and especially, why it is important for us to care about these things now. In analyzing and experiencing these stories, I also pay attention to stylistic aspects—choices that give shape, resonance, expression, and tone to the narrative. For example, the same story may be shaped into a tragedy or an inspirational journey, offered as a fairy tale or a cautionary example. Such things as tour chronology, pathways, structure, artifacts, language, focus, and emphasis all are aspects I take into account because they affect how the narrative engages the intellect, senses, and emotions.

Most historic sites weave together many stories. But not everything can be highlighted or given equal space, and attention. I might use my artwork to intervene or respond to unexplored aspects of the existing narrative, finding places to make it resonate anew, or I might choose to introduce a new thread that enriches the tapestry in compelling ways.

It is important to point out that in historic houses and other museums there are often counternarratives to every narrative, contradictions and complications and arguable assertions embedded in the sites or clinging to the stories behind the objects. Importantly, the persistence of these stories may be among the most interesting aspects of these sites. An unverifiable but well-loved or persistent tale reveals much about what people want or need from a given place. This is especially true if a story remains popular even if it isn't presented in the official interpretation of the site. It might be that the culture and audience is telling us what is interesting and important, which brings us to the next intriguing conceptual challenge of working as an artist within these spaces: the idea of "Truth."

HISTORIC SITES GRAPPLE CONSTANTLY
WITH THE IDEA OF "TRUTH VALUE"

In logic or mathematics a "truth value" indicates the relation of a given proposition to truth. In classical mathematics, propositions are either true or untrue. In intuitive logic/mathematics, a statement is true if you can build a proof, and a statement is false if you can deduce a contradiction—but it allows for the fact that statements can be possibly true or possibly untrue. (I love this, because it is the way all history—and any other endeavor, really—works. We build on what we think we know, but sometimes we discover we don't really know as much as we thought.) Finally, advanced mathematics may involve something called "fuzzy logic" or "multivalued logic." Fuzzy logic asserts that we can recognize more than two truth-values—in other words, that there are degrees of truth, shades of gray. That true and untrue are not simple binaries. That it can be a case of *both/and* rather than *either/or.*

This applies quite directly to history. Historic sites can be beautiful *and* troubling, examples of inspiration and learning as well as places that reflect social attitudes we would take issue with today. Men who built great fortunes by objectionable means may have also left behind incredible art collections or important libraries. Social reformers who worked their entire lives to benefit others might leave letters or words that make us squirm; famous architects can be both gifted designers and imperfect human beings. Humans are complicated, and the places they build can be layered with multiple and sometimes contradictory legacies.

Assertions of truth are important to museums. They are important to the discipline of history and to our understanding of place. They are especially important, in fact almost essential, for public historic sites. But an artist may want to run with a story, taking it beyond what can be documented and proven. The artist might want to imagine the servant in the room, the child of the famous man, the immigrant worker cleaning the mantel. I may want to use my artwork to introduce a sensory experience that pushes into the realm of imagination, or evoke emotion—because the imagination and emotion are a central way that we connect with historic material. But though such speculative artworks may open the site up in new and exciting ways, they may also require the institution to stretch in uncomfortable directions. And even with the support of the curators, directors, and staff, there remains opportunity for discomfort. In fact, some discomfort might also be a sign of growth.

One of my earliest *Excavating History* projects took place at the Glessner House Museum in Chicago, and it demonstrated this dynamic for me in a vivid way. The prominent architect H. H. Richardson designed Glessner House in 1887. It was one of the few private residences Richardson ever designed, and

would be a significant house for that reason alone. The fact that it was built by a member of Chicago's business elite, has a nice collection of Arts and Crafts objects, and rather miraculously survived in a neighborhood that went through significant change not long after it was built (including the conversion of the house to a printing press), and that, more than a century later, is once again becoming an enclave of upscale residences, adds to the interest. The house was placed in the National Register of Historic Places in 1976.

H. H. Richardson designed the house in close consultation with the Glessner family. As I realized after I was invited to create a project there, the layout of the house can actually be read as a blueprint for the ways society was organized in the Victorian era, especially regarding domesticity and labor. Stories about class, education, gender, labor, and immigration are all quite easily discerned via the organization of space and the records of the planning of the house. So, after months of research (drawing on newspapers, ladies' magazines of the era, immigration and census statistics, poetry, anecdotes, and archives), I created a series of installations that made legible within the text of the house the narratives of the male and female servants, the schoolmaster, the butler, and the family. (The exhibition is described in more detail later.)

At the Glessner, as in many such house museums, visitors are taken through the spaces on guided tours: the house is not available for self-guided exploration. So as I was working on the exhibition, I had multiple discussions and informal conversations with the volunteers and docents who led the public through the house. The exchanges were meaningful, in depth, and interesting, and I welcomed their suggestions for research and the information they were able to offer me about the kind of questions they heard from the public during their tours. After my installations were in place in the museum, I had several additional sessions and discussions with the docents. Many became quite deeply engaged with this new way of "reading" the house.

However, later I heard an anecdote that highlighted just how complicated this work can be. Apparently a docent leading a group though the house ignored the artwork and the stories and questions it suggested until puzzled visitors finally asked about it. It turned out she had been out of the country during the conversations and docent orientations prior to the exhibition opening and had felt unprepared and uncomfortable discussing something with which she was so unfamiliar. Since long-serving volunteers come to feel very invested in the narratives of the house, it was no doubt challenging to see it disrupted. Fortunately, follow-up conversations helped her feel more at ease in discussing the installations in the context of her tours.

Despite that occurrence, the exhibition was a great success. In a meeting with Glessner staff after the opening weekend, I heard how they were

"thrilled" with the response from both the art community and, especially gratifying to me, the public who came for their regular tours. One docent described a couple from Florida as being "almost giddy" at the exhibition. The public radio station aired a review, and there was a marked increase in attendance.

ART AND INTERPRETATION, OR ART AS INTERPRETATION?

Public historic sites are like other museums and exhibition venues in that visitors are eager for engagement with ideas outside of their daily life and primed for the experience. However, people who visit historic sites are not necessarily the same audiences who visit contemporary art exhibitions, and vice versa. As my experience with the Glessner House Museum suggests, volunteers and staff members may be invested in certain aspects of a place, aspects that may be unsettled by the independent vision of the artist. Visitors to historic sites may not be familiar with the materials, methods, and approaches a contemporary artist deploys. Likewise, art audiences—used to the idea of art objects being autonomous, exhibited without reference to context or site—might resist folding the meanings already being generated by a historic site into the artwork.

For historians, curators, artists, and educators, the nature of these issues— of art's autonomy versus its obligation to the site, or legibility to the audience; of artistic license versus documentable truth; of traditional scholarship versus alternative types of research; of the relationship between traditional interpretation and poetic suggestion—are critical. Thinking through one's attitudes around these stances and strategies is important if one is interested in working with historic sites in innovative or creative ways.

The issue of information or context is an important topic for me in teaching as well. I see students struggle to figure out how much context or background to give, and how to do it, beyond the (often considered boring and uncreative) solution of a label. Likewise, questions around labels are always active for museum people: How long should they be, how extensive, and where should they be situated? In art museums labels tend to be short. Many curators do not like to include them. Other types of museums are often more label friendly (notably science and natural history museums). Historic sites vary widely. Some depend very much on written labels. Others, which can only be visited in the context of a tour (like the Glessner House, mentioned above), have almost no labeling, since contextual information is delivered verbally in the course of the tour.

In several of my installations, the artworks themselves contained rather extensive text. In one instance in the Glessner House, I turned the jars in the kitchen pantry into "bar graphs" and used text printed on pairs of jars to connect historic issues to contemporary life. For example, in one jar I placed a small layer of pennies. The text described what domestic laborers in a similar house were paid in 1900. I filled the jar next to it nearly full of pennies and added text that referenced the famous decades-later case of Zoe Baird, whose nomination to be US Attorney General was derailed when it was discovered she had used poorly paid, undocumented immigrant workers. The text on that jar read: "In 1998 Zoe Baird withdrew from consideration as Attorney General of the United States when it was revealed she used undocumented workers as domestic labor. At the time, Baird had a household income of $600,000.00. She paid her workers $5.00 an hour." Another pair of jars held maps and text referencing source countries for domestic workers in 1900 and 2000, and another was filled with white gloves next to a jar with ocher, brown, and mahogany gloves, along with text relating to the racial background of domestic laborers.

In this installation, as in others in the Glessner, I worked within the existing museum displays and added objects, facts, and commentary—which literally "recontextualized" the collections. In these examples, the text was *part* of the artwork, although its inclusion made the point of the artwork quite clear (in fact, one reviewer suggested I veered too close to the didactic). In this case the line was blurred between strategies museums have traditionally used to interpret the exhibitions (labels) and my artistic intervention itself.

In a later project at the International Museum of Surgical Science in which I intervened in the Hall of Immortals (described below), I maintained a more traditional relationship between the artworks and the explanatory labels. The museum already had wall text explaining which "Immortal" medical hero the statues represented and why they were so honored. Beneath these existing labels I added a separate label discussing the artworks I had added to the gallery, in a different font and more poetic and reflective "voice," explaining my interventions—layering the information, just as the exhibition had multiple layers.

These examples reveal one of the animating tensions inherent in making art in historic sites: these artworks are autonomous creative expressions, *and* are simultaneously part of the interpretation of the site. Considerations of how the expectations various audiences bring to the experience can be honored and accommodated are part of the process.

The most important thing for me is understanding that these are opportunities: moments where new ideas, fresh narratives, and provocative gestures can blossom. Despite the isolated incident of the tour leader at the Glessner

House, the success of the project became clear to me again five years after the end of the exhibition. I was introduced to someone at a party, who heard my name and asked, "Did you ever do work at the Glessner museum?"

When I answered affirmatively, he told me in great detail about the "exciting, eye-opening" experience he had while visiting the exhibition. He said, "I didn't know art could do that."

BECAUSE HISTORIC SITES HAVE EXISTED OVER TIME, THEY CONTAIN MULTIPLE HISTORIES

It might seem obvious when discussing historic places that time enters into one's thinking, but certain points are worth repeating. A place or an object or an artwork might mean one thing when it is created, quite another as years of use and cultural change and multiple interpretations accrete in our minds and in the way we experience the object or place. For example, consider the way we think about a painting by Picasso. Whatever it might have meant in 1910, by the year 2010 any such painting had acquired many additional (and some contradictory) meanings. Every article about Picasso, every exhibition, every subsequent scholarly discovery or headline-grabbing auction price adds to the freight borne by the painting. And after a century, familiarity—if nothing else—changes our experiences and perceptions. The same is true for places.

What a historic site emphasizes, and how that interpretation is shaped and communicated over time, is a fascinating and often unexamined aspect of working within these places. As an artist I am drawn to the opportunity those changes might offer. Examining the difference between the reasons a house was initially preserved and the reason it continues to be supported can be a revealing avenue of inquiry. My research often asks, "Who are the stakeholders? Whose story gets told, and who gets to tell it? What sort of work is this site doing, what is it communicating? To whom?" These are complicated questions, but they are issues that need to be addressed and asked repeatedly as culture changes and what are deemed to be the important aspects of each site respond to cultural shifts. For example, perhaps at one time the biography of a wealthy family that built an important house was of greatest significance, but over time the way the servants reflected local immigration, or the medicinal plants and botanical collections of the gardens, have risen in importance and public interest.

Historic sites are palimpsests—places where stories are inscribed and reinscribed atop other stories, and where multiple meanings and interpretations of the same story and place are layered. The word *palimpsest*

originally meant a manuscript (on animal parchment) that had been written on, scraped off, and used again. *Palimpsest* comes from Latin ("again" + "I scrape"). In architecture it refers to a ghost image of what was once there; that is, the outline of a demolished structure on an adjacent building. For me, palimpsest is an evocative description of the way people experience time, as a layering of present experiences over past ones; interweaving of personal references with place; drawing connections between public events and private meanings; and seeing multiple meanings embedded in a single location.

A historic house is claimed by multiple uses and embodies multiple pasts. Such a place is already generating multiple meanings. I work to understand and "excavate" these established interpretations, but at the same time tease out new meanings that emerge from research and imagination. In artworks such as the examples below, I hope to uncover new poetry and politics layered within these places.

In these projects the artwork is both *site generated* (based on considerable research into the particular qualities, histories, and contexts the site presents) *and site responsive* (made in creative response to the research as well as to the physical and social aspects of the site). I have coined the term *site complicit* to describe the interplay.

The following are a few examples of *Excavating History* exhibitions. They have taken place in significant buildings, museums, historic houses, and important landscapes in the United States and Europe. They began with research into the various histories associated with the site and the collections, into overlooked narratives and alternative readings, along with official interpretations. These projects engage multiple contexts, narratives, and connotations of place.

HOME/WORK, HOUSE/WORK: A MEDITATION ON LABOR AT THE GLESSNER HOUSE MUSEUM

I have already described some of the research that went into the development of this exhibition. The house features several unusual aspects created in response to the Glessner family's request that it be designed so the servants could go about their work without having to pass through the family areas. The result is a building that manifests spatially the various roles and status of the people who lived and worked there. Take, for example, the case of the butler. A butler was the one servant who was supposed to be seen. Since butlers were always men, and men had more economic/employment options, it was difficult to find and keep a butler. Having one was a mark of status.

Figure 9.1. *Home/Work House/Work: A Meditation on Labor*, Glessner House Museum, 2006–2007. Courtesy of the author.

As the servant who handled the silver and the wine, butlers also were entrusted with objects of high value. In the Glessner House, the butler's pantry was placed directly off the dining room, providing a liminal zone between the family areas and the kitchen and other servant/working areas. However, the rest of the staff had to reach the kitchen (unseen) via a special servant's hallway. Likewise, the school room was situated in a sort of mezzanine all its own, halfway between the servant's level and the family rooms. The schoolmaster/tutor was not exactly a servant, but certainly not family. His position was reflected in the architecture.

The Glessner House was H. H. Richardson's final work, and is a highlight of what has been called Richardson Romanesque. But in *Home/Work House/ Work* I shifted the focus away from the architect and instead engaged the house as a workplace. The exhibition explored the relationship between immigration and people in "serving" work, yesterday and today; "women's roles"; the idea of the perfect household; and status and class. I spent months researching the social and economic realities of similar households in 1900. The installation drew on labor and immigration statistics, early twentieth-century manuals on how to hire and train servants, women's magazines, literary sources, and other journalistic documents. The media of my artwork ranged from sepia drawings on vintage curtains or inserted into antique photo albums, to using jars in the kitchen pantry to form a bar graph, to Victorian aprons adorned with paintings, re-made vintage labels, and schoolroom slates.

JANE ADDAMS HULL-HOUSE MUSEUM

The Jane Addams Hull-House Museum is the original home and settlement house of social reformer Jane Addams, preserved as a national landmark and

museum. Working there was an enormous opportunity: in addition to the inspiring example of Jane Addams herself, there is a commitment on the part of the museum to continue Addams's legacy of social justice work, and an openness to having that legacy be reengaged and brought into contemporary resonance. The narrative of innovation, service, and social purpose that infuses Hull House influenced my installation.

Addams's vision was so compelling that people from all over the world came to Hull House to live in the residence hall and join Addams's efforts. Some stayed for years, and their contributions led to the development of the professions of social work, public health, and public education. Addams was also convinced of the importance of immigrants' handicraft traditions, feeling that connections to culture were as necessary as food and shelter to people's sense of well-being. To this end she instituted classes in arts and crafts, taught for and by the immigrants with whom she worked.

The three specific data points that informed this installation were:

1. Addams recognized that some of the Mexican immigrants she was working with were skilled ceramicists, so she initiated a Hull House pottery, the products of which were sold on Michigan Avenue and other locations.
2. For all of the work the residents-volunteers did to create change in society, their letters and testimonials made it clear that they themselves were deeply changed by their experience.
3. Some of the arts and crafts classes took place in the front parlor of Addams's home, which had originally been painted a terra cotta color.

Responding to this research, I decided to line the entirety of Addams's front parlor (where some of the classes were held) with clay, painstakingly rubbing it (with the help of volunteers) into wall-sized panels cut to fit the architecture, which were then used to line the rooms. The effect was that the walls were made of softly glowing terra cotta clay. When one looked more closely, one could easily discern the fingerprints and marks left on the surface by all the individuals involved in its making. The piece clearly referenced collective labor and the Hull House history of ceramics. Perhaps more importantly, visitors were encouraged to touch the walls. Since the clay was oil based, it remained soft—allowing all who visited the exhibition to "leave their mark." However, the house also "left its mark" in return—a faint trace on the fingertips of anyone who touched the clay, creating a lovely poetic exchange.

On two separate occasions, the Hull-House Museum also allowed me to work with my students from the School of the Art Institute of Chicago. Con-

Figure 9.2. *Fingerprint by Fingerprint,* Jane Addams Hull-House Museum, 2010. Courtesy of the author.

temporary iterations of the work that Addams pursued—immigration policy, food and nutrition, advocacy for labor and civil rights—were all aspects of the work that resulted.

One of these collaborative works focused on Addams's commitment to suffrage by imagining the exterior of the house as a body. I created a giant Women's Suffrage Committee sash, wrapping the house with it. SUF-F*RAGE* buttons attached to the banners, designed by students, were for visitors to take.

PHILOSOPHER'S THRONES FOR
THE NEW MILLENNIUM

In Darmstadt, Germany, an unusual exhibition is held every two years. It is the Waldkunst—or Forest Art Biennial. This exhibition consists primarily of outdoor work, but not in a prepared landscape or sculpture garden. The art is installed in a large, unruly forest and is not meant to be permanent. When I was asked to participate, responding to the theme of Cycles and Systems, I decided to create my work completely outdoors and on site, in such a way that the public would be able to observe, discuss, or even assist in making.

In doing my preliminary research I discovered that this forest has a *Goethe Felsen*—or Goethe's stone. This was a boulder where the famous German philosopher and poet retreated to ponder and imagine. I considered how, in Goethe's time, a solitary genius created knowledge, but in our time knowledge is constructed collectively and socially. I wanted my work to reflect this way of thinking. I also wanted my project to involve people who used the forest in their everyday lives. Finally, I decided that the process and the material I used had to be environmentally responsible and essentially leave no footprint over time.

In response to these criteria, I decided to situate my pieces where two paths through the wood intersect. I used an earthen building system called "cob," which relies on a mixture of clay, sand, and straw. It is environmentally friendly and also culturally appropriate, since it was commonly used through much of prewar Europe. (There is a renaissance of interest in cob as people rediscover "greener" building technologies.) With a floor and a roof, this building system can be quite long lasting. However, my structures were designed so they would melt into the forest, reflecting the Waldkunst 2008 theme of Cycles and Systems.

The "Philosopher's Thrones" I created were on opposite sides of a crossroads. Most are in the shape of beehives, reflecting the idea that knowledge is collectively constructed and shared across boundaries and borders. The "thrones" are placed in conversational groupings. People could occupy one side and talk among themselves, or engage others across the divide. As I worked, passersby and visitors stopped and talked, or mixed cob, or lent a hand. (Occasionally this presented difficulties, as when an enthusiastic child accidentally knocked down one of the structures.)

Other "thrones" took the shape of tree trunks. The forest can also function as a social space, where trunks traditionally serve as "furniture." My trunks were a humorous gesture, meant to acknowledge the idea that placing art in a forest is a little preposterous. Finally, just as real tree trunks eventually melt away and decompose, so too did these artificial versions. I saw my role in this project as negotiating private symbolism and public meaning making.

INTERNATIONAL MUSEUM OF SURGICAL SCIENCE

In 2011 and 2012 I was invited to create an *Excavating History* exhibition at the International Museum of Surgical Science (IMSS). I chose to focus on the museum's Hall of Immortals, a large room in the former mansion lined with statues of important figures from medical history. This large permanent

exhibition dates to the mid-twentieth-century establishment of the museum. The statues of famous physicians range from Imhotep (actually declared a deity in ancient Egypt) to Madame Curie. Each statue has some indication of what the "Immortal" doctor was famous for.

I wanted to challenge this idea of the *Doctor as God*, which was the notion undergirding the Hall of Immortals. I began thinking about the way saints are depicted in Renaissance painting—holding attributes that are identified with their miraculous deeds. (For example, St. Lucy was supposedly martyred by her eyes being gouged. She is often portrayed holding her attribute of a bowl with eyes and is the patron saint of the blind.)

For each statue in the Hall of Immortals I created an additional "attribute" using materials ranging from chlorinated lime to papyrus to items found in the museum's collection. I also put gold leaf around the base of each statue to signify their "Godlike" status. Pictured here are Imhotep (with papyrus and reed pen, imported from the oldest papyrus-making site in Egypt); Roentgen and Veselius, author of the first accurate anatomy book based on human dissection.

The books piled in front of Veselius's statue are anatomy books from the museum's adjacent library, where it becomes very clear that medical information develops as each researcher takes into account what came before and adds to it. Sometimes the paths are fruitful; sometimes they are dead ends or wrong turns. To reflect this we also created an installation in the library using antique laboratory glass from the museum's collection and copper

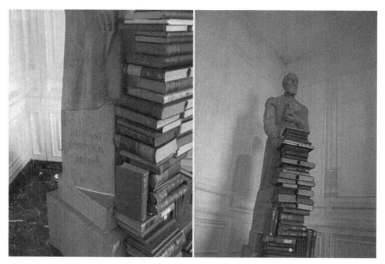

Figure 9.3. *Attributes of the Gods: Veselius,* International Museum of Surgical Science, 2011. Courtesy of the author.

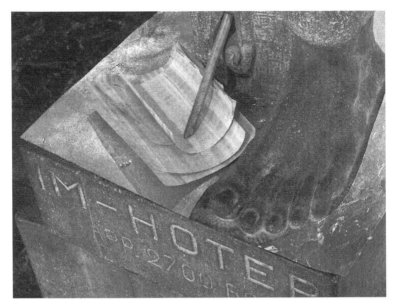

Figure 9.4. *Attributes of the Gods: Imhotep,* International Museum of Surgical Science, 2011. Courtesy of the author.

tubing. *Knowledge Distillery* underscores the precariousness of the process of research and knowledge. Finally, in an effort to puncture the solemn and somewhat morbid tone of a medical history museum, as well as address the idea of the Doctor-God with humor, I wrote out doctor jokes on Victorian mourning stationary and deposited them throughout the museum.

At the IMSS I invited several other artists who had been students in my Excavating History classes at the School of the Art Institute of Chicago

Figure 9.5. *Knowledge Distillery,* International Museum of Surgical Science, 2011. Courtesy of the author.

to participate in the exhibition. As we discussed the process it became apparent the site was so rich that we could each do multiple iterations of our ideas. I proposed a residency-exhibition, in which ideas and installations could continue to evolve even after the opening. In addition, because of this prolonged engagement, we were able to do innovative programming. This included a collaborative tour with medical professionals and a reading circle where authors brought in texts related to health and healing. For Thanksgiving we put together a program called "Feast, a Comparative Herbacopia," in which a medical historian and herbalist discussed the differences in herbal medicine between the native peoples and those arriving from Europe. The presentation was followed by a tasting of medicinal herb teas, tinctures, and baked goods. This model of prolonged engagement has been adopted by the IMSS, which now has a regular program of artists-in-residence.

WINGS AND WORDS: EXCAVATING CHESTERWOOD

Daniel Chester French, who gave us the stately image of the president in the Lincoln Memorial, was one of the most prominent sculptors of the late nineteenth and early twentieth centuries. Chesterwood is his home and studio nestled in the mountains of western Massachusetts. Now a national historic site and museum, Chesterwood is comprised of the original home, his large public studio, a smaller, more private "Meadowlark" studio, and several buildings that now exhibit a collection of French's work.

As the first artist-in-residence to activate the house (as opposed to the grounds or the studio), I worked with several tropes or themes. The first grew out of observations about French's work itself. French, as was common in his day, relied on a sculptural vocabulary of allegory and symbolic representation. This is a very different approach than that of most contemporary sculptors. Another conceptual touchstone emerged as I went through his archives. Sifting through boxes of letters, photos, invitations, reviews, clippings, and notes, I realized that French was connected to a wide circle of writers, designers, dancers, editors, and teachers as well as artists. He corresponded with everyone from Emily Dickinson and Mark Twain to Isadora Duncan. I began to see him as a bridge figure: someone who connected the pastoral America of the nineteenth century, of the Concord circle and the Transcendentalists, to the industrial modern America of the twentieth century.

After my initial visit to Chesterwood, I wrote the following in my sketchbook:

Themes: Flight; art and writing as uplift; natural beauty as path to the sublime; French's place in American arts and letters; a kind of democratic innocence in the accessibility of his imagery (allegory).

Visual and Material Tropes: veiling; molding/casting/cutting away (as both metaphor and artistic process); ethereality and transparency; winged-ness; connecting to/framing nature's beauty, writing, corresponding, connecting with other creative individuals.

From these ideas and observations I developed the following installations:

Who's Who (inspired by the illustrious people with whom French corresponded): in French's library I surrounded his typewriter, where he wrote his voluminous correspondence, with columns of books from his library, many written by his friends, forming a tableau. Yards of silk typewriter ribbon flowed from the keyboard in an artful arrangement, curling and pooling at the feet of columns of books, like a fountain.

Callers (related to the *Who's Who*): in the entry hall I placed "calling cards" of creative people who had visited the house or were connected, socially, geographically, and/or aesthetically, to French, including people such as Isadora Duncan or Louisa May Alcott. The cards contained the name of the guest on one side, and on the other, a brief indication of their relevance. These were available for people to take away, and served the additional purpose of conceptually grounding one of the themes of the exhibitions: French's connections to the important artists, writers, and thinkers of his day. This gesture of hospitality also obviated the need for a label and added power to the other work.

Taking Flight: in the passage between the kitchen and the entry hall I installed silken "wings" in such a way that the visitors were literally brushed by the silk as they passed underneath, creating the sense of entering a special place; of being touched by otherworldly concerns. This referred to the theme of nature and the function of Chesterwood as a place removed from prosaic distractions through a visual trope (wings) that French frequently used. It also connects to his studies of birds and various quotes ("I was an ornithologist before I became a sculptor"), and to the Trancendentalists with whom French is frequently associated.

Outlook: I created an intervention in the crowded but evocative spaces of the dining room and parlor by combing through pages of French's distinctive cursive, deriving a font from his handwriting, which I used to create vinyl laser-cut quotes from his letters for the windows and doors.

Conversations: in an archive I found photo studies of his works in progress. Although these were in poor shape, I digitized them and had them printed on watercolor paper, and then created drawings and paintings, sometimes using unconventional materials, upon the images that were in conversation with the photos.

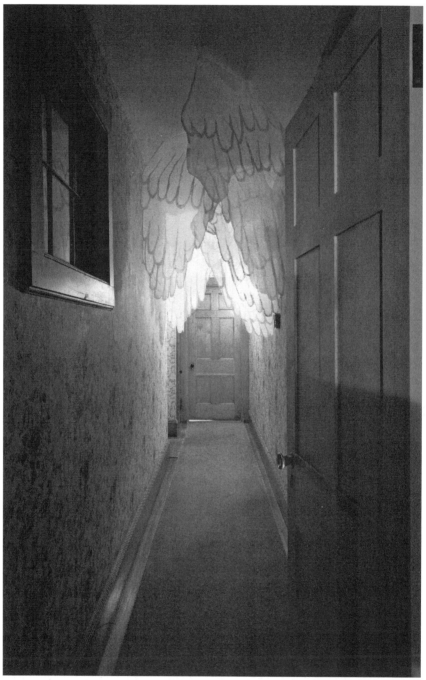

Figure 9.6. *Taking Flight*, Chesterwood, 2013. Courtesy of the author.

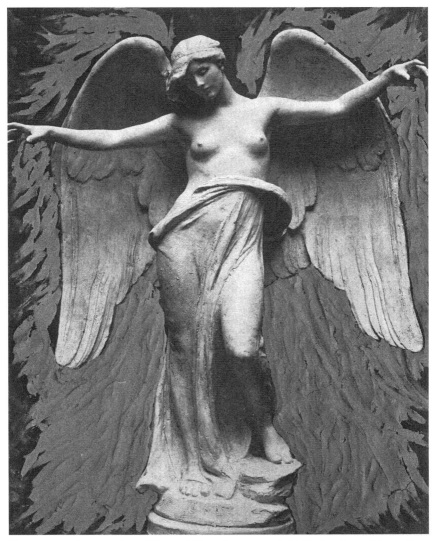

Figure 9.7. *Conversations: Wings of Clay*, Chesterwood, 2013. Courtesy of the author.

VIRTUAL SITES: OBJECT STORIES
AT THE PORTLAND ART MUSEUM

The web is now an integral part of exhibition planning and museum interpretation. Many museums also recognize it as an additional exhibition site. The Portland Art Museum (PAM) took advantage of this when they launched *Object Stories*, a multifaceted examination of how we find meanings in objects. It consists of both a dynamic online archive and a physical presence in the museum.

The "real world" presentation was in a centrally located gallery within the PAM. Several objects from the collection were exhibited on the walls and in vitrines, along with computers on tables. To one side was a video story booth. The video booth was the crucial link between the real-world objects and the online archive on the *Object Stories* website (objectstories.org).

When one visits objectstories.org, the "about" section of this searchable archive states:

"Drawing from material culture, thing theory, anthropology, museum education, and traditions of storytelling, *Object Stories* . . . is an open-ended exploration of the relationship between people and things, the Museum and the community, and the subjective and objective."

It goes on to inquire: "Do you have an object you would never give up? . . . Something that evokes a time in your life, a place you miss, or something you hope for? These connections between people and their things are at the heart of *Object Stories*."

As visitors to the website explored the online archive, they came across cards that said things like "My Cheap Old Wallet" or "Broken But Kept Forever." Clicking on these cards led to brief audio/visual clips, recorded in the museum's video booth, in which the owners hold objects up to the camera and explain why they are personally meaningful. Mixed in with stories of objects brought in by the public were stories in which museum staff or art professionals tell why they have affection or love for particular objects in the PAM collection. Some of the objects from the collection were displayed in the *Object Stories* gallery, next to computers set up to encourage exploration of the online "Object Stories" archive.

The Portland Art Museum asked me to create an intervention in this process; to use the same sort of approach I would in a more traditional *Excavating History* exhibition, but to do so with an aim toward intervening in the online archive: in other words, to use objectstories.org as my "excavation" site.

In researching the PAM collections, I discovered it is best known for its Northwest Coast Native American, Asian, and decorative arts/silver. One shared aspect of these is that many of the objects were made to be functional. The more I researched the more I began to see this as an opportunity to explore what it means when objects are removed from their original contexts and to poetically reflect on cultural and temporal displacement, on demonstrations of class and wealth, on differing notions of beauty, and on the problematics of displaying objects from dominated or colonized cultures.

If These Things Could Talk explores the hidden lives of museum objects by casting them as storytellers. I created two pieces, a monologue and a dialogue, and inserted them in the archive.

The monologue was written in the "voice" of an ornate Queen Anne English silver pitcher. The monologue imagined the pitcher as imperious, sexy,

and vain but nostalgic for human contact, and missing its rightful place at the head of a lady's table. It includes the lines:

> Little do people know, but silver is like pearls. I warm to human use. The cold white light I emit grows soft and lovely with use, even as my crevices darken with tarnish . . . filling in my chasing, my etchings, my shapes, my hollows, my secret places.
>
> How did I end up here? How is this me? What am I doing locked in this vault, this mausoleum of the beautiful and boring?

In a reference to class and value, the monologue concludes:

> Still, the people here do look at me, because this is a place that knows what is special. They lean in to see my secrets, and discover that my surface, no longer filled with wine and breath and life, is a mirror. Of what they hold important.

The second recording was a "dialogue" between a first-century Chinese storage jar and a Tlinglit spoon. Both of these functional objects draw on aesthetic traditions much different than that of a British silver pitcher. The dialogue begins with the Tlinglit spoon remembering its origins as a humble sheep's horn, and talks about being adopted into a new culture. The storage jar, older, wiser, more cynical perhaps, challenges the word *adopted* and asks if she doesn't mean *dominated* instead. I imagined the Native American spoon as the younger of the two, more earnest, trying to figure out whether or not she belongs. She is native to the place, so therefore *not* exotic, but of course, she is "other" vis-à-vis the dominant culture, and so she wavers between believing the dominant culture sees her as an honored relation . . . or as conquered and dominated.

The Chinese bowl is more worldly and skeptical, and because she is definitely foreign to these shores she has no conflict about even wanting or hoping to belong. So she claims her "other-ness" proudly and counsels the spoon to do the same.

Thus, in poetic and evocative language, the two engage in an emotional exchange in which they conclude that they share common ground as objects removed from their home cultures, made with different standards of beauty. The dialogue ends with the Chinese jar comforting the Tlinglit spoon:

> Come little sister. Nestle here. See—we things made to be of use, we almost fit. We have ourselves, our thing-ness, our otherness—the traces of the people that made us rubbed into our skins, the remembrance of their appetites, the names the people here cannot speak or spell spilling from our mouths . . .
>
> So let's claim our otherness, since that is what is left us.
>
> Our beauty that unsettles other beauties.

These works were professionally voiced and inserted into the archive, (they are now available on YouTube). These narratives illustrate how the

shift from one culture to another, and from private use to public display, transforms their value, changing them from functional objects to artifacts, and suggesting both the poetry and the politics embedded in museum collections.

IMPOSSIBLE SITES/MIGRANT OBJECTS: COLLECTIONS AS SITE

Dreams Are the Guardian of Sleep

One of the challenges I face as an artist is that my imagination may be captured by the possibilities of a site to which it is not possible to gain

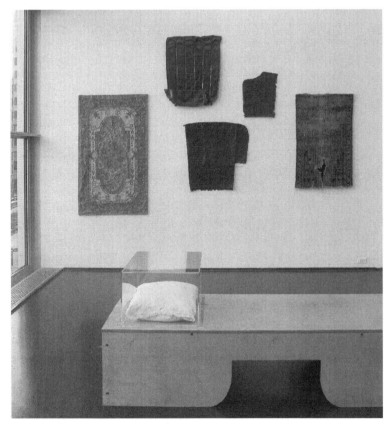

Figure 9.8. *Dreams Are the Guardian of Sleep* installation view, Museum of Contemporary Art Chicago, 2014. Courtesy of the author.

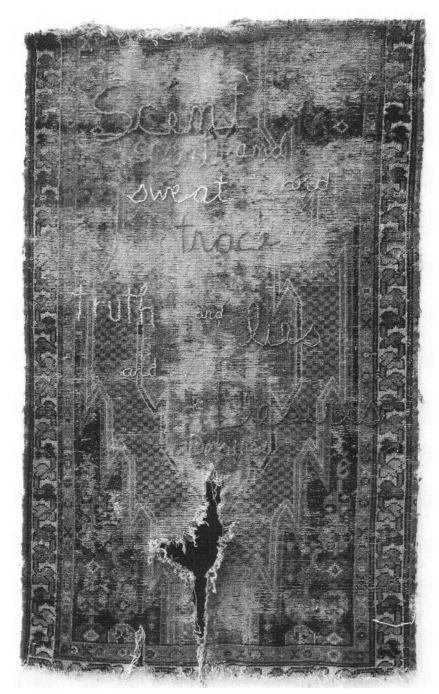

Figure 9.9. *Scent and Trace of Truth and Desire*, 2013. Courtesy of the author.

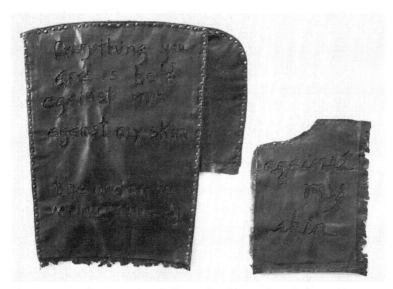

Figure 9.10. *The Organ for Binding and Writing* and *Against My Skin*, 2013. Courtesy of the author.

access. Some sites are too difficult to negotiate, or too fragile, or exist only in memory. For several years I have been developing a file/archive of ideas and sketches for these *Impossible Sites*, imagining works that were site generated but not necessarily site based. *The Way of the Shovel*—a major international exhibition that showcased contemporary art generated from historic research—offered me the opportunity to create work about one such Impossible Site: Sigmund Freud's consulting room.

Freud was a serious collector of antiquities and was very intentional in the way he deployed his artifacts in his consulting room, including the insistence that his famous couch be covered with an antique Kilim rug. This led me to imagine a sibling rivalry between the couch and the rug. Eventually this resulted in a large installation, *Dreams Are the Guardians of Sleep*, which featured vintage rugs, beaded, pierced, and torn; leather harvested from vintage couches containing text burned into the hides; and a museum bench/ sculpture, based on the design of Freud's couch, which also functioned as a vitrine to hold a pillow (asserting a connection between the dreams that Freud analyzed and the museum objects he collected).

A further iteration is my project *Impossible Sites/Migrant Objects*, which examines museum collections—made up of what art historian David Joselit calls "Migrant Objects"—as another type of site: one that shapes our thoughts about our collective pasts. So my work now is two-pronged: I continue my

Figure 9.11. *Migrant Objects.* Courtesy of the author.

engagement with physical historic sites and also pursue *Impossible Sites* and *Migrant Objects*—projects that reference historic/cultural sites but can exist autonomously or on the web.

An evolving aspect of *Impossible Sites/Migrant Objects* responds to the digitalization and other widespread dissemination of images and objects reproduced from museum collections. For one migrant object installation I used the 3-D files publicly shared by museums to create tabletop dioramas that "excavate" what it means when an object from one culture/era is placed in a museum context, its meanings partially determined by imposed systems of classification.

CONCLUSION

Museums, art collections, and historic sites of all varieties are invested in organizing the world's cultural memory and social organization, and in staking claims for certain values, narratives, and understandings. My *Excavating History* projects, and similar undertakings by other artists, explore the stories and values reflected in these sites—and within our cultural ecosystem. These projects offer a meditation on what the continual recasting of contexts and histories might mean in an increasingly complex and contingent world. They engage difficult or overlooked history and bring new audiences into historic sites and new ways for art to encounter the world, creating opportunities for collaboration and participation. My aim is that this work moves beyond institutional critique to engage broader politics and poetics, paving the way for creative and expansive programming, and opening up museums to more progressive readings. Located where architecture, history, and audiences intersect, I want these research-driven, site-generated art practices to unpack the narratives that help shape our cultural imaginary.

Conclusion

Rebecca Bush and Tawny Paul

When we set out on this project to explore the varied intersections between public history and art, as public historians we were interested in how incorporating art into our practices and working with artists as collaborators could help us interpret the past, tell stories, and engage audiences. The case studies in this volume make clear that interdisciplinary practice can be beneficial in all three of these areas. The tools and perspectives of artists can encourage us to interpret evidence in new ways, sometimes pushing at our assumptions about what constitutes legitimate historical evidence. Art can help us tell more varied, imaginative, and inclusive stories. Artistic interventions can challenge standard narratives and make new meanings of past events. And for museum visitors, from elementary schoolchildren to tourists in their cars, art helps us engage diverse audiences in creative ways. The case studies in the book reveal that collaboration can bring mutual benefits. We came at this project from the perspective of public historians. While we explored the ways in which art can push at public history, we also learned that public history can push at artistic practice and interpretation. As the studies in this book reveal, there are challenges. These emerge in all phases of a project, from planning to delivery. They come in both conceptual and practical forms, shaped, for example, by institutional contexts. The studies in this book also show that we can successfully tackle one of the biggest challenges of all: the feeling of intimidation that comes with crossing boundaries of discipline and perceived expertise. As Bob Beatty said in opening this volume: "I don't know art from Adam." But if we are going to encourage our audiences to take intellectual risks and be challenged, then so should we.

It is our belief that a good book should raise as many questions as it answers. This volume is intended to spark conversation and begin deeper discussions about the intersections of art and public history within both fields.

It is not intended to be an exhaustive treatment of the subject, and inevitably some intriguing aspects have been underexplored. It is our hope that these topics, which undoubtedly warrant serious study, will be examined in future articles and books, or in panel discussions at any number of professional conferences. The projects and methodologies presented in these pages represent a broad range of interdisciplinary approaches, but they are by no means the only worthwhile or noteworthy areas of focus.

Digital humanities and arts projects, often funded by grants and public universities, have created a myriad of new collaborative possibilities. Beyond museums' digitization of their collections into publicly accessible databases, digital humanities initiatives stretch to universities as wide ranging as the University of South Carolina, the University of California-Los Angeles, George Mason University, Loyola University Chicago, the University of Nebraska, the University of North Carolina-Chapel Hill, and the University College London. These institutions, among others, currently offer course-work and certificates in digital humanities. The National Endowment for the Humanities has established its own Office of Digital Humanities that awards its own grants. NEH staff note that one of the office's goals is to "encourage collaboration across national and disciplinary boundaries" in order to better address "the broad, interdisciplinary questions that arise when studying digital technology."[1] By building interdisciplinary study into the crux of digital humanities projects, scholars, museum staff, artists, librarians, and others signal their willingness to build on new collaborative approaches and gain an understanding of its benefits.

Digital humanities projects can connect both diverse users and distinctive forms of evidence to weave new and complex stories. The London Lives project, for example, allows users to link manuscript evidence from multiple archives in order to build up individual "biographies." The project is a major breakthrough in the field of "history from below," allowing us to access the lives and experiences of individuals often left out of the historical record.[2] Like many forms of digital humanities, the project invites a broad audience into the project of historical research. London Lives is useful to academic historians, students, and family historians alike.

Digital humanities initiatives might draw fruitfully on artistic practice. One recent and successful example is the Lowcountry Digital History Initiative (LDHI), supported by the College of Charleston. Specifically focusing on underrepresented stories of race, class, gender, and labor struggles in the Lowcountry region of South Carolina, the LDHI develops online exhibitions with the expertise of college faculty and students, as well as archivists and public historians. In *Keeper of the Gate: Philip Simmons Ironwork in Charleston, South Carolina*, the craftsmanship of master

blacksmith Philip Simmons is presented through the lens of black craft traditions in the city of Charleston. Simmons's work can be seen as part of a legacy of enslaved and free black craftsmen stretching back more than two hundred years, and the exhibition largely focuses on these connections. The intricate designs that can be seen throughout the Charleston area are chronicled through photography by Claire Y. Greene and by Simmons's conceptual design sketches housed at the local Avery Research Center. A list of sources and editorial contributors further distinguish the exhibit from any number of online "curated" projects.[3] Other exhibitions, such as *Charleston's Cotton Factory, 1880–1900* and *Nat Fuller's Feast: The Life and Legacy of an Enslaved Cook in Charleston*, employ historical art to tell Charleston's stories in new ways. Such projects represent one effective method for integrating art and history, but as with all digital efforts, this field of inquiry promises to grow rapidly. As interdisciplinary digital projects continue to produce innovative techniques for connecting with new and existing audiences, discussion of their benefits and challenges will become even more essential.

Though this volume focuses on the intersection of history with the visual arts, other forms of art also warrant consideration. Contemporary performance art, though somewhat differentiated from more traditional mediums by its ephemeral nature, presents intriguing opportunities both inside and outside the physical space of a museum or historic site. In 1992, the same year that he pioneered *Mining the Museum*, Fred Wilson presented *My Life as a Dog* at the Whitney Museum of American Art in New York. Wilson greeted a group of docents and promised to meet them in an upstairs gallery to provide a tour, only to slip away and change into the uniform of a museum security guard. Taking up a post in the appointed gallery, Wilson watched the docents wander the floor looking for him, failing to note his presence as one of the many uniformed silent guards.[4] Commenting on both the subjective invisibility of museum employees and the whitewashing of galleries often silently protected by black men and women, Wilson played with museums' roles in shaping cultural and racial hierarchies, whether or not the act is intentional. To scholars of American history, this conundrum is a familiar one, played out in numerous nineteenth- and twentieth-century cultural arenas that privileged the experiences of white Americans and effectively participated in the "othering" of non Anglo-Saxon cultures. In addition to performance art, more traditional theatrical ventures—plays, musicals, one-person shows—frequently draw on historical settings and themes. Even adaptations that engage in time shifting, such as Shakespearean works that shift the action forward from Elizabethan England, most often do so to elicit new insights for the cast and audience.

New and historical works of literature also offer varied interpretive possibilities. The written word, both read and performed, can open avenues beyond perfunctory text labels. Combining illustration and text, recent projects have turned to the graphic novel as a genre of interpretation and communication. For example, *Abina and the Important Men*, a graphic novel accompanied by a digital app, tells the story of Abina Mansah, a young West African slave who escaped to British-controlled territory and took her case to court. The project, a collaboration between Professor Trevor Getz of San Francisco State University and South African artist Liz Clarke, animates a legal document and successfully places the slave trade in a global context. Historical fiction provides another avenue in which public historians might draw interpretive inspiration. History and historical fiction have often been seen as being at odds for their different relationships with notions of accuracy. However, the popularity of Hilary Mantel's meticulously researched *Wolf Hall* and Deborah Harkness's *All Souls* trilogy, informed by her research in the history of science, suggests that scholarly informed histories need not be necessarily at odds with fictional or entertaining accounts of the past. As part of its 2014 exhibition *Connecting the World: The Panama Canal at 100*, the Mint Museum in Charlotte, North Carolina, commissioned *New York Times* best-selling author Anthony Doerr to write a short story based on accounts of the canal's construction. The result, "The Fever Dreams of William Crawford Gorgas," was published in the exhibition catalogue, combining art, history, and fiction in one intriguing package.[5]

The artistry of music and sound also presents further interpretive strategies. As part of the 1807 bicentenary of the abolition of the slave trade in England, the Plymouth Museum and Art Gallery commissioned a number of artists in its exhibition *Human Cargo* to explore the history and legacy of the transatlantic slave trade. In addition to visual artists, the museum commissioned writer and folk singer Matthew Crampton to create a story-and-song show in collaboration with the London Lubbers shanty group. To depict the experiences of emigrants from all corners of the British Isles, as well as enslaved Africans traveling on British ships, the performers present twenty-five folk songs, both obscure and well known, to dramatize uncomfortable, often terrifying, forced journeys to new lands. Folk music, an "anonymous and authentic record of popular feeling," can give voice to the traditionally voiceless through sound. Performances of traditional African American spirituals naturally lend themselves to discussions of slavery, spirituality, and the Underground Railroad. In some cases, such as the Georgia Sea Island Singers, which focus on the music of the endangered Gullah/Geechee culture, musical performances can illuminate a key aspect of history that can only be fully understood and appreciated aurally. This practice need not be

limited to folk music, either. Pianist John Davis's one-man show "Will the Real Thomas Wiggins Please Stand Up!" presents the story of enslaved autistic savant pianist Thomas "Blind Tom" Wiggins through Davis's performances of Wiggins's classical compositions, juxtaposed with historical accounts of his life and stage performances from newspapers and first-person accounts from the likes of Mark Twain.[6] The Columbus Museum in Georgia brought Davis and his show to Wiggins's hometown as part of a 2015 exhibition featuring sheet music, photographs, and other archival records related to Wiggins in the museum's collection. A digital kiosk in the exhibition also offered visitors the chance to hear Davis's recordings of these pieces. In enabling Blind Tom's original compositions to be performed in the city where he learned to play the piano, the museum engaged with a key aspect of the musician's legacy that cannot be effectively interpreted through mere words (or notes) on a page.

Though cultural institutions might create new programs that excite board and staff members, there is no guarantee that this enthusiasm will translate into success or attention from the general public. Thus, museums, historic sites, public art planners, and others should endeavor to be keenly aware of visitor reactions. This includes making formal plans for evaluations after, and ideally during, the event or installation in question, and designing smart questions that deliver meaningful answers. Even then, visitors might not be completely honest, as Tawny Paul discusses in her chapter. Museum visitors may feel societal pressure to give the "right" answers about a particularly inventive project, or one that spotlights minorities, or they might simply be overly polite, not wanting to offend staff or volunteers with an honest assessment of their experiences. Working with professionals who specialize in evaluation or visitor services can help staff members gather more helpful information than a circled "4" out of 5 and the insightful comment "Great" that can appear on unattended surveys. Purposeful visitor evaluation will result in useful data to modify existing programs or develop new ones. In educational settings, student evaluations are also insightful to measure short- and long-term effectiveness for learning, especially at the undergraduate level. Beyond measuring visitor interest, it is also essential to have commitment from all levels of the organization, including board members, directors, curators, educators, visitor services staff, docents, and volunteers. Essays from the perspective of each of these groups would broaden discussions about the intersection of art and history, as each group of stakeholders brings their own set of opportunities and concerns. Just as the success of major new projects depends on buy-in from top to bottom, the growth of interdisciplinary exhibitions and programming will be greatly strengthened by encouraging conversation with all those who participate in these initiatives.

A CALL TO ACTION

In any discussion of professional practice, real change cannot happen until action is taken by those in a position to implement that change. The same holds true when considering the integration of art and history in museums, historic sites, classrooms, and public places. Beyond being a dry recitation of theory and case studies, it is our sincere hope that the examples and reflections provided in this volume will inspire readers to experiment with their own interdisciplinary projects. Moving from the page to the real world will involve careful planning and evaluation, as well as many conversations with colleagues in other disciplines. It might necessitate learning a new professional language, or saying "I don't know" or "I don't understand" more than you usually do in your home institution. Most likely, there will be several attempts before you find the perfect fit, and progress might be halting at times. However, we believe that the effort will ultimately result in richer, more engaging experiences for visitors, as well as for boards of trustees, staff members, and volunteers.

The era of the elite model of curatorship, and the idea of an omniscient museum generously sharing crumbs of knowledge with the public, is over. Today's audiences demand a seat at the narrative table to customize their museumgoing experiences and find points of connection with their own lives. As "born digital" students become the next generation of visitors, donors, and employees of cultural organizations, this point will become even more crucial. As public historians consider these questions, it may be especially helpful to consider the basic tenets of the profession. Public historians exist to serve the public. This might seem glaringly obvious, but it bears repeating when embarking on new ventures specifically meant to engage new audiences, challenge traditional histories, or make new meanings. Without interest or support from the general public, it becomes extremely difficult to justify the existence of any museum, historic site, university humanities department, or public art program. Those who have read these chapters can likely make a compelling argument for why one particular house, artifact, or artwork should be preserved over another—or why anything should be preserved at all—but without the intellectual and financial interest of those outside the profession, these efforts will eventually be for naught. Public historians, by calling themselves such, assert that their work benefits the common good and adds value to public life. The results of this work should be accessible to the community a public historian serves, whatever the size or definition of that community. In any such project, the community should be at the forefront of planning and evaluation.

The many types of cultural institutions addressed in this volume serve important roles in communities. They tell stories so that we might learn something about ourselves. Whether the genre is traditional history, natural history, anthropology, or art, museums and historic sites seek to present information and images that will mean something to their audiences, something that will remain with visitors after they have lost their ticket stubs. Teachers and professors strive to teach critical-thinking skills and create new mental pathways of learning that will remain in use long after individual facts have been forgotten. Artists create works that linger in the memory even when the piece itself is no longer in the public eye. Not every effort will resonate with every person; universal perfection is not the ultimate goal. Instead, we can focus on creating interdisciplinary exhibitions, programs, teaching models, and art installations that innovate in the best ways. By purposefully connecting history and art, we encourage audiences to think about a historical event from a new or different perspective, view a historical figure in a new light, and make fresh connections to their own lives. Taking the best of both disciplines, learning from each other, collaborating for the betterment of our communities: these are the best and truest benefits of interdisciplinary projects, and the future is ripe with possibilities.

NOTES

1. "About the Office of Digital Humanities," National Endowment for the Humanities, accessed October 2, 2016, https://www.neh.gov/divisions/odh/about.

2. London Lives, accessed October 2, 2016, https://www.londonlives.org/.

3. "Keeper of the Gate: Philip Simmons Ironwork in Charleston, South Carolina," Lowcountry Digital History Initiative, last modified May 2014, http://ldhi.library .cofc.edu/exhibits/show/philip_simmons.

4. Jennifer A. González, "Costume: Come as You Aren't" in Alexandra Schwartz, *Come as You Are: Art of the 1990s* (Berkeley, CA: Montclair Art Museum and the University of California Press, 2014), 37.

5. The Mint Museum, "Connecting the World: The Panama Canal at 100," accessed October 11, 2016, http://www.mintmuseum.org/art/exhibitions/detail/connect ing-the-world-the-panama-canal-at-100/.

6. John Davis, "Program Offerings," last modified May 2016, http://johndavispia nist.com/programs/.

Bibliography

Anderson, Benedict. *Imagined Communities: Reflections on the Origin and Spread of Nationalism*. London: Verso, 1991.

Appel, John J. "From Shanties to Lace Curtains: The Irish Image in Puck, 1876–1910." *Comparative Studies in Society and History* 13, no. 4 (1971): 365–75.

Bal, Mieke. *Narratology: Introduction to the Theory of Narrative*, 2nd ed. Toronto: University of Toronto Press, 1997.

Bang, Molly. *Picture This: How Pictures Work*. New York: SeaStar Books, 2000.

Banta, Martha. *Barbaric Intercourse: Caricature and the Culture of Conduct, 1841–1936*. Chicago: University of Chicago Press, 2003.

Barthes, Roland. *Image, Music, Text*. Translated by Stephen Heath. New York: Hill and Wang, 1977.

Bennett, Jill. *Empathetic Vision: Affect, Trauma, and Contemporary Art*. Redwood City, CA: Stanford University Press, 2005.

Berger, John. *Ways of Seeing*. London: Penguin Books, 1972.

Bergson, Henri. *Laughter: An Essay on the Meaning of the Comic*. New York: Macmillan, 1911 (1901).

Berry, Chad, Lori A. Schmied, and Josef Chad Schrock. "The Role of Emotion in Teaching and Learning History." *The History Teacher* 41, no. 4 (2008): 437–52.

Bitgood, Stephen. "An Analysis of Visitor Circulation: Movement Patterns and the General Value Principle." *Curator* 49, no. 4 (October 2006): 463–75.

Blight, David W. *Beyond the Battlefield: Race, Memory, & the American Civil War*. Amherst: University of Massachusetts Press, 2012.

Blight, David W. *Race and Reunion: The Civil War in American Memory*. Cambridge, MA: Harvard University Press, 2002.

Blumin, Stuart M. *The Emergence of the Middle Class: Social Experience in the American City, 1760–1900*. New York: Cambridge University Press, 1989.

Booker, S. "Nation Horrified by Murder of Kidnaped Chicago Youth." *Jet Magazine*, September 15, 1955, 9.

Bourdieu, Pierre. *Distinction: A Social Critique of the Judgment of Taste.* Cambridge, MA: Harvard University Press, 1984.

Bourriaud, Nicolas. *Relational Aesthetics*. Dijon, France: Les Presses Du Reel Edition, 2002.

Brekke-Aloise, Linzy. "'A Very Pretty Business': Fashion and Consumer Culture in Antebellum American Prints." *Winterthur Portfolio* 48, no. 2–3 (2014): 191–211.

Bunker, Gary L. "Antebellum Caricature and Women's Sphere." *Journal of Women's History* 3, no. 3 (1992): 6–44.

Burke, Peter. *Eyewitnessing: The Uses of Images as Historical Evidence*. Ithaca, NY: Cornell University Press, 2001.

Cahan, Susan to Carol Bossert. "Encore: Mounting Frustration." *The Museum Life*, podcast audio September 23, 2016. https://itunes.apple.com/us/podcast/the-museum-life/id705700091?mt=2&i=374854900.

Carr, David. *Experience and History: Phenomenological Perspectives on the Historical World*. London: Oxford University Press, 2014.

"Carsten Höller: Interview." Tate Modern. Accessed September 18, 2016. http://www.tate.org.uk/whats-on/tate-modern/exhibition/unilever-series-carsten-holler-test-site/carsten-holler-interview.

Civic Art / Artes Civicas, A Public Art Master Plan for the City of El Paso, 2005.

Clifford, James. "Museums as Contact Zones." In *Routes: Travel and Translation in the Late Twentieth Century*, edited by J. Clifford, 188–219. Cambridge, MA and London: Harvard University Press, 1997.

Cobb, Jasmine Nichole. *Picture Freedom: Remaking Black Visuality in the Early Nineteenth Century*. New York: New York University Press, 2015.

Cook, James W. "Seeing the Visual in US History." *Journal of American History* 95, no. 2 (2008): 432–41.

Corrin, Lisa. "Mining the Museum: An Installation Confronting History." In *Reinventing the Museum: Historical and Contemporary Perspectives on the Paradigm Shift*, edited by Gail Anderson, 248–56. Oxford: AltaMira Press, 2004.

Cosgrove, Denis. *Social Formation and Symbolic Landscape*. Totowa, NJ: Barnes & Noble Books, 1985.

Coventry, Michael, Peter Felten, Cecilia O'Leary, Susannah McGowan, David Jaffee, and Tracey Weis. "Ways of Seeing: Evidence and Learning in the History Classroom." *Journal of American History* 92, no. 4 (2006): 1371–1402.

Creef, Elena Tajima. *Imaging Japanese America: The Visual Construction of Citizenship, Nation, and the Body*. New York: New York University Press, 2004.

Cronon, William. *Uncommon Ground: Toward Reinventing Nature*. New York: W. W. Norton, 1995.

Curtis, L. Perry. *Apes and Angels: The Irishman in Victorian Caricature*. Washington, DC: Smithsonian Institution Press, 1971.

Davis, Peter. *Ecomuseums: A Sense of Place.* Leicester: Leicester University Press, 1999.

Deaton, Stan. "The Past Never Changes but History Does." *Georgia History Today* 7, no. 1–2 (2013): 1–2.

DeGraft-Hanson, Kwesi. "Unearthing the Weeping Time: Savannah's Ten Broeck Race Course and 1859 Slave Sale." *Southern Spaces*, February 18, 2010. Accessed

December 15, 2015. http://southernspaces.org/2010/unearthing-weeping-time-savannahs-ten-broeck-race-course-and-1859-slave-sale.

Devine, Tom. *To the Ends of the Earth: Scotland's Global Diaspora, 1750–2010*. London: Penguin, 2011.

DiTolla, Tracy. "Happenings." *The Art Story: Modern Art Insight*. Accessed September 18, 2016. www.theartstory.org/movement-happenings.htm.

Dudink, Stefan, Anna Clark, and Karen Hagemann. *Representing Masculinity: Male Citizenship in Modern Western Culture*. New York: Palgrave Macmillan, 2007.

Emphasizing Identity, Public Art Master Plan for Arizona State University, n.d.

Farago, Jason. "Björk Review: A Strangely Unambitious Hotchpotch." *The Guardian*, March 4, 2015. http://www.theguardian.com/music/2015/mar/04/bjork-moma-review-strangely-unambitious-hotchpotch.

Fish, Stanley. *Is There a Text in this Class? The Authority of Interpretive Communities*. Cambridge: Harvard University Press, 1981.

Floryan, Meg. "Interactive and Participatory Art." *Art21 Magazine*, June 3, 2010. http://blog.art21.org/2010/06/03/interactive-and-participatory-art/#.VtiS6MArJz8.

Forker, Martin. "The Use of the 'Cartoonist's Armoury' in Manipulating Public Opinion: Anti-Irish Imagery in 19th-Century British and American Periodicals." *Journal of Irish Studies* 27 (2012): 58–71.

Foucault, Michel. *The History of Sexuality*. Translated by Robert Hurley. New York: Pantheon Books, 1978.

Francis, David. "'An Arena Where Meaning and Identity Are Debated and Contested on a Global Scale': Narrative Discourses in British Museum Exhibitions, 1972–2013." *Curator: The Museum Journal* 58, no. 1 (January 2015): 41–58.

Freeman, Michael. *Savannah's Monuments, The Untold Stories*. Atglen, PA: Schiffer, 2015.

Freeman Whitehurst Group and Gail M. Goldman Associates. *PASA Public Art San Antonio*, 2008, 5.

"From Token to Ornament: Indian Peace Medals and the McKenney-Hall Portraits." National Portrait Gallery. Accessed June 25, 2016. http://npg.si.edu/exhibition/token-ornament-indian-peace-medals-and-mckenney-hall-portraits.

Glueck, Grace. "The Best Painter I Can Possibly Be." *New York Times*, December 8, 1969.

Goldstein, Holly. "St. Augustine's 'Slave Market': A Visual History." *Southern Spaces* 28, September 2012. Accessed December 15, 2015. http://southernspaces.org/2012/st-augustines-slave-market-visual-history.

González, Jennifer A. "Costume: Come as You Aren't." In *Come as You Are: Art of the 1990s*, edited by Alexandra Schwartz. Berkeley, CA: Montclair Art Museum and the University of California Press, 2014.

Groth, Paul, and Todd Bressi, eds. *Understanding Ordinary Landscapes*. New Haven, CT: Yale University Press, 1997.

Halttunen, Karen. *Confidence Men and Painted Women: A Study of Middle-Class Culture in America, 1830–1870*. New Haven: Yale University Press, 1982.

Harley, J. B. "Deconstructing the Map." *Cartographica* 26, no. 2 (Spring 1989): 1–20.

Harris, Leslie, and D. M. Berry. *Slavery and Freedom in Savannah*. Athens, GA: University of Georgia Press, 2014.

Hartley, L. P. *The Go-Between*. New York: New York Review of Books, 1953.

Harvey, Karen. "Envisioning the Past: Art, Historiography and Public History." *Cultural and Social History* 12, no. 4 (2015): 527–43.

Henkin, David M. *City Reading: Written Words and Public Spaces in Antebellum New York*. New York: Columbia University Press, 1998.

Hesse, David. *Warrior Dreams: Playing Scotsmen in Mainland Europe*. Manchester: Manchester University Press, 2014.

History Relevance Campaign. "The Value of History." Last modified 2014. http://www.historyrelevance.com/value-statement.

Hobbes, Thomas. *The Elements of Law, Natural and Politic*. London, 1650–51.

Hughes, Richard L. "Minstrel Music: The Sounds and Images of Race in Antebellum America." *The History Teacher* 40, no. 1 (2006): 27–43.

Hunt, Lynn. *The Family Romance of the French Revolution*. Berkeley: University of California Press, 1992.

Ignatiev, Noel. *How the Irish Became White*. New York: Routledge, 1995.

Indianapolis Public Art Master Plan, 2003.

Isenberg, Nancy. *Sex and Citizenship in Antebellum America*. Chapel Hill, NC: University of North Carolina Press, 1998.

Jackson, J. B. *A Sense of Place, A Sense of Time*. New Haven, CT: Yale University Press, 1994.

Jackson, J. B. *Vernacular Landscapes*. New Haven, CT: Yale University Press, 1984.

Jacobson, Matthew Frye. *Whiteness of a Different Color: European Immigrants and the Alchemy of Race*. Cambridge, MA: Harvard University Press, 1998.

Joyner, Charles, and Georgia Writer's Project. *Drums and Shadows: Survival Studies Among the Georgia Coastal Negroes.* Athens, GA: University of Georgia Press, 2012.

Kemnitz, Thomas Milton. "The Cartoon as a Historical Source." *Journal of Interdisciplinary History* 4, no. 1 (1973): 81–93.

Kerber, Linda K. "Separate Spheres, Female Worlds, Woman's Place: The Rhetoric of Women's History." *Journal of American History* 75, no. 1 (1988): 9–39.

Ketner, Joseph. *The Emergence of the African-American Artist: Robert S. Duncanson, 1821–1872*. Columbia and London: University of Missouri Press, 1993.

Lambert, Stephanie Jane McKinnon. "Engaging Practices: Re-Thinking Narrative Exhibition Development in Light of Narrative Scholarship." MA thesis, Massey University, Palmerston North, New Zealand, 2009.

Landsberg, Alison. *Engaging the Past: Mass Culture and the Production of Historical Knowledge*. New York: Columbia University Press, 2015.

Lane, Christopher W. "A History of McKenney and Hall's *History of the Indian Tribes of North America*." From *Imprint: Journal of the American Historical Print Collectors Society* 27, no. 2 (Autumn 2002).

Lanser, Susan S. "Towards a Feminist Narratology." *Style* 20, no. 3 (Fall 1986): 341–63.

Lapsansky, Emma Jones. "'Since They Got Those Separate Churches': Afro-Americans and Racism in Jacksonian Philadelphia." *American Quarterly* 32, no. 1 (1980): 54–78.

Le Beau, Bryan F. "Art in the Parlor: Consumer Culture and Currier and Ives." *Journal of American Culture* 30, no. 1 (March 2007): 18–37.

Lemire, Elise. *"Miscegenation": Making Race in America*. Philadelphia: University of Pennsylvania Press, 2011.

Lengel, Traci, and Mike Kuczala. *The Kinesthetic Classroom: Teaching and Learning Through Movement*. Thousand Oaks, CA: Corwin, 2010.

Leuer, Joseph C. February 28, 2016 (9:22 a.m.), comment on Richard Hyatt, "Bringing Body Art to Galleries." *Ledger-Enquirer*, February 27, 2016. http://www.ledger-enquirer.com/news/local/news-columns-blogs/article62966782.html.

Lloyd, Katherine. "Beyond the Rhetoric of an 'Inclusive National Identity': Understanding the Potential Impact of Scottish Museums on Public Attitudes to Issues of Identity, Citizenship and Belonging in an Age of Migrations." *Cultural Trends* 23, no. 3 (2014): 148–58.

Lowenthal, David. "Patrons, Populists, Apologists: Crises in Museum Stewardship." In *Valuing Historic Environments*, edited by L. Gibson and J. Pendleburry, 19–31. Farnham: Ashgate, 2009.

Luke, Timothy. *Museum Politics: Power Plays at the Exhibition*. Minneapolis, MN: University of Minnesota Press, 2002.

Lynch, Bernadette. "Challenging Ourselves: Uncomfortable Histories and Current Museum Practices." In *Challenging History in the Museum: International Perspectives*, edited by Jenny Kidd, Sam Cairns, Alex Drago, and Amy Ryall, 87–100. Oxford: Routledge, 2014.

Lynch, Bernadette. "Collaboration, Contestation, and Creative Conflict: On the Efficacy of Museum/Community Partnerships." In *Routledge Companion to Museum Ethics: Redefining Ethics for the Twenty-First Century Museum*, edited by Janet Marstine, 146–63. London: Routledge, 2011.

Martine, Arthur. *Martine's Sensible Letter-Writer*. New York: Dick & Fitzgerald, 1866.

Martinez, Katharine. "Imaging the Past: Historians, Visual Images and the Contested Definition of History." *Visual Resources* 11, no. 1 (1995): 21–45.

Mason, Rhiannon. "Cultural Theory and Museum Studies." In *A Companion to Museum Studies*, edited by Sharon MacDonald, 17–32. Maiden, MA: Blackwell, 2010.

Mason, Rhiannon. *Museums, Nations, Identities: Wales and Its National Museums*. Cardiff: University of Wales Press, 2007.

Mason, Rhiannon. "National Museums, Globalisation and Postnationalism: Imagining a Cosmopolitan Museology." *Advances in Research: Museum Worlds* 1, no. 1 (2013): 40–64.

Masur, Louis P. "'Pictures Have Now Become a Necessity': The Use of Images in American History Textbooks." *Journal of American History* 84, no. 4 (1998): 1409–24.

McCaskill, Barbara. *Love, Liberation, and Escaping Slavery: William and Ellen Craft in Cultural Memory*. Athens, GA: University of Georgia Press, 2015.

McDaniels III, Pellom. "Arias for the Discontented: An Homage to Black Masculinity and Manhood." In Kristen Miller Zohn, gallery guide for *Leaving Mississippi: Reflections on Heroes and Folklore, Works by Najee Dorsey* (Columbus, GA: The Columbus Museum, 2014).

"Meet a Member." American Association for State and Local History. Last modified July 12, 2016. http://blogs.aaslh.org/tag/meet-a-member/.

Meinig, D. W., ed. *The Interpretation of Ordinary Landscapes.* Oxford: Oxford University Press, 1979.

Mitchell, Mary Niall. "'Rosebloom and Pure White,' Or So It Seemed." *American Quarterly* 54, no. 3 (2002): 369–410.

Monmonier, Mark. *How to Lie with Maps.* Chicago: University of Chicago Press, 1991.

Morekis, Jim. "Two Savannahs: Further Apart Than Ever." *Connect Savannah*, October 7, 2014. http://www.connectsavannah.com/savannah/editors-note-two-savannahs-further-apart-than-ever/Content?oid=2491716.

Morgan, Philip, ed. *African American Life in the Georgia Lowcountry: The Atlantic World and the Gullah Geechee.* Athens, GA: University of Georgia Press, 2010.

Morreall, John. *The Philosophy of Laughter and Humor.* Albany, NY: State University of New York Press, 1987.

Mullins, Jeffrey A. "Race, Place and African-American Disenfranchisement in the Early Nineteenth-Century American North." *Citizenship Studies* 10, no. 1 (February 1, 2006): 77–91.

Murray, Janet H. *Hamlet on the Holodeck: The Future of Narrative in Cyberspace.* Cambridge: MIT Press, 1997.

"Museum Universe Data File." Institute of Museum and Library Services. Last modified November 2015. https://www.imls.gov/research-evaluation/data-collection/museum-universe-data-file.

National Council for Public History. Accessed April 2, 2016. http://ncph.org.

Ngũgĩ wa Thiong'o. *Decolonising the Mind: The Politics of Language in African Literature.* Portsmouth, NH: Heinemann, 1986.

Ohlheiser, Abby. "How Martin Luther King Jr. Convinced 'Star Trek's' Lt. Uhura to Stay on the Show." *The Washington Post*, July 31, 2015.

Ormond, Barbara. "Enabling Students to Read Historical Images: The Value of the Three-Level Guide for Historical Inquiry." *The History Teacher* 44, no. 2 (2011): 179–90.

Otter, Samuel. *Philadelphia Stories: America's Literature of Race and Freedom.* New York: Oxford University Press, 2013.

Padurano, Dominique. "'Isn't That a Dude?': Using Images to Teach Gender and Ethnic Diversity in the US History Classroom—Pocahontas: A Case Study." *The History Teacher* 44, no. 2 (2011): 191–208.

Panofsky, Erwin. *Meaning in the Visual Arts: Papers in and on Art History* (Garden City, NY: Doubleday, 1955).

Pearce, Lynne. "Bakhtin and the Dialogic Principle." In *Literary Theory and Criticism: An Oxford Guide*, ed. Patricia Waugh (London: Oxford University Press, 2007), 223–32.

Pegler-Gordon, Anna. "Chinese Exclusion, Photography, and the Development of U.S. Immigration Policy." *American Quarterly* 58, no. 1 (2006): 51–77.

Pegler-Gordon, Anna. *In Sight of America: Photography and the Development of U.S. Immigration Policy.* Berkeley: University of California Press, 2009.

Pegler-Gordon, Anna. "Seeing Images in History." *Perspectives on History* (February 2006): 28–32.

Poria, Yaniv, et al. "The Core of Heritage Tourism." *Annals of Tourism Research* 30, no. 1 (2003): 238–54.

Poria, Yaniv, et al. "Visitors' Preferences for Interpretation at Heritage Sites." *Journal of Travel Research* 48, no. 1 (2009): 92–105.

Pressly, Paul M. *On the Rim of the Caribbean: Colonial Georgia and the British Atlantic World.* Athens, GA: University of Georgia Press, 2013.

Prown, Jules David. "Mind in Matter: An Introduction to Material Culture Theory and Method." *Winterthur Portfolio* 17, no. 1 (Spring 1982): 1–19.

"Public Art Network." Americans for the Arts. Accessed June 10, 2016. http://www.americansforthearts.org/by-program/networks-and-councils/public-art-network.

Purkis, Harriet. "Making Contact in an Exhibition Zone: Displaying Contemporary Cultural Diversity in Donegal, Ireland, Through an Installation of Visual and Material Portraits." *Museum and Society* 11, no. 1 (2013): 50–67.

Putnam, James. *Art and Artifact: The Museum as Medium.* London: Thames and Hudson, 2001.

Resonant Journey, The Public Art Master Plan for the Midtown Greenway Corridor, 2001.

Roediger, David R. *The Wages of Whiteness: Race and the Making of the American Working Class.* New York: Verso, 1991.

Rose, Gillian. *Visual Methodologies: An Introduction to Researching with Visual Materials.* London; Thousand Oaks, CA: Sage, 2001.

Ross, Susan Dente. "Images of Irish Americans: Invisible, Inebriated, or Irascible." In *Images That Injure: Pictorial Stereotypes in the Media,* edited by Paul Martin Lester and Susan Dente Ross, 131–38. Westport, CT: Praeger, 2003.

Rounds, Jay. "Doing Identity Work in Museums." *Curator* 49, no. 2 (2006): 133–50.

Russell, Preston, and Barbara Hines. *Savannah: A History of Her People Since 1733.* Savannah, GA: Frederic C. Biel, 1992.

Said, Edward W. *Orientalism.* New York: Vintage Books, 1979.

Sandell, R. *Museums, Prejudice and the Reframing of Difference.* Oxford: Routledge, 2007.

Savage, Kirk. *Standing Soldiers, Kneeling Slaves: Race, War, and Monument in Nineteenth-Century America.* Princeton, NJ: Princeton University Press, 1999.

Sayre, Henry M. *Writing about Art.* Upper Saddle River, NJ: Pearson/Prentice Hall, 2009.

Schlereth, Thomas J. *Material Culture Studies in America.* Nashville, TN: American Association for State and Local History, 1982.

Schocker, Jessica B. "A Case for Using Images to Teach Women's History." *The History Teacher* 47, no. 3 (2014): 421–50.

Schwartz, Vanessa R. *Spectacular Realities: Early Mass Culture in Fin-de-Siècle Paris.* Berkeley: University of California Press, 1998.

Sheehy, Barry, Cindy Wallace, and Vaughnette Goode-Walker. *Savannah: Immortal City.* Austin, TX: Emerald Book Co., 2011.

Simon, Nina. "Should Museum Exhibitions Be More Linear? Exploring the Power of the Fixed March in Digital and Physical Environments." *Museum 2.0*, January 9, 2013. http://museumtwo.blogspot.com/2013/01/should-museum-exhibitions-be-more.html.

Smailes, Helen. *A Portrait Gallery for Scotland: The Foundation, Architecture and Mural Decoration of the Scottish National Portrait Gallery, 1882–1906.* Edinburgh: National Galleries of Scotland, 1985.

Smith, Laurajane. "Affect and Registers of Engagement: Navigating Emotional Responses to Dissonant Heritages." In *Representing Enslavement and Abolition in Museums: Ambiguous Engagements*, edited by L. Smith, G. Cubitt, R. Wilson, and K. Fouseki, 260–303. Oxford: Routledge, 2012.

Smith, Laurajane. "'Man's Inhumanity to Man' and Other Platitudes of Avoidance and Misrecognition: An Analysis of Visitor Responses to Exhibitions Marking the 1807 Bicentenary." *Museum and Society* 8, no. 3 (2010): 193–214.

Smith, Laurajane. *Uses of Heritage.* Oxford: Routledge, 2006.

Smith, Rogers M. *Civic Ideals: Conflicting Visions of Citizenship in U.S. History.* New Haven: Yale University Press, 1997.

Sommer, Doris. *The Work of Art in the World: Civic Agency and Public Humanities.* Durham and London: Duke University Press, 2014.

Staiti, Paul. "Character and Class." In *John Singleton Copley in America*, edited by Carrie Rebora, 53–78. New York: Metropolitan Museum of Art, 1995.

Stearn, Miranda. "Contemporary Challenges: Artist Interventions in Museums and Galleries Dealing with Challenging Histories." In *Challenging History in the Museum: International Perspectives*, edited by Jenny Kidd, Sam Cairns, Alex Drago, and Amy Ryall, 101–14. Oxford: Routledge, 2014.

Stodghill, Ron. "Savannah, Both Sides." *New York Times*, October 3, 2014. Accessed December 15, 2015. http://www.nytimes.com/2014/10/05/travel/savannah-both-sides.html?_r=0.

StoryBook: Narrative in Contemporary Art. Madison Museum of Contemporary Art. http://www.mmoca.org/exhibitions-collection/exhibits/storybook-narrative contemporary-art.

"Storylines: Contemporary Art at the Guggenheim." Guggenheim Museum. https://www.guggenheim.org/exhibition/storylines-contemporary-art-at-the-guggenheim-2.

Taylor, Joshua C. *Learning to Look: A Handbook for the Visual Arts.* Chicago: University of Chicago Press, 1957.

Taylor, Susie King. *A Black Woman's Civil War Memoirs: Reminiscences of My Life in Camp with the 33rd U.S. Colored Troops, Late 1st South Carolina Volunteers.* Edited by Patricia W. Romero. New York: Markus Wiener, 1988.

Thomas, Samuel J. "Teaching America's GAPE (or Any Other Period) with Political Cartoons: A Systematic Approach to Primary Source Analysis." *The History Teacher* 37, no. 4 (2004): 425–46.

Tosh, John. "Citizen Scholars." *History Today* 62, no. 7 (2012).

Tuan, Yi-Fu. *Space and Place: The Perspective of Experience.* Minneapolis: University of Minnesota Press, 1977.

Viveros-Faune, Christian. "Norman Rockwell at the Guggenheim, for the Shallow and Jug-Stupid." *New York Press*, June 16, 2002.

Wake, Paul. "Narrative and Narratology." In *The Routledge Companion to Critical Theory*, eds. Simon Malpas and Paul Wake. London: Routledge, 2006.

Weaver, A. M. "In the Studio: Jefferson Pinder, From Cosmonaut to Escape Artist." *Artvoices Magazine*, November 6, 2012.

Welke, Barbara Young. *Law and the Borders of Belonging in the Long Nineteenth Century United States*. New York: Cambridge University Press, 2010.

Wells, Samuel R. (Samuel Roberts). *New Physiognomy: Or, Signs of Character, as Manifested through Temperament and External Forms, and Especially in "the Human Face Divine."* New York: Fowler & Wells, 1875.

Welter, Barbara. "The Cult of True Womanhood: 1820–1860." *American Quarterly* 18, no. 2 (1966): 151–74.

Willard, Frances. *Women and Temperance*. Hartford, CT: By the Park Publishing, 1883.

Wilson, Thomas D. *The Oglethorpe Plan: Enlightenment Design in Savannah and Beyond.* Charlottesville, VA: University of Virginia Press, 2012.

Winn, William. *Building on a Legacy: The Columbus Museum.* Columbus, GA: The Columbus Museum, 1996.

Witcomb, Andrea. "Migration, Social Cohesion and Cultural Diversity: Can Museums Move Beyond Pluralism?" *Humanities Research* 15, no. 2 (2009): 49–66.

Witcomb, Andrea. "Understanding the Role of Affect in Producing a Critical Pedagogy for History Museums." *Museum Management and Curatorship* 28, no. 3 (2013): 255–71.

Woolfolk, Anita. *Educational Psychology*. New York: Pearson, 2015.

Wyman, B., S. Smith, D. Meyers, and M. Godfrey. "Digital Storytelling in Museums: Observations and Best Practices." *Curator: The Museum Journal* 54, no. 4 (October 2011): 461–68.

Zuckerman, Michael. "The Presence of the Present, the End of History." *The Public Historian* 22, no. 1 (2000): 19–22.

Index

abstraction, 24, 30, 115, 148

African American art, xiv, 2–3, 23–29, 58, 103–7,183. *See also* identity; race

age, 15, 31, 35, 38, 47, 52, 54, 56, 58, 126, 128, 140, 149, 150, 152, 193; young audiences 71, 109, 142, 152. *See also* identity

architecture, 6, 119, 141, 169, 210–11; architects, 99, 159, 193, 204

art galleries, 4, 9, 10, 126, 230; in the history museum, 23–45; history in the art gallery, 117–36

artist intervention, 2, 3, 4, 8, 11, 13, 14, 18, 118, 145, 155, 201–26, 227, 242, 248

audiences, 4, 7, 8, 9, 24, 28, 49, 51, 57, 55, 56, 74, 75, 81, 87, 92, 102, 140, 152, 161, 174, 196; broadening audiences, 2, 11, 18, 25, 106, 108, 110, 146, 159, 178, 201, 202, 226, 229; engagement with, 10, 15, 17, 27, 30, 73, 93, 109, 118, 121, 123, 137, 138, 104, 142, 143, 148, 149, 150 189, 197, 202, 206, 227, 232, 233; evaluation of audience reactions, 126–30, 131, 133, 203

Barthes, Roland, 50, 51, 67

Beecroft, Vanessa, 140–42, 145, 153

bodies, 9, 62, 65–66, 82, 108–10, 143–44, 193

Bourriaud, Nicolas, 140–43, 153. *See also* relational art

Capital Improvement Plan, 163–64

Chesterwood, 216–19

cities, 13, 16, 161, 164–65, 171–72, 181; as canvases, 168–70; Calgary, 171; Chicago, 71–83; El Paso, 170–71; San Antonio, 171, 174; Savannah, 175–97; Richmond, Virginia, 172–73. *See also* place

Chicago History Museum, 71–94

citizenship, 28, 52, 57, 56–66, 64, 160, 121. *See also* identity

class, 11, 28, 31, 47, 53–65, 129–30, 144, 184, 205, 210, 220–21, 228

Clay, Edward William, 58–62

Clinton, George, 30–43

collaboration, 1–2, 6, 8–9, 11, 17, 84, 93, 101, 118, 153, 164–66, 196, 226, 228; institutional, 92–93, 194–95; student collaboration, 81, 175–200; with artists, 3–5, 7, 103–9, 125–26, 1373–9, 163, 173–75, 230; with audiences and visitors, 153, 207, 228

Columbus Museum (Georgia), 11, 99–114, 231

Common Core State Standards, 11, 71, 73, 83, 88–89
Currier, Nathaniel, 52–58

difficult histories 5, 6, 14, 17, 106, 118, 124–25, 163–65, 224, 226. *See also* slavery; Till, Emmett
digital tools, 4, 81, 103, 107, 138, 142, 159, 196, 225, 228–32, 242, 247. *See also* online exhibitions
diversity, 3, 6, 17, 25, 110, 182, 194; fostering audience diversity, 6, 25, 122–29; representation of, 23, 26, 31, 121–29
Dalton, Ronie, 108–9
docents. *See* volunteers
Dorsey, Najee, 103–7
Driskell, David, 32, 35–36, 39, 44
Duncanson, Robert, 32–35, 43–44

education, 13, 16, 18, 228; college, 47–70, 166–68, 178–97; K–12, 71–98. *See also* Common Core State Standards; pedagogy; students
emancipation, 43, 58, 190
emotions, 4, 6–7, 32, 50, 52, 82, 89, 108–9, 118, 129, 131–33, 140–41, 173, 178, 182–83, 185, 191, 203–4, 221; anger, 47, 171; empathy, 78, 132–34; grief, 108–9; nostalgia, 131–33, 137, 140, 165; sadness, 47, 67, 185, 196, 216–17, 241
entertainment, 12, 17, 71, 142, 144–46, 173, 230–32
evaluation: concerns with audience responses, 118, 126–30; course evaluation, 65, 69; developmental evaluation, 88–92, 95; of educational programing, 73–74, 84–92; pilot testing, 85–86; surveys, 65, 85–86, 88–89, 91, 93, 126–28, 231

fees, 72, 93
family, 34–35, 38, 47, 52, 53–56, 58, 101, 104, 107–8, 125, 132, 205, 208–10, 228

fiction, 38–39, 43, 74, 137, 230, 248. *See also* narrative; nonfiction
Fisher, Jules, 30–43
funding, 17, 66, 73, 161, 163–64
Florida Highwaymen, xiv–xv

gender, 11, 25, 28, 31, 54, 60, 64–65, 151, 173, 176, 184, 205, 228
Georgia Historical Society, 177, 179, 183
Glessner House Museum, 204–10

Hazoume, Romuald, 5
historic house museums, 209–12, 216–22
historical markers, 13–14, 16, 175–84, 194–97

identity, 23–31, 39, 43, 47, 56, 64, 104, 117, 117–18, 122, 124–25, 128–30, 133–34, 142, 166–67, 169, 170, 173, 196, 249
imagination, 100, 133–34, 202, 204, 209, 222
International Museum of Surgical Science, 213–16
interpretation, 1–9, 10–12, 13, 14, 16, 18, 24, 26, 44, 51, 59, 72, 78, 81, 85–89, 100–1, 104, 110, 114, 123, 131, 182, 185, 173, 176, 178, 180, 198, 203, 206–9, 227, 230; and exhibition planning, 103–6; audience participation, 50, 90, 146, 153; equipping audiences to interpret, 152; of images as objects, 51–52; of objects, 222–25; mistaken interpretation, 127; ways of seeing, 49–50

Jane Addams Hull–House Museum, 6, 210–12

landscape, xiv, 10, 32–35, 145, 161–63, 168–69, 173, 184–85, 201, 203, 209, 212
LGBTQ, 15, 139, 149–52, 173
local history, 74, 178–79

management, 17–18, 160–64

Mann, Dave 37

Maryland Historical Society, 2–4. *See also* Wilson, Fred

McKenney, Thomas: and Hall, James, 111–14; and Inman, Henry, 111

migration, 6, 107–8, 111, 118, 122–26, 129–134, 139, 145, 149, 151–52, 170, 205, 208, 210, 212

military, 7, 28–29, 102, 108–9, 169, 177, 180, 185, 190–92

municipal art. *See* public art plans

music, 29, 41, 43, 144, 230–31

narrative, 202–6; forgotten narratives, 3, 13–14, 104, 139, 175–80; multiple histories, 208–9; narratology (narrative theory), 137–53. *See also* text, writing

National Council on Public History (NCPH), 1, 161

National Park Service, 173

nonfiction, 82, 83, 85

Obama, Barack, 39, 41–42, 44

objectivity, 8, 63

online exhibitions, 4, 175, 179, 194–96, 197, 228, 229. *See also* digital tools

Panofsky, Erwin, 50

participatory art, 142, 145

Paxson, Charles, 47–49

pedagogy, 2, 51, 66; curriculum 88, 178–97; integration with public art, 166–67; Kinesthetic Classroom, 72, 81; role play, 81–83; teaching with images, 47–70. *See also* Common Core State Standards

photography, 37, 39, 47–48, 64, 102, 104, 125, 130, 132, 149, 151, 183, 184, 187–88, 190, 193, 216

Pinder, Jefferson, 30–43

place, 28–29, 123, 129, 132, 137, 139, 140, 143–45, 160, 162–63, 165, 167, 176–78, 181–82, 185, 187, 189, 195–96, 202–4, 208–9, 222–25. *See also* landscape

planning, 11, 16–17, 76, 101, 104, 123, 115, 144, 160–61, 164, 167, 169, 170–72, 173, 205–6, 219, 227, 245. *See also* project design

Portland Art Museum, 219–22

portraiture, 24, 32–33, 49, 63, 102–3, 100, 104–5, 111, 114, 117–36

project design: alignment with institutional missions, 23, 72, 93, 99, 102–3, 110, 114–15, 121, 176; defining goals, 7, 15, 17, 23–24, 25–28, 32, 39, 74, 86, 88, 91–92, 99, 115, 146, 177–79, 194–95, 196, 228; implementation, 17, 24–25, 71, 73, 84–88, 92, 94, 165–66, 232; public programing, 18, 71–72, 165–66; Request for Proposal, 164. *See also* exhibition planning; planning; workshops

public art: definitions of, 159; public artists, 159–66, 170–74; public art plans, 13, 16, 159–74;

public spaces, 12, 177

public history: parallels with public art, 160–63

race, 11, 25–26, 31, 33, 47, 50, 62, 65, 104–7, 144, 169, 176, 179, 183–84, 228. *See also* African American art; identity

relational art, 140–43

religion, 29–32, 35, 39, 125

Savannah College of Art and Design (SCAD) Museum of Art, 175–97

science, 63, 127, 141, 143–44, 206–7, 213–16, 230; science fiction, 39, 43

Scottish National Portrait Gallery, 117–36

sensationalism, 145

shared authority, 8, 140

slavery, 3, 5, 28, 33–34, 47–50, 57–58, 107, 124, 176, 178, 180–85, 187–89, 190, 192, 229–31

Smithsonian Institution, 100; National Museum of African American History and Culture, 23–46; National Portrait Gallery, 114, 119

sound, 5, 32, 39, 144, 183, 230. *See also* music

storytelling, 4–5, 146, 150, 196, 220

strategic planning, 101–3

students, 13–14, 16, 47–70, 71–98, 165, 167, 175–200, 206, 211–12, 228, 232. *See also* education; pedagogy

technological tools, 81, 123, 142–3, 228. *See also* digital tools; online exhibitions

television, 29, 39, 41–2, 116, 145, 172, 238

Telfair Museums, 181–83

text, 7, 26–27, 39, 43, 50, 52, 63–64, 75, 84, 102–3, 106–7, 109, 130, 145, 147–48, 175, 177, 179, 181–82, 185, 187, 190–91, 196, 203, 205, 207, 216, 224, 230. *See also* fiction; nonfiction writing

Till, Emmett, 35–39

training, 137, 140, 146, 159, 161; of artists, 166; of volunteers, 75, 78, 85–87, 94

Victoria and Albert Museum, 5, 100

visitor responses, 9, 43, 50–51, 66, 89, 106, 109, 126–30, 138, 140, 142–43, 152, 191, 206. *See also* emotions; evaluation

visual analysis, 50–52, 65, 79, 83–84

volunteers, 17, 71, 75, 81, 85–88, 94, 173, 205–6, 211, 231–32

Wilson, Fred, 2–4

workshops, 71–98

writers, 34, 144, 216, 230

writing, 161, 182, 217; analysis of, 76, 83, 93, 217; as form of visitor engagement, 150; as skill, 89; public history text, 85, 108, 179; re–writing history, 137; student, 72, 78, 81, 178, 182

Zuckerman Museum of Art, 138, 149–52

About the Contributors

Bob Beatty is chief of engagement for the American Association for State and Local History (AASLH), the only comprehensive national organization dedicated to state and local history, and founder and CEO of The Lyndhurst Group, LLC, a history, museum, and nonprofit consulting firm providing community-focused engagement strategies for institutional planning, organizational assessments, and interpretive direction. Since 2007, Beatty has served AASLH as Interim President and CEO, Chief Operating Officer, and Vice President for Programs, leading AASLH's professional development program including workshops, an annual meeting, affinity groups and other initiatives, and publications as editor of *History News* and the AASLH Editorial Board. From 1999 to 2007 he directed the Education Department at the Orange County (Florida) Regional History Center. He holds a BA in Liberal Studies and an MA in History from the University of Central Florida and has advanced to PhD candidacy in Public History at Middle Tennessee State University. He is the author of *Florida's Highwaymen: Legendary Landscapes* and coeditor of *Zen and the Art of Local History*.

Jennifer M. Black is assistant professor of history and government at Misericordia University in Dallas, Pennsylvania. She holds a PhD in American History and Visual Studies from the University of Southern California, as well as an MA in Public History and a BA in Art History. Her research examines the ways in which people interact with images and objects, and the power of visual and material culture to influence trends in politics, law, and society. Black has worked for several public institutions, including the National Museum for Women in the Arts in Washington, D.C. She has published in the *Journal of American Culture*, *The Public Historian*, and an anthology of advertising history (2014), and has worked as a historical consultant for the

American Society of Mechanical Engineers and Cengage Learning, Inc. Her most recent public history project produced the book *Machines That Made History* (2014), which highlights the contributions of mechanical engineers to global modernization and social life since the seventeenth century.

Julia Brock received a BA in History from the University of Georgia, an MA in Public History and Historical Administration from Florida State University, and a PhD in Public History from the University of California, Santa Barbara. She is assistant professor of public history at the University of West Georgia (UWG) and codirector of the Center for Public History. Before moving to UWG, she was director of interpretation in the Department of Museums, Archives, and Rare Books (MARB) at Kennesaw State University, where she was primarily based at the Museum of History and Holocaust Education. Prior to her current position, Brock worked, interned, and volunteered at public history venues large and small, where she honed a reflexive and community-oriented practice.

Rebecca Bush is curator of history and exhibitions manager at the Columbus Museum in Columbus, Georgia. Interdisciplinary exhibitions and multiple-perspective interpretation have been professional priorities for her, and she has presented on these topics at conferences of the American Alliance of Museums, the American Association for State and Local History, and the National Council on Public History. Bush earned an MA in Public History and a graduate certificate in Museum Management from the University of South Carolina and a BA in History from Kansas State University. She has previously curated exhibitions and worked with museum collections in South Carolina, Maine, and Kansas.

Megan Clark is the school programs coordinator at the Chicago History Museum. She has a BA in Anthropology from Luther College and an MA in Museum and Artifact Studies from the University of Durham, England. At the Chicago History Museum, Clark has overseen the development of the student workshop offerings, which serve over six thousand students annually, and assists in the design and facilitation of student programs and teacher professional development. Clark has also coauthored an article in the *Journal of Museum Education* on museums as field sites for preservice teachers, and presented at an American Association for State and Local History annual conference. Prior to her work at the Chicago History Museum, Clark was the curator of the Museums of Oglebay Institute in Wheeling, West Virginia.

Christy Crisp is the director of programs for the Georgia Historical Society. In that role, she oversees the management of the Georgia Historical Marker Pro-

gram as well as other GHS projects and initiatives such as the statewide Affiliate Chapter Program and the annual Georgia History Festival. She also directs the Society's educational efforts for teachers, students, and the general public.

Nancy Dallett has practiced public history for thirty years. She served as assistant director of the Public History Program at Arizona State University (ASU) and currently is assistant director for Veteran Academic Engagement at ASU with a goal of building bridges among faculty, staff, the public, and students who served in Iraq and Afghanistan to increase their chances of a productive transition to civilian life and academic success. She is also principal of Projects in the Public Interest, a public history consulting firm. She synthesizes the academic fields of history, art, archaeology, environmental sciences, as well as historic preservation and social issues for presentation to general and targeted public audiences. She works collaboratively to engage people via various delivery methods, including exhibits, events, trails and trail signage, print publications, and digital media. As a public historian she has worked to ensure that good history supports a diverse array of projects in museums and websites as well as interpretive signage in national parks and monuments. She has crafted ways for historians to inject good history into public art planning and projects across the country. All of her work aims to diversify perspectives, reveal significance, and explore memory and place.

Tuliza Fleming is a museum curator at the National Museum of African American History and Culture (NMAAHC), Smithsonian Institution. She received her BA from Spelman College (1994) and her MA and PhD in American art history from the University of Maryland, College Park (1997 and 2007). Prior to joining the NMAAHC, Dr. Fleming was the associate curator of American Art at the Dayton Art Institute. For the past twenty years, Dr. Fleming has curated more than twenty exhibitions and worked in and consulted for a variety of museums and cultural institutions including: the August Wilson Cultural Center, The Taft Museum of Art, The Cincinnati Museum Center, The DuSable Museum of African American History, Inc., the National Underground Railroad Freedom Center, the Spelman College Art Museum, the Art Gallery at the University of Maryland, and the National Portrait Gallery. Her publications include, "Cover Stories: The Fusion of Art and Literature During the Harlem Renaissance," "The Convergence of Aesthetics, Politics and Culture: Jeff Donaldson's *Wives of Shango*," "It's Showtime! The Birth of the Apollo Theater," "The 'Museum Baby' Grows Up: Being a Curator of Color in a Monochromatic Art Museum World," *Breaking Racial Barriers: African American Portraits in the Harmon Foundation Collection*, and *Around the Bend: Monumental Steel Sculptures by Bret Price*.

Holly Goldstein is a professor of Art History at the Savannah College of Art and Design. She teaches graduate and undergraduate courses in the History of Photography, Modern and Contemporary Art History, and Theories of Landscape and Place. She received her AB from Princeton University and her MA and PhD from Boston University. Recent publications include the essays "St. Augustine's 'Slave Market': A Visual History" in *Southern Spaces* and "A Garden of Contradictions: Contemporary Southern Landscape Photography" in *Exposure*.

Rebecca Keller is an artist, writer, and professor at the School of the Art Institute of Chicago. Her numerous awards include two Fulbrights, an American Association of Museum International Fellowship, and grants from the National Endowment for the Arts and Illinois Arts Council. She has exhibited widely, including exhibitions at the Museum of Contemporary Art and the Hyde Park Art Center in Chicago; the International Waldkunst Biennial; the Estonian National Art Museum; the Portland Art Museum; the International Museum of Surgical Science; the Tartu Art Museum; the Elmhurst Art Museum; and many others. In recent years her work has focused on history as a category and engine for art-making: her *Excavating History* projects use art and writing to expand and complicate the established narratives of historic sites. These "site-complicit" interventions have occurred in locations as diverse as an anatomy theater in Estonia and the Jane Addams Hull-House Museum in Chicago. Her book about this work, *Excavating History: Artists Take on Historic Sites*, was published in 2012. Keller was a finalist for the Chicago Literary Guild's 2013 prose award, has published short stories and essays in literary journals and anthologies, and has twice been nominated for a Pushcart prize.

Heidi J. Moisan is the school programs manager at the Chicago History Museum where she has worked for more than twenty years. She has an MA and BA in History and Museum Education from Northern Illinois University. Moisan works extensively with school audiences: creating resources, coordinating a teacher advisory board, and developing and facilitating programs that reach more than sixty thousand students. Moisan's project Great Chicago Stories, a website of realistic fiction narratives based on the Museum's collection, received several national awards. She has presented at many conferences, including the American Association for State and Local History, the Illinois Association of Museums, and the Association of Midwest Museums, and she has written for the *Journal of Museum Education* and *The Public Historian*.

Tawny Paul is senior lecturer in history at the University of Exeter (UK). Her work combines academic and public history. Alongside research in

eighteenth-century British social history, she has an interest in how migration history is presented by museums and interpreted by various publics. She earned her BA in History from Vassar College and a PhD in Social History from the University of Edinburgh. She also holds a Postgraduate Certification in Interpretation Management from University of the Highlands and Islands, Scotland. Paul has been involved in a number of public history projects and museum exhibitions throughout the UK, and has advised the Scottish Government on issues of Heritage and Diaspora Engagement Policy. Prior to joining Exeter's faculty, Paul was lecturer in history at Northumbria University Newcastle. Recent heritage publications include "Encountering an Imaginary Heritage: Roots Tourism and the Scottish Diaspora" in *The Global Migrations of the Scottish People*, eds. Angela McCarthy and John McKenzie (2016) and "Migration Heritage and National Identity in Scotland" in *Heritage and Tourism in Britain and Ireland*, ed. Glenn Hooper (2016). She has received fellowships from the Huntington Library, the National Endowment for the Humanities, and the Scottish Centre for Diaspora Studies.

Teresa Bramlette Reeves was born in Athens, Georgia, and received a BFA in drawing and painting from the University of Georgia, an MFA from Virginia Commonwealth University, and a PhD in art history from the University of Georgia. Prior to teaching at Georgia State University (2001–2011), she worked as the curatorial assistant at the following New York City institutions: The New Museum of Contemporary Art, the Guggenheim Museum, and Artists Space. She was formerly the assistant director of the New York Kunsthalle and the gallery director and curator for the Atlanta Contemporary Art Center. She is currently the director of curatorial affairs at the Zuckerman Museum of Art at Kennesaw State University. Bramlette Reeves is also a practicing artist and is represented in Atlanta by Sandler Hudson Gallery. In addition to solo shows at these commercial venues, she has presented solo projects at the Jersey City Museum, P.S. 1 Museum and White Columns, as well as being included in numerous group shows in Atlanta, New Orleans, New York, Cologne, and Paris. She was awarded a Pollock-Krasner Grant and Fellowship Residencies at the MacDowell Colony, Cite International des Arts (Paris), Hambidge Center, and the P.S. 1 National Studio Program.

Kirstie Tepper was born in Sydney, Australia, completed a BCA in fibre arts with distinction from the University of Wollongong, Australia, and has also studied Art History and Public History at the University of California, Irvine, and Kennesaw State University. She is currently a graduate student in Georgia State University's Textile program. Tepper was the recipient of the International Studies Scholarship in 2000 and has taught numerous workshops

in textiles and book arts at Texas Christian University, the University of Texas Arlington, and Kennesaw State University. In addition to participating in group exhibitions, Tepper and her work have been presented in a solo exhibition at Cedar Valley Community College, Texas. In 2005, Tepper relocated to Atlanta, Georgia, and was a member of the Kennesaw State University Art Museum and Galleries staff from 2006 to 2013. She is currently the associate curator at the Zuckerman Museum of Art, which opened in March 2014 at Kennesaw State University. Tepper has coordinated a number of projects and exhibitions with the Arts Council of the city of Prescott, Arizona; The Art Station Big Shanty in Kennesaw, Georgia; and Kennesaw State University.